De Chirico

De Chirico

Essays by

Maurizio Fagiolo dell'Arco

Joan M. Lukach

William Rubin

Marianne W. Martin

Wieland Schmied

Laura Rosenstock

Edited by William Rubin

The Museum of Modern Art, New York

Contents

Published in conjunction with "Giorgio de Chirico," an exhibition organized under the auspices of the International Council of The Museum of Modern Art and made possible by a generous grant from Martini & Rossi. Additional support has been provided by the National Endowment for the Arts, and an indemnity for the exhibition has been provided by the Federal Council on the Arts and the Humanities.

It is both appropriate and gratifying for Martini & Rossi, the international company with its roots in Italy, to sponsor this exhibition of the work of Giorgio de Chirico. We are particularly pleased to be able to assist in furthering the appreciation of an Italian artist whose work is so important in the history of twentieth-century art.

Martini & Rossi's support for the arts, and for this particular exhibition, is but a reflection of our belief that art plays an important role in our lives, fostering sensitivity, understanding, and creativity.

We are proud to be associated with The Museum of Modern Art, the National Endowment for the Arts, and the Federal Council on the Arts and the Humanities in presenting this exhibition.

Gianni Rubatto, *Chairman*
Martini & Rossi, Italy

Were exhibitions at The Museum of Modern Art dedicated to individuals, this one would surely be dedicated to James Thrall Soby. Rarely does the scholarship on an artist's work depend so heavily on the activities of a single person as in the case of de Chirico and Soby. Not only did Soby's writing and proselytizing do much to make de Chirico's early work known in America—indeed, throughout the world—but he was personally involved with many acquisitions of the artist's work by a variety of American museums—which accounts for their disproportionate share of key early de Chiricos. Soby's two books on de Chirico, the later one a model of monographic treatment of an artist, have formed the basis of the scholarly literature on Metaphysical painting, and the works in his own collection, bequeathed to The Museum of Modern Art at his death, have contributed to making our representation of de Chirico a museological rarity of depth and range. Having worked with this delightful man on and off over the years, I profited especially from our discussions of de Chirico's work, which helped me greatly in developing my own views.

Foreword

James Thrall Soby and Alfred Barr, during their years at The Museum of Modern Art, focused their collecting and exhibiting interests on de Chirico's early, pre-1920 painting. They found the artist's subsequent work both less good and less relevant to modern painting as a whole. In recent years certain critics have questioned this judgment and have vigorously championed de Chirico's later work. I find the distinction made by Soby and Barr to be essentially correct, though I have modified their policy to the extent of exhibiting and reproducing a small selection of the later work, primarily from the 1920s. I have, of course, chosen the very best examples we could obtain from this period so as to permit our visitors to make their own judgment on the change in the artist's work.

Giorgio de Chirico's best painting marks him, I believe, as the greatest Italian painter of this century—indeed, since the eighteenth century—and I am happy to have helped make possible the first in-depth, large-scale exhibition focusing on the great early work ever to be held. An exhibition that brings together works from many countries in Europe and elsewhere is bound to be a costly one, and for making this endeavor possible we are exceedingly grateful to Martini & Rossi; without their support the exhibition could not have taken place. A generous grant from the National Endowment for the Arts has also sustained this project. In addition, the Federal Council on the Arts and the Humanities, through the Art and Artifacts Indemnity Act, assisted our endeavor by providing foreign-loan coverage. The International Council of The Museum of Modern Art has provided a grant toward the cost of this publication.

The preparation of this exhibition and accompanying volume has required the assistance and collaboration of many people. On behalf of the Trustees of The Museum of Modern Art, I wish to acknowledge a great debt of gratitude to all the lenders to the exhibition, who have generously consented to share their works knowing that they would be deprived of them for many months. In addition to a number of lenders who wish to remain anonymous, our deepest thanks are due the following owners of works included in the exhibition: Kunstmuseum Basel; Albright-Knox Art Gallery, Buffalo, New York; The Art Institute of Chicago; The Cleveland Museum of Art; The Detroit Institute of Arts; Kunstsammlung Nordrhein-Westfalen, Düsseldorf; The Tate Gallery, London; Civica Galleria d'Arte Moderna, Milan; Peggy Guggenheim Collection, Venice, The Solomon R. Guggenheim Foundation, New York; The Metropolitan Museum of Art, New York; Musée d'Art Moderne de la Ville de Paris; Musée National d'Art Moderne, Centre National d'Art et de Culture Georges Pompidou, Paris; Philadelphia Museum of Art; Galleria Nazionale d'Arte Moderna e Contemporanea, Rome; The St. Louis Art Museum; San Francisco Museum of Modern Art; Moderna Museet, Stockholm; The Toledo Museum of Art, Toledo, Ohio; Munson-Williams-Proctor Institute, Utica, New York; Norton Gallery and School of Art, West Palm Beach, Florida; Kunsthaus Zürich; Mr. and Mrs. James W. Alsdorf, Chicago; Jacques Benador, Geneva; Claudio Bruni Sakraischik, Rome and New York; Giovanni Deana, Venice; Giulio Einaudi Editore S.p.A., Turin; Selma and Nesuhi Ertegun Collection; Mr. and Mrs. E. Estorick; John R. Gaines, Lexington, Kentucky; Mr. and Mrs. Jacques Gelman, Mexico City; The Alex Hillman Family Foundation, New York;

Trustees Edward James Foundation, Chichester, England; Collection Maramotti, Albinea, Reggio Emilia, Italy; Mr. and Mrs. Morton Neumann, Chicago; Ophiuchus S.A.; Giulia Pagliai, New York; Judith Rothschild, New York; Sylvia and Joe Slifka, New Jersey; Rolf and Margit Weinberg, Zurich; Mr. and Mrs. Leonard C. Yaseen; Philippe Daverio Gallery, Milan; Marie-Louise Jeanneret, Art Moderne, Geneva; Modern Gallery S.A., Geneva.

Particular thanks are due to many de Chirico connoisseurs, both scholars and dealers, who have aided us enthusiastically. Claudio Bruni Sakraischik has given liberally of his time, and his knowledgeable catalogues raisonnés of de Chirico have been especially helpful reference tools. Mario Tazzoli, Massimo Martino, and Maurizio Fagiolo dell'Arco have steadily assisted with this exhibition. They have been especially helpful in ascertaining the locations of many de Chirico works and have unstintingly negotiated on our behalf to secure essential loans.

Others who have willingly given their time and expertise to assist us in locating works and who have graciously provided valuable information are William Acquavella, Ernst Beyeler, Ester Coen, Emily Farrow, Richard Feigen, George de Geofroy, Pierre Matisse, Wieland Schmied, and Eugene Thaw. Ernst Beyeler and Eugene Thaw in addition devoted much time to assisting us with problems related to securing U.S. Government indemnification. I extend my very warm thanks for their help. Alan Dodds, Cultural Attaché at the Embassy of the U.S.A. in Rome, has kindly assisted in connection with expediting Italian loans.

We are pleased that a version of the exhibition will be seen in London, Munich, and Paris, and we wish to acknowledge the participation of our colleagues—Alan Bowness, Director, The Tate Gallery, London; Peter Ade, Director, Haus der Kunst, Munich; and Dominique Bozo, Director, Musée National d'Art Moderne, Centre National d'Art et de Culture Georges Pompidou, Paris—who have enthusiastically cooperated in plans for the European showing. Particular thanks are owed to Gérard Régnier of the Musée National d'Art Moderne, Centre National d'Art et de Culture Georges Pompidou, who has generously expended time, effort, and expertise on this project. Special thanks are also due Waldo Rasmussen, Director of The Museum of Modern Art's International Program, as well as the International Council of The Museum of Modern Art, under whose auspices the exhibition will travel.

To the authors of the essays in this volume goes a special tribute for their contributions to our knowledge and understanding of de Chirico. They have been sources of essential advice and aid.

My colleagues at The Museum of Modern Art have given generously of their knowledge, advice, and time. Foremost is my enthusiastic collaborator on this project, Laura Rosenstock, Assistant Curator in the Department of Painting and Sculpture. For her untiring attention to every aspect of both exhibition and book I am profoundly grateful. My special thanks go also to Judith Cousins, Researcher in the Department of Painting and Sculpture, who has gathered much needed documentation and whose painstaking research has benefited all the contributors to this book. Also in the Department of Painting and Sculpture, Jane Sanders has handled much of the work of obtaining photographs and carried out many related duties with great skill. My secretary, Ruth Priever, has admirably dealt with voluminous correspondence, as well as handling related projects with her customary thoroughness. Diane Farynyk, Loan Assistant, has diligently supervised the complicated logistics of various loan exchanges. My assistant, Sharon McIntosh, has been, as always, invaluable.

I should like to thank especially Richard E. Oldenburg, Director of The Museum of Modern Art, whose support and encouragement for this undertaking have been greatly appreciated. Richard Palmer, Coordinator of Exhibitions, has lent his enthusiastic cooperation to this project and supervised the many administrative details in its organization. I should also like to thank both Caroline Jones, Associate Coordinator of Exhibitions, for her attention to problems related to U.S. Government indemnification, and Mr. Palmer's assistant, Rosette Bakish.

Additional thanks are due Anita Peduto and Rose Kolmetz for their unstinting

assistance and good cheer in translating correspondence and undertaking complicated overseas telephone calls. Among many other members of the Museum's staff who have assisted in various ways I would like to thank Jean Volkmer and the Conservation Department, most particularly Terrence Mahon; Cherie Summers, Associate Registrar; Richard Tooke, Supervisor, Department of Rights and Reproductions; Kate Keller and Mali Olatunji for much of the necessary photography; Claudia Bismark; Esther Carpenter; Fred Coxen; Frances Keech; Antoinette King; Nancy Kranz; Luisa Kreisberg, John H. Limpert, Jr.; Myrna Martin; Jerome Neuner; Clive Phillpot; Ethel Shein; Angela Wigan; Sharon Zane.

A particular debt is owed the Department of Publications for the preparation of this volume. Francis Kloeppel brought his customary perception and thoroughness to the editing of this book and deserves my special thanks. Christopher Holme, Managing Editor and designer of this publication, has enriched this volume and has my profound appreciation. Timothy McDonough, Production Manager, has seen the book through with skilled professionalism. Louise Chinn, Acting Director, was particularly helpful. Andrius Balukas and others have assisted with this publication. Kathleen Fluegel translated Wieland Schmied's essay from the German. Not on the Museum's staff, John Shepley translated from the Italian the contribution of Maurizio Fagiolo dell'Arco, and Joan M. Lukach, recruited for the final phase of preparation, contributed to the realization of the book.

To all those who have so liberally given of their knowledge, time, and skill, and whom it is not possible to list, I wish to express my deepest appreciation.

William Rubin, Director
Department of Painting and Sculpture
The Museum of Modern Art

TO study the work of the great Metaphysician is a particularly delicate procedure. Aside from Soby's book and the iconography of the General Catalog, virtually nothing of consequence existed at the time (1979) when I began to publish the results of my research. Today, at least I am acquainted with all the writings, some correspondence, and many documents. I think I have clarified the problem of copies, I have identified a number of forgeries, and above all I believe I have arrived at a reliable catalog (about 130 works from the Metaphysical period, 100 from the *Valori Plastici* period until 1925, about 200 from the later Paris period until 1929). Much remains to be done, especially in the field of interpretation (complicated most often by de Chirico himself with his method of the Enigma).

It is an interesting fact that the "discovery" of Metaphysical art is recorded by the artist, in speaking of the painting *Enigma of an Autumn Afternoon* (pl. 4).

Let me relate how the revelation of a painting that I will present this year at the Salon d'Automne, entitled *Enigma of an Autumn Afternoon,* first came to me. One clear autumn afternoon I was sitting on a bench in the middle of the Piazza Santa Croce in Florence. Of course it was not the first time I had seen this square. I had barely recovered from a long and painful intestinal illness and was in a state of almost morbid sensitivity. The whole world around me, including the marble of the buildings and fountains, seemed to me to be convalescing. At the center of the square stands a statue of Dante, wearing a long tunic and clasping his works to his body, his head crowned with laurel and bent thoughtfully forward....The hot, strong autumn sun brightened the statue and the facade of the church. Then I had the strange impression that I was looking at these things for the first time, and the composition of the painting revealed itself to my mind's eye. Now every time I look at this picture, I see that moment once again. Nevertheless the moment is an enigma for me, in that it is inexplicable. I like also to call the work derived from it an enigma.

This was his first work to be free of the influences of Böcklin and also the first to be publicly exhibited (Salon d'Automne, 1912). Thus in the fall of 1910 de Chirico is in the Piazza Santa Croce in Florence: he looks at his surroundings (a broad space, a Gothic church, a nineteenth-century monument), but because of his psychological condition he succeeds in painting (and seeing) something quite different (a compressed space, a Greek temple, an ancient statue). Herein lies the whole meaning of Metaphysical art: to see something and go beyond it. And in this sense the word *meta-fisica* has a bearing on *surréalisme* (the word coined by Apollinaire, perhaps under the influence of de Chirico, and which Breton was triumphantly to introduce into twentieth-century culture).

De Chirico's early education was more philosophical than pictorial. Schopenhauer was among the first influences (I have published his translations of the poems, actually done in Paris in 1913), then Weininger and his extreme subjectivism (the same "metaphysical" conception emerges from the book *Uber die letzten Dinge),* and above all Nietzsche. In his extraordinary early writings de Chirico reveals that it was from the "mad" philosopher that he perceived the importance of *revelation:*

When Nietzsche tells how he came to conceive Zarathustra and says, "I was surprised by Zarathustra," all the enigma of a sudden revelation is contained in this participle "surprised." When (in another case) a revelation is generated by the sight of a composition of objects, then the work that is manifested in our thoughts is closely connected with the circumstances that provoked its birth. The one resembles the other, but in a strange way, as two brothers resemble each other, or rather as the image of someone we know, by having seen it in a dream, resembles the actual person, and at the same time is not the same person, as though there had been a slight and mysterious transformation of features.

"An artist for everyone and for no one," we might thus call de Chirico, paraphrasing the subtitle of *Zarathustra.*

As for the visual sources, let us state them once again: Böcklin and Klinger, the German Romantics, Greek statuary. I have shown that one of the first Metaphysical pictures, *The Enigma of the Hour* (pl. 10), derives not from Italian architecture (as Soby would have it), but is virtually lifted from a Böcklin (to become refined, in a drawing illustrated here, to the point of conceptual sublimation). Also from Böcklin derives his Ulysses

De Chirico in Paris, 1911-1915

Maurizio Fagiolo dell'Arco

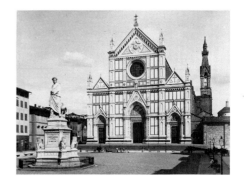

Piazza Santa Croce, Florence

consulting the oracle, in the other early picture, *The Enigma of the Oracle* (pl. 6), as do many of his self-portraits, as well as the attitude toward an art that is first mental before becoming pictorial. From Klinger derives the displacement of the object (the often-cited "glove," but also the shadow, and even the "mysterious baths," as de Chirico himself states in a piece written in 1920).

Through his philosophers and lengthy, silent experimentation, de Chirico discovered his method of the Enigma: his works have a general meaning, and every detail contains one (the flute refers to Schopenhauer, the eggs to Greek myth, the artichokes to the story of Dionysus, and so forth), but once the meaning was painted it was hidden by the Painter of Enigmas. I have often been able to catch de Chirico in the act of carefully concealing his own creations. For instance, two pictures were entitled by him *Amalfi Landscape* and *Seascape with Rocks,* while I was able to identify them with those exhibited in Buenos Aires under the titles *Prometheus* and *The Sphinx* (a kind of "double image" that anticipates Dali). I had to write a book to decipher one painting, *The Dream of Tobias* (pl. 75), which was to become symbolic of the birth of Surrealism. In January 1921, de Chirico called *Mercury Bidding Farewell to the Metaphysicians* one of his most important works, yet in a contract dated November of the same year it becomes, innocuously, *The Moving Statue* (and it is under this title that the painting still exists).

Indeed, his protector is Hermes (whence "hermetic"—i.e., secret, hidden—derives), in whose guise he painted his self-portrait in 1942. In a famous *Self-Portrait* of 1923 (pl. 88), Hermes appears behind the artist, whose hands are held in a strange pose. De Chirico at the time was in his "classical" period (another kind of searching for roots by this displaced person of art), and for those hands he copied the Virgin in Antonello da Messina's *Annunciation.* The pose derived from the older picture is by no means fortuitous: if Hermes is the messenger (equivalent to the angel of the Christian religion), de Chirico, like the Virgin, is the recipient of the message. But it all remains a hermetic mystery, an enigma.

"L'esprit nouveau"—the climate of prewar Paris was to be summed up in this formula of Apollinaire's. After Munich and Milan, Andrea de Chirico was the first to arrive in Paris (February 25, 1910), and later, summoned by his brother, Giorgio de Chirico arrived from Florence (July 14, 1911): "Paris was celebrating: people were dancing on the sidewalks, in front of the cafés, and the bands played without letup."

De Chirico explains the "modern" feeling of the city and its particular *Stimmung* (mood) in a splendid passage written on the eve of his return to Paris ten years later:

As you leave the station and enter the heart of the city, the scenery becomes increasingly magical; you have the feeling of being inside a huge jack-in-the-box, of finding yourself before the open stage of a wonderful theater: the backdrop is the soft gray mist that joins the sky to the earth and to the constructions of men, constructions that are also gray, curious and hospitable sources, standing solemnly and unexpectedly to right and left like enormous theater wings, from which

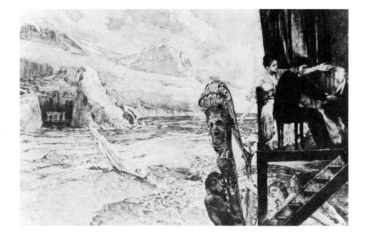

Arnold Böcklin. *Arcade in a Landscape.* 1872

Giorgio de Chirico. *Enigma of the Arcade.* 1913
Ink and pencil
Private collection

Max Klinger. "Accord," from *Brahms Fantasies.* 1894
Engraving cited by de Chirico in a 1920 article; prelude to *Mysterious Baths,* 1934

spring forth, like the figures of a magic lantern, hurrying throngs of men and vehicles, strange and variegated herds (I am reminded of a line from Apollinaire: *bergère tour Eiffel...*). ...At night the mystery does not fade. The shops close their doors, but the windows, like theaters on gala evenings, stay lit. And whole scenes, dramas of modern life, are reconstructed in the small space of the shopwindow-theater....

Metaphysical realism is sometimes carried to its height by the tricks and scrawls of an old hand at metaphysical surprises. Thus in a window showing a group of ladies and gentlemen with their children on a Riviera beach, I thought of the Odyssey and of wandering Ulysses, for indeed a piece of canvas, placed in front of the scene and artistically brushed with ultramarine blue and Veronese green, represented the edge of water lapping the beach, while all around little sandpiles offered themselves to the building games of phantom babies, and conches, few but well distributed, with iridescent spirals, completed the lyricism of this Homeric vision....

Modernity, that great mystery, dwells everywhere in Paris; you find it again at every street-corner, coupled with what once was, pregnant with what will be. The image of Pallas Athena that stands, a stone sentinel, to the right of the ancient Palais Bourbon is as solemn as certain solemn representations by the great modern metaphysical painters and as that other image of the same goddess that near the Propylaea of the Athenian Acropolis kept watch leaning on a staff, motionless in the midst of the zigzag flight of the shrill swifts in the sultry summer twilight, on that evening when not far away, under the low vaults of a prison cell excavated in the rock, Socrates awaited death while speaking of mysterious things to his weeping disciples....

Like Athens in the days of Pericles, Paris today is the city par excellence of art and the intellect. It is there that any man worthy of the name of artist must exact the recognition of his merit.

In this extraordinary passage one immediately notices the overlapping of reality and memory, vision and daydream, mythology and what I would call "pop" iconography — and out of it all the "myth" of Paris emerges. The idea of a capital city of the spirit (like, as he says, the Athens of Pericles) is present in the pages of his early writings (and later in the twenties as well). I point out a few aspects of this Paris iconography:

The Tower: In 1912 and 1913 de Chirico painted a few extraordinary pictures devoted to the celebration of this "lofty" theme. Even though it does not appear as such, it is the idea of the Eiffel Tower (years later, he remembers it by the lines from Apollinaire as *bergère* ["shepherdess"]) made more Greek and less an engineering feat. The picture he gives to Apollinaire shows a tower, perhaps also as a "metaphysical" response to Delaunay's "simultaneity."

The Chimneys: They are the emblem of the "city that rises." But in de Chirico's mind (he will rediscover these smokestacks in Ferrara) they are connected with a faithful photographic image of Paris, when he speaks of Apollinaire "in the sadness of that fatal Avenue de l'Observatoire, situated almost at the outskirts of the city, there where the smoking haven of laborious workshops begins and the forests of red chimney pots rise" (it is Montparnasse, where he lived in his Paris days).

The Signs: In the pursuit of what is twofold or absent, it is logical that the themes appearing in the paintings (especially the large eyeglasses or the large hands) should

Giorgio de Chirico. *Prometheus* (entitled by
de Chirico *Amalfi Landscape*). 1909
Oil on canvas, 46⅛ x 31⅞" (117 x 81 cm)
Private collection

Giorgio de Chirico. *The Sphinx* (entitled by
de Chirico *Seascape with Rocks*). 1909
Oil on canvas, 29⅞ x 47¼" (76 x 120 cm)
Private collection

go back, as indicated in the texts written at the same time (by Savinio as well), to the
signboards of the modern city.

The Station: "Peintre des gares" — this, it would seem, is how Picasso spoke of him
to Apollinaire. In fact (and this is confirmed by Savinio), the railroad station was always
one of de Chirico's favorite haunts. The station of his childhood was now identified
with the Gare Montparnasse, located at the edge of the city.

In short, even when de Chirico claims to be depicting Italy, his mind's eye cannot
leave out of consideration the images of the city that is giving him hospitality. And the
essential theme in his search for a "metaphysical" vision, as already attested by his first
painting, is precisely the City.

At first de Chirico lived with his mother in a hotel, and later in a dignified private mansion
at 43, rue de Chaillot, between the Etoile and the Seine (this address appears in the Salon
d'Automne catalogs). As usual he moved around: in the 1913 catalog of the Salon des
Indépendants his address is given as 42, rue Mazarine (in the middle of the Latin
Quarter), later he lived at 115, rue Notre-Dame-des-Champs (where he held a show
reviewed by Apollinaire), and finally at 9, rue Campagne-Première (between the Boulevard
Raspail and Boulevard Montparnasse, which is to say between the offices of *Les Soirées
de Paris* and Apollinaire's apartment).

In the course of four years (in the summer of 1915 the Dioscuri left for Italy to
enlist in the army), Andrea became the musician Albert Savinio, and Giorgio exhibited
his paintings for the first time at the age of twenty-four, gaining Apollinaire's increasingly
enthusiastic approval and his first contract (with Paul Guillaume) for his pictures, in
which the "metaphysical" is expressed by tangible images.

The cultural climate in 1912-13 was a fervid one. Cubism arrived at its dialectic with
Futurism through Apollinaire, who had signed a Futurist manifesto and by now was going
through the phase of Orphism (when he published *Les Peintres cubistes* in 1913,
Apollinaire was the historiographer of a movement that had stalled). The new art was
being presented at the Salon d'Automne and the Salon des Indépendants. New tendencies
were represented by the presence of Kandinsky and Mondrian in the Salons. Brancusi
and Modigliani were propounding the new sculpture (which was also the epilogue to
that ancient technique). The Futurists exhibited in 1912, but the exhibition of
Boccioni's sculptures in 1913 would seem to have been more important. The period
appears sealed by the international exhibition in the New World: the Armory Show
opened on February 17, 1913 (the Italian avant-garde did not appear in it by choice).

In the literary field Guillaume Apollinaire was pontificating in every sense of the word. Max Jacob and Blaise Cendrars (both of them always on good terms with painters) were asserting their talents. The magazine *Les Soirées de Paris,* edited by Apollinaire, printed their poems, and there were also the dissidents Arthur Cravan (with *Maintenant*) and Ricciotto Canudo (with *Montjoie!*). There were early contacts with Germany *(Der Sturm)* and later ones with Italy *(Lacerba, La Voce).* Apollinaire set the tone for the new art criticism, and other poets and writers, such as André Salmon and Maurice Raynal, followed him (they were also the first to write about de Chirico). New interests were born, as for the cinema (which was to arouse Savinio's enthusiasm): Raynal carried on a column about it in *Les Soirées de Paris,* and Apollinaire conceived subjects for this new form of communication.

It was Louis Aragon, in his extraordinary "Projet d'histoire littéraire contemporaine" (published in *Littérature* in 1922), who was to provide the key for understanding these fervent years. Along with Apollinaire, in what he calls "the period of *Les Soirées de Paris,*" de Chirico and Savinio appear among a few others.

Apollinaire became the editor of *Les Soirées de Paris* in February 1912, but it was not until November 1913 that the magazine (and the circle around it) acquired its full and striking capacity. It was financed by two extravagant characters: the Baroness d'Oettingen (she wrote under the name of Roch Grey and painted under the name of François Angiboult) and Serge Jastrebzoff (who painted under the name Serge Férat and wrote as Jean Cerusse). In the new series appeared groups of reproductions (Picasso, Rousseau, Derain, Picabia, Braque, Matisse, Archipenko, Léger), poems by the new poets (Jacob, Dalize, Cendrars), cinema, and music (Gabrielle Buffet, before Savinio). We find the signatures of Soffici and Papini, and in the last issue a good review of the Imagists, as well as accurate coverage of events in the capital of art.

It was here that Savinio's theories on music appeared, the program and account of his concert at the magazine's offices, and the text of his "Chants de la mi-mort."

In the magazine's records the name of Giorgio de Chirico appears in the list of subscribers at the end of 1913.

Savinio and de Chirico may have been introduced to this vital circle by Ardengo Soffici, who had been the Baroness d'Oettingen's lover ever since he had begun making a living in Paris by providing illustrations for the magazine *L'Assiette au Beurre.*

De Chirico's memory of this period is precise, and Savinio writes appreciatively of Apollinaire, the poet who took it on himself to turn to account the "metaphysical" art of Giorgio de Chirico and the "new music" of Andrea de Chirico. It was just at this time that the younger of the two brothers changed his name to "Albert Savinio." His first reason may have been to distinguish himself from his brother, but another may have been to emulate Apollinaire's similar gesture. As for the name he chose for a lifetime, it came, as Nino Frank recalls, from the wish to identify himself with a versatile (but now forgotten) writer named Albert Savine, a figure who also appears in Apollinaire's literary chronicles.

In February 1912, at the end of a review (of a concert of Italian music organized by Casella) one still finds the signature "A. de Chirico." The name "Albert Savinio" appears on musical scores, both on first publication (April) and in the program printed in *Les Soirées de Paris;* one can therefore suppose that the need for the pseudonym arose in connection with his debut in *Les Soirées de Paris* (from whose pages another de Chirico was known).

In Apollinaire's circle, and at the magazine's offices on the Boulevard Raspail, the Dioscuri were able to meet painters, sculptors, and poets. Francis Picabia was one of Apollinaire's close friends, and he was to be the first painter, along with de Chirico (at Apollinaire's suggestion), on whom the young dealer Paul Guillaume was to place his bets (the advertising for his gallery appears in the magazine with these names). There was Picasso with his great personality (he was one of the few artists whom de Chirico and Savinio always respected); there was Derain, with whom de Chirico was to find himself at odds; there was the great Brancusi, who was even to have an influence on the polished

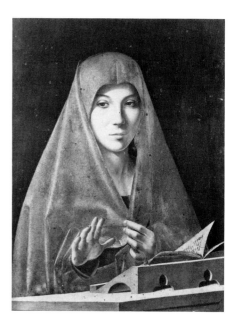

Antonello da Messina. *Annunciation*

heads of de Chirico's mannequins; there were Larionov and Gontcharova, to whom Savinio was to devote a witty short story; there was Pierre Roy, who was to make a woodcut of de Chirico's portrait of Apollinaire (and he was the first follower of Metaphysical art). For de Chirico almost all these artists were remote, virtually absent.

The circle was frequented by others as well ("removed" from the Dioscuri). First of all, the Futurists: Apollinaire was a vigorous spokesman for the movement, but later moved away from it, as can be seen in the pages of the magazine itself. Then, the isolated Modigliani, whom de Chirico (like Savinio) esteemed in the beginning. Among the poets, we find the eccentric Max Jacob, Blaise Cendrars, Pierre Reverdy, and the young Cocteau (who will become the new Apollinaire for the de Chirico brothers during their second Paris sojourn).

Confirmation of the close friendship between Savinio and Apollinaire is provided by manuscripts that still form part of the Savinio estate. The most important is the original of the first *calligramme,* published in the same issue of the magazine that reported on Savinio's concert. But there are also the definitive autographs for "Epithalame" and "L'Ignorance" (in fact it was Savinio himself who sent them to the editors of *Littérature,* the magazine in which they appeared for the first time in 1924) and other manuscripts and drawings by the poet. It is obvious that the young Savinio was drunk with admiration for his beloved poet friend (as also appears from his memoirs), who repaid his devotion with his autographs, the most precious gift from a poet.

Et moi aussi je suis peintre, proclaims the title of the first collection of *calligrammes,* published by *Les Soirées de Paris* and preceded by de Chirico's enigmatic portrait of Apollinaire rendered in a woodcut by Pierre Roy. In fact, the poet had always engaged in drawing, and his *calligrammes* are not an imitation of Futurist typography but a manner (actually found also in the French Renaissance) of composing words in images. One speaks of rain by showing it, in effect, or of a clock by arranging the words in the shape of a clock, and so on (a cigar, a necktie, a heart, a mirror, the Eiffel Tower, etc.). The first *calligramme* appeared in *Les Soirées de Paris* (June 11, 1914), and it has connections with the art of the Dioscuri. De Chirico lucidly catches the significance of the operation:

He underwent the influence of those he championed; he extolled the new painters and in him they planted new germs.

His *Calligrammes* are the product of this influence, and they have nothing in common with the Futurists' free use of words. These *Calligrammes* are collections of poems whose lines undulate softly in Egyptian hieroglyphs, tracing on the white of the paper the rectangles and spirals of his chronic melancholy as a poet with a sad destiny.

In 1929 in Paris, de Chirico returned to these poems, in an extraordinary undertaking for Gallimard: sixty-six exceptionally imaginative lithographs. René Gaffé, collector and friend of de Chirico, reports the artist's memories:

For the lithographs that you have before your eyes, he told me, I was inspired by memories that go back to the years 1913 and 1914. I had just made the poet's acquaintance. Avidly I read his poems, which frequently have to do with suns and stars. At the same time, by a detour of thought familiar to me and whose reflection is often expressed in my paintings, I was dreaming of Italy, of its cities and ruins. Quite soon, for me, by one of those flashes that, all of a sudden, let you find the object you are dreaming of at arm's reach, the suns and stars came back to earth like peaceful emigrants. They had probably been extinguished in the sky since I saw them light up again on entering the porticoes of so many houses. Was it unreasonable of me to base on the fantasy in my mind and the state of my visions the lithographs that were going to have to stand side by side with the poetic scales on which Apollinaire played as a true visionary?

It was in 1914, when attuned to the *calligrammes,* that de Chirico painted his only picture with words. This was *The Fatal Temple* (pl. 39), in which, next to the blackboard on which ("in Egyptian hieroglyphs") mathematical signs and details of faces are drawn, and alongside the mirrored figure (Narcissus?) and the upside-down fish (the same one that appears in the portrait of Apollinaire), one can read various words: "Joie-Souffrance-éternité d'un moment-énigme-chose étrange-non sens." The hieroglyphs relate it to other works of the moment, which moreover are in close harmony with the portrait of

Apollinaire. Was it only by chance that de Chirico asked the poet to dedicate a *calligramme* to him? (And Apollinaire was to do so, with the poem "Océan de terre," published in *Nord-Sud* in December 1915.)

It is well to remember at this point that the painter de Chirico was accompanied by that other Argonaut, his musician brother Andrea, who in Paris became Albert Savinio. It was Apollinaire who encouraged him and persuaded him to give his first concert, held in the rooms of *Les Soirées de Paris* (May 24, 1914). His musical theory was announced in the magazine: his wish to reunify drama and music, his desire "to reveal what modern metaphysics contains of the dramatic, the terrifying, the unknown, and the impassioned," his effort to create music that would no longer be harmonic or harmonized, but "disharmonized," with a new form of collage ("melodies that recall well-known songs, rhythms that repeat familiar rhythms to the point of obsession, peasant themes, burlesque music, the Garibaldi anthem, drum rolls, etc."). Apollinaire wrote at length about the concert and the "new music" of de Chirico's brother in certain well-known texts, but I prefer to quote an uncollected review in which (under the pseudonym Wofram) he records those present—Picabia with Gabrielle Buffet, Picasso, Jacob and Raynal, Soffici and Canudo, Archipenko and Guillaume, Roy and the mother of Andrea and Giorgio— and stresses the originality of the event:

The audience, surprised at first, was not long in discovering the composer's intentions. The simplicity of conception of "his" dramatic music has found its proper partisans. Too much knowledge is harmful, and unfortunately even the most modern music is nothing but its slave. Friends of classicism were a little disappointed. To such a degree that, shocked for a moment, they soon recognized the profound originality and innovation of intention in the works that A. Savinio executed at the piano with consummate mastery.

From these texts and other reports, it is clear that Savinio (who called himself a "Dionysiac artisan") was carrying out in the musical field a choice similar to de Chirico's in the field of painting: a reordering of memories and dreams, without binding himself to any contemporary trend.

Savinio's debut as a painter falls in this same period. His visual elements are few and all are symbolic: target figures, shadows, heads of Zeus, carefully drawn arcades, the ship of the Argonauts, his own initials large as the name on the prow of a ship, an archaic statue. The technique is uncertain, almost naïf, mindful of the work of his brother. The titles are given in French on the paper on which the paintings, small as diary pages (a diary based on the "tragedy of childhood"), are mounted. It was de Chirico who recorded Savinio's debut as a painter, but it was Guillaume Apollinaire himself who was to point specifically to this (long unknown) talent of his: "Monsieur Savinio, who is a poet, painter, and playwright, in this resembles the many-sided geniuses of the Tuscan Renaissance."

De Chirico's memoirs are particularly valuable for these early years, but Savinio also reports events with the freshness of an eyewitness. Other information can be gleaned (albeit slowly) from documents and a few surviving archives. The scene of de Chirico's debut was the Salon d'Automne and the Salon des Indépendants. By unearthing the official catalogs and comparing the various sources, it is possible to reconstruct the core of de Chirico's exhibited works. There were four Salons between 1912 and 1914, and of the thirteen paintings shown, ten can be identified with certainty. Here is the first Salon, as described in the artist's memoirs:

I was advised to exhibit at the Salon d'Automne; I knew, however, that an unknown painter who sends works to an official show where there is a jury runs the risk, ninety-nine times out of a hundred and quite apart from the quality of his works, of being rejected....A Greek gentleman by the name of Calvocoressi came to my aid; he was a music critic, or rather a musicologist; he was a friend of Debussy and had many contacts in the intellectual and artistic circles in the capital; he recommended me to the French painter Laprade, whom I had never heard of, but who was a member of the Salon d'Automne jury.

...I submitted a self-portrait [pl. 7] and two small compositions, one of them inspired by the Piazza Santa Croce in Florence [pl. 4] and containing that exceptional poetry I had discovered in

Nietzsche's books, while the other, which I had entitled *The Enigma of the Oracle* [pl. 6], contained a lyric feeling of Greek prehistory. The three pictures were accepted, and I felt much joy and pride. It was the first time I exhibited and that a jury accepted my works. My three paintings were very well hung, all three together, in a room of Spanish painters.

The three pictures had been painted in Florence, since de Chirico had done little work in this Paris period (his intestinal ailment pursued him for the whole year of his arrival—he took the cure at Vichy—until the following summer):

When the cure was over and I returned to Paris, I had recovered completely. It was some time since I had picked up a brush or even a pencil. I went back to work and resumed the thread of my Nietzschean inspiration. But I did little work and painted few pictures. The winter and summer went by; I heard confusing talk of the Salon d'Automne, of "revolutionary" painters, of Picasso, of Cubism, of modern schools, etc.

I have explained elsewhere how the paintings he had brought from Florence, and a few others begun previously and finished in Paris, had been signed on the very occasion of the Salon d'Automne: "Georgio de Chirico" is the name that appears on the pictures and in the Salon catalog (besides the other error "né à Florence" [born in Florence]). From the conception of Metaphysical art (autumn 1910) to the first public showing, there are scarcely more than ten known paintings.

It was his state of excitation, due to the quite modest success of the Salon, that made him work hard in the winter of 1912. One of the first pictures, *Melancholy of a Beautiful Day,* bears the new signature "G. de Chirico" (the very dilute and transparent paint of the pictures from 1910-12 becomes thicker): the piazza theme is expanded, the key figure of Ariadne appears, the towers rise toward the infinite. It is in this period that he was to meet Apollinaire.

In the course of 1913 his painting gains in depth: the cyclical method begins. There are many towers (Greek metaphor for the Eiffel Tower), the elements of a banquet (artichokes) appear in the foreground, even exotic ones (bananas, pineapples). Greek sculpture begins to crowd the ever more extended, absurdly perspectived space, crossed by the sharply defined shadows of the Nietzschean "great noon." In the fall he again exhibited at the Salon d'Automne, where he sold his first picture, *The Red Tower* (pl. 13). In the same period he exhibited some thirty paintings in his studio: Apollinaire's review (unknown) almost constituted recognition. The 1914 Salon des Indépendants presented his work at the height of its maturity.

It is precisely on the occasion of this Salon that we have extraordinary evidence of de Chirico's polemical attitude toward the critics. In a letter to the editor of *Paris-Midi* (March 16, 1914), he spares only Apollinaire, while directing a specific accusation at those critics who had spoken of his pictures as "scenography":

Dear Editor,
I ask your kind cooperation in protesting a misunderstanding regarding my paintings, expressed among critics who have reviewed the "Indépendants." Except for Apollinaire, almost all of them have spoken of "theatrical scenography." Now I would like these gentlemen to know that my pictures have nothing to do with scenography, a fact sufficiently proven moreover by their titles.
I would be very grateful if you would publish this in your newspaper.
Yours very sincerely,
Giorgio de Chirico

The criticism of these years is largely epitomized in the name of Apollinaire. Even in his first comments (on the studio exhibition that preceded the Salon), he gets to the heart of these new paintings, excluding any dependence whatsoever on previous art, underscoring the importance of the "enigma," and criticizing only the dark colors.

Monsieur de Chirico is exhibiting in his studio, 115, rue Notre-Dame-des-Champs, some thirty canvases whose inner art should not leave us indifferent. The art of this young painter is an inner and cerebral one that has nothing in common with the art of the painters who have emerged in recent years.

It possesses nothing of Matisse, nor of Picasso, it does not come from the Impressionists. This originality is new enough to deserve to be pointed out. Monsieur de Chirico's very sharp and

very modern perceptions generally assume an architectural form. There are railroad stations adorned with clocks, there are towers, statues, large deserted squares; railroad trains go by on the horizon. Here are some of the singular titles for these strangely metaphysical paintings: *The Enigma of the Oracle, The Melancholy of Departure, The Enigma of the Hour, Solitude,* and *The Whistling of the Locomotive.*

Apollinaire's comments for the 1913 Salon d'Automne are brief; those for the 1914 Salon des Indépendants are more ample (he speaks of calm and meditation, harmony and mystery), as are those written in May ("He is the enemy of trees and the friend of statues"; he understands the meaning of *absence* when he remarks that "for some time he has been devoting his talent to painting signs"). A short text written in July announces the purchase of a "pink glove" and foresees (good prophet) a turning point in his painting:

> Monsieur de Chirico has just bought a pink rubber glove, one of the most impressive articles that are for sale. Copied by the artist, it is destined to render his future works even more moving and frightening than his previous paintings. And if you ask him about the terror that this glove might arouse, he will immediately tell you of toothbrushes still more frightening than those recently invented by the dentist's art, the latest and perhaps most useful of all the arts.

After de Chirico had left Paris, Apollinaire notes his influence on the Futurists (Carrà) and calls de Chirico "the only living European painter who has not undergone the influence of the young French school."

But all the other judgments so far known to us are surprisingly positive as well. André Salmon calls him "the calmest of tragic artists"; Roger-Marx notes the "reactionary" aspect of his painting (in the sense of a return to the primitives); Maurice Raynal underscores "the feeling of solemnity"; Jacques-Emile Blanche sees him as primitive "but with modernism"; Etienne Charles seizes on "the ideas of mystery and enigma"; Louis Vauxcelles calls him "mysterious and aristocratic."

A few of his paintings entered collections. Apollinaire, for example, in addition to his portrait, owned *The Great Tower* (pl. 19), a drawing, and two other paintings (one of which has been destroyed). *The Great Tower* is one of the masterpieces of 1913, a true image of what Apollinaire defined as "plastic conception of the politics of time." An uncollected newspaper item by him has established that the choreographer Léonide Massine owned, besides Futurists, a canvas by de Chirico. Other collectors are recorded by Paul Guillaume: the Princess de Polignac, the Baroness d'Oettingen, Mme Peignot, MM. Allainby, Colin d'Arbois, de Macédo, André Level, Diaghilev, Lefèvre, etc. But the one whom de Chirico recalls most enthusiastically (a passage in his memoirs) is Oliver Senn, who bought *The Red Tower* at the 1913 Salon D'Automne.

Other shows followed the one held in his studio at the end of 1913 (Apollinaire records the titles of five paintings). One was even planned for Germany, in the offices of *Der Sturm,* as Apollinaire notes in *Les Soirées de Paris.* From 1914 on Paul Guillaume (who signed a contract with him) exhibited his works regularly.

It was precisely because of this contract that Paul Guillaume was to retain the greatest number of Metaphysical works. And from Ferrara de Chirico sent him new canvases (which he was to view again with sadness and regret) until his return to Paris in 1924, when he was present for the birth of Surrealism.

But there was another group of paintings, finished or unfinished, which (as de Chirico recalled in Ferrara and later in Rome) had been left behind in the studio at 9, rue Campagne-Première. It was Giuseppe Ungaretti who picked them up and delivered them to Jean Paulhan, as various sources confirm. In this connection there exists a particular letter from Ungaretti:

> De Chirico asks you to do him a very great favor. He is in need of money and would be willing to give up the pictures of his that are in your possession for a thousand francs in all. I think our friends Breton, Aragon, Soupault, perhaps Gide and others would be willing to take some of them. You would of course be able to keep one of these pictures for yourself gratis.

This is a very important episode for the reconstruction of the catalog of the Paris

Giorgio de Chirico. *Metaphysical Interior.*
Ferrara, 1916
Pencil on paper
Private collection
Formerly in Apollinaire's collection

works: the authentic works painted in these four years (sixty-seven in my opinion, plus a few unfinished ones) all passed through Guillaume, through the Surrealists, and were mostly exhibited in the large one-man show organized by Paul Guillaume in 1922, for which another poet was called upon to introduce him: André Breton. Through de Chirico's memoirs and the splendid writings of Savinio, and with the help of de Chirico's letters from Ferrara, we can reconstruct the presence of Paul Guillaume, who was responsible for the security (professional as well as economic) of the twenty-five-year-old painter. One might say that Paul Guillaume, too, was a discovery of Apollinaire's (Savinio recalls it in his *Souvenirs*). De Chirico, in competition with Modigliani and Derain, left us two portraits of his dealer (a drawing and an oil). The young and penniless dealer was to become an important landmark on their return to Paris. The terms of de Chirico's contract are spelled out by Savinio:

> Paul Guillaume was Giorgio de Chirico's first "dealer." For the monthly payment of 120 francs, the painter supplied the dealer with six pictures a month, which established the value of each picture at 20 francs. In the years following the Great War, Paul Guillaume sold these same pictures at a price of 40,000 and 50,000 francs apiece.

As the advertising for the gallery appearing in *Les Soirées de Paris* shows, Guillaume concentrated in the beginning on Picabia and de Chirico (as well as on Roy, Madeleine Berly, and Robert Lotiron), and especially on "Negro sculpture." This last was also one of Apollinaire's fixations; his apartment was full of African fetishes, and he was moreover to write important articles in 1917 ("Mélanophilie ou mélomanie") and the introduction to a portfolio of photographs, *Sculptures nègres,* published by Guillaume.

Guillaume's exhibitions began in 1914, and can be followed through Apollinaire's uncollected newspaper articles, as deduced from his album of clippings: on June 8 he writes of a show of "Tableaux modernes: Picabia, G. de Chirico, P. Roy, M. Berly"; on June 11 he records the Larionov and Gontcharova exhibition; from July 6 to July 27 he dwells once more on the permanent display of painters at the gallery.

Guillaume's activity was heightened toward the end of the war, as can be seen by his advertisements in magazines expressing the new *esprit,* Reverdy's *Nord-Sud* and Pierre Albert-Birot's *SIC.* Setting up in the Faubourg Saint-Honoré, Guillaume presented Matisse and Picasso in one-man shows (at his first location he had held the Larionov and Gontcharova show in 1914, and a Derain show at the intermediate location in 1916). From 1917 on his gallery also published a small magazine *(Les Arts à Paris),* as did Kahnweiller and later his friend Rosenberg (this relationship is known from one of de Chirico's letters) with the *Bulletin de 'L'Effort Moderne,'* which was to publish de Chirico's pictures of the Cocteau period. At the end of 1918 (as we learn for the first time from the magazine), Guillaume held a show at which it was de Chirico who gained the greatest acclaim.

But it is especially from de Chirico's letters that the figure of the dealer emerges in the round. I speak of a series of letters from Ferrara that begins on June 3, 1915, and dwindles until 1918, and which is still in the possession of the Guillaume heirs (it was mentioned by A. Tarica at the exhibition "La pittura metafisica" in Venice and published accurately by E. Coen). Here are two judgments on the dealer, one by Savinio (in a letter to Soffici) and the other by de Chirico:

> Paul Guillaume writes us letters full of hopes and promises. He is a man who will be useful to us all. He is truly *persuaded.* A highly interesting case of a man who has grasped the spirit of modern art.

> It makes me very happy to think that there is a man like you in the world who is both a friend and a collaborator; for you to be able to be enthusiastic over such, so to speak, *metaphysical* things, you must, my dear friend, have a rare, a very rare, intelligence, since the longer I live, the more I know people, the more I realize how this gift of the Gods (intelligence) is something quite uncommon; I even believe that intelligence as we ourselves understand it, Nietzschean intelligence, the kind of intelligence that has to do with God and the acrobat, the hero and the beast, is so rare that one could almost say that it is not to be found.

Adulation aside, one reads in these letters a yearning nostalgia for Paris (which

Giorgio de Chirico. *Portrait of Paul Guillaume.* 1915
Ink, 6½ x 5¾″ (16.3 x 14.7 cm)
Private collection

appears in the addresses as "Lutetia Parisiorum") and a great esteem for the "métaphysicisant" for whom he is beginning to work (in October 1915 he promises him five or six pictures a month). He congratulates him on the reopening of the gallery at the end of 1915, he sends him pictures through his mother, he speaks to him of distant friends (Apollinaire, de Zayas, Picabia — by whom he feels he has been plagiarized — and Rosenberg) and of magazines (especially *291,* with which Savinio is also in contact). From "beautiful and melancholy Ferrara," where life's destiny has brought him, he warns Guillaume about the work of Modigliani and Utrillo and indulges in an outburst of jealousy when he receives the Derain catalog with Apollinaire's preface ("double deception"). He announces his new works to him ("I am beset by revelations and inspiration"), and meanwhile the war goes on ("Day and night I invoke the goddess Peace").

Apollinaire, his head bandaged after his trepanning operation, was photographed in Guillaume's gallery next to a group of canvases by Utrillo, Modigliani, and de Chirico. (It was through the poet and the dealer that de Chirico and Savinio came in contact with Tzara — it was another avant-garde adventure.) In 1916 de Chirico sent two drawings from Ferrara: *The Melancholy of the Room* for Paul Guillaume (with a sombrero, which alludes to de Zayas, and many significant objects) and another for Apollinaire (the officers' insignia, the cookies, the sadness of separation). When de Chirico returned to Paris (1924), he found his old pictures at Paul Guillaume's, and when he settled in Paris (1925) a new relationship (though his official dealer was Rosenberg) emerged, based on an incessant form of *odi et amo.*

De Chirico also remembers Guillaume at the time of the artist's first, difficult postwar efforts:

That was a happy period of artistic activity; a young and intelligent French dealer, Paul Guillaume, bought everything de Chirico produced, organizing frequent shows in his gallery. Naturally there was no lack of envious people who, by brandishing as a corpus delicti the terrible word *metaphysical,* sought to attribute a German origin to de Chirico's art.

While in France and even outside de Chirico's fame was spreading increasingly, especially due to the shrewd Paul Guillaume, in Italy the three exhibitions of his work garbled the tongues of the critics.

In particular de Chirico asks his advice about sending a picture to the Dada exhibition organized by Tristan Tzara in Zurich for May 29, 1917 (and it is also reproduced in the magazine), and later for the 1918 exhibition in Rome — one of the exhibitions, mentioned in the last sentence, that set off his career of clashes and lack of recognition in his chosen but ungenerous "stepmother" homeland.

A few new episodes involving de Chirico and Savinio make it possible to discover a hitherto unknown connection between Paris and New York. Apollinaire's circle is the point of departure, Alfred Stieglitz's gallery and magazine the point of arrival. On November 4, 1914, four paintings by de Chirico — *I'll be there…The Glass Dog* (pl. 42), *Departure of the Poet* (pl. 27), *The General's Illness, Song of Love* (pl. 34) — sailed from Le Havre addressed to Stieglitz (but so far I have been unable to find out whether they were exhibited).

Savinio's music fills the pages of *291:* one issue contains his theory of "Sincerism," another an incisive theoretical text ("Music is the emanation of a true metaphysics"), still another a score reproduced across two pages. Even after arriving in Ferrara, Savinio prepared music to send to Stieglitz, and the magazine turns out to be one of the only bridges (as emerges from the correspondence with Guillaume) between the two brothers and the world of avant-garde.

In Paris, Savinio had also become interested in Negro sculpture (a subject taken up by de Chirico, at least in one picture) on the occasion of an evening held by Guillaume for the organization he directed under the pseudonym of Guy Romain:

In 1913, Paul Guillaume founded the Société des Mélanophiles, with offices in the rue de Navarin in Paris. About that time I wrote, for the Société des Mélanophiles, a lecture on Negro statuary, which was recorded on a Pathé disk and delivered a few days later in New York by the voice of a gramophone.

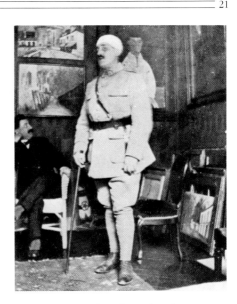

Apollinaire in Paul Guillaume's gallery. Visible are two paintings by de Chirico, *Playthings of the Prince* (near the poet's legs) and *The Seer* (upper right).

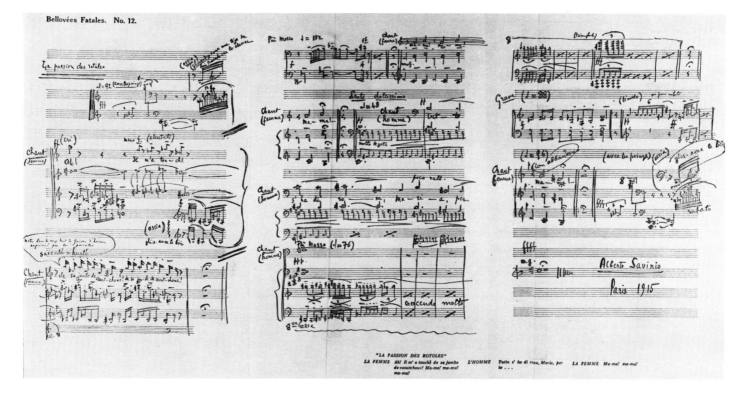

Alberto Savinio. Music score, "Bellovées
Fatales. No. 12"
Reproduced in *291,* June 1915

The final note is of exceptional importance: indeed it is almost certain that his
lecture was presented in Alfred Stieglitz's gallery (Guillaume and Stieglitz had a working
relationship, as we have seen for de Chirico's paintings), perhaps just at the time of the
exhibition of Negro art in November 1914, which consisted of works sent by Guillaume.

Another connection (this one, too, shared with de Chirico) was with Marius de
Zayas, the curious artist of Mexican origin to whom Savinio was later to devote a caustic
portrait. It was with him and Apollinaire that an extraordinary "pantomime" was con-
ceived (a "French" form for the new musical drama sought by Savinio).

An account of this fascinating collaboration can be found in the writings of
Apollinaire and Savinio:

> Meanwhile I prepared a pantomime whose title I have forgotten but the subject of which was
> derived from my poem "Le Musicien de Saint-Merry." The music was to be written by Albert Savinio,
> brother of the painter Giorgio de Chirico. The sets were to be painted by Picabia and the caricaturist
> Marius de Zayas. While awaiting the 25th I was on the verge of accompanying Picabia and Zayas to
> Etival, where they were going to Picabia's place to prepare the sets. For the pantomime was to be
> acted in the month of January in New York and I would have been there too. It promised to be a
> great success. The expenses were to be paid by Stieglitz, who would have had no trouble getting his
> money back thanks to the curiosity that our names were said to arouse in Manhattan on the banks
> of the Hudson.

> Dog days of '14 at 150 meters above the wooden paving blocks of the Boulevard Saint-
> Germain. Four of us, in Guillaume Apollinaire's packet-boat apartment….We were outlining the
> scenes of a theater piece that was supposed to be plastered across five of the leading cities in the
> United States: "What Time Does a Train Leave for Paris?" — a rather long title for the traditions of the
> long-running hit.

The portrait of Apollinaire (pl. 41), one of the most famous pictures of the Metaphysical
period, remained until recently in the possession of the poet's wife, who guarded it
jealously (as Savinio notes in reference to a show around 1932 of works of art that had
belonged to the poet); it was exhibited in 1937 at the Petit Palais, and acquired in 1975 by
the Musée d'Art Moderne. One of the less examined works of de Chirico, it is a complex
homage to the intellectual who was, for both the artist and his brother, a true prophet: an

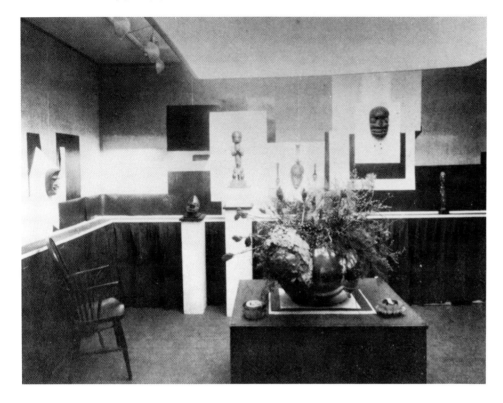

Exhibition of African sculpture held at the Stieglitz Gallery, New York, November 1914, during which it appears that a recorded lecture by Savinio on African art was presented by gramophone.

"angel of the new times," as Savinio biblically called him. The analysis here offered takes into consideration the writings and events of the period, even indirect and chance testimony, the memoirs of de Chirico and Savinio, and interpretations by Apollinaire's circle, in an attempt to reestablish around the picture the proper atmosphere by which to understand its hidden significance (the method is, as usual, the "enigma").

The picture was given by de Chirico to the poet, as we know from a letter (below), but for some still unknown reason, it was not delivered—and indeed Apollinaire asks Paul Guillaume (de Chirico's first dealer) for it in two letters:

Saturday evening

In exchange for the picture I gave you, which I will be very proud to see hanging on your walls, I should like to ask you to dedicate to me one of the poems that, as you mentioned to me yesterday, are about to be published in a volume.

Giorgio de Chirico

I should be grateful if you could ask G. de Chirico to send to my concierge, who will place it in my apartment, my portrait as a *target figure.*

I would have preferred that the *target figure* be in my home, where my mother would be able to look at it, since not only is it a singular and profound work of art but also a good likeness as a portrait: a shadow or rather a silhouette like those people used to make in the early nineteenth century.

The picture seems painted in a single burst, with great technical skill, exploiting the preparation (the fish and the shell are almost drawn on the ground, while the statue is entirely painted) with extreme sureness (only a single *pentimento* can be noted: a slight shift of the circle on the head of the silhouette in the background).

The public life of the painting began almost at once, since Apollinaire chose it as frontispiece for his first collection of *calligrammes,* entitled *Et moi aussi je suis peintre* (de Chirico, from Ferrara, felicitously calls them "idéogrammes"). The print was by Pierre Roy, and the dummy with Apollinaire's corrections (today in the Fond Littéraire Jacques Doucet) looks as though it had been published on August 14, 1914, by *Les Soirées de Paris.* Actually publication was suspended because of the war. Roy's woodcut was used,

however, for the deluxe copies of the program for *Les Mamelles de Tirésias* (1917), as Apollinaire himself wanted. The portrait by de Chirico disappears, to be replaced by a portrait by Picasso, obviously more up-to-date since it shows the poet's profile with his head bandaged because of his wound. De Chirico learned of this publication in Ferrara, as shown by his letter to Francesco Meriano:

I heard nothing more about it, this work that Apollinaire began writing a few months before the war; I remember then that I did a portrait of him that was supposed to be published in the volume; later the war broke out, I had to leave Paris, and the portrait was bought from me by the dealer Paul Guillaume, who gave it to Apollinaire; now I see that the work has been published with a portrait done by Picasso: I don't say that I'm all that unhappy about it since Picasso is a friend of mine and a worthy man, but I might still remark that these Parisians are a little like Frenchwomen whose motto is the proverb "Out of sight, out of mind [*Loin des yeux, loin du coeur*]."

Granted that the colors are essential (only the background sky surrounding the silhouette, which de Chirico was to call "Veronese sky," stands out), it might be useful to list the elements present in the painting, since the explanation of each one will help in arriving at an overall meaning. At the top, therefore, there is the silhouette, framed by a perspective chamber; the silhouette is cut by a light-colored slab in perspective on which two molds (fish and shell) are placed; on the right is another perspective foreshortening with an arcade; at the bottom is the plaster cast of a Greek divinity, altered by the addition of the sunglasses. Seven or eight elements that go to make up an elaborate allegory.

The most qualified sources for reconstructing the physical setting in which the portrait appeared are obviously Giorgio de Chirico and Alberto Savinio. Thus de Chirico writes:

Apollinaire used to officiate seated at his work table; taciturn and deliberately thoughtful individuals were seated in the armchairs and on the divans; most of them were smoking, in accordance with the fashion of that time and in those circles, clay pipes similar to those one sees in the shooting galleries at fairs.... Later two or three of my metaphysical pictures were hung, including a portrait of Apollinaire, depicted as a silhouette for target practice, a prophecy, so it would seem, of the wound that Apollinaire received in his head.

Savinio, in his turn, often speaks of the atmosphere of that small apartment in which Apollinaire's ideas encountered, and clashed with, those of artists and poets. Here are several passages:

Behind the desk, which was loaded with objects devoid of any particular usefulness but curious in themselves and pleasant, Apollinaire, with a sharp eye and ready hand, was correcting the proofs of *Le Poète assassiné*. Under his senatorial nose he was sucking on one of those little clay pipes that constitute an elegant and highly fragile target in cheap shooting galleries

From his hospital bed, under the cap that covered the hole in his skull, Apollinaire thought back on the "prophetic" portrait that Giorgio de Chirico had done of him in 1913 — that portrait in which, against a very deep green, the silhouette of the poet stands out in the shape of a target, the cranium pierced at the very point where three years later he was struck by a shell splinter.

But to return to the portrait. Recently doubts have even been raised as to whether we are dealing with a true portrait of Apollinaire (so subtly is the image worked out), but it was precisely de Chirico's wish to sum up the idea of the silhouette and the idea of the shadow, on various foundations: the children's game, projection as in a "camera obscura," absence. Here is his testimony (unknown until recently) from the extraordinary obituary published at the end of 1918 in Alfredo Casella's magazine *Ars Nova*:

When his numismatic profile, which I stamped on the Veronese sky of one of my metaphysical paintings, appears in my memory, I think of the grave melancholy of the Roman centurion intent on crossing the pontoon bridges thrown out along the conquered lands, far from the consoling warmth of hearth and the acreage of his plowed soil....
I see again, as one sees in dreams, a six-story apartment house, gray-coated, and at the top two rooms under the roof.
The curtain opens and a picture of marvelous tenderness forms in silence by itself: between the tragic innocence of the varnished canvases of the Douanier-Painter and the metaphysical architectures of the undersigned, I see the glow of an oil lamp, cheap pipes, yellow nicotine stains,

long bookshelves of plain lumber bulging with volumes, silent friends seated in the shadow;…and there, as though under the luminous ray of a magic lantern, the fatal rectangle of a Veronese sky is traced on the wall, and on that sky the profile of the sad centurion curves once again…It is Apollinaire, the returning Apollinaire; it is the poet and friend who defended me on earth and whom I will never see again.

From the first and last part of this text there thus emerges once again the image of a *profile,* which this time is *numismatic* (thereby adding to the idea of the silhouette, and that of the target, the image of an ancient figurative structure), and one becomes aware of the importance of memory and "vision": the oil lamp evokes in the darkness the idea of a magic lantern that projects the sad profile against the sky of bright "Veronese green."

This "photographic" metaphor will also return in a famous text from Ferrara ("Nine years have gone by since this discovery lighted up the camera obscura of my consciousness with a stormy and nocturnal flash of lightning; I know of no photographs more fearful than those made at night by magnesium flash in the interior of a house"). Furthermore, this camera obscura seems to me fundamental for understanding the meaning of those perspective boxes that (starting precisely with the Apollinaire portrait in which, as we have seen, it has a particular meaning) de Chirico was to introduce into many paintings of 1914, and which hitherto have been interpreted merely as an illusory perspective or a decomposition of space beyond Cubism.

Among street-fair spectacles (and this is another small step forward) the booth offering shadow plays was much in demand in Montmartre (many technical and illustrative books were devoted to the subject at the time). Thus the silhouette gains in importance with respect to the simple shooting gallery — and we know how the latter attracted de Chirico. The merry-go-round is recorded in his memoirs; in a drawing of the period, *The Apparition of the Horse,* the horse that appears in the public square with the cannon and the background tower is nothing but a carousel horse.

Conceptually, the problem of the shadow haunts de Chirico in his greatest masterpieces first of all for the Nietzschean reference to the "great noon" (of which we shall speak), but also because it is equivalent to the absence of man and thus to the metaphors of the silhouette, the plaster cast, the molds (for sweets), the signboards, to arrive at the sublime synthesis of the Mannequin. Nor should the fact be overlooked that the shadow was also of considerable interest to Apollinaire, as can be seen in various poems:

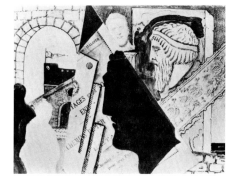

Alberto Savinio. *The Departure of the Argonauts.* c. 1914
Collage, 8⅝ x 11″ (22 x 28 cm)
Savinio Archive

Ombre encre du soleil
Ecriture de ma lumière
[Shadow ink of sunlight
Script of my light]

Soleil, je suis jeune et c'est à cause de toi;
mon ombre pour être fauste je l'ai jetée.
Pardon, je ne fais plus d'ombre qu'une étoile
je suis le seul qui pense dans l'immensité.

[Sun, I am young and it is because of you;
my shadow to be propitious I threw it away.
Excuse me, I make no more shadow than a star
I am the only one who thinks in the immensity.]

The silhouette motif occurs also in Savinio's first figurative attempts, which I place in the Paris period. One of these collages is actually a quotation from de Chirico's portrait of Apollinaire, but as always the relations between the two brothers run on alternating current (twenty years later André Breton, in his *Anthologie de l'humour noir,* was to speak of "two works almost indistinguishable in spirit"). And indeed, in Savinio's "Chants de la mi-mort" (published by Apollinaire in his magazine, and the theme of the 1914 concert), personages are expressly spoken of as *hommes-cibles* (target figures — the same that recur in the above-mentioned collage.

But there is another element that brings us to the target silhouettes: the clay pipe that de Chirico already associates with the fair booth and that Savinio later combines with the image of Apollinaire, "elegant and highly fragile target." Thus at a distance of years, the

Giorgio de Chirico. *Portrait of Apollinaire.* 1914
Dedicated to Guy Romain, pseudonym of
Paul Guillaume
Ink and pencil, 8¼ x 4⅞" (21 x 12.5 cm)
Private collection

overall image of the portrait as set in a shooting gallery (strange typology for a celebrative portrait!) is still present in the memories of the two brothers.

Indeed, this pipe was an indispensable accessory of Apollinaire's large, sympathetic, "senatorial" face — as attested by drawings (Picasso, Larionov, Vlaminck). André Derain, loved and hated by de Chirico, portrayed himself with such a Jacob pipe, and it is not improbable that the memory of the painting motivated a similar self-portrait by de Chirico (1915).

There exists a drawing, wrongly believed to be a portrait of Paul Guillaume, that shows precisely the "numismatic profile" of Apollinaire. At the bottom appears the important inscription:

To Guy Romain, the man and the patron, homage of metaphysical friendship and peaceful memory MCMXIV Georgio de Chirico.

"Guy Romain" is actually a pseudonym of Paul Guillaume's (under which he directed the "Société des Mélanophiles"): it was to this address (the same as Guillaume's) that de Chirico wrote from Ferrara in August 1915, a few days after the army doctors had declared him (along with Savinio) "incapable of withstanding the strains of the war."

Symbolically, de Chirico seems to connect Prophet and Patron in this extraordinary drawing, done on the eve of that war that is implicit in the "peaceful memory" of the dedication. Apollinaire enlisted as a volunteer, as did the two Argonauts (de Chirico: "Driven by the same impulse that drove Apollinaire to enlist in the French army, my brother and I left for Florence to present ourselves to that military district"). The motivation is that of finally "belonging to a country, to a race, and having a passport in order."

But there must also be a reason why de Chirico put the portrait of Apollinaire in the background ("When his numismatic profile, which I stamped on the Veronese sky of one of my metaphysical paintings, appears in my memory..."), while in the foreground he placed the bust of a Greek divinity.

The first error to be dispelled is that this bust is an idealized portrait of Apollinaire: many have thoughtlessly written so, but this idea does not coincide with the reality, for the true portrait is in the *homme-cible.* The second error to be dispelled is that we are dealing with a statue of Apollo (associated even with the name "Apollinaire"), understood as a metaphor for poetry and for art in general.

De Chirico was quite familiar with the typology of Apollo. In *The Song of Love* (pl. 34), painted in the same year, there appears a perfect copy of the Apollo Belvedere (one of those statues that de Chirico had copied at the Munich Academy, an exercise he proudly vindicated: "And in fact what constitutes de Chirico's superiority over most avant-garde painters is that he is someone who possesses a long apprenticeship of academy and museum"). The Apollo Belvedere also appears on the title page of the book by Salomon Reinach, often quoted by de Chirico and paraphrased in long passages by Savinio.

That it cannot then be a question of Apollo is also confirmed by a passage from Savinio that demonstrates the scant esteem in which that deity was held (and we are familiar with the accord between the two brothers in their knowledge of Greek mythology): "Apollo is the most fatuous of the Olympian gods, the most foppish, the least significant. This cumbersome dandy, unfit for any serious occupation, was made Musagetes, i.e., leader of the muses, because they didn't know what else to do with him, a job that any man supplied with a minimum of dignity would have refused with scorn. The plastic representation reflects this characteristic of Apollo, superficial and devoid of consistency. The so-called Apollo Belvedere is the portrait of a golfer."

The bust that appears in the *Portrait of Apollinaire* bears in fact a great similarity to the Venus of Milo — except that the hair in the middle has been removed to make it look like a masculine figure. It is obvious that this plaster cast in the foreground has a meaning, and I will anticipate it before demonstrating it. De Chirico wants to represent Orpheus, the clairvoyant musician and poet (and we will see why he is associated with Apollinaire),

and since an ancient prototype for this divinity does not exist, he has created his own typology.

At this point we must have recourse to Apollinaire himself. In May 1911, the collection of poems *Le Bestiaire ou Le Cortège d'Orphée* was published, with woodcut illustrations by Raoul Dufy accompanying each quatrain. Here are two sufficiently explicit poems, followed by a comment on the first poem by Apollinaire himself:

Admirez le pouvoir insigne
Et la noblesse de la ligne:
Elle est la voix que la lumière fit entendre
Et dont parle Hermès Trismégiste en son Pimandre.

[Admire the arrant power
And nobility of line:
It is the voice made audible by light
And of which Hermes Trismegistus speaks in his *Pimander.*]

Que ton Coeur soit l'appât et le ciel la piscine!
Car, pécheur, quel poisson d'eau douce ou bien marine
Egale-t-il, et par la forme et la saveur,
Ce beau poisson divin qu'est Jesus, Mon Sauveur?

[May your heart be the bait and the sky the pool!
For, fisherman, what freshwater or ocean fish
Can equal for either form or flavor
This beautiful holy fish that is Jesus, My Savior?]

Quite soon, as we read in the *Pimander,* the darkness fell...and from it issued an inarticulate cry that seemed like the sound of light. This "sound of light," is it not drawing, i.e., line? And when the light is fully expressed, everything becomes colored. Painting is really a luminous language.

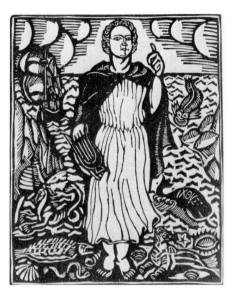

Raoul Dufy. *Orpheus.* 1911
Illustration for *Le Bestiaire ou Le Cortège d'Orphée* by Apollinaire
Woodcut

If we analyze Dufy's pictures, we see how Orpheus appears triumphant with his lyre, or in relation to the Sirens (one poem speaks of their "fatal songs"), or on the shore of the sea with two fish to the right, the ones that Orpheus transformed into musicians. And here is another glimmer for the understanding of the *Portrait of Apollinaire:* the fish is clearly associated with this aspect of Orpheus' personality, while the shell seems to allude not only to the sea but to the lyre (which, mythically, derives precisely from the shell).

But to broaden the circle of implicit meanings, it is indispensable to take another look at the story of Orpheus (as usual a multiform hero) in mythology:

Without Orpheus, the wonderful singer and lyre-player, we could not now imagine the Argo. Ancient artists already show him as one of the Argonauts. He, if anyone, could be useful to their company, which wished to make its way into the other world. The very thing for which Orpheus was famous was that he had been capable of undertaking the dangerous journey into the underworld quite alone. He was not the first of whom it was said, in the tales of gods and heroes, that he had performed miracles with his singing and lyre-playing (the two made up but one art). We know that Hermes invented the lyre and was the first to sing to its strains. Among the gods, he presented the lyre to his brother Apollo; among the heroes, to another brother, who later quarrelled with Apollo, Amphion. When we are told concerning Orpheus that the endless flocks of birds flew about over his head as he sang, and the fish leaped high from the dark-blue sea to meet him, we know that this was the effect of his song. We see him, lyre in hand, travelling on the Argo.
[C. Kerényi, *The Heroes of the Greeks,* trans. H. J. Rose (New York: Thames and Hudson, 1959), p. 279.]

Orpheus is thus connected with Apollo (and therefore with light, as Apollinaire says), he is the protector of the Argonauts (and we will see that this detail, too, has a meaning), and he is associated with Dionysus (the eternal binomial that de Chirico and Savinio learned through Nietzsche). And another small solution can be found in Savinio's acute observation: "The name of Orpheus, of Egyptian and Phoenician origin, is composed of aur (light) and rophae (healing, health). Orpheus is he who brings men light and truth. Orpheus is not dead."

To return to the fish motif, I recall that in a fine passage about Jean Cocteau (the

other great prophet of the two Argonauts), Savinio explicitly compares Cocteau to Orpheus: "At the present hour Jean Cocteau is an Orphic poet…he who from the stern of the ship Argo converted the silent fishes into raving musical maniacs." And besides, even Picasso, who several times portrayed Apollinaire with the most varied attributes, represented him once with the lyre and once with a strange fish.

But there is also another motif (which will recur time and again in de Chirico's painting)—that of the "sacred fish." In the poem quoted above, Apollinaire concludes with the equation fish=Christ: in Dufy's illustration, the fish at the bottom bears the theological inscription *ichthys,* in Greek. The fish is thus another indication: the key to a new religion. More or less the one embodied by Apollinaire when he divines that Cubism and Futurism may open a new path: "The reign of Orpheus begins."

Orphism was announced in the lecture of October 9, 1912, at the Galerie de la Boétie, and triumphed in 1913 as an idea of conciliation (the same that "sur-réalisme" and "l'esprit nouveau" were to have in 1917 and 1918 respectively): It is related to Futurism as the *calligrammes* are to "words in freedom" (or rather it is a dialectical response).

In *The Dream of the Poet* (pl. 40), another de Chirico painting that uses the same elements as the portrait of Apollinaire, associated with the plaster cast with sunglasses and the fish is one of those strange inscriptions also containing the form of the Greek "X." This painting is particularly important, because, in my opinion, it is the first in which the mannequin makes its appearance—born in this case as a plastic image from the silhouette (which, for obvious reasons, has disappeared, since we are not dealing with a portrait of Apollinaire).

This "motif" will have a future: one need only think of the enigma of *The Sacred Fish* (Ferrara, 1918, pl. 77), or the extraordinary *Dream of Tobias* (Ferrara, 1917, pl. 75), in which the fish once again has a soteriological meaning, in the sense that it restores sight. As I have demonstrated (in a 1980 booklet), the painting did not die with its execution: André Breton chose it as an emblem of Surrealism, and had himself photographed by Man Ray with that very picture in the background (while at the center is Giorgio de Chirico in person), and on the second page of the first issue of *La Révolution Surréaliste* there appears an identical fish, crossed by the inscription "SURRÉALISME."

Two other elements remain to be considered: the arcade on the right side of the painting and the sunglasses worn by the antique bust.

That arcade on the right cannot be fortuitous: it is, in formal terms, the counterpoint of the cubical perspective box on the left, but perhaps also another attribute for the Roman Apollinaire. Several times in their writings de Chirico and Savinio compared Apollinaire to the Roman centurion who sets out to conquer a new world. And, in de Chirico's language, "arch" stands for "Rome" (where the artist went in October 1910), as is shown by one of his early manuscripts:

There exists nothing similar to the enigma of the arch invented by the Romans. A street, an arch. The sun seems different when it submerges a Roman wall in light. In all this there is something more mysteriously sad than in French architecture.

And also less cruel. There is something fatal about a Roman arcade. Its voice speaks by means of enigmas imbued with a strangely Roman poetry; the shadows on ancient walls and a strange music, of a deep blue, somehow similar to an afternoon at the seashore.

The dark glasses have inspired much (usually bad) writing and some attempts at interpretation based on chance. Actually they represent an expedient for visualizing the blinding quality of poetic light (Apollinaire had spoken of it in his note on the Orpheus poems), understood also in a hermetic and mysteriosophical vein. They are an attribute of the *seer,* like Homer blind, but also like the soothsayer Tiresias about whom Apollinaire was to write his famous play.

Often there appears in de Chirico's writings some reflection on the importance of *vision* (later theoretically juxtaposed by Savinio to the *dream* of Surrealism). The importance of the "inner gaze" appears in the 1912 passage, or in explicit words ("What I hear is worth nothing; there is only what our eyes see, when open, and even more when closed"), and even in passages from letters ("We ourselves who see").

Man Ray. Photograph that appeared on the cover of *La Révolution Surréaliste*. Breton stands in front of *The Dream of Tobias;* de Chirico is in the back row, center.

There is also another nuance in these glasses: the reference to signboards (Paris today is still full of them) on which eyeglasses, like other elements in de Chirico's pictures, take on a—precisely "metaphysical"—life of their own. De Chirico speaks of this experience in connection with the signboard with the glove (which looms in some paintings of the same year), but at least once he places gigantic spectacles on the scene, in the eccentric trapezoidal painting *The Serenity of the Scholar* (pl. 35). The relation between the statue seen from the back and the background with the puffing train, in the camera-obscura perspective, is strengthened precisely by the strange form of two large circles joined by a crossbar: in other words, a huge eyeglasses signboard. (Except that the seer is here associated, as in the painting *The Child's Brain* [pl. 33], painted in the same year, with the problem of the father and the consciousness of childhood. Again parenthetically, it would not be pointless to note that the hermetic figure who appears in this picture has his eyes tightly closed.)

From all this analysis it should be clear that every element stressed by de Chirico is a double one (be it silhouette, antique cast, mold, shadow): the *Portrait of Apollinaire* in a certain sense marks the highest point in his exploration of *absence* (what de Chirico was to call "the tragedy of serenity"). The triumph of Orpheus becomes metaphorically the supremacy of painting (since Orpheus knows, as Apollinaire says, that "painting is really a luminous language").

In addition, we need not exclude the idea that this emphasis on Orpheus was dictated by a careful study of Apollinaire's personality (possibly conducted in collaboration with Savinio), and including an implied automythography as well: as has been said, Orpheus more than once saved the Argonauts during the voyage in search of the Golden Fleece. This was one of the favorite myths of de Chirico and Savinio, who had themselves come from the Thessalian shores from which the mythical heroes (painted repeatedly by de Chirico—from the masterpiece of 1909 to the extraordinary synthesis of 1920) had originally sailed.

De Chirico was to return many times to the Orpheus myth. But he did so at least once with a meaning that clarifies the enigmatic *Portrait of Apollinaire:* this was a portrait executed for his friend the poet Raffaele Carrieri (c. 1942) in his new baroque style. Draped in ancient robes, his forehead crowned with laurel, his left hand holding a lyre, Apollinaire "the prophet" appears in his true personality, since de Chirico has by now resolved this old enigma. Apollinaire=Orpheus.

De Chirico is a great painter (think merely of his glazing technique, his color contrasts) and as such should be considered. But in this essay I shall continue to explore the meaning of his work, in an attempt to show that nothing in his paintings is fortuitous. There is the deliberate construction of an automythography: thus the myth of Ulysses (and his wanderings), the myth of the Argonauts (in search of the Golden Fleece), the myth of the Dioscuri (as Breton was to say, de Chirico and Savinio were almost inseparable). There is departure and there is return (the "return of the prodigal son"): the Nietzschean enigma, so to speak, of the serpent that bites its own tail. I intend now to explore a mental influence (Nietzsche), the meaning of a theme (Ariadne), and the importance of a search for roots (Italy).

It was de Chirico himself who declared that his painting was originally set in motion by "meditations of Nietzschean origin": obviously it is never a question of illustrating that ominous text, but rather of the faithful recovery of a *Stimmung*. It is perhaps Savinio who clarifies the importance that the Dioscuri gave to Nietzsche's writings: the sense of "lyrical illumination," the need to transcend the "literal meaning," the "gratuitous game," etc. I should like to add a few hints, certainly not to exhaust the problem: thus proceeding, in mental sequence, from profound attitudes to the simple iconographic suggestion.

Melancholy: De Chirico's first self-portrait (a program for his whole life) presents, alongside the famous line "What shall I love if not the enigma?" (pl. 7), an obvious theme: melancholy. The artist rests his cheek on his hand in the old gesture of Dürer and of all those "born under Saturn." This theme is in Nietzsche as well, and emerges once again from the pessimism of Schopenhauer. (De Chirico's melancholy, associated with enigmas, is related besides to the myth of Oedipus and the Sphinx.) In the pages of *Zarathustra* is the extraordinary "Song of Melancholy" in which Zarathustra's "adversary par excellence" comes to light:

> But already he assails and subdues me, this spirit of melancholy, this demon of twilight....The day is fading, now it is becoming evening for all things, even the best things; so hear and see, you higher men, what a demon this spirit of twilight melancholy is.

It is clear that this *Stimmung* lies at the source of all of de Chirico's reflections on twilight associated with melancholy (besides, did not Nietzsche have himself photographed in this old pose?).

The hour, the shadow, the "great noon": In many of Nietzsche's pages, time and weather are punctiliously indicated; the flow of the hours forms part of Zarathustra's long monologue, in the inexhaustible enigma (this too is a Nietzschean noun) of existence. The hour is indicated by the shadow, as can be seen in one of de Chirico's first masterpieces, in which a brick with his initials G C is placed under the station clock in that apparently "realistic" but actually "metaphysical" piazza—"metaphysical" since it offers two perspectives (an equivalent of space-time in memory). The shadow tells the hour, but almost always (another double effect) in de Chirico the long shadow does not correspond to the hour indicated on the clock. The shadow is the daughter of the hours, and Nietzsche often imbues it with divine values (*The Wayfarer and His Shadow* is the title of one of his early writings, often rewritten in his classical texts). Generated by the hours is the "great noon," the image that runs through all of *Zarathustra* (one fine chapter is actually devoted to "The Shadow") until the very last page:

> "Zarathustra has ripened, my hour has come:—This is *my* morning, *my* day begins: *rise, come forth, great noon!*"
> Thus spake Zarathustra, and left his cave, ardent and strong as a morning sun that comes from black mountains.
> End of *Thus Spake Zarathustra.*

Turin: What de Chirico calls "the square city" is once again the reflection of a myth: just as he loves Florence and Italy through Böcklin and Burckhardt, so he boasts the "metaphysical" quality of Turin by an indirect Nietzschean myth. It was Nietzsche who had spoken of the "severe and solemn public squares," who proclaimed that "the arcades seem to correspond to a necessity," who spoke of the "marvelous light" of this city

"beyond good and evil." But it is also the city where the great philosopher received the illumination of madness. There is a painting by de Chirico, exhibited in the great New York Surrealist show of 1936 (it belonged to René Gaffé and has recently reappeared), in which in the usual sliding space with its "camera-obscura" perspective three strange toys are placed. The title of the picture appeared in the catalog as *Still Life "Turin 1828"* (pl. 49); on closer inspection, one can decipher the date "1888," near the horse. It is an enigmatic homage to the day on which the philosopher, in that city of "unbridled perfection," embraced a horse.

The game: The importance assumed by games in Nietzsche's late thought is well known—in short, it represents the return to childhood. De Chirico, very acutely in his early writings, confirms this:

To be truly immortal a work of art must go completely beyond the limits of the human: logic and common sense will have to be completely absent. In this way it will approach the dream state and mental attitude of a child. I remember that often after reading Nietzsche's immortal work *Thus Spake Zarathustra,* I received from various passages of the book an impression that I had formerly had as a child in reading *The Adventures of Pinocchio.* A strange similarity that reveals the profundity of the work. In this case, there is no naiveté, there is none of the naive charm of the primitive artist; the work possesses a strangeness similar to that which is often created by the impressions of children—but consciously.

To live in the world as in an immense museum of strange things, of curious variegated toys that change their appearance, which we as children sometimes break to see how they are made inside, and, disappointed, we discover they are empty.

It is only in this vein that the endless representations of toys (increasingly unrecognizable) that appear in the perspective foregrounds of the paintings of 1914 can be explained. The titles speak of princes and kings, and in the background of this Olympian detachment lies a connection between the "tragedy of childhood" and the serenity of the sage.

Greece (as is natural for a painter of memory) is a constant reference point. It is a Greece that most of the time is filtered through books (de Chirico and Savinio copy Reinach's manual, as I will show, to the point of plagiarism). Every picture retains something of this remote love:

Thinking of the temples dedicated to the sea gods, built along the arid coasts of Greece and Asia Minor, I have often reevoked those soothsayers leaning forward to hear the voice of the waves ebbing from that ancient land. I imagined them with head and body wrapped in a chlamys, in expectation of the mysterious revealing oracle.

This passage is the perfect explanation of a picture that I found some years ago, *Autumnal Meditation* (pl. 11), a painting in which "absence" attains the highest philosophical level.

But it is the myth of Ariadne that seems fundamental in the first Paris years (and also in a broader sense, for the *labyrinth* becomes a new key to the interpretation of his pictorial structure and imaginative method). The myth of Daedalus is a complex one, connected with the Labyrinth, the Minotaur, Theseus and Ariadne, and the final arrival of Dionysus. First of all, it should be noted that Daedalus personifies the artist (or rather *homo faber*). Welcomed to Crete by Minos, he constructs the Labyrinth (in which his son Icarus will later be imprisoned for punishment). Guarded by the Minotaur, the secret of the Labyrinth is betrayed by Ariadne, who gives Theseus, who is in love with her, the thread whereby to enter, kill the Minotaur, and reemerge. But Theseus abandons Ariadne, who thereupon becomes the bride of Dionysus. In translating the ancient myth into symbols, Ariadne becomes the enigmatic passage between an early moment in which she personifies the search for awareness and a later one in which she personifies Dionysiac rapture. In Nietzschean terms, "the gay science."

Metaphysical art had its birth (if for the moment we may neglect Weininger and Böcklin) under the sign of Nietzsche. And de Chirico says so in one of his early manuscripts, in which he hints at the creation of *The Enigma of an Autumn Afternoon* (pl. 4):

A few times I painted pictures small in size; the Böcklinian period was over and I had begun to paint subjects in which I tried to express that strong and mysterious feeling I had discovered in Nietzsche's books: the melancholy of beautiful autumn days, of afternoons, in Italian cities.

De Chirico specifies that he began painting again in Paris: "I resumed the thread of my inspiration of Nietzschean origin." It is not by chance that we find Ariadne among the first themes present in his public squares. In Nietzsche this myth is connected with the spirit of knowledge and thus with the enigma (to the point of tragic identification, when in January 1889 he writes to Cosima Wagner: "Ariadne, I love you. Dionysus," and then as an epitaph, "No one but myself knows who Ariadne is"). Turning to *Zarathustra*:

To you, intoxicated with enigmas and happy in the twilight, to you whose souls are led astray by flutes to labyrinthine abysses. Since you do not want to grope with a cowardly hand along a thread; and where you are capable of *guessing*, you hate to *deduce*.

In the *Dithyrambs of Dionysus*, written in the same period, appears "Ariadne's Lament," and at the end Dionysus speaks: "Be sensible, Ariadne:/We should not first hate each other if we are to love each other/I am your labyrinth."

We are beginning to get to the heart of the problem: "Ich bin dein Labirinth," says Dionysus, the symbol of a total unity that de Chirico strives to rediscover in the silence of the Italian public squares painted in 1912 and 1913. There are seven pictures in which the figure of Ariadne appears (the double typology is taken from Reinach). In *Ariadne*, formerly belonging to Jean Paulhan, the figure is in the near foreground, and in the background is the sea with a lighthouse (the same one that recurs in the Paris *Self-Portrait*). In *The Soothsayer's Recompense* (pl. 15), Ariadne is set against the desert and palm trees, just as in Nietzsche's *Dithyrambs of Dionysus*. In *Ariadne* (private collection, U.S.A.), the statue is seen in perspective, with an arcade to the right that reechoes (as Weininger would have wanted) her feminine significance. *The Lassitude of the Infinite* (pl. 14) and *Ariadne's Afternoon* (pl. 21) should be considered together, also for the problem of format: the first is long like the horizon, the second tall like the infinite. In *The Joys and Enigmas of a Strange Hour* (pl. 17), Ariadne is mingled with the tower, the train, the perspective, the wanderers, and the shadow. But it is a picture from the Estorick Collection (pl. 12) that supplies "Ariadne's thread." On the pedestal of the statue appears the inscription "MELANCONIA," fundamental for understanding the spiritual position of the painter who had made his debut with the melancholy self-portrait bearing the inscription "ET QUID AMABO NISI QUOD AENIGMA EST." A comprehension of this self-portrait reveals one of de Chirico's first labyrinths: knowledge combined with melancholy and the enigma.

For de Chirico, Ariadne signifies "melancholy," but also "journey." She is placed before the sea, against a puffing train, within the idea of Africa, and connected with the theme of the infinite. Thus Ariadne evokes melancholy, but the true protagonist is still the man who leaves: Theseus — a new identification for de Chirico.

The Ariadne theme is also one bequeathed by de Chirico to Surrealism, as can be seen in one of those leaflets that take up again the Dadaist idea of the aphorism used as a slogan:

"Ariadne ma soeur! De quel amour blessée
Vous mourûtes aux bords où vous fûtes laissée!"

[Ariadne, my sister! Wounded by what love
Did you die on the shores where you were abandoned!
(Racine, *Phèdre*.)]

Born in Greece of Italian parents (Giorgio in Volos in Thessaly, Andrea in Athens), brought up in Greece until the death of their father (1904), returning to Italy where they remained from 1905 to 1906, educated in painting and music in Munich (autumn 1906 to 1909), and then unquestionably born to art in prewar Paris, Giorgio and Andrea de Chirico could consider themselves of Italian origin, even though they had spent only a few years in Italy. In the summer of 1909, de Chirico rejoined his mother and brother. Andrea left for Paris in February 1910, while de Chirico found lodgings in Florence (with

an occasional move, like the trip to Rome in late 1910) until the summer of 1911, when he, together with his mother, joined his brother in Paris. Altogether Andrea had spent about two years in Italy, Giorgio about three.

For de Chirico, the most important Italian sojourn was in Florence, where he probably lived with his Uncle Gustavo; his memories of Athenian Munich and the monuments of Milan are summed up in the perspectives of the capital of the Tuscan grand dukes (he speaks explicitly in one of his writings of the metaphysical character of Piazza Cavour) and in his emotions in the great museums. As I have pointed out many times, de Chirico considered himself a Florentine ("né à Florence" state the catalogs of the Salon d'Automne, he calls himself "florentinus" in his Schopenhauer translation, and even Soffici calls the two brothers "Florentines").

As for the mythical sojourn in Turin, it was a brief stopover ("a couple of days," de Chirico was to write in his memoirs) on the way to Paris, also to see the exposition commemorating fifty years of Italian unity. Nevertheless, the Italy he reevokes in Paris can be largely recognized in the *Stimmung* of the Savoy metropolis. In this case, too, it is a question of a "filtered" love: Turin, to be sure, is the city that brought the Risorgimento to life (a myth also for Savinio) and was the capital of the country, but it was also the city of Nietzsche.

The idea of the Risorgimento appears several times in de Chirico, but once at least it is textual. A drawing from 1913 with a mistaken title has recently come to light: from careful examination and a check of the facial features, the figure with the eyeglasses turns out to be none other than Cavour, and *L'Enigme cavourien* the handwritten title of the drawing. Cavour means Risorgimento, and Risorgimento means Italy.

This myth appears in Savinio's writings, too. The subtitle of "Les chants de la mi-mort" is "scènes dramatiques d'après des épisodes du Risorgimento," and time and again in the course of the text echoes of the king of Italy and of military songs return; in the writings that appeared in *291* there is this particular sentence: "Tout était doux de lumière dans la citadelle de Turin." In his book *Hermaphrodito,* written in Ferrara, Savinio evokes the "Epoca Risorgimento," and even Verdi is celebrated in a patriotic vein, as a statue with red lungs that become detached from the body. It seems almost the transcription of *I'll be there…The Glass Dog* (pl. 42), an enigmatic painting by de Chirico. The figure on the left is the cast of a Greek statue (the Norman Aphrodite, from Reinach), but the whole idea of the window with the heart and the green background (a metaphysical tricolor) is developed in this "Italian" spirit.

A worthwhile study could be made of the monuments in his paintings. In *Still Life: Turin, Spring,* a king appears on horseback, and on the pedestal is the inscription "NUELE II TORINO"—i.e., [VITTORIO EMA]NUELE II — even though the equestrian statue still seems to be Carlo Alberto, as does the one behind the portico in *The Red Tower* (pl. 13), or the one in the dazzling background of *The Departure of the Poet* (pl. 27). But such critical identification is of no interest: de Chirico mingles typologies because he does not want to reproduce any particular monument, wishing instead to depict Turin and the Risorgimento through an equestrian monument that is the summation of those epic times.

The statues of standing figures may also resemble that of Cavour: in particular the extended right arm suggests this identification, and especially (in *The Enigma of a Day,* pl. 29, a work painted shortly after *The Cavourian Enigma*) the small eyeglasses of the authoritative figure. In a picture from the end of the Paris period, *The Seer* (pl. 55), amid an iconography that reconsiders *The Enigma of the Oracle* (pl. 6), one can clearly make out on the soothsayer's blackboard, along with geometric or astronomical signs, perspectives and the shadow of a statue, the inscription "TORINO."

At this point I must introduce another theme, starting from a fact that has always disturbed me in the paintings of 1913-14: the long perspectives of terrain give way to public squares that do not suggest the city, but in their deep and dirty yellow evoke the desert. Among the more solemn examples of this type, I am thinking of *The Enigma of a Day* (pl. 29) and *The Departure of the Poet* (pl. 27). Another element associated with this feeling is the exotic fruit: the bunches of swelling bananas that appear in late 1913, the

Giorgio de Chirico. *Cavourian Enigma.* 1913 Ink and pencil, 5 x 3¾″ (12.7 x 9.5 cm) Private collection

palm trees from late 1912. De Chirico appears to justify all this (in his early writings) as an initiation banquet, but there must be some further significance in this avowed exoticism.

All these elements signify Africa. By turning to the pages of de Chirico and Savinio, one gains a little more enlightenment:

Finally the twelfth hour arrived. Solemn. Melancholic....African feeling....The happiness of the banana tree, luxury of ripe fruits, golden and sweet.

The bananas gave a glimpse
of a soldier of the colonies.

The advent of the Futurists was in a most highly fortunate harmony with the Libyan enterprise. Italo-African metaphysics. Wonder and miracle....Mysterium mirabile.

I would suggest that these "African" quotations, culled from the writings of Giorgio de Chirico and Albert Savinio between 1912 and 1914, be considered in the light of the very strong shock provoked by Italy's colonial venture. The two brothers would have been able to learn of each event, day by day, from the pages of newspapers and magazines (I myself have followed it all again at the Bibliothèque Nationale, on the covers and in the reports of that extraordinary publication *L'Illustration*). It was the conquest of new territories that imparted another mythical accent to their Italy. And the invasion of Libya, seen from afar, must have been another moment in the search for identity by the two Argonauts. De Chirico spoke of "African feeling," but it was Savinio who made the connection Metaphysical/Italy/Africa.

— Translated by John Shepley

Note: Given the absence of critical footnotes, the reader is referred to my studies:
"De Chirico vita e opere," in *Giorgio de Chirico* (Milan: 1979; Munich: 1980; Paris: 1981).
"Et quid amabo nisi quod aenigma est?"/ Studi su de Chirico (De Luca, Rome: 1980-1981).
Un interno ferrarese e le origini del Surrealismo/Il tempo di "Valori plastici"/Il tempo di Apollinaire.

THE definitive change in the art and aesthetics of the Italian avant-garde from the modernist idiom of Futurist dynamism to the conservative reappearance of a more traditional form of art took place during World War I. Most chroniclers of the period simply state that Futurism "failed"; implying that Italian art thereupon picked up where it had left off, they bury Futurism without further discussion. But Futurism did not die suddenly. Futurist artists, chiefly Carrà, Soffici, and Severini, were involved in transforming their own art. De Chirico's return to Italy in 1915 with his Metaphysical painting played an important part in the transformation. How this happened is complex and deserves investigation.

In the first place, the interpretation of Metaphysical painting by those who knew de Chirico best between 1915 and 1918 has been overlooked. De Chirico was much closer to Soffici, de Pisis, and Savinio during the war years in Italy than he was to the other Metaphysical artists, Carrà and Morandi. Carrà was indebted to de Chirico for a new approach to painting as he abandoned Cubist-Futurist breakup of form. He had begun before 1915 to reject the tendency toward abstraction that had been developing in modern painting, and he sought to be precisely what he discovered in de Chirico, a brilliant formal innovator who did not destroy the legibility of objects. The transformation of Carrà from radical modernist to traditional artist was underscored by his own writings and those of his admirers. Carrà's espousal of Metaphysical painting therefore attracted general attention, and his interpretation of it became the better known. It differed, however, from the interpretation of de Chirico's painting that can be read in the statements of de Pisis and Soffici before 1918, and in de Chirico's own observations on his art published in 1918 and 1919. What these various interpretations were will be discussed here.

The most striking element of de Chirico's and Carrà's Metaphysical paintings to many observers was the enigmatic subject matter, but this element did not have the strongest effect on Italian painting. Edita Broglio, artist and wife of the founder of *Valori Plastici,* the magazine which promulgated the postwar conservative message, explained that de Chirico was the inspiration for the restoration of a sense of volume to figurative art, "then in fragments," and she spoke with admiration of what she saw as his innate sense of geometry.[1] De Chirico's experiments with pictorial construction, taken over by Carrà as a firmly imposed architectural structure within the painting, were recognized by many Italian painters and critics as fundamentally Italian. Few twentieth-century Italian artists had wished to relinquish a sense of volume and the third dimension. Even the Futurists had intended to solve the "question of volumes in a picture, as opposed to the liquefaction of objects" favored by the Impressionists.[2] De Chirico's inventive manipulation of early Renaissance geometric composition and perspective (an interest shared by Morandi) became in Carrà's words the "Italian tradition." Such ideas about the nature of Italian art, formulated between 1915 and 1919, have been perpetuated until this day, although their origin now appears forgotten. De Chirico's arrival in Italy with the reputation of a very modern artist, just at the moment when a new generation was seeking a post-Futurist aesthetic, and his meeting with Carrà are at the heart of it.

The Italy to which de Chirico and his brother Savinio returned had to a great extent been captured by Marinetti and the Futurist painters and writers. They had succeeded partly because young artists tend to wish to create their world anew and partly because Italy since unification was a young country and seemed to call for a new, twentieth-century Italian vision. For the succeeding generation of artists the concepts and practice of Futurism were readily available; as Boccioni ruefully observed, "…one sees the new arrivals to Futurism grasping the ideas, mounting them, and running at breakneck speed…"[3] Futurist declarations of 1910 and 1912 will serve as examples: all forms of imitation must be deplored; all forms of originality glorified; traditional subjects must be replaced by those of contemporary life, especially related to machines and to speed. Intuition was emphasized. In Futurist painting, the synthesis of what is remembered and what is seen would reflect simultaneity of states of mind. The dynamic sensation, the particular rhythm of each object as well as its influence on its neighbor, would be rendered; the spectator was to be placed in the center of the painting. Activity in the

De Chirico and Italian Art Theory, 1915-1920

Joan M. Lukach

Notes to this essay begin on page 51.

painting would be expressed by lines of force; force-lines tending to the infinite were termed by Boccioni "physical transcendentalism."[4]

Before the original Futurists held what would be their final exhibition, in Naples, May-June 1914,[5] other artists had begun to rally to them. Prampolini and Morandi, for example, sent works to the "Free International Futurist Exhibition" held in Rome in 1914,[6] and in Milan another group, including Funi, Dudreville, and Sant'Elia, called their exhibition "New Tendencies" and demonstrated their espousal of Futurist ideas.[7] In 1915 Balla and Fortunato Depero published the wonderfully presumptuous "Futurist Reconstruction of the Universe," proclaiming their determination to renovate every aspect of contemporary life in accord with Futurist precepts.[8] Balla held a one-man exhibition in Rome at the end of 1915,[9] showing recent paintings of "interventionist demonstrations," like _The Flag on the Altar of Its Country_ and _Tricolor Song._ Such themes were derived from Futurist ideas of progress, one of which was that Italy needed to free itself definitively from the Austro-Hungarian Empire even if this meant going to battle (this was called "joining our Latin brothers"). Italy entered the war in May 1915. And just as the de Chirico brothers had followed a patriotic urge, many of the original Futurists, who had agitated for intervention, were quick to enter military service.

De Chirico was perfectly familiar with Futurism well before 1915. He had been living in Italy in 1909, the year Marinetti launched the movement in Paris and Milan with his two statements, the "Founding Manifesto of Futurism" and "Let's Kill the Moonlight." And he was still in Italy when the artists issued the _Technical Manifesto of Futurist Painting_ on April 11, 1910, and as a group presented "Futurist Evenings" in Milan, Turin, Naples, Venice, and other cities. In 1911 Pratella began to write manifestos of Futurist music, which must surely have interested Savinio, who only a few years later would remark that "any man who is not a fool is a Futurist."[10] When the first Futurist exhibition took place in Paris at the prestigious Galerie Bernheim-Jeune, de Chirico and Savinio were in Paris, acquainted with Apollinaire, who wrote about Marinetti and Futurist art as well as Savinio's music and de Chirico's painting. When the brothers were discovered by Soffici in 1914, the influential Italian artist-critic was an actual member of the Futurist group. Whether de Chirico reacted positively or negatively to the ideas expressed in Futurist writings is still very much open to discussion, but there can be no question that he was thoroughly familiar with the Futurists' program and their activities before he returned to Italy. De Chirico's strongest response to Futurism took place in Paris, as Marianne W. Martin has so effectively pointed out,[11] and the majority of his paintings that reflect this reaction were painted in Paris, and not seen in Italy before 1920, or after de Chirico's initial series of Metaphysical paintings was concluded. Besides his brother, only Soffici and the _La Voce_ circle in Florence (and certain acquaintances in Ferrara) knew these earlier paintings—a telling point in itself and one to be discussed here. Further investigation into de Chirico's relationship to Futurism before 1915, which deserves extended research, lies outside the scope of this essay.

The connection of de Chirico with Soffici during this transitional period in Italian art requires attention. Certain of Soffici's essays of 1916–18 are crucial to this discussion, for in them he set forth the precepts of Metaphysical art from the point of view of de Chirico. Ardengo Soffici had been a noted critic since the turn of the century, and besides art criticism he wrote poetry, novels, literary criticism, and journalism.[12] He had lived and worked in Paris from 1900 to 1907, then returned to his native Florence and with Giovanni Papini founded the acerbic _Lacerba._ Following a visit to Paris in 1914, Soffici wrote an enthusiastic review of Savinio's music and de Chirico's painting, stimulated by works such as _Nostalgia of the Infinite_ (pl. 28), _Joys and Enigmas of a Strange Hour_ (pl. 17), and _Enigma of a Day_ (pl. 29), which had been exhibited in the 1914 Salon des Indépendants. This important early review is often justly cited, but generally interpreted in the later context of Surrealism, whereas it should be borne in mind that at the time Soffici wrote it he was participating in Futurist exhibitions.

De Chirico was already known to a small group in Paris for his thoroughly unusual approach to painting. Soffici set out to define it:

Imagine a painter who, amid the fire of increasingly risky research blazing all around in this city which is the worldwide crucible of genius, continues to paint with the calm and application of a solitary old master, a kind of Paolo Uccello enamored of his divine perspective and insensible to everything but his geometric beauty.

I have written the name of Paolo Uccello without any intent to affirm an essential resemblance. Giorgio de Chirico is above all absolutely modern, and if geometry and the effects of perspective are the principal elements of his art, his ordinary means of expression and emotion, it is also true that his work does not resemble any other, ancient or modern, that might be made of those same elements.

The painting of de Chirico is not painting, in the sense that we use that word today. It could be defined as a writing down of dreams. By means of almost infinite rows of arches and facades, of extended straight lines, of gigantic masses of simple colors, of almost funereal darks and lights, he truly succeeds in expressing that sensation of vastness, of solitude, of immobility, of stasis which certain sights reflected by the state of memory sometimes produce in our mind, just at the point of sleep. Giorgio de Chirico expresses as no one else has ever done the poignant melancholy of the close of a beautiful day in an old Italian city where, at the back of a lonely piazza, beyond the setting of loggias, porticoes, and monuments to the past, a train chugs, the delivery van of a large department store is parked, or a soaring factory chimney sends smoke into the cloudless sky.[13]

De Chirico interested Soffici because his art was so modern. Soffici was not given to looking backward, and he did not see de Chirico's paintings as expressions of nostalgia for Italy. To him, the old piazzas in de Chirico's paintings with their characteristic architecture seemed melancholy because de Chirico had juxtaposed or contrasted with the traditional setting certain unmistakable elements of the contemporary machine age — the locomotive, the factory, and the department store. Whether he was saddened by the incongruity of the juxtaposition of Renaissance and twentieth century or by the seeming ineffectiveness of the modern in the Italian setting is difficult to say. But it was the contrast that struck Soffici, as apparently it had also fascinated de Chirico, and not a sentimental admiration for past glories.

Soffici's recognition of de Chirico's familiarity with and manipulation of traditional perspective is also noteworthy, and his choice of Uccello as a comparison is particularly apt. Soffici pointed out the hallucinatory quality obtained by de Chirico with his exaggeration of traditional compositional elements. In the paintings mentioned above, Uccello's perspective is distorted; lines of the diminishing arcade do not lead to a central vanishing point; the scale of individual elements is either too large (the factory chimneys in *Enigma of a Day*, pl. 29), or too small (the two conversing figures). In these paintings, each carefully constructed element has its own geometry, rather than being united to the overall composition by means of a unifying scale or module.

Giorgio Morandi, who would later become a Metaphysical artist, had decided to take part in the "Free International Futurist Exhibition" in 1914 after completing six years at the Bologna Academy of Fine Arts. Like de Chirico, he combined a traditional academic art foundation with a good knowledge of recent modern innovations. Since 1911 Morandi had studied the frescoes of Uccello, Giotto, and Masaccio as thoughtfully as he considered the paintings of such moderns as Courbet, Fattori, Cézanne, Braque, and Boccioni.[14] Thus, though the two did not meet until 1917 and were never close, de Chirico and Morandi had common interests that led others to think of them as part of a movement.

When Marinetti, Boccioni, Russolo, Sant'Elia, and Soffici departed to take part in the war, the original Futurists were forced to cease their provocative group assaults upon the consciousness of the general public. This did not spell the end of the Futurist movement, however, for there were others in Italy who were eager to claim Futurism for themselves and to set forth their own ideas as further developments of it. Among these were Prampolini in Rome, members of the university community in Bologna, and Soffici. Only a few months before de Chirico returned to Italy, Soffici, who had agreed to combine forces

with Marinetti and the painters in 1913, had had second thoughts. In February he and fellow *Lacerba* editors Papini and Palazzeschi preempted the expressive title "Futurism," declaring that only they, with Carrà, Severini, Govoni, Pratella, and Tavolato, were "Futurists," while Marinetti, Balla, Boccioni, Russolo, Giannattasio, and MacDelmarle were only "Marinettians." [15] It must be understood that the issue was one of control over the movement, not an effort to abolish it. All concerned were the avant-garde, open to radical solutions for constructing works of art. At the same time there were the conservative elements that staunchly opposed any modernist solutions and would have been pleased to see all evidence of Futurism completely erased from Italian art. Pratella's response was that without Marinetti there would have been no Futurism.[16] Balla and Russolo also remained allied with Marinetti, but Carrà drew nearer to Soffici.[17]

When de Chirico and Savinio arrived in Florence they sought out Soffici, and they continued to correspond with him from Ferrara, where the army sent them; occasionally he visited them there. Soffici was on active duty throughout the war and did not paint, but devoted much energy to writing. Pondering the nature of art, he wrote a series of essays published serially in 1916 and 1917 under the general heading of "Principles of a Futurist Aesthetic." Soffici's new aesthetic was formulated after his rejection of Marinetti and precisely during the years when he was in regular contact with de Chirico. In the essays he set forth principles of Metaphysical painting much as de Chirico himself would later define it.

Soffici objected to recent experiments with abstract and nonfigurative painting, and it might have been this development that led him to formulate an artistic credo. His rejection of total abstraction was generally shared in Italy — except, notably, by Prampolini. Soffici's grounds were aesthetic, but other critics, like Broglio, gave moralistic reasons.

Soffici believed that a new aesthetic was needed for a "purified art." [18] The artist might draw the elements of his art from his own fantasy, but must not "turn his back on nature and dive into abstraction," for a work of art "is not alive if it is not capable of communicating…the emotion felt by the author; and such an emotion can only be communicated by means of recognizable forms, which inspire *a certain vision and not another.*" Soffici held that the number of invented forms was limited, while "reality offers an unlimited number of them…it generates infinite variety, surprise, and thus the maximum of enjoyment and aesthetic satisfaction." [19] Among the artists of Soffici's acquaintance there is none whose work relates as closely to these tenets as that of de Chirico.

Just as strongly, Soffici objected to art used to point a moral or tell a tale:

The fundamental character of true art is lucidity, the cold radiance of the diamond; the divine calm that it should have…in common with science. Each is an expression of relationships, without finality beyond this: to manifest the mysterious harmony of life and the world. To do this, then, it is necessary that the artist like the scientist work with maximum calm, clarity, and disinterest. His role is not…to educate, incite, or dominate, but solely to accomplish a new and perfect accord of sensations, forms, and images.…

In pure art all is resolved in a serene enjoyment, an ecstatic contemplation, in a perfect equilibrium of the senses and the intelligence…[20]

As he demonstrated in "Art as Generator of the Marvelous," Soffici did not equate calm and balance with lack of emotion:

In analyzing pure sensation, which according to our aesthetic is the first foundation of art…we discover that this is at bottom no more than a prolonged surprise before a reality that reveals itself always new and unpredictable. To express this surprise, to communicate by means of signs and accords are, taken together, the necessity and first aim of the artist…[21]

He knew that Apollinaire had written of de Chirico that "to describe the fatal character of contemporary things, the painter uses that most modern recourse — surprise," [22] and he appears to have been considering why "surprise" was a "modern recourse." Part of it had to do with the unpredictability of reality (which an artist can demonstrate but not control), and a good part of it had to do with the artist's originality. "Every artist," Soffici wrote, "succeeds solely by means of that which he brings to the common whole

of aesthetic values which is *absolutely* original." To be original meant to "conceive and translate reality" in a profoundly personal way. It was "not a natural quality" but a "difficult conquest."[23] It is possible that de Chirico's ingenious solutions were welcomed by Soffici as proof that a modern artist did not need to "dive into abstraction." In almost every other way Soffici allowed for the artist's "Freedom" outlined in three axioms: "Art is not a serious thing," "Art is not venerable and must not command respect," and "It does not matter if art is understandable."[24] Art was "a jargon," Soffici declared, just as "all Castes, Churches, Sciences, Mysteries have had…their symbolic jargon, their secret language, their Signs. We accept that so also do artists understand each other, these elect of the elect, these supreme seers, the scientists of the absolute Real…"[25] Seers, soothsayers, oracles, and clairvoyants (pls. 6, 15, 55) regularly figured in de Chirico's paintings before and after his arrival in Italy. This imagery was taken up by others of his circle in Ferrara, including de Pisis and Carrà.

When Soffici defined "Irony" as the "aristocratic acceptance of the world for what it is worth," and "cheerful science of man cured of the illness of 'transcendency and dignity,'" once again he could have been speaking for de Chirico. The "main formula of our metaphysic," concluded Soffici in 1916, "the prime aim of our speculative research, the great Problem of our deepest soul; The Sense of Senses, is nothing other than…Nonsense; a simple operation badly started, and therefore insoluble…"[26] De Chirico would reiterate this belief in his 1919 essay "Noi metafisici."

Soffici had said previously that art was pure sensation, need have no meaning, but must express the artist's emotion. In 1917 he returned to these points, using the image of the acrobat as a metaphor, and this essay, "Acrobatism-Clownism," caught the attention of many of his Italian contemporaries. Soffici wrote:

Having arrived at the point of considering art as a simple activity of the imaginative spirit, without any purpose, without other aim than the perfectioning of its own game…no difficulties will be met in recognizing that art inclines after all toward a supreme freedom, becoming ultimately nothing more than a *diversion.*

But, he insisted, it was a "diversion of a spiritual and absolute order." Like the acrobat, the artist was not concerned with sentimental, religious, or moral problems; he proclaimed nothing; did not advance judgment. The source of our pleasure in an art work, as at the circus, said Soffici, was "in the spectacle of difficulty conquered…"[27] Few artists would disagree, for certainly a source of pleasure for the artist lies in difficulty conquered. Art as a diversion was a thought on the same order as Matisse's 1908 statement about art as a good armchair for the mind, an art of balance, purity, and serenity devoid of troubling subject matter. But there were those in Italy who would take strong exception to such a definition of art, for one, Mario Broglio.

Of the clown, Soffici was equally eloquent:

The clown is…a revelation of freedom, a discoverer of novelty, a species of demon who creates on his own account one world in substitution for another, and all made of marvels.

The clown, who "solves a moral problem," can "stir the imagination and even the envy of a true thinker." He is a "symbolic operator whose words and whose acts can represent an attitude of the spirit, can convey visibly a metaphysical principle." His costumes suggest infinite possibilities, above all, "rebellion from any system of logic whatever." Soffici concluded that the "occult significance" of the clown would be the "metaphysical, skeptical, and ironic substratum of the futurist work."[28]

This metaphor of the clown, freed of all systems of logic, was an apt characterization of de Chirico's painting, from *The Evil Genius of a King* (pl. 47), which was reproduced in *Dada 2,* December 1917, to the *Evangelical Still Life,* painted in Ferrara and reproduced in *La Raccolta,* July 1918. De Chirico explained in 1919 that he had discovered this idea of rebellion from systems of logic in Nietzsche and Schopenhauer. In his contemplative search for a new art form that was modern yet figurative, harmonious yet capable of producing surprise, expressive of emotion but not religious or sentimental, Soffici defined Metaphysical art.[29]

Giorgio de Chirico. *Evangelical Still Life.* 1917-18
Oil, 35½ x 23⅝″ (90 x 60 cm)
Private collection
Reproduced in *La Raccolta,* July 15, 1918, and *Valori Plastici,* VII-VIII [1920], and exhibited in the *Epoca* exhibition, Rome, 1918, and *Das junge Italien,* 1921.

The Italian audience for Soffici's new aesthetic, eager to be part of the development of a post-Futurist aesthetic, did not as yet have before them a body of paintings that might exemplify these new principles. De Chirico did not exhibit in Italy until 1918, and before that his work was known to very few. It fell to his brother to introduce the family imagery into Italy. In his first article, which appeared in *La Voce,* February 1916, Savinio, sounding more like Nietzsche than Marinetti, promoted the idea of the "man to come," whose birth he believed was imminent:

From this ferment will spring the prototype of the Mediterranean genius—the man in the wings, the religious man, the man-pelican who rends his breast from whence gushes lightning and shade, and a flaming heart!

But this man, where is he? Who is he?[30]

The idea of the "Mediterranean genius" as the man of the future was an attractive one to his readers.

On March 31 *La Voce* began to serialize Savinio's satirical poetic drama *Hermaphrodito.* The first portion, "Songs of the Half-Dead: Drama of the Southern City," had appeared in *Les Soirées de Paris* in May 1914. Not surprisingly, there is a similarity between Savinio's imagery and that in certain paintings by de Chirico, in particular *I'll be there... The Glass Dog* (pl. 42) and *The Span of Black Ladders* (pl. 44), painted at about the same time, and *The Duo* (pl. 53) and several with statues of politicians and sleeping Ariadnes:

It is noontime.

¾ of the stage is occupied by an immense plaque of excessively white and polished marble... Further back, a platoon of tin soldiers. Piles of polychromed boxes. Some iron palm trees. Assorted vegetation: medlar trees, pineapple plants, coconut palms. The green sky navigated by white storks describing long spirals.

A man enters, wearing a [cabinet] minister's frock coat. In place of his missing head he wears a little flag implanted like a steel antenna. He has three rigid legs, unarticulated and inflexible like the legs of a photographer's tripod. He skates on metal rollers that squeak horribly.

Upon arriving at the middle of the marble plaque he unbuttons his frock coat and his waistcoat and then a third jacket which, when opened, reveals two wings of living flesh and all the anatomical details of his thorax with its play of organs.

The man rummages in his lungs and extracts from them an enormous heart, red as a blood pudding swollen with blood.

This figure sings that he saw statues of politicians die:

...they bent their heads and uttered their last song, then broken at the sides, they fell like abandoned Ariadnes..[31]

Savinio's ironic prose continued to appear side by side with Soffici's new aesthetic in *La Voce* throughout 1916. A third voice issuing from the same pages was that of Carlo Carrà.

Carrà had affiliated himself with Soffici as he grew uncomfortable with both the ideas and the formal procedures of the Futurist program, even with those he himself had formulated. As a leading Futurist, Carrà possessed a certain authority, as Edita Broglio asserted,[32] and was observed closely by his colleagues. His writings throughout the war period testify that he was undergoing a deeply stressful time of change, and it was his poetry and essays that reached his colleagues, since he did not exhibit between 1915 and 1918. Given the importance of his relationship to Metaphysical art, a summary of his writing is required. At the end of 1915 Carrà informed Soffici by letter that his most recent paintings dealt with "concrete forms (men, women, bottles, glasses, horses, etc.) placed in space"—which he thought would please Soffici.[33] He referred to paintings such as *The Cab* and *The Flask,* in which extremely simple figures are set upon a flat but textured ground that resembles an ancient wall. Carrà uses "concrete" in the same sense as Soffici in his dictum "Art is a convention, but its terms must be real and concrete,"[34] and might have been explaining to Soffici that he had moved away from the nonfigurative approach he had used in 1914.

Then in his poem "Christian Night" ("Notte cristiana"), the Futurist artist confessed

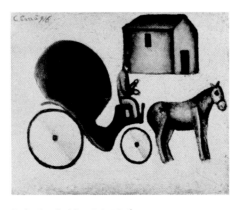

Carlo Carrà. *The Cab.* 1916
Oil on canvas, 20⅛ x 23⅝" (51 x 60 cm)
Private collection
Reproduced in the catalog of Carrà's one-man exhibition in Milan in 1917-18 and in *Valori Plastici,* I [1921].

to the rebirth of his religious faith: he was ready to leave the "absurd ways of worldly theologies" (possibly a reference to his earlier adherence to the cause of the anarchists, or even the Futurists) and return to an older, Christian faith (*La Voce,* January 31, 1916). How the Futurist Carrà came next to write about Giotto is not clear ("Speaking of Giotto," *La Voce,* March 31, 1916). Perhaps in the light of the above poem we may say that his interest was aroused by what he described as "presence of spirit" in Giotto. Carrà analyzed the work of his artistic ancestor as if seeing it for the first time, like a revelation, and responded to what Berenson had called "tactile values," but even more strongly to a sense of the "visionary" and to "vibrations of the spirit." And in "The Parenthesis of the Self" ("Le Parentesi dell'Io," *La Voce,* April 30, 1916) he emphasized the role of the spirit as the moving force that makes for genius in art. His search for new beginnings had led him to the primitive[35]: "With Henri Rousseau I construct the new European painting," he declared. His Christian sentiments were repeated:

I am not blood and flesh but spirit made form. The force that moves me is the love of love. It is the highest love that is directed at the heaven of the soul. Only the genius is allowed to enter into this paradise of art.[36]

This avowal that the artist genius must be a primitive and Christian mystic to discover real truths was a further revelation from the Futurist Carrà which helped form the expectations of his audience as they awaited his new paintings.

In the June 30, 1916, issue of *La Voce* he published a poem about his new painting *The Drunken Gentleman,* which was not reproduced. The full title of the article was "Orientalism: Critical soliloquy. Sung monologue. Analysis and synthesis of my recent painting *The Drunken Gentleman.*" The ideas and the style are part of Carrà's Futurist background, but they also seem very reminiscent of Savinio's "Songs of the Half-Dead."[37] The first part of Carrà's article is a stream of ideas on conscience and feeling. The second part appears to describe the painting poetically, although the description does not greatly resemble the painting as it is known today.[38]

When he wrote about Uccello on September 30, 1916, he spoke of looking at Uccello's works as others look in a mirror. Describing Uccello's "supreme passion for severe painting," he admired the "new accords of plastic movements" in which Uccello had "discovered weighty cubicity"; his "exploratory boldness" manifested in his "pictorial depth of soul"; and the "cubicity contained on a plane" in the Uffizi *Battle.* He praised Uccello's austerity, virtuousness, studiousness, and devotion to art, seeing him as a simple, good-natured person who was misunderstood and even ridiculed by his friends (Carrà had some of these impressions from reading Vasari). Carrà implied (differing from Soffici) that purity in a painting occurs when the artist himself is austere and virtuous, and he ended dramatically: "Oh, we may well remember this needy martyr; for whom art was the greatest virtue fulfilled…"[39]

While it must have become clear that Carrà was abandoning certain earlier beliefs, the assumption must surely have been that he was turning to a philosophy of essentially Christian mysticism and that his search for beginnings for a new art had led him to an appreciation of those Italian primitives, Giotto and Uccello. His work at this point might have gone straight to *Lot's Daughters* of 1919 and *Valori Plastici* without the hiatus that Metaphysical art represented, for his Metaphysical works, though brilliant, passed quickly and left little trace in Carrà's subsequent painting. Carrà's piety was greatly at odds with Soffici's metaphysics and his purified art displaying the "cold radiance of the diamond," favorably compared to science, and also at odds with Soffici's insistence that art must not express sentiments, even religious ones. Carrà's views also ran counter to those of Severini, who made a point of stating his belief in the validity of science as a support for already-held convictions and as a means of control, adding that

this sympathy for science existed also in the time of Paolo Uccello, Andrea del Castagno, Domenico Veneziano, Luca Signorelli, Leonardo, etc., who were realist painters in the largest sense of the word, as we are.[40]

This divergence however was not so evident in 1916. Moreover, there was little as yet to

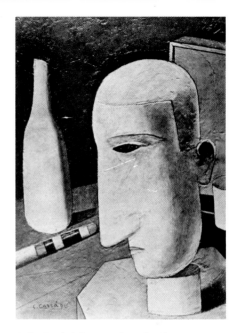

Carlo Carrà. *The Drunken Gentleman.*
Oil on canvas, 23⅝ x 17½" (60 x 45 cm)
Private collection
The outline of a folded glove, mentioned by Carrà in the 1916 poem, seems visible lower right in the area between the mallet handle and the nose of the bust.

Carlo Carrà. *Lot's Daughters.* 1919
Oil on canvas, 43¼ x 31½" (110 x 80 cm)
Private collection
Reproduced in *Valori Plastici,* November-December 1919.

suggest what new form Carrà's painting actually had acquired, beyond his new emphasis on the need for "weighty cubicity," which he had earlier criticized in Cézanne[41] but now admired in the early Renaissance Italians.

If Carrà's painting was unknown in the years 1916-17, at least his words were heard. De Chirico, on the other hand, remained a nearly unknown factor to those Italians he had not known previously. Savinio was publishing regularly in *La Voce,* but de Chirico had had no further exposure before the Italian public since Soffici's 1914 review, which had described him as simultaneously Uccello-like in his dedication and absolutely modern. This situation changed when a young art historian from Ferrara, Filippo de Pisis (1896-1956) decided to become his champion. He later became a respected painter, but in 1916 de Pisis had just entered the University of Bologna to study art history (he received his *laurea in lettere* in 1920). Although just turning twenty, he was already an accomplished writer who had written scholarly articles on older Ferrarese art, several one-act plays in the style of Marinetti's "Synthetic Theater," and a volume of poetry, *I Canti de la Croara.*[42] When he was not in Bologna at the university, de Pisis lived at home in Ferrara on via Montebello. One can imagine the delight of this young aesthete when two artists from Paris moved in across the street. De Chirico was equally intrigued by the younger man, writing in warm recollection of their introduction:

Carlo Carrà. *Hermaphrodite God.* 1917
Oil on canvas, 26 x 16½" (65 x 42 cm)
Private collection
Exhibited in Carrà's one-man exhibition in Milan in 1917-18 and reproduced in *La Raccolta,* March 15, 1918, and *Valori Plastici,* I [1921].

> In Ferrara I met Filippo de Pisis…one could not say he was a champion and an example of normality, however, he was and is still filled with talent…When I met him he did not yet paint but drew a lot and studied fine arts at Bologna. In Ferrara, in his father's house, he lived in a strange room filled with heteroclite and bizarre objects: stuffed birds decayed into strange forms, flasks, vials, and potsherds of every sort, old books that fell into ruins at a touch. He lived in this sort of sorcerer's laboratory, a true Surrealist *ante litteram.*[43]

De Pisis belonged to that younger generation of Italians who came of age after the Futurists were well established and who readily grasped their ideas and "ran with them at breakneck speed," to quote Boccioni. But his loving study of Ferrara's glorious past indicates that de Pisis did not accept every Futurist tenet, but adopted only those that suited him. When he began his profile of de Chirico, "one of the luminaries of modern painting," he found it only logical to consider whether or not he was a Futurist. Deciding that he would term the elder artist "a Futurist," he also described him as *"a seer in solitude"* who worked "tranquilly with tenacity and sharp clairvoyance." This "seer" scrutinized "the oppressive roar of modern life," then transcribed aspects of it with the "spontaneity of a baby." De Pisis believed that "we must be men of our time: know all its aspects and all its secrets, and seek to portray them with new means or old (little matter)." De Chirico, he said, succeeded by means of "novelty"; his "acute, analytic, and above all psychological study of things, of the most insignificant objects, *gives us the shiver* of modern life intensely lived." De Pisis divided de Chirico's career into stages: paintings with mythological-romantic subjects, in the manner of Carducci; others with "Eastern mythical" themes, such as had flourished in Italian painting sixty years earlier; and "truly Italian" piazzas, which de Pisis found joyful. With this summation he placed the art of de Chirico squarely in an Italian context. Then, as he considered why these paintings had impressed him, de Pisis praised the "sure power and clarity" of his draftsmanship, his ingeniousness in invention and composition, his pure colors and sharp forms (the reader had no idea what de Chirico's paintings actually looked like), and called him "a *new artist* who above all endeavors to set forth the *solid and architectonic aspect in painting…*" And he singled out de Chirico's originality in returning to "forms that seemed dead" and reviving them, or creating other, entirely unexpected forms from them.[44]

For de Pisis, de Chirico's unexpected uses of "forms that seemed dead" represented a "truly new art" which differed from and surpassed Futurism. Edita Broglio later also stressed the great impression made by de Chirico's use of past art in unexpected ways.[45] But the 1916 reader, unfamiliar with the artist's paintings, might well have drawn other conclusions about a revival of earlier art forms, particularly as Carrà at this time was

describing "new art" as solid and architectonic, while also praising Italian primitives and insisting on a pietistic basis for art.

Throughout 1917 the public, including most of the avant-garde, remained unaware of what this new art actually looked like. Exhibitions held during the year represented a continuation of prewar artistic activity. Following his death, Boccioni's achievement was elaborately presented in a large-scale retrospective of his work in all media given for him in Milan by Marinetti, December 28, 1916, to January 14, 1917. Over 340 works were included.[46] Equally impressive was the visit to Rome of Diaghilev and the Ballets Russes in 1916 and 1917. Diaghilev brought with him Cocteau, Stravinsky, and Picasso, and commissioned ballet sets from Balla and Depero. At the opening of the ballet season on April 12, 1917, Diaghilev exhibited Léonide Massine's collection of contemporary art, with works by Picasso, Gris, Léger, Gleizes, Gontcharova, and Larinov, as well as Balla, Depero, Carrà, and Severini.[47] Word of all this spread around Italy, but the effect upon Italian art was negligible. Prampolini claimed to have seen Picasso's Raphael-inspired drawings,[48] but if he did he was the last one in Italy to follow suit, being a serious nonfigurative artist, and neither Balla nor Depero was to show an interest in Raphaelesque painting. Thus the visit by the Ballets Russes and the near-mythic originator of Cubism generated much excitement and enthusiasm, but very little change.[49] Zurich Dada manifestations were also known to Italian artists. Tristan Tzara had toured Italy in 1916 soliciting participation, and Prampolini, de Chirico, Savinio, and de Pisis, among others, had expressed interest. But Italy after all had already experienced Marinetti's manifestos and Futurist Evenings, ideas which the Dadaists utilized, and Dada doctrines did not produce an appreciable change in Italian aesthetics.

Early in 1917 Carrà went to Ferrara, where he and de Chirico, who knew one another by reputation, finally met. It is no secret that in his few months in Ferrara, Carrà, who was in a receptive state, seeking ways to leave Futurism (and Cubism) without going to total abstraction, began to paint subjects identical to de Chirico's, as the latter pointedly observed.[50] When Carrà's Ferrara paintings later became known, certain Parisians did not fail to notice their resemblance to de Chirico's painting. Apollinaire wrote on April 13, 1918: "Today the young Italian Futurists submit to a new influence, that of their fellow countryman Giorgio de Chirico who painted in Paris before the war…"[51]

Hints about the nature of the new art began to appear in the avant-garde magazines, particularly those from Bologna, which had become a caldron of intellectual activity. The first work by de Chirico to appear in an Italian publication was a drawing, *Hector and Andromache* (pl. 106), reproduced in the October–November 1917 issue of *La Brigata*.[52] A single drawing in a little magazine was not likely to make a great impression on even the avant-garde, but those who noticed it might have been curious at the theme, the tragic royal couple who represented the end of ancient Troy, legendary source of Italian culture. And they might have wondered at seeing Hector and Andromache portrayed as two dummies, one unconventionally constructed of draftsman's tools and measuring devices.

Then, at this expectant moment, the Metaphysical paintings, or the "new art," began to appear: Carrà's one-man exhibition of 1917-18, a de Chirico painting (pl. 47) reproduced in *Dada 2,* a monograph on Carrà by Giuseppe Raimondi early in 1918, and group exhibitions in Rome, Viareggio, and Florence in 1918 in which de Chirico and Carrà appeared together. Their extraordinary paintings took the Italian audience off guard and were greeted with only hedging approval, but there could be no question that this represented a change from prewar Futurist art, recently reviewed in the Boccioni retrospective, and from various other modernist art forms represented in the Diaghilev-Massine exhibition.

As Edita Broglio put it, Carrà's espousal of de Chirico's style was his "stamp of approval" for this new art.[53] His paintings of 1915 and 1916, also seen for the first time in his one-man exhibition, indicated that Carrà had arrived at his new painting by way of a rethinking of various primitive styles (as he said himself). Paintings exhibited at the end of 1917 included *The Cab, The Drunken Gentleman, Hermaphrodite God,* and *Metaphys-*

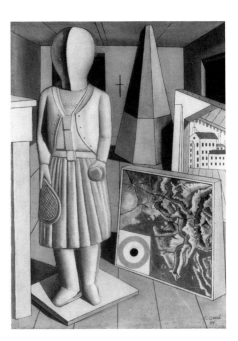

Carlo Carrà. *Metaphysical Muse.* 1917
Oil on canvas, 35½ x 26″ (90 x 66 cm)
Pinacoteca di Brera, Milan
Exhibited in Carrà's one-man exhibition in Milan in 1917-18 and in the *Epoca* exhibition in Rome in 1918; reproduced in *Valori Plastici,* I [1921].

ical Muse. Carrà provided a lengthy exposition of his new approach, in the introduction to his catalog of his one-man exhibition.[54] He immediately established his connection with Futurism, praising it for being "intellectual." At the same time he reclaimed his artistic heritage with a reference to "austere Italy," the home of Giotto, Masaccio, and Uccello. He agreed with Marinetti that Italy had fallen into "postcardish banality." But Carrà claimed that the Futurists had revived "plastic Italian virtues" and re-created values equivalent to those of "our great primitives," for "we who feel ourselves to be not unqualified sons of a great race of constructors have always pursued substantial and precise figures and ideal atmosphere..." He lamented that recent art expressed only the void; French Naturalism and Impressionism were materialistic — and Carrà meant this in a dogmatic theological sense — and could never "express true greatness" and "give voice to the universal spirit." Recent avant-garde painting lacked, even denied, any spiritual expression. Carrà had no use for scientific thought. He spoke of the content of his new work as "metaphysical" without further explanation, and urged artists to restore religious feeling to their art.[55]

It was certainly possible to understand from this that by "metaphysical" Carrà now meant "spiritual" and "pious." He also forged a new link between Futurism and traditional Italian art. This emphasis on his artistic ancestors was observed by Carrà's Italian colleagues, but he had not been the first of the Futurists to override the belief that Futurists had to deny their artistic heritage. In 1913 Severini had been at pains to insist that his art was a logical continuation of the true Italian tradition:

We [the Futurists] are unfairly accused of severing all connection with tradition. The force with which we rid ourselves of the yoke of the Past and our hatred of that Past, do not prevent our recognizing brethren in every great epoch through which Art has passed. Every expression of Art which possesses true depth bears a natural connection with tradition.

We must come to an understanding as to this word "tradition." There is, to my mind, but one artistic tradition among the painters of the West: that of Italy. It is to the Italian tradition that the most advanced painters of our day, from Cézanne to the Cubists, are attached. Whether in the work of Greco, Rembrandt, or Ribera, the solidarity of the modelling, the aristocratic sobriety of tones, and the balance of values are altogether Italian. Delacroix, too, is Italian and, therefore, the Impressionists likewise.[56]

Severini's 1913 paragraph on "tradition" fundamentally described the approach to painting taken by the majority of artists in Italy in the 1920s. Even before Carrà began to re-state it and add his own belief in the need for "religious feeling," Severini had suggested that "classicism" was derived from the "Italian tradition":

The work of art today, as in all great eras, must be composed of both elements [reason and sensibility].

In the works that I am exhibiting, and which belong to different periods [of my work], one can find this search for a balance between reason and sensibility. I have wished also, in obeying that tendency toward composition that I have inherited from the ancient Italians, to attain a new classicism through the construction of the *tableau.*[57]

If the above passage, which was taken from a statement Severini wrote for Alfred Stieglitz, did not immediately reach an Italian audience, the review of Carrà's exhibition and of the Raimondi monograph by a French acquaintance of Severini's did. Pierre Albert-Birot, editor of *SIC,* wrote that Carrà now seemed to him the most congenial of the Futurists, precisely because he seemed to leave them:

We see here [in the Raimondi monograph], and in the catalog of a recent exhibition, illustrations of works that show a lively interest on the part of their author in Negro art, Rousseau, Chirico. These are excellent classical intentions; the future will say if Carrà came to them by reason or by nature.[58]

This quite accurately categorized Carrà's recent paintings, though it is not clear why Negro art, Rousseau, and de Chirico together represented "classical intentions."

Raimondi's monograph[59] is enlightening about the nature of the esteem which the younger generation had for Carrà. In this tribute Carrà was saluted for his laborious investigation of primitive art forms in his search for a new art. Raimondi acknowledged in

passing that de Chirico had influenced his most recent paintings, but nevertheless claimed the hour for Carrà. Raimondi's enthusiasm was not in fact for painting but for poetry, and most of his text is a paean to specific literary pieces by Carrà, many of them already discussed here. To Raimondi, Carrà's achievement as a Metaphysical artist was not as a painter but as a writer.

It was just at this point, following Carrà's exhibition and the publication of the monograph about him, that de Chirico's paintings were at last seen in Italy, in the "Exhibition of Independent Art to Benefit the Red Cross," which was held in the galleries of the newspaper *L'Epoca* in Rome in May-June, 1918.[60] It was organized jointly by Prampolini and Mario Recchi, a critic. The other exhibitors were Carrà, Prampolini, Soffici, Ferruccio Ferrazzi, Maria Mancuso, Riccardi, and Marino Tartaglia-Jakulitch. De Chirico sent six paintings and a seventh category, "Drawings." The paintings were: *The Troubadour* (pl. 69), *Hector and Andromache* (pl. 70), *Evangelical Still Life, The Great Metaphysician* (pl. 73), *Cassandra,* and *The Revenant.* Carrà contributed eight paintings: *The Oval of the Apparitions, Western Rider, Metaphysical Reality, Penelope, Solitude, Metaphysical Muse,* and two *Still Lifes.*

Recchi was as eager as his contemporaries to discover the new Italian art. Much of his introduction to the exhibition seems clearly to have been distilled from Soffici's "Principles of a Futurist Aesthetic," with some recognition of Severini's "Avant-Garde Painting" as well.[61] Recchi declared that the exhibitors were in the forefront of young Italian painting, equally distant from the "senility of Academicism" as from the "anxious inventions of Futurism," by reason of uprightness of conscience and sincerity of intent. They had chosen to be independent rather than be identified with art of the official exhibitions, which expressed the miserable state into which Italian art had fallen. They believed in discipline and order in art, and they were opposed to "exaggerated individualism." (Severini had written that a "new collectivism" was developing in French art.) Italian art would become great once again, wrote Recchi, only when it became "the collective and nearly anonymous expression of spiritual promptings…" He was strongly opposed to "abstraction of the real," and equally opposed to "mere reality." The latter was only the motif from which artists took their cue, the "insignificant pretext from which they take off for the conquest of totally pure relationships; let us remember that art is a convention and cipher on which to exercise decorative motifs." Recchi scorned "instinctive intuition" and urged that "teaching and craftsmanship" be reintegrated into art. And he expected that the viewers would find in the exhibition

a strong orientation toward our tradition—if no longer Renaissance or Academic—more genuine and pure. A return, lyric and not willful, to the principally authentic forms of our race, to the qualities most intimately ours and Western, of the centuries in which the world of appearances was more strictly transcended by a rigorous and immutable order.[62]

Recchi's intention was to be modern, not academic, and his aesthetic for the most part considered form and not content, and was drawn from the theories of artists who were seeking to proceed from discoveries made by advanced artists. Still, a reactionary could find in his essay a path directly away from the discoveries of recent modern art. It was only necessary to follow such clues as "uprightness of conscience," "discipline and order," "expression of spiritual promptings," "teaching and craftsmanship," "strong orientation toward our tradition," and return to "authentic forms of our race." Much of the groundwork for Mario Broglio's introduction to his new magazine *Valori Plastici,* written later the same year, was laid by this catalog introduction of Recchi's.

The paintings were not well received, and the audience might well have expected something different from de Chirico and Carrà after reading about their new art. Both artists later wrote in their autobiographies of their disappointment at the coolness with which their paintings were received. De Pisis, dismayed by the reaction, endeavored to stem a rapidly growing rush toward revivalist ("past-ist") painting. When Carrà, de Chirico, and Prampolini appeared in another group exhibition in 1918, in Viareggio, de Pisis lectured and wrote articles to support the new painting. The artists apparently

exhibited the same works that had been in the *Epoca* exhibition earlier in the year. (Others exhibiting at the Kursaal in Viareggio in "Avant-Garde Italian Painting," August 15-30, 1918, were Depero, Conti, Lega, M. Levy, Viani, Porcella, and Tartaglia.)[63] Taking a firm stance, de Pisis called the painting of de Chirico and Carrà "Metaphysical," adding that it was one of the most important post-Futurist attitudes. He also said that Carrà was influenced by de Chirico. Metaphysical art was outside of all tradition, he asserted, and bore the value of its own true invention. To the metaphysician, objects presented "their new looks" as if "to console him." This "new art which we call Metaphysical" has the "value of a discovery that expands the barriers of the knowable immeasurably."[64] The new artist "feels the need to set down certain lucid moments of painful discomfort and the direct vision of mystery, contained in the most common and insignificant objects…" Seeking a new beauty, he finds, invents, creates "new and vital forms from nothing, so to speak (except genius)." Only the new has essential value, insisted de Pisis, for "what is a work of art that adds nothing to human thought?"[65]

Invited to contribute to the initial issue of *Valori Plastici,* de Pisis continued his argument along the same lines. The new artist sees things with new eyes; he is one who looks at the mystery of existence close up. Like one who comes from the dark and from complete silence, "objects have shown new aspects [to him], and the demons hidden there timidly have jumped forth."[66] De Pisis was here speaking directly for de Chirico, whose article "Zeuxis the Explorer," with its phrase "the demon in everything must be discovered," appeared in the same issue.[67] And in still another article on de Chirico, de Pisis noted sadly that the most profound and lyrical works, almost inevitably, would be given the most hostile reception, because of their "independent character of novelty and audacity."[68]

De Chirico remained silent until later in 1918, but Carrà continued to write. In a series of essays for the Bologna magazine *La Raccolta,* Carrà made the boy Tobias his spokesman, and the inference can hardly be avoided that Carrà saw himself reflected in the Apocryphal figure. He stressed that this was not the Prodigal Son who felt that his former ways were erroneous and begged forgiveness; on the contrary, having discovered that his father/homeland was blind, Carrà/Tobias intended to invoke a cure, and described himself as the Evangelist bringing a new art. The Tobias essays contain images of machinery that has failed, and suggest that the concept of progress has not had a lasting effect.[69]

La Raccolta had been founded in March of 1918 by several of de Pisis' acquaintances, one of whom was Raimondi, and for its year of existence it contained much material pertinent to the post-Futurist aesthetic then being formulated. Raimondi had written that this was Carrà's hour, and the artist was lionized in *La Raccolta,* but others who appeared included de Pisis, Savinio, Raffaello Franchi, and de Chirico and Morandi in reproduction. In Paris the editor of *SIC,* Albert-Birot, wrote that *La Raccolta* appeared interesting, for it

seems both to wish to be genuinely modern and to leave to its gambols the boisterous Futurism, which was a necessary reaction in Italy and could lead far on condition that it was left behind, and it particularly seems to me that spirits such as de Chirico and Savinio are destined to orient the Italian artistic movement toward a period of art more simple, more human, more grand, approaching the classic French orientation. Italy needs a calm and powerful medium, capable of leading the artists to work quietly. I hope *La Raccolta* will be this medium.[70]

Few if any of the Italian painters then at work would have agreed that Italian art needed to approach the "classic French orientation." Rebuttal to this notion was not long in coming. Raffaello Franchi wrote to dispute Albert-Birot on this point. After explaining that Italy was undergoing a long formative period full of confusion, Franchi doubted the value of a "relinking to the purest classical spirit," suggesting that it would be a "repudiation of the long interior process that leads us on." Franchi was certain that parallels to the current Italian effort in art could not be found anywhere else, not even in France. "Never as in these years have we affirmed the uncorrupted Latinity of our race," he wrote. Culture for the Italian, he stressed, was not something learned from textbooks, but was part of that "primordial consciousness of the race, the language." Italian art had

foundations that were found nowhere else. Franchi, who also enthusiastically supported the still little-known Morandi, agreed with Raimondi that the "most advanced person in this Italian research" was Carrà.[71]

Carrà had tentatively taken up the designation "Metaphysical" for his painting in his 1917-18 one-man exhibition. In his book *Pittura Metafisica* and related articles he grasped it firmly, although his definition of Metaphysical painting had very little in common with de Pisis', and in fact contradicted him. The book *Pittura Metafisica,* which was published in 1919, was a collection of essays, some previously published, some with nothing to do with Metaphysical art.[72] The two essays "Metaphysical Painting" and "Artistic Italianism" are of greatest concern to us here.

Carrà began "Metaphysical Painting" by disapproving of modern art. He believed that it was a negation of "our" spirit, for the soul of the modern artist contained "a void."[73] But certain new artists had appeared who sought to "revive the plastic virtues" of the Italians, and for them (they were not identified) "originality and tradition are not contradictory terms." Contemporary Italian painters were, he repeated, sons of a great race of construc- tors who had concentrated upon solid forms precisely depicted. He wished to perpetuate this heritage, and at the same time bring back to painting the spiritual element, the ideal atmosphere that "lifts painting above mere technique." This was something he felt had been present in Italian art before the Naturalists and Realists had begun to concentrate upon "episodic nature."[74] And this apparently was for Carrà the Metaphysical element.

Carrà's essay "Artistic Italianism" was singled out by Broglio for publication in *Valori Plastici* as a representative excerpt from the book. In the opening sentence Carrà coined the term "metaphysical Italianism."[75] He was at pains to elucidate an artistic principle which he felt was Italian in origin but which could be applied to painting in general:

In fact it is a constant phenomenon in the history of Western art that the "Italian principle" takes a predominant position every time that a European painter seeks a radical affirmation in order to leave no doubts of any sort about the constructive necessity of his creations.

He believed that this was happening again, and that his paintings and those of "dear imperfect friend de Chirico" were "only the first buds of an almost agelong thaw." "Originality" was not a part of the Italian principle, while an "orientation toward tradition" was. Carrà emphasized that the study of the old masters was necessary in order to build one's own art upon the solid foundation of tradition, saying that he who abstains from the study of the great artists for fear of losing his native sensibility will only create a form of art without roots and without real excellence. Carrà urged Italian artists particu- larly to make use of their heritage because it had been so glorious for so many centuries and had inspired artists of other nations (he mentioned Dürer, Delacroix, Ingres, and Cézanne).[76] Carrà had now recanted everything that could be construed as Futurism as it was originated by Marinetti. He had adopted the style and the subject matter of de Chirico, together with the epithet given to de Chirico's painting years earlier. But his definition of Metaphysical was greatly at odds with the definitions supplied earlier by Soffici and de Pisis, who remained in the realm of aesthetics, while Carrà's personal philosophy included the pious and also embraced the hope that modern Italian art might proudly claim a derivation from its undeniably grand past. To achieve this link with tradition, Carrà was willing to relinquish modernity. Carrà's ideas of 1916-19 (if not his painting) held great appeal for his colleagues, though some admirers (like Franchi) demurred at a complete rejection of the modern in favor of the past. In general, Carrà's vision of Metaphysical art was in the ascendancy.

De Chirico began to speak out for himself. In "Zeuxis the Explorer," which appeared in the first issue of *Valori Plastici,* he stated that he had begun to perceive the "first phantoms" of a more complete, more profound, more metaphysical art before he left Paris. Otherwise this short piece was more poetic than critical.[77] Reproduced in the same issue was *The Great Metaphysician* (pl. 73), dated 1918. Then in 1919, when he was given his first one-man exhibition in Italy at the Casa d'Arte Bragaglia in Rome, he wrote "We Metaphysicians" for Bragaglia's *Cronache d'Attualità,* slyly noting that he used "we"

euphemistically. Evidently de Chirico wished to explain that what had come to be seen as a group movement was strictly his own invention. De Chirico tried to remove certain misconceptions, saying that Metaphysical art was not a return to the era of primitives, nor was it an evocation of the dead Golden Age of Greece. Along the way he rejected Impressionism, a line of thought he would subsequently develop more fully.[78] De Chirico also debunked certain philosophies that others had been espousing, for example, Plato's separating of intellect and pleasure. De Chirico maintained that this opposition was spurious, for intellect could itself be pleasurable. Next, he said that it was Plotinus who had "confused art with mysticism," believing that art might serve as a sort of stairs or tramway for raising man to the knowledge of the highest good. De Chirico's rejection of an idea so earnestly held by Carrà repeats the maxim of Soffici that art has no purpose. De Chirico explained that it was Schopenhauer and Nietzsche who taught the "profound non-sense of life" and that this non-sense could be transmuted into art, and even "constitute the skeleton of a truly new, free, and profound art." To de Chirico, the "good new artificers" were "philosophers who have surpassed philosophy"; turning away from it, they confront the rectangle of their canvas or contemplate their walls rather than the infinite. The void, he said, was located in the materials of their craft. De Chirico sought to emphasize that the "new art is joyful," its good humor the result of overcoming obstacles (this is identical to Soffici's dictum in his passage on the acrobat that pleasure in art is the result of difficulty conquered). The suppression of the logical sense in art (Soffici's clown) was not his invention (or Soffici's), but that of Nietzsche, noted de Chirico. If his painting suggested fragments to some (probably critics), he pointed out that it differed from Cubism and Futurism. He allowed that those art forms had had merit for transforming and stretching the visual aspect of things, for offering new sensations. De Chirico realized that he was not yet understood, for even before the war, in Paris, his painting had been dubbed "literature." In his mind, Metaphysical art was tranquil, not gloomy, and had a "non-sensical beauty." His objects, such as cookies, or the corner formed by two walls meeting, were, he insisted, "at the antipodes of confusion and fogginess," and appeared Metaphysical to their author through the very "clarity of their color" and "exactness of their measure." De Chirico called this the "spectral evocation of those objects which universal imbecility relegates to the useless."[79]

Reading this today, we can enjoy the wit and commiserate with the irascibility. But in 1919 in Italy, de Chirico was at a real disadvantage, one not faced by artists whose work first appears to an unprepared audience and is later evaluated by commentators. In de Chirico's case the audience heard of the paintings long before the paintings were ever seen. First he was given high praise for being modern, novel, and post-Futurist. Then two philosophies developed around his designation "Metaphysical" art, one (Soffici's and de Pisis') which was close to his own beliefs, and the other (Carrà's) not in accord with theirs. Next, "Metaphysical" paintings by another strong artist appeared, which were similar to his own. When de Chirico's paintings were finally seen, the audience had if anything been too well prepared, and it is not difficult to understand how these paintings were misunderstood and even resented. Even though Soffici, and especially de Pisis, had written about his work from a standpoint very close to his own, their comments had perhaps come too long before the paintings were known to make a definite impression, and Soffici's aesthetic was of a general nature and did not mention de Chirico.

Paintings known to be in the Bragaglia exhibition included the *Great Metaphysical Interior* (pl. 72) of 1918, with its veristic painting of a spa by a lake. This painting-within-a-painting is braced up on a multitude of supports that rest on a table, together with a framed construction consisting of two crullers, a military epaulet, part of a rectangular frame, and an empty oval frame. In the foreground are a green and a red box; at the rear is an open window with a brown and white shade hung before it, and upper left, a lovingly painted corner where two walls meet. All are painted so simply as to recall de Pisis' remark about the newness of the appearance of objects to one coming out of the dark.

This work reveals certain changes in de Chirico's painting since his arrival in Ferrara in 1915. No longer does the space within the painting seem illogical. Although we are

pressed up close to the table and its contents so that our perception is distorted initially, further looking reveals the completely logical spatial arrangement. In comparison, Carrà's *Metaphysical Muse* is in an unrealistically cramped space. Perspective in Carrà's painting-within-a-painting of apartment buildings is distorted as well. Carrà's distortions of scale are like those in an earlier de Chirico, for example, *Joys and Enigmas of a Strange Hour* (pl. 17) or *Enigma of a Day* (pl. 29). Carrà also borrowed de Chirico's target and map of Greece (pls. 60, 62, 68), surely with the intention of communicating to other artists by means of signs, to paraphrase Soffici, and refer as de Chirico had done, to Savinio, who was then with the army in Greece.

In *Great Metaphysical Interior* (pl. 72), the painting of a spa in a hilly landscape, like the interior painting in *Metaphysical Interior [with Tree and Waterfall]*,[80] may originally have been included as one more commonplace item, like the cookies and epaulets. Copying these simple views seems to have awakened de Chirico's interest in mastering various techniques as well as the compositions of earlier artists; this determination accelerated once he had moved to Rome and was surrounded by resplendent Baroque masterpieces.

Papini wrote a review of de Chirico's Bragaglia exhibition that was pure encomium, and combined the views of de Pisis with those of Carrà. To Papini, de Chirico was a "solid constructor, enemy of all deliberate clumsiness," who had not submitted much to the avant-garde. Papini asserted that he had reached "the highest degree of clairvoyance, which confers on his paintings a profound spiritual value" that could be called, in the artist's own term, "metaphysical." De Chirico's painting was the "blooming of a new lyricism," the first powerful expression in Italian painting since Futurism. But Papini also said that his work could be called "classic," and likened it to the "great Italian tradition" through the "weight of colored material, the solitude, the fatality, and the equilibrium."[81] The equation of Metaphysical art, classical art, and the Italian tradition of architectural construction and three-dimensional forms now began to be formulated, and it only remained to reiterate it, as Broglio would in *Valori Plastici,* for it to become firmly entrenched.

From 1918 to 1921 Broglio gave great emphasis to the paintings of de Chirico, Carrà, and Morandi in his publications, and while he devoted one issue of *Valori Plastici* to Synthetic Cubism,[82] the general tone was more in the nature of "our heritage" and "the return to the craft."[83] Before founding the magazine, Broglio, who was an art critic (he did not begin to paint until the 1920s), had decided that "the avant-garde was exhausted," like a rootless plant that cannot live.[84] Broglio believed that all recent modernist painting had developed from Impressionism, but Impressionism for him equaled scientific experimentation and positivism, and was therefore immoral, and not truly artistic. At this stage of his career anyway, deep down Broglio's philosophy of art was based on nineteenth-century Catholic dogma. He wished to propose a new norm for art, one that had a moral sense. In the first issue of *Valori Plastici,* Broglio laid out his program quite clearly. He was opposed to the concept of personality, to absolute novelty and originality, and to purely formal interpretations of painting. Art to him was not a "manual exercise" but an integral conception of spirit, will, and faith. Comparing earlier and recent art, he found that the aim of the first had been to raise a given subject to the greatest expressive significance, in which "supreme and universal end" the "concept of personality" was lost. Recent art—which he categorized as "hypodermic Impressionist crystallization of pure colorism," the "form-color congealment" of Cézanne, the "nostalgic decompositions" of Picasso, Futurist physical transcendentalism (Boccioni's term), and Eastern teachings—gave him only a sense of "profound delusion"; he believed that these various forms of art were all built on the same "fragile base" of a "distressing optimism," which took the place of "an absent faith." The "defect" of recent art, as Broglio saw it, was that it had renounced its metaphysical function, that whatever meaning it was supposed to have was simply hyperbole, for it lacked evidence of the spiritual, that is, religious faith. Broglio hoped that his magazine would provide a forum for proposals for a new art form.[85]

Broglio did not indicate very precisely how painting should look. But his attack upon

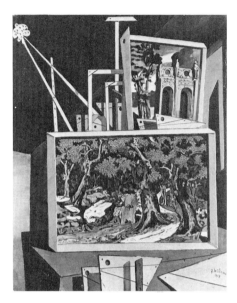

Giorgio de Chirico. *Metaphysical Interior [with Tree and Waterfall]*. 1918
Oil, 24¾ x 20⅛" (63 x 51 cm)
Private collection
This painting was one of the twenty-six by de Chirico included in the exhibition *Das junge Italien,* which Mario Broglio sent to Germany in 1921. Reproduced in *Valori Plastici,* VII–VIII [1920].

the "painting of light" with its "vague appearance" implies that he preferred an art with a more pronounced structure and sharp definition of forms. Broglio's title, "Valori plastici," may thus be understood as "Plastic Values" in which "plastic" suggests a capability of being formed or modeled, and implies three-dimensional form (several of the writers in the magazine substantiate this definition). It might also mean "pictorial values" with the emphasis on *values,* moral values even.

To establish his new norm in painting, Broglio sought out artists "who appeared intent on confronting the problems in a manner analogous to his interpretation of them," according to Edita Broglio. Upon seeing the paintings of de Chirico and Carrà at the *Epoca* exhibition, he was "taken with a faith in them," she said.[86] Broglio seems to have interpreted their paintings according to the more conservative slant of Recchi's catalog essay, and Carrà's new philosophy was completely in accord with that of Recchi. De Chirico's was not, but he had the great distinction of being seen by Apollinaire as "the only living European painter who has not been influenced by the young French school."[87] This alone would have made him estimable to Broglio, to whom recent French art was anathema, and de Chirico himself was willing to agree with Apollinaire.

Papini was probably the final critic of the day to consider de Chirico's art in relation to Futurism. When Savinio defined what he still termed "the new art" for *Valori Plastici,* he rejected Futurism together with Cubism and set about constructing the evolution of a "new classicism." Savinio denied that Cézanne was the father of modern painting, for he felt that Cézanne's art was a "link between the last vestiges of classicism – dried up in the academies... and the beginnings of a new art leading to a new classicism." For Savinio it was Gauguin who took the "plunge into the most naked beginnings, the most genuine barbarism." That was the beginning of "the new art," and Savinio then traced its evolution through the work of the Fauves, particularly Matisse, then Derain, and "finally arriving at the smoothing out of a new classicism – which appears for the first time in the paintings of Giorgio de Chirico and Carlo Carrà." Savinio was of the opinion that the entire development of painting from Gauguin onward was summarized in Carrà's oeuvre. De Chirico, on the other hand, had not been carried away to the same extent by the "mechanism of the evolution of form," but had always inclined toward "spiritual affirmation."[88]

In an issue of *Valori Plastici* that might be called the "our heritage" number, Savinio wrote that the French period in art was over and the Italian period had begun. Italian artists were not inclined solely toward formalism, but toward classicism:

Classicism, that is, be it understood, not the return to earlier forms, borrowed and consecrated from a past era, but a reattainment of the form most suited to the realization of a thought and an artistic will – which does not at all exclude the innovation of expression, but includes it, even requires it.[89]

De Chirico began to copy certain old masters in the Galleria Borghese in Rome. He too now rejected Futurism, saying that the "intelligent few... learned little from Futurism, and that little good they have done and are doing, they would have done just as well without the Futurist interlude." But now, he said,

we have reached the second half of the parabola.... Hysteria and roguery are condemned.... More than one painter will return to the craft, and those who have already done so can work with freer hands and their works will be better appreciated and recompensed.

As for me I am happy, and I decorate myself with three words that I wish to be the seal of each of my works: *Pictor classicus sum.*[90]

When Marinetti returned from the war he organized an enormous "Grand National Futurist Exhibition" with over 450 entries by fifty artists, which opened in Milan in March 1919 and then traveled to Genoa. There had been no marked change in Marinetti's thinking, and he declared:

Italian Futurism is the soul of the new generation which has fought against the Austro-Hungarian Empire and victoriously annihilated it. The Futurist artistic movement, which during the war underwent a forced slowing down, today takes up again its exciting and renovating dynamism.[91]

Giorgio de Chirico. Copy after a portrait by Lorenzo Lotto in the Galleria Borghese, Rome. 1919
Oil. Size unknown
Whereabouts unknown
From an old photograph in the *Valori Plastici* archives.

Almost every artist who had taken part in Futurist-sponsored activities before the war sent work to this exhibition. Notable exceptions were Carrà, Severini, Soffici, Morandi, and Prampolini. Prampolini did unite with Marinetti in the 1920s, and Balla and Depero continued to remain strong figures in the renovated Futurist artistic program. For the most part, however, Marinetti would soon discover that Futurism was not the soul of the new generation which had fought in the war, for within a year of the "Grand National Futurist Exhibition" most of the young artists, including Funi, Dudreville, Giannattasio, Conti, Ferrazzi, and Sironi, were enthusiastically following the tenets of the *Valori Plastici* group, painting naturalistic forms directly seen and bearing the stamp of some former era of Italian painting varying from early Renaissance to Mannerist. Broglio and his colleagues had captured the mood of the returning artists to a much greater extent than Marinetti.

The idea that what others, particularly the French, called "classicism" was a natural quality inherent in Italian painting not surprisingly appealed to the postwar generation. Renaissance painting verified it, and this quality continued to be known in Italy as the Italian tradition throughout the 1920s and 1930s, and generally continues still. To Carrà, to Broglio, and to *Valori Plastici* can be attributed the additional dogma that the basis of any art must be spiritual, religious, Catholic, Christian. Stated by Carrà as a personal belief, taken up by Broglio as a critical position, by the mid-1920s their definition of Italian art had become a truism.

Perhaps it can now be seen that the accepted view of Metaphysical painting before 1919 is not accurate when applied to de Chirico, and that it was the combined theories of Carrà, Broglio, and Savinio, in particular, that swung the post-Futurist generation toward traditional or classical painting. De Chirico apparently forswore his own achievement, that of reviving "forms that seemed dead" and creating new and unexpected forms, to devote himself for the next half-decade to that revival of interest in the craft of painting and traditional form which he had helped to foster.

Notes

1. Sandra Orienti, "Il ritorno di *Valori Plastici:* Incontro con Edita Broglio," *La Fiera Letteraria,* Jan. 14, 1973, p. 17.

2. "The Exhibitors to the Public," Feb. 5, 1912. Trans. in Joshua C. Taylor, *Futurism* (New York: Museum of Modern Art, 1961), p. 129.

3. To F. Balilla Pratella, June 16, 1916. Trans. in Marianne W. Martin, *Futurist Art and Theory 1909-1915* (Oxford: Clarendon Press, 1968), p. 204.

4. From "Futurist Painting: Technical Manifesto," Apr. 11, 1910, and "The Exhibitors to the Public," Feb. 5, 1912. Trans. in Taylor, *Futurism,* pp. 126-29.

5. "Pittura Futurista: Boccioni, Carrà, Russolo, Balla, Severini, Soffici," Naples, Galleria Futurista, May-June 1914.

6. "Esposizione Libera Futurista Internazionale," Rome, Galleria Futurista, Apr.-May 1914.

7. "Prima Esposizione d'Arte del Gruppo Nuove Tendenze," Milan, Famiglia Artistica, May 20-June 10, 1914.

8. Reproduced in Martin, *Futurist Art and Theory,* pls. 217, 218.

9. "Esposizione Fu Balla e Futurista," Rome, Sala d'Arte A. Angelelli, Dec. 1915. The contents have not been established with certainty.

10. Alberto Savinio, "La realtà dorata: Arte e storia moderna—Guerra—Conseguenze, parte temporale," *La Voce,* Feb. 29, 1916, p. 79.

11. Marianne W. Martin, "Reflections on de Chirico and *Arte Metafisica,*" *Art Bulletin* (June 1978), pp. 342-53.

12. To indicate the range and zeal of Soffici's literary productivity, let us note that in 1915 alone he published fourteen articles or poems in *La Voce,* together with three books, *BIF & ZF + 18: Simultaneità e chimismi lirici* (poetry), *Serra e Croce* (criticism), and *Giornale di bordo* (a critic's journal). Until his induction he also continued to paint.

All translations unless otherwise noted are by the present author.

13. Ardengo Soffici, "De Chirico e Savinio," *Lacerba*, July 1, 1914. Reprinted in Giuliano Briganti and Ester Coen, *La pittura metafisica* (Venice: Istituto di Cultura di Palazzo Grassi, 1979), pp.110-11.

14. For further discussion see Joan M. Lukach, "Giorgio Morandi, 20th Century Modern," in *Giorgio Morandi* (Des Moines: Des Moines Art Center, 1981), pp. 19-39.

15. "Futurismo e Marinettismo," *Lacerba*, Feb. 14, 1915.

16. "Marinettismo," *Lacerba*, Feb. 28, 1915.

17. Severini, who had returned to Paris in November 1914, was able to remain on good terms with all the others, as suited his noncombative nature. Chronically ill with a lung disorder, he was exempt from service.

18. Soffici, "Principî di una Estetica Futurista: Necessità di una nuova estetica. Origine del fatto artistico," *La Voce*, Jan. 31, 1916, pp. 43-44.

19. Soffici, "Principî di una Estetica Futurista: Rapporto fra arte e natura. L'arte e il sentimento," *La Voce*, Mar. 31, 1916, pp. 140-41.

20. Ibid., pp. 142-43.

21. Soffici, "Principî di una Estetica Futurista: L'Arte come generatrice del meraviglioso. Originalità," *La Voce*, May 31, 1916, p. 229. The relationship between Soffici's aesthetic and the writings of Remy de Gourmont is worthy of study.

22. *Les Soirées de Paris*, Mar. 15, 1914, p. 186. Trans. in James Thrall Soby, *Giorgio de Chirico* (New York: Museum of Modern Art, 1955), p. 46. It is perfectly possible that de Chirico himself was the source of this description of an element of his art.

23. See n. 21: pp. 229-30.

24. Soffici, "Principî di una Estetica Futurista: Libertà," *La Voce*, July 31, 1916, pp. 305-08.

25. Soffici, "Principî di una Estetica Futurista: I due piani dell'arte. L' Arte un gergo. Ironia," *La Voce*, Dec. 31, 1916, pp. 429-30. Severini presents an interesting parallel to Soffici, for he had written about an art of signs and symbols in "Symbolisme plastique et symbolisme littéraire," *Mercure de France*, Feb. 1, 1916, pp. 466-76.

26. Ibid., pp. 431-33.

27. Soffici's "Acrobatismo-Clownismo" appeared in *L'Italia Futurista* in 1917 or early 1918. Reprinted in Soffici, *Opere*, vol. 1 (Florence: Vallecchi Editore, 1959), pp. 711-14.

28. Ibid., pp. 714-16.

29. The complete texts of Soffici's essays on "Principles of a Futurist Aesthetic" should be read for a fuller understanding of Metaphysical art. These essays are translated and discussed at greater length in Joan M. Lukach, "*Plastic Values*: Painting in Italy 1915-1919" (Ph.D. diss., Harvard University, 1976).

30. Savinio, "La realtà dorata," p. 90 (see n. 10).

31. Savinio, "Hermaphrodito: Microscopio-Telescopio. Concerto. Canti della mezza-morte—Dramma della città meridiana—Epoca Risorgimento—Il Papa in Guerra—"Frara" Città del Worbas—La Guerra—L'Ora Ebrea—Dramma Pomeridiano fra due Stagioni—Finale," *La Voce*, Mar. 31, 1916, pp. 151-59.

32. See n. 1.

33. Letter of Dec. 27, 1915. Cited in Maria Drudi Gambillo and Teresa Fiori, eds., *Archivi del Futurismo*, vol. I (Rome: De Luca Editore, 1958), p. 368.

34. Soffici, *La Voce*, Mar. 31, 1916, pp. 140-41.

35. For further discussion see Ezio Bassani, "Carrà e l'arte 'negra'," *Critica d'Arte*, July-Aug. 1973, pp. 7-17, and Carlo Ragghianti, "Bologna cruciale 1914," *Critica d'Arte*, Oct.-Nov. 1969, pp. 3-144.

36. Carlo Carrà, "Le Parentesi dell'Io," *La Voce*, Apr. 30, 1916, pp. 215-16.
 Carrà had begun to hark back to the dialectics of Italian Renaissance Neoplatonists' discussions of love and beauty. This is another aspect of the return to traditional art that needs further study.

37. Savinio and Carrà appear to have been on good terms for a longer period than were Carrà and de Chirico, to extrapolate from available correspondence; see *Alberto Savinio* (Ferrara: Galleria Civica d'Arte Moderna, July 5-Oct. 5, 1980).

38. Carrà, "Orientalismo: Soliloquio critico. Monologo cantato. Analisi e sintesi sul mio recente quadro *Il gentiluomo briaco*," *La Voce,* June 30, 1916, p. 269. Carrà evidently repainted *The Drunken Gentleman* in 1917 or 1918. For discussion, see Lukach, "*Plastic Values*: Painting in Italy."

39. Carrà, "Paolo Uccello costruttore," *La Voce,* Sept. 30, 1916, pp. 378-79.

40. Severini, "La Peinture d'avant-garde," *Mercure de France,* June 1, 1917, pp. 458-59.

41. In his article "Da Cézanne a noi futuristi," *Lacerba,* May 15, 1913, and republished in Carrà, *Guerra pittura* (Milan: Edizioni Futuriste di "Poesia," 1915), p. 59.

42. This information from *Filippo de Pisis* (Ferrara: Galleria Civica d'Arte Moderna, July 1-Sept. 30, 1973).

43. Giorgio de Chirico, *Memorie della mia vita,* 2nd ed., enl. (Milan: Rizzoli Editore, 1962), p. 127.

44. Filippo de Pisis, "Il pittore Giorgio de Chirico," *Gazzetta Ferrarese,* Oct. 11, 1916; reprinted in de Pisis, *La Città dalle Cento Meraviglie e altri scritti* (Florence: Vallecchi Editore, 1965), pp. 144-49.

45. See n. 1.

46. *Grande esposizione Boccioni, pittore e scultore futurista* (Milan: Galleria Centrale d'Arte, Dec. 28, 1916-Jan. 14, 1917).

47. No catalog of this exhibition seems to have existed. For my reconstruction of it from a variety of sources see Lukach, "*Plastic Vlaues*: Painting in Italy."

48. Discussed in Vittorio Orazi [Alessandro Prampolini], "Il primo incontro di Picasso con Roma," *Strenna dei Romanisti,* 1966, pp. 329-33.

49. This essay is concerned only with painting and drawing and therefore does not extend to theater and dance. In those arts the interaction between the Roman Futurists and Diaghilev's entourage was very lively. For discussion see Lukach, "*Plastic Values*: Painting in Italy," and especially M. Martin, "The Ballet *Parade*: A Dialogue between Cubism and Futurism," *Art Quarterly* (Spring 1978), pp. 85-111.

50. De Chirico, *Memorie,* p. 129.

51. *Les Arts à Paris,* Apr. 13, 1918; cited in Briganti and Coen, *La pittura metafisica,* p. 127.

52. Reproduced in *Alberto Savinio* (Ferrara), n.p.

53. See n. 1.

54. *Mostra personale del pittore futurista Carlo Carrà* (Milan: Galleria Paolo Chini, Dec. 18, 1917-Jan. 10, 1918).

55. Ibid.

56. *Gino Severini's Exhibition* (London: Marlborough Gallery, Apr. 1913), pp. 4-5. In English.

57. Reprinted in *Critica d'Arte,* May-June 1970, pp. 50-53, from a document in the Severini archives. Its authenticity can be substantiated by means of quotations that appeared in the New York press in the spring of 1917 at the time of Severini's exhibition at "291."

58. *SIC,* Apr. 1918, n.p.

59. Giuseppe Raimondi, *Carlo Carrà* (Bologna: Vighi & Rizzoli, 1918).

60. *Mostra d'arte indipendente pro Croce-Rossa* (Rome: Galleria dell'Epoca, May-June 1918).

61. Severini's article had a wide circulation, not only in the *Mercure de France* (see n. 40); it was reprinted in *De Stijl* (Dec. 1917) and serially in Prampolini's magazine *Noi* (Feb. 1918 and Jan. 1919).

62. See n. 60.

63. Also called "Painters of Today," the exhibition was seen as well in Florence, at the gallery Fiorentina Ars, Oct. 17-Nov. 15, 1918.

64. Text of a lecture de Pisis gave in Viareggio, Aug. 29, 1918. Cited in de Pisis, *La Città dalle Cento Meraviglie,* pp. 126-43.

65. De Pisis, "Esposizione di pittura moderna a Viareggio: Carlo Carrà — Giorgio de Chirico," *Fronte Interno,* Aug. 30, 1918.

66. De Pisis, "Pensieri per una nuova arte (L'arte figurativa e l'arte plastica)," *Valori Plastici,* Nov. 15, 1918, pp. 16-18.

67. De Chirico, "Zeusi l'esploratore," *Valori Plastici,* Nov. 15, 1918, p. 10.

68. De Pisis, "Disegni di Giorgio de Chirico," *La Provincia di Ferrara,* Feb. 21, 1919, p. 1. De Pisis

here added the useful information that in the drawings de Chirico developed and commented upon favorite themes already expressed in oils, and gave as an example *La Dea Estia* (Eastern Goddess), which "miraculously" comments upon the painting *The Disquieting Muses*.

69. Carrà, "Il ritorno di Tobia," *La Raccolta,* Mar. 15, 1918; "Tobia futurista," *La Raccolta,* Apr. 15, 1918; and "Tobia futurista," *La Raccolta,* June 15, 1918.

70. *SIC,* June 1918, n.p.

71. Raffaello Franchi, "Terrazza," *La Raccolta,* Aug. 15-Oct. 15, 1918, pp. 99-100.

72. Carlo Carrà, *Pittura metafisica* (Florence: Vallecchi Editore, 1919). (The second edition, published in 1945, was greatly revised.)

73. Ibid., p. 217.

74. Ibid., pp. 221-29, passim.

75. Carrà's more general use of "metaphysical," the term de Chirico had originally allowed to designate his own painting, still continues, as for example in the catalog by Renato Barilli and Franco Solmi, *La Metafisica, gli anni venti: Pittura, scultura* (Bologna: Galleria d'Arte Moderna, May-Aug. 1980).

76. Carrà, "L'Italianismo artistico," *Valori Plastici,* Apr.-May 1919, p. 1. The essay also appears in Part II of the 1919 edition of Carrà's *Pittura metafisica.*

77. See n. 67.

78. In "Impressionismo," *Valori Plastici,* June-Oct. 1919, pp. 25-26.

79. De Chirico, "Noi metafisici," *Cronache d'Attualità,* Feb. 15, 1919; republished in Briganti and Coen, *La pittura metafisica,* pp. 142-46.

80. These two paintings were included in the Valori Plastici exhibition that was sent to Germany in 1921. See *Das Junge Italien* (Hannover: Kestner-Gesellschaft, May 22-June 19, 1921): no. 25, *Interieur mit Baum und Wasserfall/ Interno metafisico;* and no. 32, *Metaphysisches Interieur mit Luftkuranstalt/ Interno metafisico.* There were eight works by Carrà, nineteen by Morandi, and twenty-six by de Chirico in this exhibition.

81. Giovanni Papini, "Giorgio de Chirico," *La Vraie Italie,* Mar. 1919, pp. 56-57.

82. *Valori Plastici,* Feb.-Mar. 1919.

83. *Valori Plastici,* June-Oct. 1919 and Nov.-Dec. 1919.

84. See n. 1.

85. Mario Broglio, "Pittura ultima: Svolgimento dell'impressionismo, Arte, naturalismo e rivoluzione. La pittura pura. Considerazioni sulla pittura metafisica di Carrà. Contributo di esperienze plastiche," *Valori Plastici,* Nov. 15, 1918, p. 19.

86. See n. 1.

87. See n. 51.

88. Alberto Savinio, "'Anadioménon': Principi di valutazione dell'arte contemporanea," *Valori Plastici,* Apr.-May 1919, pp. 6-7. Savinio added the interesting information that in Paris de Chirico had felt obliged to work through the course of this formal transformation for his own benefit in order to return once more to a spiritual end, which he could then affirm with a full organic plasticity.

89. Savinio, "Fini dell'arte," *Valori Plastici,* June-Oct. 1919, p. 21.

90. De Chirico, "Il ritorno al mestieri," *Valori Plastici,* Nov.-Dec. 1919, pp. 15-16.

91. *Grande esposizione nazionale futurista* (Milan: Galleria Centrale d'Arte, Palazzo Cova, [Mar. 1919]), pp. 3-4.

NO other body of critical writing on a major twentieth-century painter reveals such deep disagreements, such abutting contradictions, as that devoted to Giorgio de Chirico. The admirers of his pioneering Metaphysical pictures (1911-17) often seem united by little more than their admiration; they differ profoundly both in their interpretations of this remarkable work and in their analysis of its immediate artistic context and possible antecedents. Even more conflicting in character—at least in recent years—are the estimates of de Chirico's subsequent painting, that of the years from 1918 until his death in 1978.

The received view of what is universally called "the early" de Chirico[1]—the de Chirico of 1911-17—is of a loner whose *sui generis* enterprise was not only at odds with that of his Italian Futurist compatriots, but bore little or no relationship to the dominant Parisian styles of that decade. Jean Cassou, for example, compared the Metaphysical painter's "intense reaffirmation of the past," which he considered "marked above all by a will to classicism," with the Futurists' "concern for the present, for modernity." "As much as Futurism was engaged in formal and ideological relations with Impressionism, Divisionism, Cubism, and Expressionism," Cassou argued characteristically, "so much does Chirico's painting appear as a countercurrent of all that was attempted in those years."[2] And while James Thrall Soby, in his exemplary monograph, was to suggest a possible influence of Cubism on de Chirico's early work,[3] even he saw this rapport as marginal. The admiration of Guillaume Apollinaire and others in his circle for the Paris de Chiricos was thus taken as something of a curiosity. "The French poet's enthusiasm for the young Italian," wrote Soby, "is the more remarkable in that de Chirico's road ran *counter* to the direction of Cubism..."[4] Indeed, criticism has consistently rendered homage to de Chirico's own repeated assertion that his work in Paris and Ferrara from 1911 through 1917 "was *absolutely different* from that which was being done at the moment."[5]

The conception of de Chirico as a "classical" painter, which plays so important a role in criticism since World War I, is in the first instance a result of a seeming affinity of his early painting with that of the Florentine masters of the fifteenth century. Not only did his imagery play host to "classical" props (antique sculptures such as Ariadne and Apollo Belvedere), vaguely classical if highly simplified architecture, and, after a time, mannequins identified by such classical names as "Hector and Andromache" and "Muses," but his painting aesthetic was based on the primacy of *disegno* and—in all evidence against the grain of modern art—on a structuring of space through perspective. These components of imagery and method fused in what Haftmann calls a "dry, harsh, frescolike style" that recalls the "archaic simplicity...[of] Giotto, Uccello, and Piero della Francesca."[6] De Chirico's interest in Florentine painting (as well as his nostalgia for the city that he left to go to Paris) is probably reflected in his listing of Florence as his birthplace in the catalogs of the Salon d'Automne beginning in 1912[7] (he was actually born of Italian parents in Volos, Greece).

Nowhere, however, in those of de Chirico's writings that are contemporaneous with his early paintings do we find the Italian Renaissance posited as an ideal pictorial model. This notion appears only in the context of the "return to tradition" which de Chirico first began to preach in 1919-20. By that time he had abandoned his early style, having redirected his art toward an almost old-fashioned illusionism and his rhetoric toward those all-encompassing denunciations by which, in increasingly strident and paranoid terms, he sought to "unmask" modern art as "bad faith or cretinism" and as a speculation of dealers and critics.[8] Nor is the term "classicism" to be found in his early writings—indeed, in any of the early writing *on* him. It, too, makes its appearance only in 1919, when de Chirico conferred upon himself the title "Pictor Classicus."[9]

These facts notwithstanding, the critical characterization of even the pre-1919 de Chirico as a "classicist" is commonplace. This is crucial to the argument of those who admire his later work, for they take the assertive and self-conscious Neo-Classicism of those years as but a logical and natural extension of the early work. Wieland Schmied, for example, sees the artist "remaining the same, in his substance," throughout his career.[10] Indeed, Jean Clair suggests that this later Neo-Classicism was, at least in certain respects,

De Chirico and Modernism

William Rubin

Notes to this essay begin on page 76.

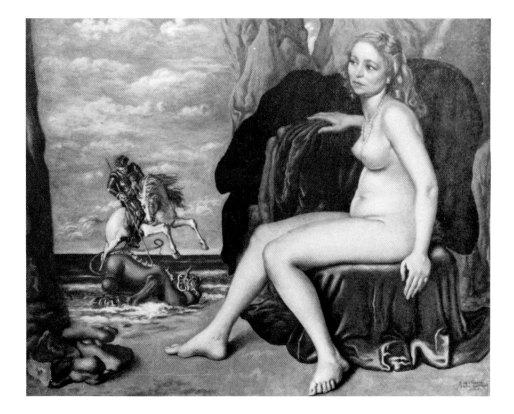

Fig. 1. Giorgio de Chirico. *Roger and Angelica*. 1940
Oil on canvas, 30⅜ x 55⅞″ (77 x 142 cm)
Private collection

the fuller realization. Clair, who characterizes de Chirico's early cityscapes as "but the resurgence of a classical landscape disguised as a modern city," compares the mannequin figures in the early work to the fleshed-out, less abstract later ones in which he finds — "despite the tendency to a more realistic illusionism" — that de Chirico's unique poetry "persists even more strongly."[11]

Yet the idea that the early de Chirico was a classical painter and the assumption that his aesthetic affinities were more with the Florentine masters than with the moderns of his own day are problematic, to say the very least. Given de Chirico's inversion, conversion, and even perversion of fifteenth-century practices, his early style seems to me far more a critique of classicism than a celebration of it. That there was a nostalgia for a classical quietude and order in his images of Italian squares is certain. But it *was* a nostalgia precisely because neither the then deeply troubled painter nor his pictures possessed such stability. Indeed, that "magnificent sense of solidity and balance" which de Chirico proclaimed in 1920 as "the hallmark of great Italian painting"[12] is precisely the quality that is systematically undermined in his own earlier work. His tilted grounds and precarious spaces, peopled with spectral figures and menacing shadows, are far more Romantic than Classic, and their *Stimmung* of melancholy and lassitude finds its counterpart in the verse of the Romantic Giacomo Leopardi[13] rather than in the work of the classical poets. A trip through what Gordon Onslow-Ford has called "Chirico City"[14] is unquestionably — as the title of one painting puts it — an *Anxious Journey*. Indeed, the recurrent keywords in de Chirico's early titles — "infinite," "inconsistency," "uncertainty," "disquiet," "enigma," "mystery," "surprise," "anguish," "melancholy" — rather suggest a Latin version of that specifically modern urban sentiment, agoraphobia — the *Platzangst* of the Expressionist painters from Munch onward.

The early critical literature on de Chirico — to say nothing of his own writing after 1917 — is more than usually tainted by the art politics of the times. Once beyond the polemics of de Chirico vs. Futurism, the texts emanate largely from two sources, both of narrow persuasion: the Surrealists, who saw the early de Chirico as a "sentinel" on the path of their own development, though they vehemently rejected his post-1918 painting; and the *Valori*

Plastici group, leaders of the postwar conservative reaction — the "recall to order" — who celebrated the more conventional and Neo-Classical de Chiricos of the twenties that the Surrealists found corrupt. Writers of both these groups were almost exclusively concerned with the image content of the work, and, as a matter of fact, the early de Chirico's unique imagery influenced modern painting in the twenties and thirties in a variety of ways.[15] But the component of modernism he shared with contemporary artists during the early Paris and Ferrara years when he executed his great pictures lies particularly in the area of style. Hence, in this essay we shall want to explore questions of style more than those of iconography. Yet the ultimate inseparability of the two requires that we consider the underlying principles of de Chirico's imagery, all the more because his realization of an essentially poetic technique — that of irrational or incongruous juxtaposition of familiar objects — is at the center of his historical legacy.

To be sure, the principle of *dépaysement* had already been well established as a literary device by the French Symbolist poets (and certain pictorial enigmas of this order are to be found in the paintings of Henri Rousseau, whose importance for the early de Chirico has been virtually overlooked). But Symbolist poetic imagery tends to the exotic and the recherché, and its subtle vocabulary and syntax are aimed at the rarefied sensibility. De Chirico's symbols — bananas, artichokes, cannons, clocks, architecture, and statues — are comparatively banal. Yet their very commonplaceness gives his work a universality that eludes the more attenuated imagery of Symbolism. De Chirico's probing of commonplace reality for those poetic, metaphysical possibilities obscured by our everyday, practical relationship to objects is rather more in the spirit of the "studio situation" subject matter from which the Cubists unlocked a much-overlooked poetry through the disjunctive grammar of their style. But de Chirico's search for a "second identity" in objects (the starting point for a whole branch of Surrealism) finds a still closer counterpart in Duchamp — though otherwise that ironist and he moved in opposite directions. De Chirico might almost have been speaking for Duchamp when he wrote:

> Every object has two appearances: one, the current one, which we nearly always see and which is seen by people in general; the other, a spectral or metaphysical appearance beheld only by some rare individuals in moments of clairvoyance and metaphysical abstraction, as in the case of certain bodies concealed by substances impenetrable by sunlight yet discernible, for instance, by X-ray or other powerful artificial means.[16]

For Duchamp, as in the *Large Glass,* which is a kind of imaginary X-ray plate held up to reality, the "second identity" would be projected literally; for de Chirico, it remained a matter of the viewer's intuition, his ability to appreciate the resonance of the image's interwoven poetic and plastic incongruities.

De Chirico's pictorial mixed metaphors often have a stunning force and simplicity that his Surrealist followers were never able to equal. In *The Song of Love* (pl. 34), perhaps his masterpiece in this respect, the head of Apollo Belvedere, red rubber glove, ball, and railroad locomotive set amidst arcaded buildings are unrelated logically. Yet the signals released by these juxtaposed symbols cross-fertilize to create a remarkable fabric of associations, no less telling than Lautréamont's classic evocation of a sewing machine and an umbrella on a dissection table. As de Chirico's image unfolds in our mind, the received mythology of Apollo is undermined by a subterranean Freudian countercurrent, and the other familiar objects seem suddenly alien. This is "the world as . . . an immense museum of strange things," in which the young painter said he wished to live. The power of *The Song of Love* is also inseparable, however, from the extraordinary plastic intensity with which the image components are configured — and without which its pictorial poetry would be reduced to "literature." Hence, though the translation of the Symbolist poetic principle into pictorial terms was de Chirico's primary, most influential — and most easily discerned — contribution, it would not in itself have sufficed to give him the important place he occupies in twentieth-century art. The latter depends no less on the pure plastic power and originality of that style which the artist perfected as a pictorial vehicle for his poetry in the two years preceding the extraordinary Piazza series of 1913. A close look at

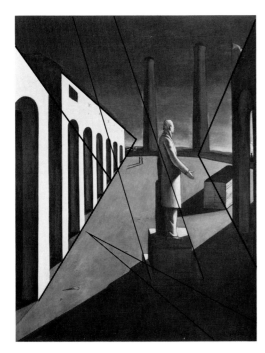

Fig. 2. Giorgio de Chirico. *The Enigma of a Day*. 1914
Oil on canvas, 73¼ x 55″ (185.5 x 139.7 cm)
The Museum of Modern Art, New York, James Thrall Soby Bequest

Fig. 3. Giorgio de Chirico. *Gare Montparnasse (The Melancholy of Departure)*. 1914
Oil on canvas, 55⅛ x 72⅝″ (140 x 184.5 cm)
The Museum of Modern Art, New York, gift of James Thrall Soby

the way de Chirico actually painted during the years of his finest work will show—received criticism and art history notwithstanding—that this majestic vehicle was as alien to its supposed classical, fifteenth-century models as it was dependent on the Parisian painting of its own moment. Despite first appearances, de Chirico will emerge as much a modern painter as the poet of a specifically modern sensibility.

That the early de Chirico is routinely (if wrongly) said to have resurrected fifteenth-century perspective[17]—indeed, even "academic perspective"[18]—as an aspect of his supposed classicism, any review of the de Chirico literature will confirm. Even Soby speaks of his "revival" of "illusory, linear perspective."[19] Ironically, it is precisely through a careful comparison of de Chirico's perspective with that of his presumed Renaissance model that we can best begin to isolate the peculiarly twentieth-century character of the painter's early aesthetic.

Fifteenth-century perspective was, in its most profound sense, a branch of humanism. For the first time—at least in a systematic manner—the world was imaged not according to a hierarchy of collective values attributed to the subject matter, but rather as that subject matter would be perceived from the vantage point of an individual, the now mobile viewer. Systematic focus perspective was, of course, an abstract geometrical system whose projections did not conform exactly to the nature of visual reality. But they came much closer to that reality than had earlier ways of imaging. The scientific underpinning of perspective enhanced its humanistic aim of picturing the world as made up of logically related entities situated in a rational, measurable space. And while this system would later be employed by the Mannerists to make convincing illusions of asymmetrical, anticlassical scenography, the Renaissance painters who created it used it to reinforce precisely the qualities of symmetry and order fundamental to their classical world view.

Renaissance perspective projects a space that is secure and eminently traversible. De Chirico's tilted ground planes, on the contrary, produce a space that, when not positively obstructed, is shallow and vertiginous. The viewer understands fifteenth-century space as an illusory continuation of his own space; his place in relation to the *donnée* of the picture—and thus, by extension, to the general scheme of things—is clear and logical. And the unity of that relationship is expressed mathematically and visually in fifteenth-century perspective by its systematic focus, which draws all orthogonals to a single vanishing point. Consider, by way of contrast, de Chirico's *Enigma of a Day* (pl. 29 and fig. 2). Here the orthogonals of the arcaded building at the left meet not at, but above, the horizon line, to the left of the lower smokestack; those of the right-hand building meet at

the foot of the other chimney; and the vanishing point of those of the statue's socle is somewhere far outside the pictorial field. The same multiplicity of vanishing points is evident in *Gare Montparnasse (The Melancholy of Departure)* (pl. 32 and fig. 3). In this powerful composition, the virtually continuous alignment of the station's front lintel (parallel to the picture plane) with its side one (receding from it) forces us to fix our perspectival eye at the lintel's height in space — so that we feel suspended insecurely in a void (as is also the case in *Enigma of a Day*), rather than having our feet firmly planted on the ground at the point where the space begins, as in fifteenth-century perspective. The multiple vanishing points of these de Chiricos thus subvert the coherence of Renaissance perspective by confronting the viewer with a network of conflicting spatial tensions that undermine, psychologically speaking, any initial impression of quietude or stability.

De Chirico alludes to the irrational, indeed, fantastical nature of his perspective in occasionally including, as a picture-within-a-picture, a canvas shown at the preliminary stage of its line drawing. In *The Seer* (pl. 55), for example, a mannequin sits before an easel on which the framed picture (fig. 4) is a perspectival plan for a painting showing a long arcade behind which looms a toga-wrapped figure earlier borrowed by de Chirico from Böcklin's *Odysseus and Calypso* for his 1910 *Enigma of the Oracle* (pl. 6). At first glance, the image on the easel almost appears an exercise in the science of perspective; its diagrammatic form and negative light-on-dark drawing also suggest an engineer's or architect's blueprint, recalling the materials of the painter's engineer father. We see architecture and space projected within a context of perspective orthogonals, compass and ruler forms, numbers and upper- and lower-case letters resembling the keys to cross sections or elevations, and the cryptic city name, "Torino" (Turin).

On closer inspection, however, the diagrammatic image in *The Seer* reveals itself as a fantasy of science — a cabalistic projection no closer to systematic focus perspective than to actual plans of an architect or engineer, and in that sense parallel to Duchamp's "funny physics." The looming Odysseus figure interrupts the scale established in the architecture, overturning that logic and order which Renaissance perspective imposed on pictures (though making the figure all the more menacing and thus satisfactory to de Chirico's expressive needs). And the geometrical projections, like the orthogonals, turn out to be either illogical or (in any rational sense) meaningless, the numbers and letters as cryptic as the "Torino."[20] What all this adds up to here and elsewhere in the early work is a virtual parody of perspective, an "irrationalization" of a system that in the fifteenth century was a branch of projective geometry. The "classical" thus finally emerges in de Chirico's early work — whether as formal structure or as subject — essentially as a metaphor. By subverting classicism, by turning it inside out, he communicates the singular malaise of modern life.

But de Chirico's modernist instinct undercuts traditional perspective in still other, even more radical ways. The illusionism of fifteenth-century painting was not a matter of linear perspective in and of itself. The linear schema was but a web of coordinates within which the figures and objects were — as a necessary concomitant — *modeled in the round.* Hence the realistically illusioned empty space was also measured by the displacement of realistically illusioned solid forms (Berenson's "tactile values"). In Renaissance painting, the mass of the figure is seen quantitatively, with modeling in the round creating the illusion of a continuous turning that completes the cylinder of the mass, while the empty space acts as a foil to the relief of the figures and objects, enhancing their tangibility by contrast. Moreover, in the mid-fifteenth century, painters learned to "shade" the empty air, so to speak, by reinforcing their illusion of deeply receding space through the technique of aerial, or atmospheric, perspective.

In total contrast to this methodology, the realization of figures and objects in de Chirico's crystalline, unatmospheric early paintings ranges from a very low relief modeling to a simple — and frequently rather crude — hatching. This deprives his figures and objects of the very weight and bulk that are, in Masaccio or Piero, the aesthetic vehicles for communicating the subject's ethical and emotional *gravitas.* Indeed, de Chirico's pseudomodeling — which rarely forces our eye to see a plane *turning* away from the

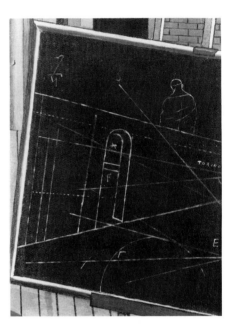

Fig. 4. Giorgio de Chirico. *The Seer.* Detail. 1915 Oil on canvas, 35¼ x 27⅝″ (89.6 x 70.1 cm) The Museum of Modern Art, New York, James Thrall Soby Bequest

Fig. 5. Giorgio de Chirico. *The Silent Statue.*
Detail. 1913
Oil on canvas, 39¼ x 49⅜″ (99.5 x 125.5 cm)
Kunstsammlung Nordrhein-Westfalen,
Düsseldorf

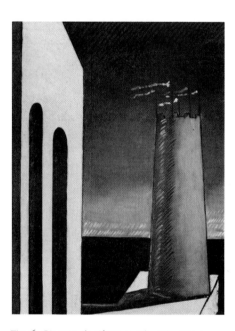

Fig. 6. Giorgio de Chirico. *The Silent Statue.*
Detail. 1913
Oil on canvas, 39¼ x 49⅜″ (99.5 x 125.5 cm)
Kunstsammlung Nordrhein-Westfalen,
Düsseldorf

picture plane—so diminishes or dissolves the solidity of masses as to finally constitute little more than a decorative convention for articulating the planar surface, and its effect is often to turn even stone statues into weightless, disembodied, seemingly spectral forms.

The extreme of de Chirico's substitution of shading (the way we articulate a flat plane) for modeling (the way we illusion a curving one) may be studied in the details reproduced here of Ariadne's torso and the tower from *The Silent Statue* (pl. 18). Observe how, in the representation of the breasts (fig. 5), the painter substitutes for the kind of graduated modeling that would force our eye to see those round planes as turning in space a bold hatching that produces an essentially two-dimensional effect. This flattening is enhanced by the maximized contrast of light and dark in the highlighted and shadowed areas of the breasts. And lest our eye read the shaded lower area as retreating into space, de Chirico carefully makes his bottom hatch-marks contrastingly bright—which visually forces that supposedly retreating edge forward toward the picture plane. A similar technique is employed to reduce our assumption of cylindricity with respect to the tower (fig. 6): though the left side is darkened as in shadow, a line of white hatch-marks just where the surface should be darkest subverts the rotundity of the form, optically pulling its turning plane forward toward the picture surface.

The undermining of solidity and cylindricity, as in the shading of *The Silent Statue,* has its counterpart in both the deliberate inconsistencies and low relief of such modeling as de Chirico *does* undertake. This is best understood by comparing a passage from an early picture with a similar subject from a late de Chirico, in which the modeling is more conventional. Take the two heads of Apollo reproduced here. That of the 1962 still life (fig. 7) is modeled with careful graduation and creates a convincing illusion of a sculpture in the round despite its contrast with the dark background. The handling of the head in the 1914 *Song of Love* (fig. 8), on the other hand, suggests bas-relief—an effect enhanced by the absence of the dark shading that should model the turning planes of the hair, ear, and neck on the right; the white edge given the hair in the upper right pulls that area toward the picture plane, while the strong black outline of the neck on the right obviates any impression of a turning of that cylinder in space. When we study the base of Apollo's neck, we realize that de Chirico has in fact represented this three-dimensional head as if it were a plaster cast, the back of which was sawn off to form a relief. This flattening is perfectly logical, of course, as it makes this early Belvedere's head more assimilable to the essentially abstract, spatially shallow, planar structure of the picture as a whole.

What I have called de Chirico's "pseudomodeling," with its concomitant inconsistent lighting, is most readily perceived in his treatment of spheres, such as the green ball in *Song of Love* and *The Evil Genius of a King,* 1914–15 (pl. 47). In both, the flattening effect is intensified by an illogical highlight on the shadow side of the object, by the black outline that encircles the ball as strongly on the side facing the light as on the other, and by the abstract schema of superimposed black arabesques, which, linking with the outline, constitute an autonomous linear pattern that checks rather than fosters the suggestion of roundness.

Now the early de Chirico was nothing if not consistent in these inconsistencies, and what they entailed in terms of the modeling of objects was a negation of the traditional unified light source, a negation that parallels his suppression of the unified vanishing point. Such autonomous lighting of individual forms is alien to the art of the Renaissance, but it is at the very heart of Cubism. I am not insisting that de Chirico consciously derived this from Picasso, whom he knew and admired in his Paris years—though that may, indeed, have been the case. Suffice it to say that the painter made a thoroughgoing system of this "dissociation" soon after his arrival in Paris. Nor was Cubism the only available modern model for what Breton would later call "disorganizing lighting systems"; not unrelated effects are anticipated in the pictures of Rousseau, whose work de Chirico knew well in his Paris years through Apollinaire, Picasso, Serge Férat,[1] and the Bernheim-Jeune retrospective of 1912, and in the pictures of Seurat, whose *Sunday Afternoon on the Island of the Grande Jatte* de Chirico had obviously studied, borrowing from it the little

running girl in the middle ground for one of his greatest paintings, *The Mystery and Melancholy of a Street* (pl. 31).

Nor should we be surprised to discover that in his early work de Chirico carried over into the handling of cast shadows the purposeful "irrationality" of his shading and modeling. Here again, he undermined the aims and methods of his putative *quattrocento* models. In Italian Renaissance art, cast shadows speak of the reality and logic of the real world by attesting to the concreteness of solids as forms blocking the passage of light, by confirming the ground as a solid entity supporting the figures, and by literally measuring the intervals between solids. In de Chirico, the extraordinarily inventive cast shadows have a life of their own, free from the demands of a consistent light source. Sometimes their contours are so unrelated to the objects by which they are thrown as to imply hidden presences. Or the reality of an object is called into doubt by the absence of a proper shadow. And frequently, as in *The Mystery and Melancholy of a Street,* haunting, unintelligible, and even menacing shadows are cast by objects outside the field of vision. This "disembodied" shadow is perhaps the most startling of de Chirico's poetic devices, and it was to be much exploited by certain Surrealists.

The standard comparison, then, which pits the modernity of the Futurists (loudly proclaimed, but ultimately ambivalent, as we shall see) with a supposed revival of classical Renaissance techniques in de Chirico seems to me thoroughly wrongheaded. No matter that statements by the Pictor Classicus himself (published, as noted, *after* he had given up his early style in favor of old-fashioned illusionism) provided whatever "authority" was needed for most critics to assume that even his early work pointed in a direction opposite to the modernism of his contemporaries.

Fifteenth-century Italian painting, like all old-master art, is illusionistic. De Chirico's early painting, like all great modern art, is nonillusionistic. Soffici had intuited this fact, insisting that "if geometry and the effects of perspective constitute the principal elements of [de Chirico's] art…it is also true that his work resembles no other work…based on the same elements." Yet how, the reader may legitimately ask, can an art using perspective lines, however scrambled, be considered nonillusionistic? The answer follows from the definition of illusionism itself. The modern effect of the early de Chirico depends upon the fact that his linear perspective—and this is the nub of the matter—by *not* being reinforced through the traditional concomitants of modeling in the round and/or aerial perspective, *remains a purely schematic scaffolding* that does not force a picture into a condition of spatial illusionism.

The common denominator of all the great modern styles—whether figurative or not—is the suppression of illusionism (an optical effect alien, in any case, to simple or schematic forms of representation). When linear perspective is supported by modeling in the round and atmospheric perspective, as in Renaissance (or academic) art, the eye is confronted by an indivisible illusion of receding space, to which perception it is *obliged* to respond. But perspective orthogonals alone—because they propose deep space conceptually rather than optically—leave the eye a choice. As long as the orthogonal lines are disengaged from modeling, their position on the surface remains equivocal and permits a double reading: they can be *understood* as a schematic indication of three-dimensional space, or they can be *seen,* alternatively, as simply a pattern of lines on the flat surface, a pattern that in no way interrupts the lateral continuity of the configuration. De Chirico's early work abounds in the fruit of this perception. Consider the magnificently shaped sunlit plaza whose ambivalent plane "recedes" to the distant train in *Gare Montparnasse* (pl. 32). While we understand this plane as retreating in space, de Chirico's handling of linear perspective and shadow tilts it so vertically that the eye is strongly invited to see this powerful geometrical shape as parallel to the picture plane.

Nor was de Chirico unique in the recognition of this particular ambiguity. Matisse's *Red Studio* (fig. 9), executed in 1911, just as de Chirico was forming his style, is an object lesson in the principle involved. The orthogonal lines of Matisse's floor and table indicate

Fig. 7. Giorgio de Chirico. *Still Life with Table-Setting.* Detail. 1962
Oil on canvas, 38⅛ x 54¼" (97 x 138 cm)
Private collection

Fig. 8. Giorgio de Chirico. *The Song of Love.* 1914
Oil on canvas, 28¾ x 23⅜" (73 x 59.1 cm)
The Museum of Modern Art, New York, Nelson A. Rockefeller Bequest

Fig. 9. Henri Matisse. *The Red Studio.* 1911
Oil on canvas, 71¼" x 7'2¼" (181 x 219.1 cm)
The Museum of Modern Art, New York, Mrs.
Simon Guggenheim Fund

Fig. 10. Paul Klee. *Perspective of a Room with
Inhabitants.* 1921
Watercolor and oil drawing on colored sheet,
19⅜ x 12⅝" (48.5 x 31.7 cm)
Paul Klee Foundation, Kunstmuseum, Bern

three-dimensional space, but they do not illusion it, because the normal concomitants of shading and modeling are suppressed. The chance that the eye will read these lines as retreating in space—and thus interrupt the image's lateral decorative continuity—is further minimized by the painter's having endowed the walls, floor, table, and chair with a common Indian red that becomes identified with the picture plane. Like de Chirico (pl. 61), but in a different spirit and with other expressive aims, Matisse also inverts the perspective of foreground objects, as witness the orthogonals of the chair, which narrow toward the viewer rather than away from him. Indeed, with magisterial wit, Matisse continues the game of ambiguity—of eye versus mind, perception versus conception, illusion versus schematic representation—by applying local color only, or almost only, to objects which are in themselves flat (the oil paintings, wainscoting, and decorated dish).

The paintings of Klee are also replete with indications of deep space that somehow never destroy his surface unity or compromise the modernity of his style—and for the same reasons. In his *Zimmerspektive mit Einwohnern* (fig. 10), for example, we are presented with what appears at first a classic "perspectival box." As in de Chirico and Matisse, however, the "receding" planes of Klee's room seem to cling to the two-dimensional surface. While this results in part from the "unfocus" of Klee's perspective—the absence of a unified vanishing point—it has even more to do with the suppression of supportive modeling or shading along the orthogonals of his forms. There is, to be sure, considerable shading in the image, and it does create a kind of atmosphere. But the lights and darks of that shading form an autonomous pattern that not only disengages from but contradicts the perspectival indications of both objects and empty space. Finally, with a wit less sovereign but more affectionate than Matisse's, Klee introduces a pun based on the ambiguity of the potential readings: Are we to see the man, woman, and child in the lower right as standing up or lying on the floor?

The Surrealists most influenced by de Chirico's early art—Tanguy, Dali, Magritte, and Delvaux—understood its poetry but failed to grasp the essence of its plasticity. They made the same mistake as so many of de Chirico's commentators: they mistook the perspective referents of his spatial theater as constituting a revival of old-master illusionism. Compare

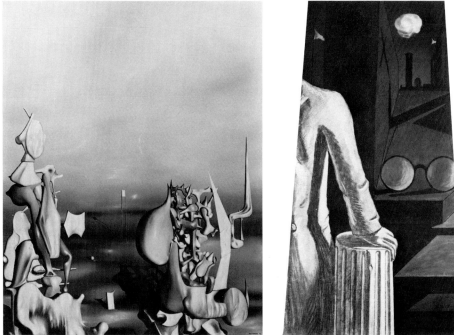

Fig. 11. Yves Tanguy. *Hands and Gloves.* 1946
Oil on canvas, 36 x 28¼" (92 x 71 cm)
Private collection

Fig. 12. Giorgio de Chirico. *The Serenity of the Scholar.* 1914
Oil on canvas, 52 x 28⅝ bottom x 21⅜" top
(132 x 72.7 x 54.3 cm)
Collection Sylvia and Joe Slifka, New Jersey

the Tanguy and de Chirico paintings on this page (figs. 11, 12). To many viewers, the Tanguy would seem the more modern picture because it represents abstract forms rather than recognizable ones. Yet I find that the Tanguy looks old-fashioned, indeed, academic, while the de Chirico has a modern appearance. Tanguy's academicism lies precisely in the smoothly graduated modeling in the round and the aerial perspective with which he endows respectively his solids and empty spaces. Together, these techniques make the Tanguy an illusionistic picture in a way that the de Chirico is not. Hence, the unfamiliar, "abstract" shapes of Tanguy appear more real—more solid in the tactile sense—than the identifiable shapes in the early de Chirico. And Tanguy's sculptural biomorphs displace a space that—because of aerial perspective—obliges the eye to accept an illusion of great depth.

The work of admirable small masters such as Tanguy notwithstanding, none of the greatest moderns has painted illusionistically, whatever the degree of realism of his style. This finding does not, of course, imply any a priori value judgment with respect to illusionism itself. We must keep in mind that the greatest painting we know—the succession of masters from Masaccio to Courbet—is all illusionistic. There seems, nevertheless, something in the modern spirit that has resisted expression through a language originally formed to image the world with a tactility transcending even that of sculpture[22] All the more because, in that language, the substitution of illusion for schematic depiction rendered the picture plane "transparent" and thereby reduced awareness of its tangible painted surface. The vigorous reaffirmation of that surface by the Impressionists opened the way not only to many modern painting styles, but ultimately to new pictorial conceptions such as collage and constructed relief. Modeling could still play a role in modern painting, but only, as Cézanne demonstrated, in relation to the fronts of forms, and these would have to elide in a simulacrum of bas-relief (which remains essentially pictorial) as opposed to the simulacrum of sculpture in the round that obtained in the work of the Renaissance masters. It was de Chirico's intuition of this informing modernist zeitgeist—whether he was conscious of it or not—that makes his art of the period 1911-17 assimilable to that of the other great modernists of the time.

De Chirico himself would not have agreed—at least after 1917. When, in 1912, he sent four paintings to the Salon des Indépendants, Dunoyer de Segonzac, who shared responsibility for the hanging, congratulated him on the "decorative" character of his canvases. Remembering that event from the perspective of his later conservatism, the

Fig. 13. Pablo Picasso. *Bread and Fruitdish
on a Table.* Early 1909
Oil on canvas, 64⅝ x 52¼" (164 x 132.5 cm)
Kunstmuseum, Basel

Fig. 14. Giorgio de Chirico. *Gare Montparnasse
(The Melancholy of Departure).* 1914
Oil on canvas, 55⅛ x 72⅝" (140 x 184.5 cm)
The Museum of Modern Art, New York, gift of
James Thrall Soby

Fig. 15. Henri Matisse. *Piano Lesson.* 1916
Oil on canvas, 8'½" x 6'11¾" (245.1 x 212.7 cm)
The Museum of Modern Art, New York,
Mrs. Simon Guggenheim Fund

Pictor Classicus charged Dunoyer with "bad faith" and claimed that he "understood absolutely nothing" of the de Chirico enterprise.[23] Now Dunoyer may or may not have recognized the unique poetry of de Chirico's paintings, but he was quite right with regard to the formal character of the work. The word "decorative," in the studio parlance of the day, meant "cohering well on the flat surface" — whether in the Cubist manner of Dunoyer himself or in that of Matisse or Derain. He was paying de Chirico a compliment based upon the perception of the very real contemporary spirit in his work at that time. That de Chirico was not able to understand this — at least after 1917 — is at the heart of the problem of his later work.

What Dunoyer had in mind — what I would call the broad affinity of the early de Chirico for the main body of early twentieth-century modernist painting — is clear when we compare de Chirico's art, especially at its boldest and most structural, with that of Picasso and Matisse. If *Gare Montparnasse* (fig. 14) is one of the most "architectural" of de Chirico's compositions, *Bread and Fruitdish on a Table* (fig. 13) is likewise one of Picasso's. The affinity here seems to me inescapable. It follows from the commonality of the broadly brushed, semitransparent handling of bold and simple planes; the shallow, low-relief modeling; the compression of space through a blunting of orthogonals that produces a vertical tilting of horizontal planes; the autonomous (and thus logically inconsistent) handling of light and shade; and the reduction to a near-monochrome palette. Many of these qualities are also held in common by *Gare Montparnasse* and Matisse's *Piano Lesson* (fig. 15), one of Matisse's most architectural canvases, which reflects *his* assimilation — at even greater distance in some respects than de Chirico's — of Cubism. It is a comparison that speaks for itself.

That there should be a particular affinity between Picasso's *Bread and Fruitdish* and the painting of de Chirico is perhaps not surprising to the extent that, in a sense, they share a common ancestor. *Bread and Fruitdish* is one of those compositions that reflect Picasso's proximity — both personal and artistic — to the Douanier Rousseau (as well, of course, as to Cézanne, who was a pervasive presence during early Cubism). Indeed, the original for ⌐ of the composition that ended as *Bread and Fruitdish* was a dining scene containing symbolic representations of Rousseau, Cézanne, and Picasso himself in what amounted to a transformation and apotheosis of the celebrated *banquet Rousseau,* which had just recently taken place. Though the banquet image evolved into a still life, the presence of Rousseau (as of Cézanne) was retained in the form of stylistic allusions.[24]

What is the relevance of Rousseau to de Chirico? When Carlo Carrà took up Metaphysical painting in 1917, he claimed in print a variety of forerunners for his enterprise, among them Rousseau in particular. But the idea that de Chirico might have owed a debt to the Douanier—as I proposed a number of years ago[25]—had never suggested itself to critics of the artist. Even Soby mentioned only a shared spirit of "poetic naiveté" that "gives commonplace objects an air of legerdemain."[26] But the affinities go much deeper.

Rousseau's peculiar light, like that of de Chirico, is decidedly nonatmospheric. And unlike real light, it does not modulate form. Whether foliage in the background or figures in the foreground, all seems made visible with a flat, frontal light, independent of any single source, that tends to bring the entire composition forward toward the picture plane and thus create an impression of spatial shallowness. Moreover, it is impossible to say whether this illumination is daylight or moonlight. Like de Chirico's enigmatic "white light," Rousseau's light possesses a supernatural, dreamlike clarity. (It was Leonardo who first observed that we see things more clearly in dreams than in the light of the real world.)

This mysterious illumination provides, of course, just the right ambiance for the dreamlike mixture of motifs drawn from unrelated contexts and presented, in both Rousseau and de Chirico, as if suspended in an eternalized moment in time. The sofa from Rousseau's studio that sits in the middle of the forest in *The Dream,* the lion that unaccountably overlooks its human prey in *The Sleeping Gypsy* (like the juxtapositions resulting from the telescoping of time in the Douanier's play, *The Revenge of a Russian Orphan*) anticipate the poetic aspect of collage juxtaposition. Rousseau's forests, like de Chirico's piazzas, have a spell on them; both are pervaded by a pregnant and eerie silence that anxiously anticipates—or, as sometimes in Rousseau, actually witnesses—both terror and violence.

Rousseau, like de Chirico, used to be thought *sui generis,* a figure entirely apart; or, alternatively, he tended to be associated even more wrongly with twentieth-century "primitives" or "naifs." Today we understand his simple, bold, and decorative style as an aspect of Post-Impressionism, just as we see his poetic effects as related to Symbolism. That Rousseau was admired and supported by both Gauguin and Redon is eminently logical, and when one considers such Rousseaus as the *Portrait of Pierre Loti,* which was probably a source for de Chirico's *Child's Brain,*[27] one finds it hard to believe that the Italian painter did not learn from what Gauguin admiringly called Rousseau's "mysteri-

ous" use of black. Like Rousseau, the early de Chirico has seemed until now to stand outside the art of his moment, as the painter himself had always insisted. But on the level of style, at least, we must now recognize that de Chirico is as assimilable to the vanguard art of his decade as Rousseau was to the *fin de siècle*. Both painters intuited the essence of what constituted the modernism of their day, whatever degree of consciousness we may wish to attribute to their appropriation of it.

Apollinaire had missed this aspect of both painters. He once described de Chirico as "the only European painter who has not been influenced by the new French school."[28] Nevertheless, given his successive friendships with both Rousseau and de Chirico—the Douanier died in 1910, de Chirico arrived in Paris the following year—and the fact that the works of both hung in the poet's studio, it struck me as a little surprising that nowhere in his varied *Chroniques d'art* did the poet indicate any awareness of a possible affinity between the two artists (especially as this affinity had certainly not escaped the eye of his friend Picasso).[29] I am therefore delighted to report that not long ago I came upon the following remark by Apollinaire reprinted from a lost earlier source in an album of de Chirico reproductions that appeared a year after the poet's death[30]: "The first time I saw [de Chirico's] paintings," Apollinaire is quoted as saying, "I thought instinctively of the Douanier." The poet goes on to say that "this is admittedly a risky comparison; de Chirico is, before all else, an artist profoundly aware of what he does." Apollinaire need not have pulled his punch. For if de Chirico was more conscious of his means than the poet had thought at first, the Douanier was surely less naive than Apollinaire liked to imagine.

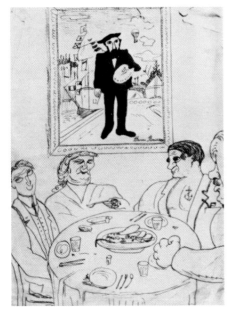

Fig. 16. Giorgio de Chirico. *Picasso at Table with the Painter Léopold Survage, Baroness d'Oettingen, and Serge Férat.* 1915
Pen and ink, 12¾ x 9¼" (32.4 x 23.5 cm)
Private collection

The progress of de Chirico's style between his arrival in Paris and his departure from Ferrara reflects, in any case, a gradually increasing consciousness of means, whose effects combined in an art much closer to Paris modernism than the work de Chirico executed in Florence before his departure in 1911. The perspectives in the 1913 paintings plunge more radically than in the few comparable 1912 works we possess (such as *Enigma of the Hour,* pl. 10); and by 1914—in *Philosopher's Promenade* and *Serenity of the Scholar* (pl. 35)—the horizon line quite literally reaches new heights. Toward the end of 1914, the space is compressed even further in *The Span of Black Ladders* (pl. 44), where, for the first time, both horizon line and distant vista are eschewed. Such a picture shares with characteristic works of Synthetic Cubism a variety of qualities: a shallow space, in which the objects are brought close up to the viewer; a dry medium (we would better appreciate this propinquity if most Cubist paintings had not later—much to Picasso's and Braque's distress—been varnished); a bold planar arrangement of abstract forms situated ambiguously in a shallow space; and finally, such abrupt shifts in scale (e.g., the eyeglasses in *Serenity of a Scholar*), changes in "notation," and dissociations in image content as are characteristic of collage and *papier collé*. The most abstract form of this last tendency in de Chirico's early painting may be seen in *The War,* of 1916 (pl. 63). Here the black shape at the top (perhaps a fragment of a cast shadow) is impossible to define or identify, while the verisimilitude with which the biscuits are illusioned makes them appear literally collaged to the surface.

Another aspect of the early de Chirico's modernism that was surely absorbed from Cubism is his break with traditional notions of surface unity and continuity. Pursuing Cubist options opened in collage and in oils containing trompe-l'oeil of collage (such as false wood paneling),[31] de Chirico permitted himself, at least in certain pictures, an entirely anticlassical mélange of mediums, surface textures, and notational techniques. This aspect of the work—a matter of both actual and illusory surface variations—is rather difficult to apprehend through reproductions. Easiest to make out are passages such as the torso in *I'll be there... The Glass Dog* (pl. 42) and the fish and shell molds in *Portrait of Guillaume Apollinaire* (pl. 41), in which the painter shifts from an oil medium to the use of charcoal over canvas priming. In *The Span of Black Ladders,* the thick oil paint of the écorché hand in the lower right immediately detaches this form optically—as if it had been collaged on—from the smooth but dense and opaque medium of the black triangle that closes the right side of the picture and from the thinly painted, semitransparent green

medium of the vertical shape on the left. All these areas distinguish themselves in turn from the unpainted central panel of charcoal-drawn fish molds.

Despite the gradual accretion of School of Paris influences, de Chirico's development from 1914 through 1917 was by no means monolinear. Side by side with his most abstract, spatially compressed compositions we find others that retain distant vistas—though always within the stylistic limits I defined previously; and the economy, the instantaneity, that characterizes the poetry of many Piazza paintings and others such as *The Song of Love* and *The Serenity of the Scholar* is counterbalanced by a more literal, storytelling tendency in the mannequin pictures. When the mannequins first appear in 1914, they seem enigmatic, isolated beings (e.g., *The Torment of the Poet,* 1914; *The Two Sisters,* 1915, pl. 50). But beginning with such late 1915 paintings as *The Duo* (pl. 53), a more "social" and distinctly sentimental strain is noticeable. This reaches its climax in 1917, when—as in *Troubadour* (pl. 69) and *Hector and Andromache* (pl. 70)—titles are used to expand the literary aspect of the narrative situation.

Quite another, more elliptical kind of borrowing from Cubism by de Chirico, this time for his wooden scaffoldings, was obscured by his transformation of his sources. Representations of such scaffoldings begin to inhabit de Chirico's paintings at the end of 1915, first as fragments, and then as anthropomorphic analogues of whole figures. *The Duo* may be the earliest painting in which this "carpentry" appears, in the form of a right angle resembling a piece of a painting stretcher that supports one of the mannequins from behind. The mannequins' need for support (a motif later adapted by Dali to a more specifically sexual context) is an important aspect of their pathos. So is their anatomical segmentation, which in *The Duo,* as in many de Chiricos, takes a form reminiscent of tailors' dummies (e.g., the "plug" that marks the mannequins' armlessness). But the metal armatures that largely serve as supports in *The Duo* allude less to the world of couture than to that of the artist's studio, and point to quite another of the many sources of the mannequin image—the nineteenth-century studio "lay figure."

While carpentry remained a marginal note in *The Duo,* wooden scaffoldings become elaborate and complicated in the paintings of 1916. In *Politics* (pl. 60), and especially in *Evangelical Still Life* (pl. 68), their articulation comes to resemble the abstract scaffoldings of high Analytic Cubist pictures like Picasso's *Ma Jolie.* Such Cubist scaffoldings sometimes originate in still-life objects in Picasso's and Braque's painting of 1911-12. But more often they represent a structure "analyzed" from a figure (as in *Ma Jolie*), and it is precisely to this point that de Chirico pushed his represented carpentry in the extraordinary construction called *The Jewish Angel* (pl. 59 and fig. 18). Here the giant eye, which stands for the entire visage, signals its origin in collage-construction not only by its disjunction in scale, but by being represented as a sheet of heavy paper or *carton,* tacked to the wooden structure at its upper left (an impression reinforced by the folded corner of its plane, with the concomitant Cubist-type cast shadow).

If the scaffolding of *The Jewish Angel* seems to be composed mostly of stretchers (or "strainers," to use the more precise term for these unkeyed structures), it nevertheless contains a variety of other elements, such as the partly polka-dotted curved shape and the alternately green and white rule both situated below the giant eye in the center of the construction. These two forms are extrapolated from instruments that would have been around the house during de Chirico's childhood because they were used by designers and engineers of rail lines. The arabesque-shaped tool is generically called an Irregular Curve and closely resembles the Railroad Curves of our day, which often have surprisingly Baroque forms.[32]

The Cubist origin of de Chirico's scaffoldings is obscured to the extent that Cubist scaffoldings seem abstract structures while those of the Italian painter appear to be literal objects seemingly carpentered from recognizable materials. But the scaffoldings and grids of high Analytic Cubism also originally derived from real objects around the studio, and, indeed, among the most common were stacked canvases and stretchers. Thus, in a painting like Picasso's *Girl with a Mandolin* (fig. 17), executed in early 1910 just as the curvilinear forms of earlier Cubism were increasingly giving way to the frontality and

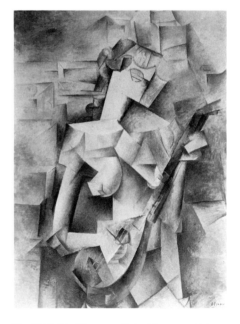

Fig. 17. Pablo Picasso. *Girl with a Mandolin* (Fanny Tellier). 1910
Oil on canvas, 39½ x 29″ (100.3 x 73.6 cm)
The Museum of Modern Art, New York,
Nelson A. Rockefeller Bequest

Fig. 18. Giorgio de Chirico. *The Jewish Angel.*
1916
Oil on canvas, 26½ x 17¼″ (67.3 x 43.8 cm)
Collection Mr. and Mrs. Jacques Gelman,
Mexico City

Fig. 19. Giorgio de Chirico. *The Child's Brain.*
1914
Oil on canvas, 32 x 25½″ (82 x 64.7 cm)
Moderna Museet, Stockholm

rectilinearity of what would come to constitute the high Analytic Cubist "grid," the architectural forms that build up the picture's scaffolding around the figure are all in fact representations of frames and stretchers stacked behind her. To be sure, there is still quite a distance to be traversed from this and the more abstract Cubist scaffolding of 1911-12 to the construction in *The Jewish Angel.* But while not wanting to diminish de Chirico's considerable leap of the imagination here, we should note that the gap between them was at least partially bridged by Picasso's own constructions and by the Picasso-inspired constructions of Boccioni and others that de Chirico saw.[33]

The lyric pathos of de Chirico's mannequins derives variously from their isolation, their incompleteness (the absence of facial features and limbs), their need for physical support, their inability to move, and their being made of "stuff" — alternately represented as cloth, wood, metal, cardboard, as well as other materials. They prove the perfect metaphor for the modern antihero in a universe where heroism in the form that the antique, indeed, the entire premodern world understood it — that of an Achilles, Hector, or Roger — is no longer possible. With the notable exceptions of a few portraits and the extraordinary *Child's Brain* (pl. 33 and fig. 19) — unanimously accepted as a "fantasy portrait" of the painter's father — human figures virtually never appear in de Chirico's early work except as tiny ciphers in the backgrounds of empty spaces. Anthropomorphic references enter primarily in the form of statues (often fragmented), toga-shrouded specters, and humanoid shadows whose functions are subsequently in part subsumed by the mannequins. The rightness of the mannequins as embodiments of an antihero proper to the inside-out classicism of de Chirico's 1911-17 universe can be gauged by the loss of poetic as well as visual consistency that overtakes the painter's vision in the twenties when the mannequins become physically "humanized." Even more unbeliev-

able than these humanized dummies are the still later images in which the Pictor Classicus represents heroes through more flat-out realism. (Paintings such as *Roger and Angelica,* 1940 [fig. 1], for example, strike me as faintly laughable.)

The wood-scaffold construction called *The Jewish Angel* is not a mannequin, but it functions in a parallel manner, as a human analogue. Its frontal, hieratic presence recalls, at least in spirit, the domineering and omniscient father image of the 1914 *Child's Brain,* whose mysteriously closed eyes are now replaced by the giant all-seeing eye. There is a certain symmetry of opposites involved here, as if the 1916 *Jewish Angel* were an "abstract," Cubist-inspired counterpart of the "realistic" father of the earlier picture (an association reinforced by the inclusion of the artist's father's professional tools in the later picture). That *The Jewish Angel* might be in part a Picasso-influenced restatement of the earlier father image is consistent with the fact that it followed hard upon the closest period (1914-15) of the de Chirico-Picasso acquaintanceship. And such a situation appears even more likely if the transformation is understood as de Chirico's response to a specific painting by Picasso of 1915 that was itself inspired precisely by *The Child's Brain.*

It has heretofore gone unobserved that one of Picasso's most important Cubist paintings, the monumental *Man with a Pipe* in the Chicago Art Institute (fig. 20), is an abstract transformation of the looming personage in *The Child's Brain,* which Picasso would have seen in de Chirico's studio, Apollinaire's apartment, or Paul Guillaume's gallery. The closed, half-circle eyelids and wide mustachios of the semisomnolent head in Picasso's work leave no doubt as to its model. Picasso was obviously struck by the quietly menacing character of de Chirico's figure, and even though he realized the figure's body within the gay, abstract conventions of his ornamental Cubism of 1915, he preserved the underlying menace by giving the visage a sinister smile. It is unlikely, of course, that such an unusual homage by the "king" of Paris painters—who was also a friend ("un mio

Fig. 20. Pablo Picasso. *Man with a Pipe.* Detail. 1915
Oil on canvas, 51¼ x 35¼" (130.2 x 89.5 cm)
The Art Institute of Chicago, gift of Mrs. Leigh Block in memory of Albert D. Lasker

Fig. 21. Max Ernst. *Pietà or the Revolution by Night.* 1923
Oil on canvas, 45⅝ x 35" (116 x 89 cm)
The Trustees of The Tate Gallery, London

amico," de Chirico called him) — would have been overlooked by the young Italian. And it is in this context that I permit myself the hypothesis of the "reciprocity" proposed above. (Picasso's addition of a Kronstadt hat to the de Chirico-inspired head, a hat much earlier associated by him with another kind of father figure, namely Cézanne,[34] anticipates Max Ernst's much remarked adaptation of the same de Chirico figure in his *La Révolution la nuit,* fig. 21).

We saw at the outset that the received view of de Chirico in relation to Futurism stressed the latter's commitment to modernity as against the metaphysical painter's supposed archaizing classicism. Having never found this simple antithesis satisfactory, I years ago pointed out without elaborating[35] that by turning the image of the classical world inside out de Chirico had actually communicated a peculiarly modern experience in a truly modern style. And that ironically, the Futurists — especially as judged by their finest artist, Boccioni — though seemingly committed to a rationalist, scientific, technology-oriented modernism, often produced work of unexpected poetic subjectivity in a spirit and form-language which, despite the painters' rhetoric, frequently emerged as more historically retrospective than anything in de Chirico. While the Futurist Manifesto, for example, celebrated the modern racing car to the scorn of the Victory of Samothrace, Boccioni's greatest sculpture, *Unique Forms of Continuity in Space,* reminds us more of that antique work than of the vanguard sculpture of its own moment, just as his monumental *The City Rises,* with its surging horses, suggests a Rubens in pointillist disguise more than an image of modern urban construction.

The Futurists' commitment to modern science notwithstanding, only in the Renaissance, when advanced mathematics and engineering were on today's first year high school level, could artists literally use science for their work as either substructure or image — as, indeed, Leonardo and others did. Yet if Seurat's approach to painting could be described, at least methodologically, as scientific, and if he could still use the advanced science of *his* day in respect to color theory, the science of the Futurist years could hardly be comprehended by artists — not to say literally recapitulated in their pictures. Thus, when we see Balla titling an image of abstract patterns *Line of Speed — Vortex,* we know we are back at what amounts to another version of "funny physics," just as distant from the real thing as de Chirico's diagrammatic dreams of science and, indeed, not entirely different in spirit.

In recent years, Marianne Martin has gone well beyond my brief comparison of de Chirico's art with that of Futurism. Not only has she definitively discredited the notion that the two were antithetical, but she convincingly demonstrated that they were "two sides of the same coin." In addition to outlining many subject affinities, such as the recurrent theme of voyaging, Martin presented de Chirico and the Futurists as confronting in common an "accelerated collision of past and present." Far from being detached from the art of his time, de Chirico, she concluded, participated in "a part-serious, part-ironic discourse with Futurism...at least through 1917."[36]

The reader has doubtless understood from my insistence on the early de Chirico's involvement in the vanguard painting of his day that this essay is intended, in effect, as a corrective. What the reader cannot know, however — unless he or she has traversed the already considerable literature on this painter — is the degree to which correction is called for. No other body of critical writing in the annals of modern painting depends so much for its observations on texts (especially by the artist) and so little upon direct confrontation of the paintings. And most of what little proceeds from looking at paintings rather than from extrapolating texts deals with iconography — precisely that area of de Chirico's early work which *does* set him off from his immediate contemporaries.

If, however, my observations are intended as a corrective, they are not intended to constitute a "revisionist" theory. Much of what has been written about the literary and biographical sources of de Chirico's work is of considerable value. But the problems of the de Chirico literature remain more acute than those having to do with any other

twentieth-century artist. To be sure, they begin with a tendency endemic to art history, a kind of *mal de métier* if you will, which is to treat statements by artists with an almost religious piety, as a kind of logos. This is most evident among art historians who have never lived in close proximity to artists. It seems not to occur to such investigators that much of what is said or written by artists about their work is selective, mistaken, misleading, and even mendacious. Why this is so relates to questions of the artists' personalities, psychologies, their social and historical context, their strategies for securing a place in the sun, and numerous other considerations we cannot explore here. Of course, much of what is said and written by artists is also insightful, revelatory, and extremely valuable. But the decision as to the category into which an artist's assertion falls *must begin with its verification against the work.* This is not generally the case — and, in the de Chirico literature, hardly ever the case. Thus, to take a typical example, the 1920 de Chirico extols the Italian tradition as an art of "solidity" — and Castelfranco[37] later picks up that same word to describe, against all visual evidence, the artist's earlier paintings.

It was, of course, the artist's change in style after 1917 — what Motherwell in 1942 called the "degeneration" of an earlier "contemporary taste"[38] — that has especially complicated writing about de Chirico. The change ("something happened," wrote Motherwell, "to alter de Chirico's conception of painting") immediately influenced what the artist would say about his painting, as it would more gradually also alter his imagery. Not surprisingly therefore, de Chirico's early work is frequently misinterpreted through the application of later texts, which make up the bulk of his writing. Indeed, everything published by de Chirico himself — and there is a great deal — postdates his artistic conversion, while the two texts contemporaneous with the early paintings (the Eluard and Paulhan manuscripts, the former in the collection of Picasso) were first published only in 1955 by Soby.[39]

That de Chirico's two early meditations on painting are almost entirely poetic in character and say little about style or composition is hardly surprising. This is the rule among poetic painters, and is often true even of those of abstract persuasion. Nevertheless, de Chirico himself distinguished between imagery and configuration,[40] and while he preferred to say little about the latter, that hardly excuses critics or art historians from considering it. Moreover, even within the confines of de Chirico's poetic mode of writing we can identify in the early texts a number of specifically modern attitudes that directly contradict positions taken by the artist after he began publishing in 1918. Hence, for example, though the Pictor Classicus would declare in 1919 that the fundamental problem of painting was one of *métier,*[41] or craftsmanship, he treated the art of drawing a few years earlier in a typically modern spirit when he spoke of "unlearning" it — an attitude important in such painters as Cézanne, Picasso, and Pollock. "Technique doesn't count," the early de Chirico asserted, and he described a period in which he "drew less and less…to the point of even forgetting the technique of drawing."[42] Not surprisingly, such drawings as remain from his Paris years (pls. 97-101) are spontaneously executed, free of modeling, and often so simplistic as to suggest children's drawings (fig. 22). Indeed, the early de Chirico — in contrast to the "savant" he would later become (fig. 23) — recommended approaching creation "with the mental attitude of a child."

By the same token, the young artist extolled "the poetry of insignificant things," a view in harmony with that of the Cubists, though hardly reflected in the heroic imagery the Pictor Classicus celebrated after 1918. And while much of his later work was to be marked by bravura and virtuoso effects, the aim of de Chirico's six or so years of early painting was spareness. The best artists, he wrote at *that* time, "will renounce something every day." Were we to look in the early manuscripts for a remark characterizing the ideal artist, we might select an observation made there more than once by the young de Chirico: his praise of painters who "invented something that didn't exist before." These were precisely the words by which Picabia — who exhibited with de Chirico at Paul Guillaume's in those early years — would later define the role of the modern artist.

To de Chirico's recollection of his early self as an isolated, unique genius, entirely cut off

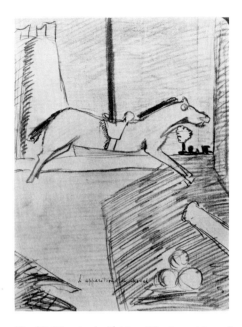

Fig. 22. Giorgio de Chirico. *The Apparition of the Horse.* 1913-14
Colored pencil
Private collection

Fig. 23. Giorgio de Chirico in his studio, Piazza di Spagna, Rome. c.1952
Photograph by Herbert List
Courtesy Max Scheler, Hamburg

from the art of his own day, we must necessarily prefer the image of a genius who had one eye cocked on Parisian painting and the other on the Futurists. What happened to this genius after 1917? Motherwell, the reader will recall, described the problem as a change in de Chirico's "conception of painting." Indeed, by 1920 de Chirico's art had altered profoundly, and the theoretical statements he published at that period confirm and detail his reactionary about-face.

But conceptions of painting are themselves more effects than causes, and I suspect that de Chirico's conversion was ultimately of psychological origin. This much is suggested by his friend and dealer Claudio Bruni, who describes the painter in 1919 as having "started everything all over again, freed from the torments of his youth and from his inner anxieties."[43] The malaise and neurasthenia that accompanied his earlier poetic mental state were evidently overcome in part through such psychological security as could be purchased by a commitment to conservatism and tradition.

A loss of poetry concomitant with the resolution of mental crisis is hardly unique in the history of modern painting. It obtained in varying degrees, for example, in the cases of Munch and Vuillard, both of whom share with de Chirico a history of a short period of genial painting followed by a much longer disappointing one. In all three cases the decline begins precipitously, but the lowest ebb is some years in arriving. Thus the Munchs and Vuillards of the early twentieth century—while hardly comparable to their work of the 1890s—are better than the artists' subsequent paintings. And the de Chiricos of the 1920s—though profoundly different from his Paris and Ferrara work—are manifestly superior to the efforts of his final five decades.

Munch suffered a loss of poetry after his 1908 crisis, and his subsequent pictures are unsure and flaccid as compared to his best work. But he nevertheless remained largely faithful to his personal imagery and style. And his career continued to reveal an underlying authenticity, which permitted him to break through on rare occasions to pictures of considerable inspiration. The case of Vuillard was less happy. There, the out-and-out academicism of the later decades is without redeeming qualities. But even *that* evidenced a certain consistency of artistic conviction.

De Chirico was something else again. Though his rhetoric after 1918 was inspired by a return to the classic tradition, the work itself became essentially eclectic. Thus along with Neo-Classicism (pl. 81 and figs. 1, 25), we can identify, at the very least, art-school academicism (fig. 24), Neo-Romanticism (pls. 79, 80, 85), Neo-Baroque (pls. 90, 91), and, somewhat curiously for a technician who would add to Pictor Classicus the title Pictor Optimus, a kind of awkward style approaching Neo-Primitivism (pl. 96)—ironically, in my opinion, the best of the bad bargain of de Chirico's later years.

The later Munch is saddening; the later de Chirico is a tragedy that turned into a farce. The later Vuillard is a bore; the later de Chirico is never that—but he is often insincere and, in certain respects, corrupt. This last aspect can only be appreciated if we add to the catalog of the previous paragraph yet another category, Neo-de Chirico: the variants (fig. 27) and facsimiles (fig. 28) tantamount to forgeries of Paris and Ferrara pictures that the maestro ground out in increasing numbers and with increasing cynicism during his later years. These begin with certain "re-creations" of the early twenties, through the making of which the Surrealists rather naively hoped de Chirico would rediscover his muse. Paul Eluard, for example, commissioned a second version (pl. 89) of *The Disquieting Muses* (pl. 71), which de Chirico assured him would be an "exact replica" that would "have no other fault than…being executed in a more beautiful medium and with a more knowledgeable technique."[44]

By the later twenties the Surrealists had given up on de Chirico, reviling his contemporary painting and ridiculing his theories; he entered their list of the living dead. De Chirico's response was to dismiss and even disown his Paris and Ferrara paintings[45]—a position he maintained until certain considerations led him to equivocate and return to the production of reproductions. He defended this practice by arguing that the old masters had done the same thing. But second—to say nothing of third and fourth—versions of pictures are extremely rare among the old masters, and were never executed

Fig. 24. Giorgio de Chirico. *Self-Portrait in the Paris Studio.* 1934
Oil on canvas, 51⅛ x 30⅝" (130 x 78 cm)
Private collection

Fig. 25. Giorgio de Chirico. *The Judgment of Paris.* 1946
Oil on canvas, 39⅜ x 55⅛" (100 x 140 cm)
Private collection

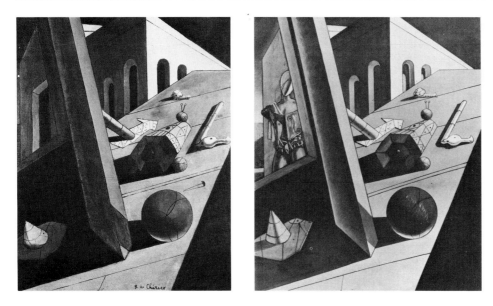

Fig. 26. Giorgio de Chirico. *The Evil Genius of a King.* 1914-15
Oil on canvas, 24 x 19¾" (61 x 50.2 cm)
The Museum of Modern Art, New York, purchase

Fig. 27. Giorgio de Chirico. *Metaphysical Exterior with Troubadour.* 1960
Oil on canvas, 28¾ x 23⅝" (78 x 60 cm)
Private collection

after the artist had given up the style and/or iconography of the original. De Chirico might better here have pointed to Munch, who did in fact make three or four versions of a few pictures. This still left him a long way, however, from the Pictor Optimus. The copy of *The Disquieting Muses* executed for Eluard in 1924 was but the first of a series of that image, which eventually numbered no less than nineteen (fig. 28).[46] Nor was de Chirico loath to pass off such late facsimiles as original works of his Metaphysical period. At least some late versions inscribed with dates of the teens were sold by the painter directly from his studio to collectors who were assured their dates were authentic.[47]

Although most serious collectors and museums have preferred to keep their distance from de Chirico's works of the 1920s and after (neither Soby nor Alfred Barr considered them acceptable for The Museum of Modern Art collection or for the de Chirico exhibitions held here), there has been a movement under way in Europe for more than a decade in favor of a drastic upward revaluation of the late de Chirico. This reconsideration is doubtless justified to a very limited extent. De Chirico did not become a bad painter overnight. There are some fine paintings in the 1920s and some interesting ones — here and there — even later. And these should be appreciated for their own qualities rather than be compared to the Metaphysical pictures. (For this reason, I have broken with Museum of Modern Art tradition and included a small selection of post-1918 works in the exhibition this book accompanies.) Yet the claims made by some fervent critics and art historians for the late de Chirico go much further. And they see their revaluation as establishing a major art-historical shift — one which quite clearly relates to the current vogue of realism in historical studies as well as in contemporary art.

My own resistance to the late de Chiricos has finally something to do with a perception of the pictures that goes beyond aesthetics — a response to something I will have to call the "ethos" of the work. It does not follow from anything I know about the paintings or their author (such as the practices described above), but from something I see in them, the way I see an ethical imperative in a Giotto, Rembrandt, or Cézanne. This view has nothing to do with the subject represented in the picture; that concern was a nineteenth-century confusion, dispelled since Pater, Wilde, and Croce. But suspending judgment on the morality of a painting's subject — or the morality of the artist who made the painting — does not leave us merely with a plastic ensemble that remains on the level of sensation. On the contrary, the more we look at pictures, the more we perceive their essence as an ethos that inheres in the work. Despite all I have said about the extraordinary stylistic and poetic originality of de Chirico's early work, it is finally on this truly metaphysical level that it convinces me of its greatness. And it is this form of immanence, more than anything else, that seems to have fled with the young de Chirico's loss of innocence.

OVERLEAF:

Fig. 28. Eighteen versions of de Chirico's *The Disquieting Muses* (original executed 1917) dating from 1945 to 1962. Courtesy Carlo Ragghianti and *Critica d'Arte*

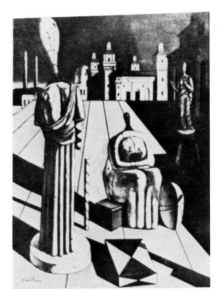

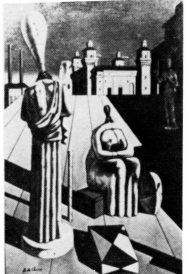

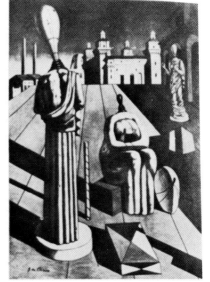

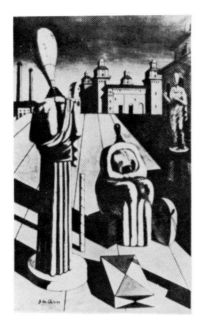

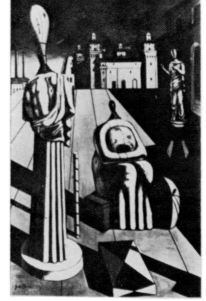

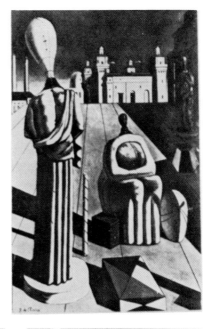

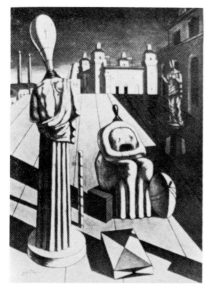

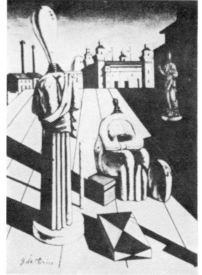

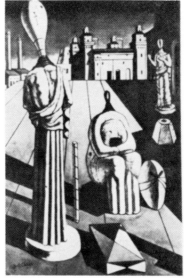

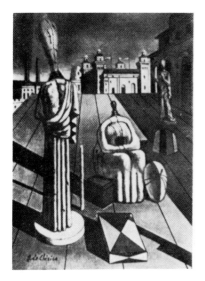

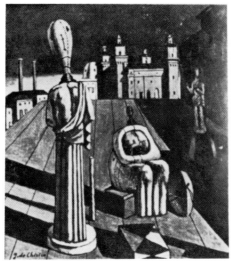

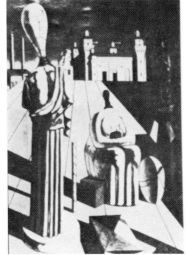

Notes

1. This appellation reflects the decisive break that occurred between the work of 1911-17 and that of the last sixty years of the painter's life. De Chirico is thus referred to even in the titles of monographs, e.g., James Thrall Soby, *The Early Chirico* (New York: Dodd, Mead, 1941), and Italo Faldi, *Il Primo de Chirico* (Venice: Alfieri, 1949).

2. I have collated these remarks by Jean Cassou from two texts: "La Peinture métaphysique" in *Panorama des arts plastiques contemporains* (Paris: Gallimard, 1960), pp. 464, 467, and the Introduction to the catalog *Exposition d'art moderne italien* (Paris: Musée National d'Art Moderne, 1950), p. 2.

3. James Thrall Soby, *Giorgio de Chirico* (New York: Museum of Modern Art, 1955), pp. 65, 79.

4. James Thrall Soby, "The Scuola Metafisica" in *Twentieth Century Italian Art* (New York: Museum of Modern Art, 1949), p. 19. (Italics mine.)

5. Giorgio de Chirico, *Memorie della mia vita* (Milan: Rizzoli, 1962), p. 71. (Italics mine.) An earlier volume, *Memorie della mia vita* (Rome: Astrolabio, 1945), constitutes the first part of the present volume, which covers in its second part the years 1945-60.

6. Werner Haftmann, *Painting in the Twentieth Century,* trans. Ralph Manheim, vol. 1 (New York: Praeger, 1960), p. 180.

7. Marianne W. Martin, "Reflections on de Chirico and *Arte Metafisica,*" *Art Bulletin,* LX, June 1978, p. 342.

8. Cited in F. E., "De Chirico a Venezia 'smaschera' il modernismo," *Corriere Lombardo,* Milan, Sept. 28, 1949.

9. Although in 1914 Apollinaire found de Chirico "more classical" than Chagall, the terms "classical" and "classicism" were not, to my knowledge, used to characterize de Chirico's style until Papini, in 1919, said his work could be called "classic" ("Giorgio de Chirico" in *La Vraie Italie,* Mar. 1919). Later that year de Chirico ended his essay "The Return to Craft" with the assertion "Pictor classicus sum" ("Il ritorno al mestiere," in *Valori Plastici,* I, no. 11-12, Nov.-Dec. 1919, p. 19). I owe this reference to Joan M. Lukach; see her essay herein for complete citation.

10. Wieland Schmied, "Giorgio de Chirico," preface to exhibition catalog *I de Chirico di de Chirico* (Ferrara: Galleria Civica d'Arte Moderna, 1970), p. 1.

11. Jean Clair, "Metafisica et Unheimlichkeit," in *Les Réalismes 1919-1939* (Paris: Centre Georges Pompidou, 1981), p. 29. This text contains the best discussion anywhere of affinities between de Chirico and Freud.

12. Giorgio de Chirico, "Il senso architettonico nella pittura antica," *Valori Plastici,* II, no. V-VI, May-June 1920, p. 60.

13. I am not the first to point out the rarely mentioned affinity in spirit between certain texts of the poet of "Immortal Ennui" and the early landscapes of de Chirico. (In noting this affinity we must of course allow for the fact that the poet was addressing nature and the painter the city.) According to Apollinaire, de Chirico was in 1918 himself "citing Leopardi." *Chroniques d'art, 1902-1918,* ed. L. C. Breunig (Paris: Gallimard, 1960), p. 443, for July 20, 1918. Herewith an excerpt from Leopardi's "L'Infinito":

 Ma sedendo e mirando, interminati
 Spazi di là da quella, e sovrumani
 Silenzi, e profondissima quiete
 Io nel pensier mi fingo...
 Infinito silenzio a questa voce
 Vo comparando: e mi sovvien l'eterno,
 E le morte stagioni, e la presente
 E viva, e il suon di lei. Così tra questa
 Immensità s'annega il pensier mio:
 E il naufragar m'è dolce in questo mare.

14. References to Gordon Onslow-Ford's lecture "Chirico City" are to be found in Soby, *Giorgio de Chirico,* pp. 34, 67.

15. I have written about his influence on Dada and Surrealist painting in "Toward a Critical Framework, 2: Giorgio de Chirico," *Artforum* (special issue on Surrealism), Sept. 1966, pp 41-47, and *Dada and Surrealist Art* (New York: Abrams, 1968), pp. 130-36; and Laura Rosenstock enlarges upon this subject in her essay "De Chirico's Influence on the Surrealists" in the present volume. Also in this volume, in "De Chirico and the Realism of the Twenties," Wieland Schmied discusses de Chirico's influence on German painters.

16. Giorgio de Chirico, "Sull'arte metafisica," *Valori Plastici,* I, no. 4-5, Apr.-May 1919, p. 16.

17. Raffaele Carrieri finds characteristically that de Chirico's "elaborate constructions" are nevertheless realized "with a perfect knowledge of the rules of perspective" ("Giorgio de Chirico" in *Forme* [Milan: Milano-Sera-Editrice, 1949], p. 72). H. H. Arnason summarizes the common assumption in stating that "de Chirico's space is uncompromisingly that of Renaissance perspective" (*History of Modern Art* [New York: Abrams, 1968], p. 286).

18. Giorgio Castelfranco and Marco Valsecchi, *Pittura e scultura italiane dal 1910 al 1930* (Rome: De Luca Editore, 1956), p. 19.

19. Soby, "The Scuola Metafisica," p. 19.

20. The city name "Torino" exists in another painting, which is inscribed "Torino 1888" (pl. 49). This work was discussed in an article by Wieland Schmied ("Turin als Metapher für Tod und Geburt" in *Neue Zürcher Zeitung,* Nov. 1-2, 1980, p. 67) and was also one of a group of little-known paintings included by Maurizio Fagiolo in his annotated "addendum" to Soby's 1955 monograph on de Chirico ("Ecco i de Chirico antichi mai visti prima," *BollafiArte* [Turin], Oct. 1981, p. 60). If Soby neglected "Torino 1888," he deserves on the other hand to be acknowledged for discerning the fundamental role played by the city of Turin — its association with Nietzsche identified with its role as the setting for the painter's spiritual birth — as a point of departure, together with Florence, in the creation of de Chirico's "poetic reconstructions of the dream-lit piazzas of Italy" (Soby, *Giorgio de Chirico,* p. 28). De Chirico himself stopped in Turin in 1911 on his way to Paris, and he speaks of it in his *Memorie...* as the Italian city par excellence where the rare and significant phenomenon based on *Stimmung,* which he termed the philosopher's most significant innovation, is most apparent (Soby, *Giorgio de Chirico,* p. 28). Turin is also where Nietzsche in 1888 suffered the mental breakdown (he fell down in tears embracing a horse that had collapsed after being whipped) that led to complete insanity, and it is this incident, according to Maurizio Fagiolo, which de Chirico here pays homage to and which explains the presence of the horse just below the date "1888" (*Giorgio de Chirico, Il tempo di Apollinaire: Paris 1911/ 1955* [Rome: De Luca, 1981], p. 59). However, there is no clear rational explanation for the appearance of "Torino" in the imagery of *The Seer,* and its presence may be more in the nature of a psycho-poetic association than a specific designation of the Piedmontese city and the philosopher associated with it. The kind of fantasy geometry accompanied by cryptic numbers, letters, and signs exemplified in *The Seer* was to find an echo in the American-period work of Matta and, around the same time, certain early works of Pollock. Cf. William Rubin, "Pollock as Jungian Illustrator: The Limits of Psychological Criticism," I, *Art in America,* Nov. 1979, pp. 104-23; II, *Art in America,* Dec. 1979, pp. 72-91.

21. De Chirico was friendly with the Russian painter Serge Férat (pseudonym for Serge Jastrebzoff), who had been a friend of Rousseau and possessed during de Chirico's years in Paris a number of paintings by the Douanier, including his great self-portrait of 1890, now in the National Museum in Prague. De Chirico memorialized a dinner he attended at Férat's with Picasso in a drawing (fig. 16) that shows the Rousseau painting on the wall. Seated at the table with Picasso are Serge Férat, the Baroness d'Oettingen (who wrote under the name of Roch Grey an essay on Rousseau published in 1914 in *Les Soirées de Paris*), and the painter Léopold Survage.

22. The triumph of Italian Renaissance painting was in certain respects a triumph of painting over sculpture in the round. Beginning with Giotto, whose modeling endowed his figures with a tactility and weight that went beyond, as Panofsky observed, the plasticity of the French Gothic sculpture that was his model, and continuing through Masaccio, who first set this illusion of cylindricity and solidity within systematic focus perspective, the Italian painters developed a language capable of communicating an illusion of sculptural plasticity more intense than that of actual sculpture in the round (in part because, unlike sculptors, they could fully control the effect of light, as it was not the light of the real world but that of their own illusionism).

　　Insofar as the painters could also join many figures in narrative situations while endowing each of them with the plasticity of sculpture in the round (Berenson's "tactile values"), they had, in effect, beaten the sculptors at their own game. Sculpture in the round was limited essentially to the single figure. Relief sculpture could and did, of course, present narrative situations, but at the cost of accepting a pictorial framework and of sacrificing the tactility of sculpture in the round. Thus, for example, there is a more insistent plasticity to the sculptural effects of the figures in Masaccio's *Tribute Money* than the roughly contemporary reliefs of Donatello or Ghiberti.

　　There is no doubt in my mind that this absorption into painting of the plastic quality of sculpture in the round accounts for the virtual eclipse of the latter art for the long period during

which illusionism held sway. There are comparatively few great sculptors between 1450 and the rise of modernism. The choices were to partially break with the received illusionism, as did Michelangelo—this is part of what Morey meant when he called Michelangelo the "last Gothic sculptor"—or to compete with the illusionism by endowing sculpture with virtuosic pictorial effects, as did Bernini. But the advent of an occasional great sculptor in no way obviates the fact that during the same centuries there were, comparatively speaking, countless great painters. Thus the art of sculpture, which had been dominant in the ancient world and certainly more central than painting in late medieval times, would not really flourish again until the illusionism which had "usurped" its role ceased to hold sway in painting itself. This took place in the late nineteenth century when the advent of modern painting opened the way to a redefinition of sculpture as well.

23. De Chirico, *Memorie della mia vita,* p. 73.

24. In a lecture at Harvard University on February 20, 1981, I presented an iconographic analysis of the various studies for Picasso's so-called *Carnaval au bistrot,* a projected large painting of 1909 which was altered from a banquet scene into a still life *(Bread and Fruit Dish on a Table,* Kunstmuseum, Basel) while it was being painted. The alteration was marked by what I called a "transmigration of forms" in which shapes that remain constant pass to new identities; here the forms first used for the figures remained in many cases on the canvas surface but were made to stand in the new context for still-life constituents. I demonstrated that the three male figures in the original sketch—Harlequin, Gilles, and a man wearing a Kronstadt hat—were intended to stand for Picasso, Rousseau, and Cézanne. Although these personages disappeared as such from the painting, they survived symbolically to the extent that Picasso's finished still life showed quite clearly, on a stylistic level, passages derived from Rousseau and Cézanne. The material of this lecture is now being organized into an article intended for the *Art Bulletin.*

25. *Dada and Surrealist Art,* pp. 127-29.

26. Soby, *Giorgio de Chirico,* pp. 48-49.

27. Cf. Robert Melville, "Rousseau and De Chirico." *Scottish Arts and Letters* (Glasgow), no. 1, 1944, pp. 33-35.

28. "News and Views of Literature and the Arts" in *L'Europe Nouvelle,* Apr. 13, 1918; reprinted in *Apollinaire on Art: Essays and Reviews 1902-1918 by Guillaume Apollinaire,* ed. Leroy C. Breunig, trans. Susan Suleiman (New York: Viking Press, 1972), p. 461.

29. Picasso spoke of a "lien évident" between Rousseau and de Chirico when this writer and he were looking at Rousseau's works in his collection. De Chirico's name had arisen in the conversation in relation to the authorship of *The Sleeping Gypsy,* long rumored not to have been the work of the Douanier. There is no longer any dispute about the picture's authorship, but its sudden appearance on the market in 1924 had given rise to a spate of rumors that it had been faked, rumors that persisted until the 1950s. According to different sources—critics, dealers, and friends of the artists in question—Picasso, Derain, and de Chirico were among those said to have painted *The Sleeping Gypsy.* When I asked Picasso about this he admitted sheepishly that he was probably a source of rumor in regard to both himself and de Chirico, and that some of these rumors would have resulted in *boutades* made around the time (1924) when he was first shown the painting by Kahnweiler. The picture, said Picasso, was so evidently painted by Rousseau (the opinion he transmitted to Quinn shortly before the latter purchased it) that when he (Picasso) was persistently questioned about it, he occasionally made facetious answers, jesting that he had painted it himself or that de Chirico had painted it. Picasso doubted, however, that he had even jokingly proposed Derain (my notes show Picasso saying something to the effect that Derain would not have been up to it). As late as 1949, André Breton, famous for not knowing when Picasso was pulling his leg (he reported the artist deploring "the need to use paint for lack of a satisfactorily durable piece of real, dry excrement" in one still life), was indignant that Picasso, who "says he knows the real author" of *The Sleeping Gypsy,* had done nothing to put a stop to the imposture (*Flagrant Délit* [Paris: Thésée, 1949], p. 17).

30. Quoted in *12 Opere di Giorgio de Chirico precedute da giudizî critici* (Rome: Edizioni di Valori Plastici, 1919), unpaginated (2 pages of quotations from critical appraisals plus 12 plates).

31. Such trompe-l'oeil could, of course, be considered a traditional usage insofar as it resembles *faux marbre* and other techniques used by painters and painter-decorators (*peintres d'impression*) since the Renaissance. But de Chirico's use of it (as in *Metaphysical Interior,* 1916, pl. 61) far more resembles that of the Cubists, whose paintings of 1913-15 provided immediate models.

32. I would not have recognized these ornamental Irregular Curves as such had I not learned about them from Frank Stella, who used them integrally as components in his various Bird series of painted metallic reliefs.

33. In view of de Chirico's friendship with Picasso, especially during 1914-15, we must assume minimally the usual exchange of studio visits. In Picasso's studio, which I suspect de Chirico visited more than once, he would have seen Cubist constructions on the wall. It is probable that Apollinaire had at least one in his apartment, which de Chirico visited frequently as early as 1913. In any case, Apollinaire reproduced them in *Les Soirées de Paris,* which we know de Chirico read. We also know that de Chirico visited the famous 1912 Paris exhibition of the Futurists, and, given his professed admiration for Boccioni, he must have visited Boccioni's Paris exhibition of sculpture in 1913 (Apollinaire's review of the show expressed its forcible effect), where he would have seen his Futurist constructions. (Cf. Marianne W. Martin, "Reflections," p. 346 and n. 30, p. 349 and n. 50). In 1913-15 many Parisian artists were making Cubist-inspired constructions, and de Chirico no doubt saw some by lesser artists, such as Vladimir Baranoff-Rossiné, a friend of Serge Férat and thus possibly an acquaintance of de Chirico. That the painter himself remained silent about such objects, which precede in time the imaginary ones he represented in his paintings, is not surprising, given his posture of total independence.

34. Cf. the Kronstadt hat in Picasso's 1909 *Still Life with Hat,* also known as *Cézanne's Hat.* This hat was taken by Picasso from Braque's studio to his own after Braque had purchased it in celebration of their shared devotion to Cézanne.

35. *Dada and Surrealist Art,* pp. 132-34.

36. Martin, "Reflections," pp. 342-53.

37. Cited in Giuseppe Marchiori, *Arte e artisti d'avanguardia in Italia (1910-1950)* (Milan: Edizioni di Comunità, 1960), pp. 92-93.

38. Robert Motherwell, "Notes on Mondrian and Chirico," *VVV,* June 1942, pp. 59-61.

39. Soby, *Giorgio de Chirico,* Appendix A (pp. 244-50), Appendix B (pp. 251-53). Hereafter, any unfootnoted citations are drawn from these appendices.

40. Soby, *Giorgio de Chirico,* Appendix A, p. 246.

41. De Chirico, "Il ritorno al mestiere," *Valori Plastici,* I, no. 11-12, Nov.-Dec. 1919, pp. 15-19.

42. Soby, *Giorgio de Chirico,* Appendix A, p. 246.

43. Claudio Bruni Sakraischik, *Giorgio de Chirico,* text in Italian and English, trans. Helen Barnes (Rome: Edizioni Galleria La Medusa, 1976), p. 15.

44. Cited in Soby, *Giorgio de Chirico,* p. 134.

45. De Chirico's aspersions on his own early work, made to a variety of artists and critics, began in the later 1920s and continued until World War II. Even after that he continued to criticize and reject individual works, though he was busily reproducing others. For the better part of his career he was involved in fierce disputes and legal battles over the so-called false de Chiricos (the second part of his *Memorie della mia vita* covering the years after 1945 abounds with references to polemics and legal actions). Some of the celebrated trials were initiated by him; for example, he brought suit against the Venice Biennale of 1948 for showing his early work, and in 1968 against the publisher of a projected catalogue raisonné of his 1910-30 paintings. But more often he was sued for claiming early works of his were fakes— in 1968 in Milan and in Rome, in 1970 in Rome again. In 1946, for instance, he had insisted to *Time Magazine* that *The Double Dream of Spring* (pl. 54) in the Museum of Modern Art collection was a fake (though he later revised that opinion).

46. In his "Il Caso de Chirico" (*Critica d'Arte,* XLIV [n.s.], fascicule 163-65, Jan.-June 1979, pp. 11-13), Carlo Ragghianti reproduced eighteen copies of *The Disquieting Muses* dating from 1945 to 1962 (fig. 28). He omits the first such copy, commissioned by Eluard (pl. 89), and others that may have been painted before 1945 or after 1962.

47. The private files of Soby, now in the archives of The Museum of Modern Art, contain documents confirming this practice of de Chirico.

O N March 16, 1914, in what was probably his first public statement, de Chirico protested against a "misunderstanding of…[his painting] widespread among the critics who reviewed the Indépendants [Salon of that year]. Except for M. Apollinaire," he continued, "almost all of them spoke of 'theater scenery'…[but] I would like these gentlemen to know that my paintings have nothing to do with scenery, which moreover is sufficiently proved by their titles."[1] Although de Chirico's art has until recently continued to be "misunderstood," there seems to be no doubt that the "theater" in a broad sense of the word forms the bedrock of his creative imagination. Evidently, such a view of his work implies a "theatricality" of a far deeper kind than the dismissive allusion to stage sets and perspectival space noted by the critics of 1914.

The comments that follow are a renewed attempt to gain access to de Chirico's elusive stage, but are still a mere rehearsal awaiting further directions from the late maestro's archives and other materials unavailable to me.[2] My observations are therefore intended to point up the urgent need of coming fully to grips with the art of de Chirico so as to establish finally its proper place in the mosaic of modernism. Naturally, de Chirico developed his art, consciously and unconsciously, from a very rich and varied background, and the few items from the background that are isolated in this discussion are only an indication of its still largely unexplored wealth.

It may be helpful at the outset to state at least roughly what is to be understood by the "theatricality" of de Chirico's art and to distinguish it from the stagelike element that underlies representational painting as a whole. The latter has, of course, some formal and expressive roots in the theater. It may be correct to say very generally that in the course of history these theatrical roots became so closely identified with painting itself as to lose their independent meaning, and modern abstractionist tendencies have helped to suppress these roots almost entirely. De Chirico, who deliberately swam against the current almost his entire life, may be said to have reinvested painting with its original "theatrical" forces, not only those relating to a novel kind of quasi-illusionism, but, more important, the transcendent forces of "drama" or "tragedy" in a Nietzschean sense, as will be seen.

As might be expected, de Chirico provides practically no explicit clues for such a reading of his art, and his titles, regardless of who devised them, serve only to derail the spectator from falling into easy or naive associations with the theater. Yet, with the help of personal and circumstantial evidence from the artist's life and, of course, from indications found in his painted and written oeuvre, some insights into the substance of his theatrical vision can be obtained and a rough skeleton key to his "mysteries" provided.

The word "mysteries" is used advisedly, for it would seem that this is exactly what de Chirico sought to depict — that is, mysteries at least partially comprehensible to alert and sensitive initiates comparable to those attending the ancient Dionysiac or Orphic rites. However, the artist's oblique reenactments of human destiny are often informed by the irreality of *fin de siècle* dream plays or of early trick and mystery films.

As is well known, the voluminous writings, autobiographical, semiautobiographical, and theoretical, by de Chirico and his brother Andrea, who later called himself Alberto Savinio, provide an essential complement to their other artistic activities, and hence are of particular relevance in our quest. Naturally, it is imperative to respect the different and individual sensibilities of both brothers, but one cannot disregard their close personal and artistic association, which led to inevitable creative exchanges as well as an implicit sibling rivalry. Thus it must not be forgotten that Savinio wrote music and drew since his early youth and de Chirico possessed a fine musical ear, studied the cello, and composed before becoming a full-time painter.[3]

The predominant format of the brothers' nontheoretical writings (and of some theoretical ones) is an actorlike transposition of personal reminiscences into quasi-fictive events. The outpourings of their minds and psyches pass vividly before one's inner eye like ineluctably shifting dramatic scenes or colored film stills. That de Chirico considered his mental processes in such terms, literally or metaphorically, is brought out on many

On de Chirico's Theater

Marianne W. Martin

Notes to this essay begin on page 97.

occasions. For example, in an essay honoring the musician Alfredo Casella, his old friend and associate, the artist emphasized the identity of his thoughts with images:

For a long time I realized that I think by way of images or configurations. As a result of lengthy reflection I have concluded that at bottom the image is the principal expression of human thought and that other factors by means of which thought is expressed, as for example, words, gestures …are but secondary expressions that accompany the image, the principal agent in our thought.[4]

Such "thought-images" are put into a dream-theater context in his recollections of Apollinaire composed in 1918:

…when the history of this fearsome European artistic renaissance is written,…[Apollinaire's] place will be amid the best…But today, in this city echoing with fanfares, full of flags for the victories and the epilogue of the drama…my wandering thoughts go back again to the bridges of the muddy Seine.…I see again, as one sees in dreams, an apartment house with six stories daubed in gray, and high above two rooms beneath the roof.…The curtain closes and a miraculously tender picture forms itself silently: amid the tragic innocence of the lacquered canvases of the douanier-painter and the metaphysical architecture of the undersigned I see…as if within the luminous ray of a magic lantern the fatal rectangle of a Veronese blue sky that projects itself on the wall, and on this sky the profile of the sad centurion bends anew.…It is Apollinaire, Apollinaire the returned one.[5]

Seven years later, while longing for Paris as a place to live and work, he dreamily conjures up the city as a combination stage set and cinematic projection:

Paris is like a large surprise box…The backdrop consists of fog of the softest gray which unites the sky with the earth and human constructions. These are also gray yet are curious and hospitable springs, solemn and surprising, like enormous stage wings to the left and right, from which emerge troops of hurrying men and vehicles, strange, speckled herds, like figures in a lanterna magica. This reminds me of the strange lyricism of those colored pictures that I saw one evening on the screen of a cinematograph where that marvelous metaphysical film called *The Ten Commandments* was shown.[6]

In 1941 de Chirico asserts the interchangeability of the perpetually evolving stage image with the innumerable chambers of the creative mind. These chambers he likens to the symbolical richness of the Apocalypse, which he had just illustrated. He postulates a "change of position" as the necessary condition for such a revelation. "Many people do not realize," he writes,

that in order to understand certain exceptional creations of the human spirit it is necessary to begin to dig *within* the work. One must never fix one's glance on the surface in the hope of advancing into depth, but start from the wings,…the background, to reach the surface and the footlights.…Thus changing position, I entered the Apocalypse…

And by holding the "so-called known and unknown worlds," "Points A and B," in abeyance, the artist installed himself at "Point C," where under the "security cover of *relativity*" he

drew; I did not need to copy models, take measurements…the points united themselves by means of strokes; the strokes closed by points felt secure; every sign of the mysterious stenography felt itself happily at home. And this is how my drawn *spectacles* were born.[7]

De Chirico's remarkable text and partial *roman à clef, Hebdomeros,* which was composed during the mid-1920s, is his most extensive verbal example of a chain of dramatic visualizations of enigmatic experiences that are still in need of close analysis. Important in this context is the frequent use of the theatrical or cinematic metaphor by means of which these extraordinarily fluid events are conjured up. This fluidity is enhanced by the ubiquitous presence of water, which acts like a fade-out of the seemingly precise images. On a number of occasions de Chirico ironically rationalizes the resultant shifts and non sequiturs as mechanisms of the stage or the camera. We read, for example: "Hebdomeros…sat down on a stone…and plunged into deep meditation; gently, before each memory of the past, the curtain lifted." Or, after recounting a particularly perplexing sequence of images, de Chirico interposes a pseudoexplanation: "'It's a trick by the local

Mollas' Shadow Theater, Athens. The character Karaghiozis (or Karagöz in Turkish). Reproduced in L. Reiniger, *Shadow Theaters and Shadow Films*

photographer," people whispered in the cafés…Another movement: a plane of the decor changed, a screen removed, a curtain raised, and now it is *the ball*." In a series of key scenes relating de Chirico's continuing mental journey into his own past and into the more comforting racial past of the Jews, which finally is transposed into the cosmic time of the stars, the artist uses "several one-act plays" performed by quarreling actors as anchoring point for his vast spatiotemporal flights.[8]

Savinio makes perhaps the most explicit if sardonic allusion to the interchangeability of the illusory worlds of the stage or art and life in his play *Capitano Ulisse,* written in 1924 but published in 1934. In the past Ulysses had been a favorite personification of the two brothers' creative efforts. In this play he is absolved of his burdens by allowing himself to be guided through the small stage door onto the stage where "the set, the air of the theater, his immersion in the lofty atmosphere of the stage, his passage through this sterilizing machine, this superior *vacuum cleaner,* finally worked the miracle…[and have] broken the anchor that kept him moored to that cursed shore. And sweetly, trusting like a very good child, Ulysses…Ulysses called *hero,* commander and *captain,* allowed himself to be led into the *Colored Adventure….*As everyone can see," Savinio concludes, "this definition of theater was achieved by itself without my even dreaming of seeking it."[9]

There is no doubt that Pirandello, James Joyce, and the Surrealists affected the later modes of thinking and writing of the de Chirico brothers. Also, older precedents, from Lautréamont to Rimbaud, Jarry, Apollinaire, and others, can be pointed out for their various ways of self-dramatization and for their philosophy of art. As a whole, the theatricalizations of the de Chiricos can be seen as perennial attempts at comprehension of the incomprehensible and simultaneously as ways of preserving the viability of this mystery. They deliberately sought to remain "enigmas to themselves," to rephrase one of the memorable dicta of the stage-mad king, Ludwig II of Bavaria.[10]

It is important to bear in mind that the theater in one shape or another formed an almost continuous presence in their lives. Their indomitable mother, Donna Gemma, whose Genoese background is somewhat obscure, apparently was an operetta singer before her marriage to Don Evaristo. Savinio, in his haunting ruminations about his childhood, *Tragedia dell'infanzia,* devotes an entire chapter to his first visit to the theater. This exciting early experience at the Teatro Lanara, a modest Greek outdoor summer theater, indelibly associated itself with the attendant physical and mental symptoms that later also earmarked the "impurities of love." The older Giorgio undoubtedly was included in this theater treat, and it is possible that the ambiguous identity of stage and ship's deck found in a number of his Metaphysical pictures of 1915-17, such as *Hector and Andromache* (pl. 70) or *The Duo* (pl. 53), goes back at least in part to his own recollection of this theater. Apparently, it "bordered on a shipyard for sailboats and other small craft." Likewise, the fact that "behind the fence that separated the stalls from the shipyard there rose the shell of a Levantine barge"[11] may well have impressed itself upon de Chirico's mind, furnishing emblems of voyages and fortunes in time and space which later reappear in his Metaphysical pictures.

At the age of fifteen Savinio composed an opera, *Carmela,* for which, in keeping with the ideals of Wagner, he also wrote the libretto. According to de Chirico, Mascagni, the composer of *Cavalleria rusticana,* is said to have found some promise in it. Savinio continued to write the music and libretti for his "drame-ballets" and "scènes dramatiques" at least until he entered the Italian army in 1915. These activities and interests brought both brothers in touch with musical and theatrical circles in Munich, Paris, and later on, Rome. They led to consequential friendships with men like M. D. Calvocoressi (the noted music critic and former associate of Diaghilev), Alfredo Casella, Fokine, Bragaglia, Pirandello, and many others. Both brothers met their future wives in the theater, where both women were active as performers, and de Chirico blames Savinio's untimely death in 1952 on the extremely hard work that the theater exacted from his brother, especially at that moment. Indeed, the last time he saw Savinio alive was at the Teatro Communale in Florence during a rehearsal of Rossini's *Armida,* for which Savinio had designed sets and was the stage manager. In a touching passage, de Chirico records how his ailing brother

Louis Aragon and André Breton. *Here Lies Giorgio de Chirico.*
Assemblage. Whereabouts unknown
Reproduced in *La Révolution Surréaliste,*
March 15, 1928

slowly walked to the last row of the empty orchestra and sat down exhausted while the action proceeded on the stage.[12]

From the mid-1920s until their deaths de Chirico and Savinio executed major commissions for theatrical decors in Italy and abroad, but more often than not de Chirico seems to have been troubled by the results. Whether this dissatisfaction was caused by the unfortunate circumstances connected with most productions or by his ambivalence about the actual staging of his theatrical vision or both is difficult to know. His early Italian patron, Giorgio Castelfranco, said once that although de Chirico "always worked with great mental zeal for the theater, he was never happy with it…perhaps he had exhausted his taste for the theater in his Metaphysical works."[13] This question will be considered in greater detail in the concluding section of this essay.

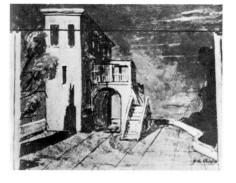

Giorgio de Chirico. Study for set, *La giara.* 1924
Oil and tempera on canvas
Private collection

Page from *Montparnasse,* December 1, 1924, with an unknown drawing for the set of *La giara*

In the autumn of 1906 when Donna Gemma and the two de Chirico boys arrived in Munich, the city was still glorying in its title of "the modern Athens on the Isar." And although Giorgio later called Munich the cradle of "two exceedingly ominous events…: modern painting and Nazism," he also records, possibly somewhat tongue-in-cheek, that at one time he thought of the city as "paradise, a paradise on earth."[14] It is small wonder that in 1906 their ambitious mother took her talented sons to Munich to further their education in the arts.

Böcklin and Nietzsche are usually cited as "the paramount influences on the young de Chirico during his years in Munich." The two influences continued to deepen and expand as the years passed, as is confirmed in word and deed by the artist himself, but the contribution of these sources to de Chirico's "theatricality" seems to have escaped notice. Thus Soby in his admirable book observes that "presumably de Chirico was especially impressed by Nietzsche's *The Birth of Tragedy,*"[15] but he and other writers have not taken account of the fact that this influential book deals with the aesthetics of the theater, namely, the deeply metaphysical Attic tragedy which Nietzsche regarded as a paradigm in man's search for knowledge and order. At the time when Nietzsche wrote *The Birth of Tragedy* he was still under the spell of Wagner and believed that the spirit of the Greek tragedies was reincarnated in Germanic form in *Tristan and Isolde* and *Lohengrin.* This last point especially would not have escaped de Chirico, who admitted in his autobiography that while in Munich he was "molto Wagneriano…[and] never missed the opportunity of hearing the music of Wagner either in the theater or in concerts."[16]

De Chirico and his brother undoubtedly longed for the real Greece of their childhood, especially while living among the smug, hellenizing Bavarians. Thus they must have been moved by Nietzsche's evocation of an ideal and distant Greek culture fashioned from the dialectic between the Dionysian and Apollonian impulses as expressed in ancient tragedy. Nietzsche had asserted "that the highest goal of tragedy and art in general is attained when the relation of the Apollonian and the Dionysian…[is] symbolized by a fraternal union of the two deities; Dionysus speaks the language of Apollo; Apollo, however, finally speaks the language of Dionysus." Nietzsche identified Dionysus with the primordial spirit of music and lyric poetry, and at bottom, like Hegel, had little use for or understanding of the contemporary visual arts, relegating them to the individualizing, Apollonian aspirations of man. Nonetheless, the philosopher allowed that in some sense every artist is an "imitator," that is to say, either an Apollonian artist in dreams, or a Dionysian artist in ecstasies, or finally — as for example in Greek tragedy — at once artist in both dreams and ecstasies.[17]

As mentioned earlier, Savinio, like many of his contemporaries, followed the path laid out by Wagner and Nietzsche, composed operas and musical melodramas, and in 1914 even signed the score of his musical ballet *Niobé* "Albert Savinio artisan dionysiaque."[18] De Chirico, perhaps fired in part by brotherly rivalry, proceeded to render the Dionysian/Apollonian musical tragedy in paint — an endeavor undertaken by a host of other visual artists before and after him. Yet it is likely that no other painter grasped Nietzsche's "theatrical" ideas more deeply than he. Indeed, it may be said that much of de Chirico's oeuvre is dedicated to an expression of what Nietzsche had called "the

metaphysical joy in the tragic [which] is a translation of the instinctive unconscious Dionysian wisdom into the language of the scene." And Nietzsche had added, "Dionysian art...seek[s] this joy not in phenomena, but behind them."[19]

The Nietzschean task that de Chirico thus set for himself was a subtle and difficult one and had to take account of the double visionary activity that Nietzsche perceived in Greek drama. Hence de Chirico's canvases depicting his Dionysian/Apollonian visions can be seen as both concrete, individualized Apollonian manifestations as well as preverbal evocations transposed into painted images of the double dream of the Dionysian artist.

The seemingly irresistible immediacy yet intangible "reality" of de Chirico's "dramas" may have received an additional impetus from Nietzsche's contention that there was no opposition in Attic tragedy between the chorus of the orchestra and the public, which "in an overabundance of contemplation" imagined itself "one of the chorus." Nietzsche thought of the chorus as "a self-mirror of Dionysian man" and the stage above as the Apollonian vision or the dream of the Dionysian man. As a result of this hypothetical identification of the spectator with the chorus, everyone, according to Nietzsche, in "the terraced structures of the theatron rising in concentric arcs [was able] to *overlook* in an actual sense the entire world of culture around him."[20]

With this in mind, it may not be too farfetched to propose that in a good many of de Chirico's early Metaphysical pictures, such as *The Soothsayer's Recompense* (pl. 15), *The Transformed Dream* (pl. 23), or *The Uncertainty of the Poet* (pl. 22), both the "overviewing" position of the spectator and his imagined immersion in a comparable dual dramatic vision are expressed, albeit not quite in so precise a way as the quotations from Nietzsche might suggest. Because of the high viewing point or other spatial manipulations, the viewer seems to hover over or exist within the pictorial field, which is divided into two realms: a prominent foreground dominated by objects evoking sensual experiences and behind them, as if limiting and guarding the enclosed domain that lies before them, other objects that appear to offer promises of or explorations into a quasi-measurable infinity. By various means the artist has imbued both realms with a strange visionary quality, which also accentuates their tacit conflict and the inherent demise that seems to be foretold by the deep, encroaching shadows. It would be naive to press the Nietzschean theatrical analogy too far, yet it seems an impoverishment of the content of these pictures not to think of it at all. Once the influence of Nietzsche is mentioned, de Chirico's two domains of man's dreams plausibly take their place as counterparts to the Dionysian and Apollonian voices that Nietzsche discerned in the tragedies of Aeschylus and Sophocles.

A year before the de Chiricos reached Munich, one of the demigods of the local art world, Arnold Böcklin, was suddenly hurled from his pedestal. This was accomplished by the critic and art historian Julius Meier-Graefe, whose *Der Fall Böcklin* appeared in 1905. This book must have seemed like a fulfillment of the Savonarolesque rage against contemporary artistic license expressed by Thomas Mann's Hieronymus, the pathetic hero of his story "Gladius Dei." Although not so moralistic or ambivalent about the values of the spirit and the flesh as Mann, Meier-Graefe would have agreed with him on the supposedly unhealthy state of art in Germany. *Der Fall Böcklin* first led to a vehement debate but soon accomplished its purpose, for little public attention was paid to Böcklin thereafter until the 1920s, when the Surrealists and the Neue Sachlichkeit artists, following the example of de Chirico, started to look again at his pictures.

It evidently took courage as well as contrariness and innocence on the part of the young de Chirico to focus his sights on the rejected hero. He did, however, find an early ally and likely cicerone to Böcklin in Max Reger, with whom his brother studied counterpoint. When not acting as interpreter for his brother, who was less fluent in German than he, de Chirico, on their visits to the composer's house, apparently pored over "a great album containing magisterial engravings that reproduced the paintings of Böcklin."[21] Thus it is not likely that de Chirico remained unaware even when in Munich of Meier-Graefe's book or of the fact that much of his case against Böcklin rested on what Meier-Graefe described as the artist's confusion of painting with theater. By this Meier-

Giorgio de Chirico. Costume for a Peasant, *La giara,* 1924
Gouache on paper
Dance Museum, Stockholm

Giorgio de Chirico. Costume for a Peasant, *La giara,* 1924
Gouache on paper
Dance Museum, Stockholm

Graefe meant the use of the canvas merely as illusionistic "stage for decor effects" in the manner of the Pre-Raphaelites, whom he despised. In cases such as these, he maintained, "the artist is the producer of...[the] scene; a regisseur who knows how to place his people and objects effectively," but "Böcklin creates poor theater, loud and vulgar," much like most of the prevalent German theatrical offerings. Almost a third of Meier-Graefe's book is devoted to Böcklin's supposedly misguided theatricality, which he saw manifested in the artist's intentions and methods and ultimately regarded as symptomatic of the condition of German art as a whole. As a result, he concludes that "der Fall Böcklin ist der Fall Deutschland."[22]

Given the extraordinarily active theatrical revival that prevailed in Europe and particularly in Munich at this moment, it is not surprising that Meier-Graefe should see Böcklin in this theatrical light. And he briefly considers how a painter might deal properly with the demands of the actual theater. He cites the decors of Vuillard, Denis, and Bonnard as promising starts, but, as might be expected, perceives no true potential in the direction taken by Böcklin.[23]

It is only in 1920 that there is written evidence of de Chirico's familiarity with the great debate that surrounded Meier-Graefe's book. De Chirico's comments and subsequently those of Savinio, however, suggest an extensive and prolonged acquaintance with the critical predicament of Böcklin. Thus the first paragraph of de Chirico's distinguished vindication of this painter declares that the "greatness" of some men is "inevitably associated with certain misunderstandings...created by false interpretations of their art."[24] In the same essay he mentions Böcklin's refusal to create sets for Wagner at Bayreuth, an event extensively discussed by Meier-Graefe and many others. De Chirico appears to have had Meier-Graefe's censure of Böcklin's theatricality in mind when in his contemporaneous essay on Klinger he discusses this artist's *Crucifixion:*

The whole picture is theatrical, but not in the way usually connected with this word. In fact, while in some artists the theatricality of the work is an element that creeps in without the intervention of the artist's will, and diminishes the aesthetic and spiritual value of the work, in this painting by Klinger the theatrical aspect is *desired* and *conscious* because only the metaphysical side has been used, and, as I mentioned, this element, rather than diminishing the spiritual power of the work, augments it.[25]

This paragraph could be read as a defense of his own pictures that appear to have evolved both in spite of and because of Meier-Graefe's "misinterpretation" of Böcklin.

Savinio, in his still later essay on Böcklin, speaks specifically of the three long essays by Louis Gillet in *La Revue de L'Art Ancien et Moderne* of 1907-08.[26] Gillet entered the Böcklin debate somewhat belatedly and had made a half-hearted attempt to redress the balance in the artist's favor. What is noteworthy besides Gillet's stress on the classicism of Böcklin, emphasized also by de Chirico, is his approval of the very tendencies that Meier-Graefe had denounced as "theatrical." These tendencies both authors found summed up in the painter's famous declaration that the purpose of art was "Not to see but to think." The German critic ridiculed this view by citing additional comparable statements by Böcklin, such as "A picture should tell something and make the spectator think and move him like a piece of music."[27] Gillet, on the other hand, discovered in Böcklin's dictum a welcome "reclamation of the painter's right to think and feel and to speak in painting."[28] To him Böcklin's paintings represented a "poetics." He granted that such a "literary" view of his art expressed "the most serious reproach made against...[it] nowadays," but for Gillet it was a much-needed counterpoise to the monopoly of "the plastic sense." Gillet maintained that

this sixth sense has forgotten the five others and the soul itself. The essential error of this concept is its lack of aliveness; it is a theory of intellectuals and analysts, a theory of tired mandarins who amuse themselves with the play of forms and find pleasure in the representation of things that the things themselves no longer give them...People will never understand that the sign cannot detach itself from the object signified. Primitive paintings started by being a hieroglyphic system, a veritable writing, and something from this background has always remained [in art].[29]

Giorgio de Chirico. Cover of piano transcription of score for *La giara* by Alfredo Casella, published 1925 Universal Edition, Vienna

De Chirico's Metaphysical art certainly evolved from such a view—with or without his knowledge of Gillet—but one wonders whether Gillet would have been willing to follow the artist all the way.

While in Munich and partaking of its many theatrical offerings, the de Chiricos could not have missed the activities of Georg Fuchs. Fuchs was the founder and director of the Munich Künstlertheater, which was erected as an integral part of the ambitious local Arts and Crafts Exposition of 1908. It stood on the fairgrounds adjacent to the Theresienwiese. Fuchs was one of the most vocal and dynamic spokesmen of the German theatrical reform movement. His achievements represented in a sense the culmination of some of the various theatrical, architectural, artistic, and nationalistic ideals enunciated or put into practice from Goethe to Schinkel, Wagner, Nietzsche, and especially Behrens.[30] They also took into account foreign theatrical experiments such as those of Antoine, Lugné-Poë, Appia, Craig, and others. In a more local sense the efforts of Fuchs were a realization of the aims of the Munich Symbolists and Secessionists, who searched for "a synthetic art form and significant expressive means."[31]

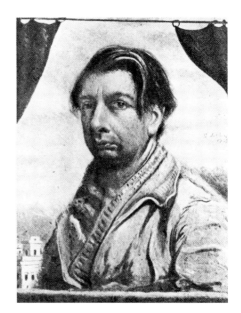

Giorgio de Chirico. *Self-Portrait.* 1925
Galleria Nazionale d'Arte Moderna
e Contemporanea, Rome

Besides laboring at the Künstlertheater, Fuchs was a tireless pamphleteer, and his forceful little book *Die Schaubühne der Zukunft* was a first statement of his ideals. It appeared in 1905, a short while after Meier-Graefe's *Der Fall Böcklin,* which is acknowledged in a footnote as a sign that "views and demands [like those of Fuchs] are very much in the air"[32]—a comment that is also apposite to our attempt at fleshing out the background of de Chirico's Munich years.

Among the ideas and practices of Fuchs that seem pertinent to this discussion the following might be cited: (1) He advocated an extremely simple, wide, and relatively shallow stage with a permanently closed back that accentuated its planar, relieflike aspect, in deliberate opposition to the deep, perspectival illusionism of the "realistic" *Guckkasten* (peephole) stage. The stage was divided into three stepped-up parts, of which the forestage, the deepest of the three, projected considerably into the auditorium—so as to bring the drama closer to the spectator. (2) Fuchs placed particular emphasis on light and its management, and therein lay possibly his most significant contribution. The forestage and midstage were to be lit from above, when feasible by the daylight that streamed through the glass roof of the auditorium. The backstage, which could be lowered or raised, was lit from below; unwanted shadows could thus be canceled. As a result of such variable illumination and the flexibility of the stage—it could also be narrowed by movable screens—extraordinary nonnaturalistic and mysterious spatial effects could be achieved. Infinity could be suggested through the "dematerialization of the physical presence," and by "means of relations between light and mass any physical or psychological environment…[could be] created."[33] At the same time, the desired planar, compressed, and architecturally ordained stage was preserved. (3) Fuchs stressed especially the architectural or structural integrity and unity of the Künstlertheater; this idea embraced the entire theater building, the stage and the production, the last of which Fuchs regarded as a "rhythmische Gesamtarchitektur." Visual prototypes for the scenery, what little there was to be, and the production itself were seen in the planar, architecturally conceived pictures of von Marées, of Puvis de Chavannes, and of *trecento* and *quattrocento* artists. In the spirit of Meier-Graefe but with much greater conviction, Fuchs predicted that painting as "the true art of the coloristically and graphically animated plane will again receive a place of honor on the stage." (4) Finally, Fuchs considered the drama to be a fundamentally "silent, unarrestable rhythmic movement," and therefore granted an important place to dance and pantomime in its execution. Understandably, the marionette theater with its obedient, typologized puppets was viewed as a helpful antidote to the self-centered individualism of most contemporary actors. At the same time, Fuchs also envisioned grand syntheses of all the arts that were to achieve cohesiveness through the underlying "rhythmic movement" that was the basis of drama.[34]

Alberto Savinio. *Oracle*
Private collection

It seems scarcely necessary to point in detail to the uncanny parallels between Fuchs's theater and a great many aspects of de Chirico's early Metaphysical pictures. A

Cover of *Rivista di Firenze,* May 1925, with a sketch for de Chirico's set for *La morte di Niobe* by Alberto Savinio

Giorgio de Chirico. Page from program for *La giara,* 1929

number of these have already been discussed in the context of Nietzsche. The actual productions at the Künstlertheater, some of which de Chirico could have witnessed, may have provided plastic images to be stored with other stimuli in his infallible memory. Such recollections from Munich seemingly retained their force through his two-year stay in Italy,[35] 1909-11, and into his Paris sojourn, contributing to the particular vision that crystallized into the early Metaphysical pictures we now know.

As we noted earlier, most of these pictures appear to extend into the spectator's space, and their background is clearly delimited, usually with a wall and/or large, centrally placed architectural piece. These interact visually and contextually with a solid, yet strangely luminous sky, thus seemingly conforming to Fuchs's demands for a shallow, structural scenic effect. The planar quality of de Chirico's canvases is reinforced by the large, dryly painted surfaces found in many pictures. This counteracts the illusion of mass that shadings and deep shadows tend to assert. That light is one of the chief dramatic forces in de Chirico's pictures hardly needs to be mentioned. Just as Fuchs explored the novel effects that could be achieved with the new electric stage illumination with and without the help of daylight, so de Chirico creates a heightened sense of luminosity that seemingly prolongs an unforgettable moment into the eternity of human drama. Like Fuchs, as well as Appia and Craig, de Chirico betrays some of his Jugendstil sources; for example, the angular linear patterns created in his pictures by the sharply contrasted light and dark areas and slanting objects are as much an outgrowth of the linear structure of the designs of artists like Behrens as of the modernism of the Cubists, Futurists, and Matisse. Lastly, one wonders whether the drastically varied formats of de Chirico's early paintings that contain partial views of "scenes" and some close-ups — for instance, *The Transformed Dream* (pl. 23) and *The Silent Statue* (pl. 18) — do not refer back to the heightened, reduced, or partial stages of the Künstlertheater on which the action could be shifted forward, backward, to the sides, or upward. This particular aspect of de Chirico's pictures may also have received some suggestions from the cinema, as will be seen.

Among other types of theatrical entertainment that attracted the attention of the youthful avant-garde at the turn of the century was the ancient shadow-theater. This art form undoubtedly had come back into fashion at the turn of the century because of its ethnic and technical variants and because of its kinship to the marionette theater and early cinematic experiments. The insubstantial character types and objects that function within the magical realm of the light screen used by the shadow theater must have appealed as much to de Chirico as to a good many other artists who followed the antinaturalistic paths of the Symbolists and post-Symbolists. In his *Portrait of Guillaume Apollinaire* (pl. 41) we seem to be looking at a shadow or cinema screen, and the monumental silhouette that hovers at its edge appears to be perforated like a shadow-theater figure, albeit partly in a highly enigmatic fashion that has often been remarked upon.[36] The penetrating incisiveness of this image combined with its imponderable irreality brings to mind the comment by the eighteenth-century physiognomist Lavater, who considered the related scissor-cut silhouettes or "the shadow picture of a man...the most feeble, emptiest...truest and...most faithful picture...of a man. For it is nothing positive, it is only negative...[it is] the direct print of nature."[37] Such a "proto-Metaphysical" definition of shadow images might have been acceptable to de Chirico, who would have extended it to the mordant shadows of his inanimate objects if not to his entire pictures.

In 1907 Alexander von Bernus opened a shadow theater in Munich. It was held in such high esteem by the local literary and artistic vanguard that it was made a part of the comprehensive Arts and Crafts Exposition in Munich of 1908.[38] De Chirico may have visited it, as well as Parisian shadow theaters such as Paul Vieillard's renowned Théâtre Noir et Blanc. Founded in 1910, it was one of the many imitators of Le Chat Noir, the most celebrated older shadow theater in Paris, which had ceased to function in 1897. Also, Greece had a venerable and popular shadow-theater tradition of its own that must not be forgotten. It had evolved from the imported Turkish shadow-theater, which, in turn was rooted in the much older Far Eastern sources of this art. The Greek shadow-theater, like its Turkish parent, always centered on the chief humorous character, Karagöz, meaning

Black Eye.[39] Karagöz was always distinguished by a heavily outlined, disproportionately large eye with a big black pupil that gave him a faintly Byzantine appearance. One is tempted to see a reminiscence of the eye of Karagöz in a number of Metaphysical still lifes like *Greetings of a Distant Friend* (pl. 58) or *The Jewish Angel* (pl. 59), which probably are portraits.[40] In these works the eye has become a quasi-occult sign that, like most of de Chirico's iconography, rests on a collage of ancient and modern sources.

Shadows themselves played an important role in popular Greek superstitions down to modern times and thus could very well have reinforced the personal, theatrical, literary, and artistic associations that informed their use by de Chirico. Thus in the section devoted to "The Soul as Shadow and Reflection" in the third volume of Frazer's *The Golden Bough,* we are told that especially in Greece great powers are attributed to the shadow cast by a man and that correspondences between its size and the health and strength of the person casting it are noted. It was also common practice for Greek builders to bury the measure of the shadow of an unwitting passerby into the foundation of a new building to make it strong and lasting. The man whose shadow was thus captured was believed to die within a year.[41] The large and occasionally melancholy shadows cast by people and objects in de Chirico's early Metaphysical pictures appear to communicate something of the mysterious chain of sacrificial energy that the naive Greek builder sought to enshrine in his own handiwork. Such Greek superstitions associated with shadows lend additional force to the artist's oft-quoted pronouncement made before 1915: "There are more enigmas in the shadow of a man who walks in the sun than in all the religions of the past, present, and future."[42]

We have no indication until 1923 that de Chirico was familiar with Frazer's work; in that year he is said to have read Frazer's *Sur les traces de Pausanias* with much interest.[43] But the highly literate de Chirico brothers were not likely to have remained unacquainted until then with Frazer's *Golden Bough,* which had become a source book for cultivated minds of their generation.[44] If no one else, their knowledgeable friend Calvocoressi, who was active as music critic for several London papers, would have drawn their attention to this monumental work. In 1913, or perhaps before, Calvocoressi and Savinio had begun to collaborate on a number of "drame-ballets," of which one, *Le Trésor de Rampsénit,* was based on an ancient Egyptian tale recounted by Gaston Maspero.[45] This nineteenth-century "giant of Egyptology" is frequently quoted by Frazer, especially in the section of *The Golden Bough* entitled "The Soul as Mannikin," in which the Egyptian idea of the Ka, or "the soul as double," is discussed.[46] Obviously, de Chirico's mannequins as well as the entire substance of his early Metaphysical pictures can be regarded as Ka-like doubles. This is confirmed in a little-known essay by de Chirico of 1918 on "Metaphysical Art and Occult Science," in which he speaks of the Ka as an index to the metaphysical solidification of the ineffable, which is art.[47]

After the de Chirico brothers had settled in Paris and joined Apollinaire's circle, they were exposed to the enthusiasm for the cinema that was shared by many members of the group. As has often been noted, this interest appears to have left traces in the literary and artistic creations of this and other vanguard groups, although there is no doubt that the ideals of poetry and art affected the early cinema in turn.

Reference has already been made to some cinemalike effects in de Chirico's pictures. If nothing else, the technical usages and astounding content of early trick and detective films must have assisted de Chirico's pursuit of totally imaginary, provocative configurations for his rendition of the drama of the human mind. Cinematic close-ups, multiple exposures, shifts of viewpoint, cutting—provoking spatial and temporal discontinuity, suggestion of flux, animation of the inanimate, simultaneous assertion and denial of the third dimension—were undoubtedly of much interest to him.[48] These were probably among the visual sources for paintings like *The Anxious Journey* (pl. 25), *The Torment of the Poet, Evil Genius of a King* (pl. 47), *Endless Voyage* (pl. 43), *Portrait of Guillaume Apollinaire* (pl. 41), *Double Dream of Spring* (pl. 54), and many others.

In the *Portrait of Apollinaire* one suspects a semihumorous reference to Fantômas, the phantomlike personage in the popular mystery stories by that name which were

Giorgio de Chirico. Study for Backdrop for Scene I, *Le Bal,* 1929
Pencil and gouache collage on paper
Wadsworth Atheneum, Hartford

Le Bal, Scene I, 1929
Actual set with dancers

De Chirico at work on backdrop for Scene I, *Le Bal,* with Russian painter Kockokine

Giorgio de Chirico. Costume for the Woman
in the Italian Entrée, *Le Bal*
(worn by Eugénie Lipkovska)
Pencil, watercolor, and gouache on paper
Wadsworth Atheneum, Hartford

Giorgio de Chirico. Costume for the Young
Woman, *Le Bal*
(worn by Alexandra Danilova)
Pencil, watercolor, and gouache collage
on paper
Wadsworth Atheneum, Hartford

subsequently filmed and which Apollinaire praised as "one of the richest, most imagina-
tive works ever produced."[49] The black silhouette resembling Apollinaire, which appears
above on the screen in de Chirico's painting, may thus be an evocation of Fantômas
himself, that "Master of Shock,…King of Terror, King of Crime…above all and above
everything." In the mysteries he is always paired with his antagonist, Police Inspector Juve,
who, together with his "sempiternel journalist at his side," forms something like his
recording alter ego. De Chirico seems to have conflated Juve and the journalist into the
seerlike blind Apollo-Homer, whose pale, stony bust below appears to ward off the
would-be audience from indulging in the imaginative excesses on the screen. These
black, insubstantial images could be read as the Dionysian ecstasies of Inspector Juve/Apollo,
and the picture as a whole as an embodiment of the dialectics of artistic creation. This by
way of a Nietzschean interpretation of this perplexing work!

The July-August 1914 issue of Apollinaire's *Les Soirées de Paris,* which carried
Savinio's partial text for "Les Chants de la mi-mort," also printed the declaration by its film
critic, Maurice Raynal, that a Fantômas film "est du meilleur Hugo, et c'est trop beau,
vraiment!" And Max Jacob was represented in the same issue with a poem published "on
behalf of the 'S.A.F.'" (Société des Amis de Fantômas),[50] which indicates the intensity of
the Fantômas cult in Apollinaire's circle.

Some two years earlier, another Parisian writer, Riciotto Canudo, had perceived the
artistic potential of the cinema and announced prophetically, "Today the 'moving circle'
of aesthetics finally closes triumphantly in this total fusion of the arts called Cinematogra-
phy."[51] This Francophile Italian poet and purveyor of the sentiments of the avant-garde
then lacked both the practical and theoretical framework for such an updated version of
the *Gesamtkunstwerk,* but he may have been familiar with Kandinsky's stage efforts that
pointed in such a direction and were to have included cinematic projections. Between
1912 and 1914 the art and thought of Kandinsky came to be viewed with increasing
sympathy and understanding by the Parisian vanguard, most notably by Apollinaire and
his friends.[52] And because of their knowledge of German, the de Chiricos could have read
the scenario for *Der gelbe Klang* (The Yellow Sound) and Kandinsky's theoretical exegesis
"On Stage Composition," both published in the Blaue Reiter almanac of 1912. It may
therefore be worth while to consider briefly some of the implicit parallels between the
theatrical endeavors of Kandinsky and the de Chiricos.

To be sure, Kandinsky's vision of a post-Wagnerian *Gesamtkunstwerk* was a
trans-European dream, and his Christian, utopian, and ultimately nonobjective artistic
ideal is diametrically opposed to the pessimistic atheism and basically representational
classicism that inform the work of the de Chiricos. But all three wished to plumb
unsullied spiritual depths by means of mystical, occult paths that originated to a consid-
erable extent in the cultural milieu of Munich. As Weiss and Long have pointed out,
Kandinsky's synthetic theatrical aims embodied in *Der gelbe Klang* received many
leading suggestions from the Munich Symbolist group and from the work of Georg
Fuchs. And an analogous theatrical synthesis forms the basis of Kandinsky's increasingly
nonobjective paintings of the pre–World War I years.[53] In the foregoing pages it has been
argued that de Chirico's Metaphysical pictures also embody such a theatrical synthesis,
which Savinio transformed into actual performances, particularly after his arrival in Paris
when Apollinaire looked over his shoulder as well.

An indication that Savinio was aware of the content of the Blaue Reiter almanac, and
especially of Kandinsky's and Schönberg's essays on the relation between the various
media, is found in his own first theoretical statement, "Le Drame et la musique," which
appeared in *Les Soirées de Paris* in April 1914. After dismissing the endeavors "of certain
very advanced musicians of the Viennese school" as half-hearted, because their
"production…consists above all of *songs* written to words" (songs by Schönberg, Berg,
and Webern were printed in the almanac), Savinio declares, much like Schönberg and
Kandinsky, that the association of music and drama must be conceived as a "a completely
disinterested rapprochement." Otherwise, Savinio argues, the inherent capacity of music
to express "drama and human psychology" would be greatly reduced. In other words,

music must not be forced to "translate states of mind or represent actions and phenomena." Savinio's "metaphysical artist"—the term appears to be used for the first time in this essay—thus submits his art not "to the metaphysical influence arising from a phenomenon that is external and foreign to him, but submits himself to the material fashioned from his art and its personal metaphysical influence." Such a creative process is comparable in many ways to what Kandinsky had described as "the inner necessity...[or] the only source" for artistic creation.[54]

Savinio's music for his "Les Chants de la mi-mort" certainly was conceived in this spirit. The extravagantly percussive piano reading of the score, which accentuated the "total absence of all polyphony, the greatest indifference to all harmonic pursuits,"[55] was graphically reported by Apollinaire and Soffici, and bespeaks the literalness with which he adhered to the quest for musical autonomy. Savinio's accompanying scenario-poem likewise holds its own as a piece of literature. Significantly, its generalized human types, like the Yellow Man, the Bald Man, the black men, and the symbolical yellow flowers, appear to echo Kandinsky's unspecified, coloristically individuated beings, such as "yellow giant," "man in black," and "*huge* yellow flower," all of which have common roots in Symbolist literature and art. But whereas Savinio the musician underscored the efficacy of music as "emanation of a real metaphysics," both de Chirico and Kandinsky expressed doubts as to its usefulness as metaphysical vehicle.[56] These doubts reveal not only their own personal ambivalence about music, which they both loved, but also the then prevalent unwillingness on the part of painters to continue to subscribe to the Symbolist subordination of the visual arts to music.

The de Chiricos' contribution to a collaborative multimedia stage effort, which only recently came to light again, is noteworthy because in a sense it represents a mundane French proto-Dada counterpart to Kandinsky's otherworldly *Der gelbe Klang*. Entitled "A quelle heure un train partira-t-il pour Paris?," this unproduced, unpublished pantomime drama was conceived during "the dogdays of 1914." Its scenario was written by Apollinaire and based on his poem "Le Musicien de Saint-Merry," published in February of that year. Savinio was to have composed the music, and Picabia and de Zayas were to have been in charge of the sets and of production, respectively. This "teatralità," as Savinio called it, was to have "plastered [intonacato] five of the most conspicuous cities in the U.S.A."[57]

Although de Chirico was not an active participant in this venture, his own as well as his brother's theatrical visions left a strong mark on the pantomime, as is clearly brought out in the extant scenario. The very title, a line taken from Apollinaire's poem, refers to de Chirico's steam-emitting trains, most of which seem blocked and unable to move. The tableaux themselves rely heavily on the appearance and mood of de Chirico's pictures of 1913–14, suggesting that Apollinaire grasped instinctively the "theatrical" force of his art.[58] Among the most conspicuous elements drawn from de Chirico are the ominous sign with a black hand, Ariadne, factory chimneys, a fountain, clock, bananas. The pantomime starts with an eerie projection of moving black silhouettes that are reminiscent of the shadow theater and Fantômas. In fact, the entire first scene, in which the Poet is located "on the side," "between the footlights and the screen," is astoundingly close to de Chirico's *Portrait of Guillaume Apollinaire* (pl. 41), on which the artist may well have been working at this time.

Bohn has attempted a careful reconstruction of the creative interchanges between Apollinaire, de Chirico, and Savinio during the years of their friendship and has provided some convincing examples of their mutual give-and-take.[59] Thus he has observed the indebtedness of Savinio's main character, the Bald Man (also called the Man without a Face), to Apollinaire's protagonist in "Le Musicien de Saint-Merry," whose description as "a man without eyes, nose, and ears" Savinio took over literally. Bohn also suggests that this personage became the prototype for de Chirico's later mannequins. Although such a direct line of descent is very likely, it should be added that a number of other sources were combined in these dehumanized personages as well: the sculpture of Boccioni, Brancusi, knights in armor, Marinetti's hero Mafarka, Diaghilev's dancers clad in tights, dressmakers' dummies, and possibly Kandinsky's mute figures. De Chirico's Ariadnes, on

Giorgio de Chirico. Costume for the Young Man, *Le Bal*
(worn by Anton Dolin)
Pencil, watercolor, and gouache on paper
Wadsworth Atheneum, Hartford

Giorgio de Chirico. Costume for the Astrologer, Masked, *Le Bal*
(worn by André Bobrow)
Pencil, watercolor, and gouache collage on paper
Wadsworth Atheneum, Hartford

Giorgio de Chirico. Man's Costume, *Le Bal*
Pencil and watercolor on paper
Wadsworth Atheneum, Hartford

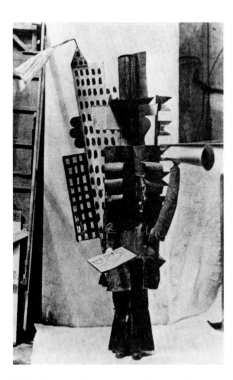

Pablo Picasso. Costume for Manager from
New York, *Parade*. 1917
Old photograph

the other hand, formed the literal inspiration for her appearance in Apollinaire's poem and pantomime, and Bohn persuasively suggests that she represented a shared allusion to the dual nature of man's strivings.

More central to our discussion is the fact that in the pantomime the nostalgic, desperate mood of Savinio's "Les Chants de la mi-mort" prevails over the triumphant Dionysiac revels of "Le Musicien de Saint-Merry." Thus the self-annihilating course proclaimed in the poem and then by the anonymous voice in the first scene of the pantomime, "I sing the joy of erring, and the pleasure of dying from it," is actually achieved when the "automatic Sovereign," presumably the double of the poet, shoots himself. Probably the reality of the war and the more cynical pessimism of the two de Chiricos dampened the buoyant optimism of Apollinaire and brought "A quelle heure un train partira-t-il pour Paris?" in line with the sacrificial spirit of Kandinsky's stage piece. We shall probably never know what the de Chiricos thought of Kandinsky, but we have evidence that the theater was both the actual and hypothetical domain in which their respective dramas of man's fate unfold.

In conclusion, let us note de Chirico's participation in actual productions, so as to round out this discussion of his "theatrical" art and call attention to an extensive but largely unknown aspect of his oeuvre. Between 1924 and 1970 de Chirico had a hand in at least twenty-three productions, all but two of which took place before 1962, when the enlarged edition of his autobiography was published.[60] Surprisingly, the artist mentions only six productions, of which four occurred after World War II, even though the larger portion of his theatrical work preceded it. Because there never seem to be simple explanations for any of de Chirico's actions, one naturally looks for reasons that would justify the lack of emphasis on this aspect of his work, and particularly the total omission of his first productions, *La giara* (The Jar) and *La morte di Niobe* (Death of Niobe) of 1924 and 1925, respectively.

It is likely that de Chirico's silence regarding his initial theatrical ventures was dictated by a desire for discretion about efforts in which his first wife, the dancer Raïssa Lork, was associated.[61] More generally, the bitter recollections of the Surrealists' cruel censure of his participation in what they considered bourgeois amusements may also have been a strong factor in his seeming indifference to this side of his art.[62] Yet it is still more probable that a deep ambivalence regarding the transformation of a private and highly personal theatrical vision into a collaborative, public, and largely commercial vehicle was at the heart of his hesitancy to recount this use of his talents more fully. To be sure, one side of de Chirico was never opposed to achieving financial as well as personal success. However, de Chirico the artist seems always to have known that his best and most profound efforts arose from what might be described as creative modesty and spiritual innocence or detachment from fashion, which more often than not were at odds with the extroverted showmanship of an actual performance. There are some indications that such an attitude prevailed, but it is hoped that further research will unearth more precise records of his views about the nearly two dozen productions on which he worked.

On the whole, de Chirico's decors, like those of other modern artists called upon to collaborate in performances, share the chief characteristics of his roughly contemporaneous paintings, and frequently ideas developed in the theater are carried over into pictures. De Chirico's sets, however, are not only visually appealing, but are distinguished by an acute sense of the theater, as might be expected. The best of his decors truly distill the total spirit of the piece into visual form and greatly unify the production. These qualities are frequently lacking in the scenographic work of many of his peers, who often produced only enlargements of their easel pictures without much knowledge of the stage or concern whether their decors would work.[63] In the case of de Chirico one notes a strengthening, over the years, of this "stageability," which reached a first climax in the decors for Diaghilev's ballet *Le Bal* (The Ball) of 1929 and the opera *I Puritani* (The Puritans), produced in 1933 by the first Florentine Maggio Musicale. Undoubtedly his musicality assisted him in his stage tasks, which testify to the enduring Nietzschean

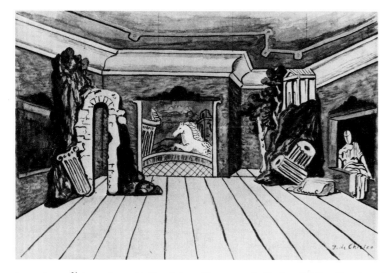 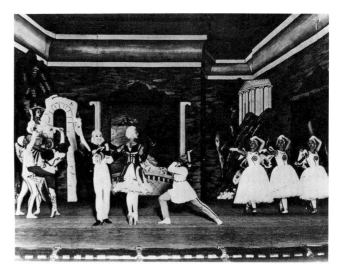

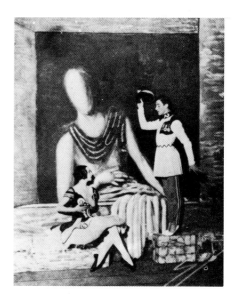

impetus of his entire artistic vision. Because *Le Bal* and *I Puritani* set the standard for the rest of de Chirico's decors, my comments will be confined to them and the ones that preceded them.

Alfredo Casella, the composer of the score for the ballet *La giara*, in his autobiography gives a short account of how this production came into being.[64] Rolf de Maré, the enterprising and wealthy director of Les Ballets Suédois, wished to stage an Italian folkloric ballet in an attempt to outdo Diaghilev's highly acclaimed *Le Tricorne* of 1919. This ballet had a Spanish theme, music by de Falla, and sets by Picasso. Erik Satie, who was then collaborating with de Maré, had called his attention to the up-and-coming Casella, who in turn suggested Pirandello and de Chirico. Pirandello adapted the plot for *La giara* from his older short story of the same title.[65] This story, which is set in Sicily, tells of an old hunchbacked potter who gets trapped in a huge earthenware oil jug that he has just mended. The avaricious landowner to whom the jar belongs will not break the vessel to free the old man without compensation by him. The kindhearted daughter of the landowner takes pity on the artisan and outwits her father by inciting the local folk to noisy revels that awaken him in the middle of the night. In his anger he kicks the jar; it breaks and the potter is freed.

One can well imagine de Chirico's interest in this terse, ironic tale. Its Sicilian background, which was also his own on his father's side, and, more important, its deliberate Italianism, were in line with his own direction and that of the *Valori Plastici* milieu of which he had been one of the leaders since the war. And the liberation of the courageous old artisan from the broken vessel must have reiterated his commitment to the revitalization of the Mediterranean tradition, which needed to be delivered from exploitation by its greedy and thoughtless possessors.

De Chirico's stark and simple set is complemented by distinctly Sicilian but completely theatrical costumes. The severe red farmhouse with its lofty staircase that dominates the scene stands above a broad, light sandy ground and beneath an intense blue sky, both of which highlight the huge actual jar, the vital focal point of the ballet. De Chirico's strong clear colors create a sense of spaciousness and planarity that bespeak a classical order indicative of his renewed admiration for Poussin and Claude.[66] These masters seem, however, to have been filtered through the eyes of Böcklin, as well as Carrà's attenuated revisitation of early Italian Renaissance art.

According to Casella, de Chirico's "decor…was not realized as well as it merited," nor, for that matter, did the choreography of Börlin, the principal dancer of the Swedish Ballets, "accentuate the intrepid, almost 'electrifying' side of the music."[67] It is noteworthy that in Casella's letter of instructions for the performance, the composer urged de Maré to be sure to bear in mind that "Sicily is a country with somber manners, superstitious, tragic, even in its joyous manifestations, and that the total life of the country is always weighed down by an atmosphere of fatality and anguish."[68] It surely is more than

Giorgio de Chirico. Study for backdrop for Scene II, *Le Bal*. 1929
Pencil and watercolor collage on paper
Wadsworth Atheneum, Hartford

Le Bal, Scene II
Actual set with dancers. 1929
Old photograph

Le Bal, Scene II
Danilova and Dolin, 1929
Old photograph

Le Bal, Scene II
Serge Lifar, 1929
Photograph with dedication to de Chirico

Giorgio de Chirico. *The Archaeologists.* 1927
Private collection

accidental that these observations expressed not only the essence of Pirandello's writings, but also of de Chirico's art. For the painter's spare set does indeed suggest the perplexing tensions of ancient drama that the more showy music also sought to convey.

The first performance took place on November 19, 1924. Most of the critical honors went to Casella, although de Chirico received a few accolades as well. One gathers from the publicity and the reviews that de Chirico was kept very much in the background of the enterprise. The artist may well have chosen to avoid the public limelight, especially as the dancing did not transcend the exotically pleasing, thereby missing the point of the plot and the set. *La giara* also suffered from being mounted at the same time as Picabia's *Relâche,* which was surrounded by enormous notoriety even before its premiere and, as is well known, gave the coup de grace to the Swedish Ballets.

De Chirico was evidently haunted by the irreal reality of this ballet, as is brought out in his *Self-Portrait* of 1925, in which he is enframed by the stage curtains that are also used in the painted setting of *La giara.* This type of curtain harks back to older and simpler stages; it was also present in his own *Enigma of the Oracle* (pl. 6) of 1910, as well as in a little-known drawing of 1908-09 by his brother. In all of these pictures, as in *La giara,* these curtains suggest multiple visions. Thus in *La giara,* after the heavy stage curtains are parted and the performers are seen on the stage, the painted yellow curtain reminds the spectator of the artifice of the artistic vision that he perceives. And the artistic vision performed on the stage embodies a quasi-Nietzschean dialogue between Dionysian and Apollonian dreams expressed by the wild carousal of the populace and the calm, calculated acts of the potter. In the *Self-Portrait* the artist sems to exist on the spectator's stage and within the space of the painted artifice. His bold sculptural presence is challenged by the enframing curtains and sky above and parapet below, which accentuate his apparitional effect.

Between *La giara* and *Le Bal* of 1929 de Chirico created at least one more decor, that of *La morte di Niobe.* The music and scenario for this "tragedia mimica" were composed by his brother, who had started on the work before the war. The pantomime was produced on May 14, 1925, in Rome under the auspices of Pirandello's Teatro d'Arte, and the future wives of both de Chirico and Savinio performed in it.[69] At present only one study for the set is known, and the details of the original production are just in the process of being reassembled.[70] The ominously expectant mood of de Chirico's study evidently embraces a number of ingredients of his prewar and postwar Metaphysical pictures, such as *The Enigma of an Autumn Afternoon* (pl. 4) of 1910 or *The Departure of the Argonauts* of c. 1920, all of which bring the planar stage of Georg Fuchs to mind. Of special interest in this first explicit collaboration between the two de Chiricos is the further affirmation of their continuing artistic give-and-take, which is indicated in the pantomime by the suggested transformation of sculpture into humans and vice versa. Such metamorphoses had been incorporated into Savinio's "Les Chants de la mi-mort" of 1914 and his "Drame de l'après-midi entre deux saisons" of 1916,[71] and form, of course, a central element in de Chirico's pictures with painted sculpture and mannequins. In Savinio's *Niobe* this interchangeability alludes to the perennial human dreams and the attendant sufferings, the causes of which elude comprehension. Thus in the pantomime the sculptures of Apollo and Diana step from their pedestals and for no apparent reason kill Niobe's children. With the joy of her life gone, Niobe is petrified into a monument to enduring pain that encompasses all mothers and the Italy of the Risorgimento.

In de Chirico's decor for *Le Bal* the animation of sculpture and even architecture becomes the unifying element of the ballet. In 1924 in the joint program for *La giara* and *Relâche,* which Picabia had designed, de Chirico was quoted as saying that "once the ballet is freed completely from a certain aestheticism still corrupting it and has enriched itself with new elements, it will, together with the cinema, replace the prose theater and the opera, which are slowly disappearing."[72] Unquestionably, this comment was inspired by the iconoclasm of *Relâche,* which combined choreography with film and an active, luminous set, but de Chirico's contribution to *Le Bal* may well embody his own version of the kind of theater he had in mind.

Boris Kochno, Diaghilev's literate aide-de-camp, wrote the scenario for *Le Bal,* which he based on a story by Count Vladimir Sologub. The facile Rieti composed the music, and Balanchine, the talented new recruit to Les Ballets Russes, created the choreography. The romantic plot of the ballet seems to have struck de Chirico's fancy. At an elegant ball a young man is struck by the beauty of a young woman who is accompanied by an old astrologer. She disappears, and when they meet again she is wearing a mask. The young man begs her to remove her mask; when she does, he is shocked to see a wrinkled old face. The woman now pursues the young man. The ball ends, and just as he is about to leave he encounters the masked woman and her companion once more. She takes off her mask and the wrinkled old face reappears; but then she removes a second mask and turns once again into a beautiful young woman. At the same time, the old astrologer is transformed into a handsome youth. The young man faints and is carried off.

De Chirico made the most of this story and used it to depict various kinds of reality that exist beneath the surface of appearances. Thus for the first scene, which represents the opening of the ball, he painted a drop curtain showing the stony front of a large palace decorated with huge reliefs of two very animated male nudes, one dancing, the other playing the cymbals. Their seeming aliveness is complemented in the second scene by the costumes of the beautiful woman and the other characters (save the Young Man and the Astrologer), which structurally identify their bodies with details or parts of classical architecture. This interdependence between man-made environment or human action and man's external appearance testifies also to their shared and ineradicable past and present.

The idea of identifying the architectural environment with man in a dancing costume had a recent and spectacular precedent in Picasso's Managers from the ballet *Parade,* which Diaghilev produced in 1917,[73] but de Chirico inverted the metaphor: Picasso's characters were transformed into monstrous, threatening urban structures, whereas his own were "dignified" by the absorption of their constructs into their own human form. Yet de Chirico also includes a subtle note of loss; for not only do some classical fragments appear to have lost their meaning, but in one of the leading dancers they are actually replaced or supported by the smokestacklike arms and legs that attest to the rise and fall of civilizations. Only the Astrologer and the Young Man wore costumes without architectural elements. The coat of the first, however, was covered with the insignia of the heavens, thus suggesting a transcendent spatiotemporal architecture, and his face seems to have been given the look of Chronos. And the Young Man was clad in an ironically stylish officer's uniform with an enormous appliqué of medals on his chest, which he sported like supporting talismans or naive promises of immortality.

The set for the second scene represented a seemingly confined room with a low

Giorgio de Chirico. Study for set of *I Puritani,* Scene I. 1933
Watercolor on paper
Galleria Ferretti, Viareggio

Giorgio de Chirico. Study for set of *I Puritani,* Scene V, Armor Hall. 1933
Watercolor on paper
Galleria Ferretti, Viareggio

Giorgio de Chirico. Costume for Elvira,
I Puritani. 1933
Watercolor on paper
Galleria Ferretti, Viareggio

Giorgio de Chirico. Costume for Sir Bruno
Roberton, *I Puritani.* 1933
Watercolor on paper
Galleria Ferretti, Viareggio

ceiling, a decklike floor, and a rectangular protrusion at the far end. But the solid walls of this chamber had apparently yielded to all kinds of invading visions that bring to mind the interpenetrating events described in de Chirico's *Hebdomeros* or his interiors like the Archaeologist series of the mid-1920s. The extraordinary openings and deposits that appear to have violated the integrity of the closed chamber extended into distant historical and mythical realms. The resultant "presences" that took the form of cinemalike images and three-dimensional assemblages expressed artistic dreams, such as the splendid leaping Pegasus behind the opening in back, or the shipwrecked residues of architectural ideals, or a giant faceless father-figure that benignly observed the foolish progress enacted below.

The brilliant colors of the decor greatly contributed to its memorable effect. Its creams, whites, and light reds achieved a luminous transparency that undoubtedly strengthened the hallucinatory quality of the plot, and the willful choreography collaborated in achieving a sense of magic. Most of the spectators missed the "poetic…mysterious and unearthly character" of the ballet and saw it merely as a divertissement, as Kochno recalled.[74] The redoubtable Parisian dance critic and historian André Levinson grasped at least some of the ingenious depth of de Chirico's contribution: He wrote in *Comoedia:*

> The art of this Italian painter, whom some partisans have greeted…as the leader of a Latin reaction…[is] a deliberate and cerebral art which is above all an operation of the intelligence. No haze shades the dried surface of his canvases, where allegory is substituted for direct vision. In his spaces where the air appears to have been pumped out and all organic life banished, this calculator arranges at will architectural elements and classical sculpture, fluted column shafts, moldings, lurid Pegasuses with chalky manes that keep company with leather-headed mannequins. How to put in motion all the "pure spirits" cast in plaster?…The scene designer imagines the clever subterfuge of a costume ball which has architecture as the subject. This allows the personages to cover themselves with capitals…to wear white wigs with stucco curls, to put on their clothing a panoply of decorative details. In a sand-colored hall with a gray ceiling, the masks perform by fits and starts, barely awakened from their stony sleep, like fifty statues of the Commendatore….[75]

Le Bal opened on May 9, 1929, in Monte Carlo, and during the next two months it was performed in Paris and London to high acclaim. On all of these occasions a large share of the triumph was given to de Chirico. *Le Bal* was the last production of the Ballets Russes. A month after it opened in London Diaghilev was dead, and once more de Chirico's opportunity to work with a major theatrical company was cut short. But de Chirico himself seems to have had doubts about such activities. He records in his autobiography that at the end of the performance in Paris the "audience applauded and…shout[ed] 'Sciricò! Sciricò!' I had to come on stage to thank them together with Rieti and the principal dancers…but all these successes satisfied me only partially, and as a painter I did not have a very clear conscience. I returned to the study of truth and painted a whole series of nudes and still lifes. Through their plastic power some of these paintings are among the best of all my work."[76]

Four years later, in the spring of 1933, he executed the sets and costumes for the opera *I Puritani,* which was performed under the auspices of the Maggio Musicale. Given de Chirico's attitudes to opera and his theatrical work, it seems as if the artist accepted this commission almost in spite of himself. Probably the flattery of his first official recognition in Italy—he had just painted a large mural for the Milanese Triennale—made him yield also to this offer, especially as it included large funds to be used at his discretion.[77]

The decor for *I Puritani* follows the precedent set by *Le Bal,* although the sets seem spatially somewhat more conventional, perhaps in response to external pressure. Nonetheless, the artist succeeded in transforming the heavy and awkward melodrama based on Sir Walter Scott's *Old Mortality* into a seemingly weightless, almost white apparition that has the dynamic feel of a ballet rather than an opera. Indeed, de Chirico imbued his decor with the essence of drama, which according to Fuchs consisted of "unarrestable rhythmic movement in space,"[78] and thereby harmonized it with the vital flow of the music. The litheness and fancifulness of his calligraphically conceived sets and costumes

equaled the linear purity of Bellini's soaring *bel canto* arias, and evidently endowed the entire production with sparkle. As in *Le Bal*, much of the truly theatrical, "metaphysical" effect was due to the high-keyed luminosity of the decor, which a sensitive critic described as "C-major." De Chirico is said to have sought the brilliance of "one million candles"[79] with which he irradiated and released unknown dimensions of the opera. This metaphysical quest apparently won the favor of neither the staid nor the vanguard members of the audience. Anton Giulio Bragaglia, the erstwhile Futurist photographer and filmmaker turned impresario, who had given de Chirico his first one-man exhibition in 1919, attacked his *"ottocentismo* and regretted not seeing 'the metaphysics of his better art'" on the stage."[80] Two highly perceptive spectators, the composer and writer Bruno Barilli and the stage director Max Reinhardt, saw the merit and originality of de Chirico's interpretation of the opera. Barilli's review, published in *Il Lavoro Fascista,* took the bull by the horns and asserted that de Chirico's sets achieved "an audacious, clear, brilliant rapport with the music — without pride and without humility, but with the courage of a fighter: the kind of scandalous rapport that flows between modern painting and old opera music." He concluded that, "after all, tradition sometimes needs to be betrayed if we are to recover it and love it anew."[81] Fifty years later one still concurs with Barilli that de Chirico placed Bellini's inspired music in a refreshingly new perspective, thus freeing it from the empty ritualistic veneration accorded to past creations.

De Chirico could not have wished for a more insightful appreciation than Barilli's. But when Reinhardt, who appears to have been equally impressed, invited him to design "scenery and costumes for Shakespeare plays that [the German director] . . . was to stage in the British capital, [he declined] . . . the invitation politely, because all this type of thing did not suit me and suits me now less than ever."[82] Yet the artist proceeded to accept the numerous other theatrical commissions that ensued soon after *I Puritani* and undoubtedly continued to be torn by the conflicts between his silent, private theater and that of the public at large, geared above all to "the bitch goddess" success.[83]

Giorgio de Chirico. Costume for Sir Riccardo, *I Puritani.* 1933
Watercolor on paper
Galleria Ferretti, Viareggio

Notes

1. *Paris-Midi,* Mar. 16, 1914; cited in W. Bohn, "Metaphysics and Meaning: Apollinaire's Criticism of Giorgio de Chirico," *Arts Magazine,* Mar. 1981, p. 112.

2. See M. W. Martin, "Reflections on de Chirico and *Arte Metafisica,*" *Art Bulletin,* LX (1978), pp. 342-53.

3. A. Savinio, "La mia pittura," *Alberto Savinio* (Milan: 1949), n.p.; G. de Chirico, *Memorie della mia vita* (Milan: 1962), pp. 40, 64.

4. G. de Chirico, "Casella," *La Rassegna Musicale,* May-June 1943, p. 129.

5. De Chirico, "Apollinaire," *Ars Nova,* 1918; cited in M. Fagiolo, *Giorgio de Chirico: il tempo di "Valori plastici" 1918/1922* (Rome: 1980), p. 12.

6. De Chirico, "Vale Lutetia," *Rivista di Firenze,* Feb. 1925, p. 13.

7. De Chirico, "Perchè ho illustrato l'apocalisse," reprinted in *Giorgio de Chirico,* exh. cat. (Milan: Palazzo Reale, 1970), p. 78.

8. De Chirico, *Hebdomeros* (London: 1964), pp. 50, 44, 88-89.

9. Savinio, *Capitano Ulisse* (Rome: 1934), Introd., p. 15.

10. W. Blunt, *The Dream King: Ludwig II of Bavaria* (Harmondsworth: 1970). The example of Ludwig II as possible inspiration for the de Chiricos seems worth exploring.

11. Savinio, *Tragedia dell'infanzia* (Florence: 1942 [1939]), pp. 75, 77-78. The book was composed in 1919-20.

12. De Chirico, *Memorie,* p. 242.

13. Cited in L. Spagnoli, *Lunga vita di Giorgio de Chirico* (Milan: 1971), p. 178. The author tends not to provide sources for her quotations, as in this instance.

14. De Chirico, *Memorie,* pp. 61, 57.

15. J. T. Soby, *Giorgio de Chirico* (New York: 1955 [1966]), pp. 27, 28.

16. De Chirico, *Memorie,* p. 64; see also p. 86.

17. F. Nietzsche, *Ecce Homo and The Birth of Tragedy* (New York: 1927), pp. 319, 174. Indeed,

Nietzsche grants, p. 321, that "the *tragic myth* is to be understood only as a symbolizing of Dionysian wisdom through Apollonian art media."

18. Cited in D. Fonti and M. Fagiolo, "Cronologia," in *Alberto Savinio,* exh. cat. (Milan: 1976), p. 144.

19. Nietzsche, *Birth of Tragedy,* p. 278.

20. Nietzsche, *Birth of Tragedy,* p. 213. Cf. de Chirico's statement of 1919 on the "Metaphysical Aesthetic" in which he says that Greek architects "were guided by their philosophical aesthetic; porticoes, shadowed walks, and terraces were erected like theater seats in front of the great spectacles of nature (Homer, Aeschylus): the tragedy of serenity." Reprinted in M. Carrà et al., *Metaphysical Art* (New York: 1971), p. 90.

21. De Chirico, *Memorie,* pp. 61, 62. In 1907 Reger was appointed to the University of Leipzig; hence Savinio's work with him could not have been very extensive. Reger's continuing devotion to Böcklin is manifested in his orchestral suite, *Tondichtungen nach Böcklin,* op. 128, of 1913.

22. J. Meier-Graefe, *De Fall Böcklin und die Lehre von den Einheiten* (Stuttgart: 1905), pp. 208, 270. Pages 200-70 deal with Böcklin's "theater." K. Moffett, *Meier-Graefe as Art Critic* (Munich: 1973), p. 58.

23. Meier-Graefe, *Böcklin,* p. 216.

24. De Chirico, "Arnold Böcklin," reprinted in M. Carrà, *Metaphysical Art,* p. 157.

25. De Chirico, "Max Klinger," reprinted in M. Carrà, *Metaphysical Art,* p. 134.

26. Savinio, "Arnoldo Böcklin," *Narrate uomini, la vostra storia* (Rome: 1942), p. 31.

27. Meier-Graefe, *Böcklin,* p. 226; "Nicht sehen, sondern denken!"

28. L. Gillet, "Arnold Boecklin," *La Revue de l'Art Ancien et Moderne,* XXI (1907), p. 387. This statement singularly anticipates Duchamp's retrospective comment about his own efforts: "I wanted to put painting once again at the service of the mind."

29. Gillet, "Boecklin," p. 388.

30. See G. Fuchs, *Die Schaubühne der Zukunft* (Berlin: 1905), passim, and also the expanded edition of it, *Die Revolution des Theaters, Ergebnisse aus dem Münchner Künstlertheater* (Munich: 1909). See also P. Behrens, *Feste des Lebens und der Kunst, eine Betrachtung des Theaters als höchsten Kultur Symbols* (Leipzig, 1900).

31. P. Weiss, *Kandinsky in Munich* (Princeton: 1979), p. 93; for an excellent summary of the Munich Künstlertheater, see chap. 9.

32. Fuchs, *Die Schaubühne,* p. 106.

33. Weiss, *Kandinsky,* p. 95.

34. Fuchs, *Schaubühne,* p. 76, and passim. The emphasis on a planar, relieflike stage grows out of A. Hildebrand's influential *Das Problem der Form in der bildenden Kunst* (Strasbourg: 1893). The German sculptor was much involved in Fuchs's activities.

35. The role of Italy in the development of de Chirico's art is treated in my "Reflections on de Chirico and Arte Metafisica"; see n. 2 above.

36. The customary reference to shooting-gallery targets is undoubtedly correct as well. See also Savinio's stage description for act 2 of his "Les Chants de la mi-mort," published in July-Aug. 1914 in *Les Soirées de Paris,* p. 420, which contains "Des hommes-cibles en tôle rangés contre le mur, l'endroit du coeur signé par un coeur rouge." The perforation on Apollinaire's shoulder and the little round hole nearby (present also in *The Dream of the Poet,* 1914) are strongly reminiscent of the perforations and holes found in shadow figures, the little holes designating joints that can be moved.

37. Cited in L. Reiniger, *Shadow Theatres and Shadow Films* (London: 1970), p. 13.

38. Weiss, *Kandinsky,* p. 99. See also *Karl Wolfskehl 1869-1969: Leben und Werk in Dokumenten,* exh. cat. (Darmstadt: Hessische Landes- und Hochshulbibliothek, 1969), pp. 210-13.

39. "Karagöz" became "Karaghiozis" in Greek. Karaghiozis shows were particularly popular in Athens, at least until World War II. Greek children used to buy Karaghiozis characters and paste them on cardboards. Reiniger, *Shadow Theatres,* p. 27 ff.

40. See Martin, "De Chirico," p. 351.

41. J. G. Frazer, *The Golden Bough,* vol. 3, *Taboo and the Perils of the Soul* (New York: 1934), p. 89.

42. Reprinted in Soby, *Giorgio de Chirico,* p. 245.

43. Spagnoli, *Lunga vita di Giorgio de Chirico,* p. 162. Frazer's poetic descriptions of the mythical

Greece that Pausanias sought to recapture apparently were suggestive for de Chirico's own nostalgic evocations of ancient Greece. See Soby, *Giorgio de Chirico,* p. 162.

44. Although at least one volume of *The Golden Bough* was translated into French in 1903, it was not possible to verify its contents or to ascertain when additional volumes were available in that language.

45. G. Maspero, *Popular Stories of Ancient Egypt* (New Hyde Park: 1967 [1882]), pp. 196-201. The story on which the ballet was based is entitled "The Story of Rhampsinitus." Savinio, "M. D. Calvocoressi," in *Souvenirs* (Palermo: 1976), p. 235.

46. Frazer, *Taboo and Perils of the Soul,* pp. 28-29.

47. Cited in Fagiolo, *De Chirico 1918/1922,* p. 13.

48. Both de Chiricos seem to have been very keen on the movies. In his 1920 essay on Klinger, de Chirico compares the German artist's feeling for "modern drama" expressed in his etchings to "the dramatic sense of certain moments in the cinema in which people inhabiting tragedy and modern life appear frozen in the spectrality of the moment, scenes that are terrible and real." M. Carrà, *Metaphysical Art,* p. 133. De Chirico described the movie *The Ten Commandments* as "quel film meraviglioso di metafisica." "Vale Lutetia," *Rivista di Firenze,* Feb. 1925, p. 13. In 1932 Savinio wrote a most perceptive appreciation of the cinematic art of René Clair, published in *Souvenirs,* pp. 168-74.

49. Cited in R. Abel, "The Contribution of the French Literary Avant-garde to Film Theory and Criticism (1907-1924)," *Cinema Journal,* XIV, Spring 1975, p. 22; from *Mercure de France,* CV, July 16, 1914, p. 423.

50. Cited in P. Bergman, *"Modernolatria" et "Simultaneità"* (Stockholm: 1962), p. 387.

51. Abel, "The Contribution of the French Literary Avant-garde," p. 20.

52. V. Spate, *Orphism: The Evolution of Non-figurative Painting in Paris 1910-1914* (Oxford: 1979), pp. 34-35, 39; R. Washton Long, *Kandinsky: The Development of an Abstract Style* (Oxford: 1980), pp. 138-39. Apollinaire awarded a "Rose" to Kandinsky in his manifesto "L'Antitradition futuriste," dated June 29, 1913.

53. Long, *Kandinsky,* especially chap. 5. The role of theater in the development of Kandinsky's style is also one of the theses of Weiss, *Kandinsky.*

54. Savinio, "Le Drame et la musique," *Les Soirées de Paris,* Apr. 15, 1914, p. 243. Kandinsky, "On Stage Composition," *The Blaue Reiter Almanac* (New York: 1974), p. 201.

55. Cited in L. Rognoni, "Savinio musicista," *Alberto Savinio,* exh. cat. (Milan: 1976), p. 27.

56. The first sentence in de Chirico's manuscript "No Music" states that "Music cannot express the essence of sensation…there is no mystery in music…[in contrast to] that hidden music that one does not hear…[of] light and shade, lines and angles…" (Reprinted in Soby, *Giorgio de Chirico,* p. 245.) This manuscript was composed between 1911 and 1915. Kandinsky believed that "painting is ahead of music…[because it] can present to the spectator the whole content of the work at one moment." (From *Uber das Geistige in der Kunst,* cited in Long, *Kandinsky,* p. 64.) It is significant that Max Morise quotes de Chirico's "Pas de musique" as epigraph in his review of the artist's exhibition at the Galerie de 'L'Effort Moderne' published in *La Révolution Surréaliste,* July 1925, p. 31.

57. Savinio, "Il poeta assassinato," *La Voce,* VIII, Dec. 31, 1916, p. 439. Apollinaire's manuscript is in the Arensberg Archives of The Francis Bacon Library, Claremont, California.

58. See W. Bohn, "Metaphysics and Meaning," *Arts Magazine,* Mar. 1981, for a discussion of the poet's deep understanding of de Chirico's art. It should be pointed out that Apollinaire also incorporated into the pantomime some distinctly Parisian ingredients that bring to mind the art of Delaunay, and that the poet seems to have heeded some of the Futurist performance desiderata as well.

59. W. Bohn, "Apollinaire and De Chirico: The Making of the Mannequins," *Comparative Literature,* XXVII, Spring 1975, pp. 2, 154 ff.

60. These statistics are based on the following sources: his autobiography; G. Amberg, *Art in Modern Ballet* (New York, 1946); *Giorgio de Chirico, Scene e costumi,* exh. cat. (Turin: Palazzo Madama, 1973); M. Fagiolo, *I Puritani* (Viareggio, 1981).

61. Raïssa Lork was the stage name for the Russian pantomime artist-dancer Raïssa Kroll, née Gurievich, who later became the archaeologist Raïssa Calza, the noted expert on the antiquities

at Ostia. When de Chirico met her in Pirandello's circle she was still married to the choreographer Giorgio Kroll.

62. De Chirico was not the only member of the Surrealist group to be criticized for such activities; both Ernst and Miró were expelled because of their work for Diaghilev. But Aragon's and Breton's revenge on de Chirico was particularly severe and cunning. The March 15, 1928, issue of *La Révolution Surréaliste* reproduced a photograph of a stagelike box construction by Aragon and Breton which contained some elements of de Chirico's earlier pictures, so far as one can make out. Although it bore the cruel title *Here lies de Chirico,* their macabre joke suggested at the same time that they grasped the artist's theatrical vision and that they resented its presumed commercialization.

63. See the provocative discussion of this issue in Amberg, *Art in Modern Ballet,* especially pp. 28-30.

64. A. Casella, *Music in My Time* (Norman: 1955), pp. 167-69.

65. Pirandello transformed *La giara* into a play in 1917.

66. De Chirico's set with its tall house and arched staircase is reminiscent of Poussin's magnificent wash drawing with a Roman arch entitled *View near Villeneuve-lès-Avignon* (Musée Condé, Chantilly). This drawing was reproduced in *Il Primato,* Sept.-Nov. 1921, as headpiece for A. Maraini's article "Refaire Poussin sur nature."

67. A. Casella, "Souvenirs et appréciation," *Les Ballets Suédois dans l'art contemporain* (Paris: 1931), p. 177.

68. Undated typescript in the collection of the Dance Museum, Stockholm.

69. According to the program, Raïssa Lork had the role of Niobe, and Maria Morino, Savinio's wife-to-be, those of La Signora Smancerosa and Diana.

70. See references given in Fagiolo, *I Puritani,* Appendix, p. 10.

71. Savinio's "Drame de l'après-midi entre deux saisons" was first published in *La Voce,* Dec. 31, 1916, and forms the last part of *Hermaphrodito,* which appeared in book form in 1918.

72. Cited in *Les Ballets Suédois dans l'art contemporain,* p. 141.

73. See Martin, "The Ballet *Parade:* A Dialogue between Cubism and Futurism," *The Art Quarterly,* I, Spring 1978, pp. 106-07.

74. Cited in R. Buckle, *Diaghilev* (New York: 1979), p. 524.

75. A. Levinson, *Comoedia,* May 30, 1929; cited in *Diaghilev: les Ballets Russes,* exh. cat. (Paris: Bibliothèque Nationale, 1979), p. 151.

76. De Chirico, *Memorie,* p. 135.

77. The huge mural, which no longer exists, was surrounded by a mosaic by Severini. As Fagiolo pointed out, the horse that appears to leap across Severini's mosaic is a quotation of the Pegasus from *Le Bal I Puritani,* p. 6; de Chirico, *Memorie,* pp. 140-41.

78. Fuchs, *Die Schaubühne,* p. 76.

79. B. Barilli, "I Puritani di de Chirico," cited in full in Fagiolo, *I Puritani,* p. 4.

80. Cited in Fagiolo, *I Puritani,* p. 8, n. 5.

81. Barilli in Fagiolo, *I Puritani,* p. 4.

82. De Chirico, *Memorie,* p. 140.

83. My deep gratitude for their generous assistance in the work on this essay goes to Ursula Jonsson, Archivist, Petr Klastersky, Curator, Dance Museum, Stockholm; Maurizio Fagiolo, Rome; Elizabeth S. Wrigley, Director, The Francis Bacon Library, Claremont; Joan M. Lukach, New York; Laura Rosenstock, Assistant Curator, Judith Cousins, Researcher, Francis Kloeppel, Senior Editor, The Museum of Modern Art, New York; Edward Aiken, Boston College. This essay was written with the support of Boston College and the Bunting Institute of Radcliffe College.

IN speaking of Giorgio de Chirico's influence on twentieth-century art, we have grown accustomed to focusing almost exclusively on the Surrealists. Of at least equal significance, however, was his influence on the various realist painters of the twenties, particularly those of the Neue Sachlichkeit (New Objectivity) and Magic Realist movements as they developed after World War I, primarily in Germany, but also in Italy, France, and the Netherlands.

The art of the Neue Sachlichkeit brought with it not only a new attention to the material world—in conscious negation of all abstract styles of the early years of the century—but also a new confrontation with objects. "We painted from the outside in," the Hannover painter Ernst Thoms once said, and this simple statement characterizes both the point of departure and the goal of the movement. The Neue Sachlichkeit painters began with the banal and commonplace objects that surround us, but in depicting them attempted to reinterpret the world. It was an attempt, following the destruction of war and in the midst of political, economic, and social crises, to regain control of things, and more: to penetrate them spiritually through accurate and unselfconscious observation, to comprehend them in their true essence, their genuine mystery, their subtle emanation. In this way, the Neue Sachlichkeit attempted empirically and inductively to create a new order in a chaotic and incomprehensible world and to grasp its intrinsic unity.

Within this new confrontation with the material world, this skeptical attempt at a new realism in the twenties, there were two opposing artistic positions. The Magic Realists manifested the attempt as an often desperate effort to reunite the shattered pieces of a once harmonious world. The veristic, critically engaged painters of the Neue Sachlichkeit (whom we find only in the Weimar Republic, unlike the Magic Realists, who worked in many European countries) made us aware of the fragmentation and contradictions of our modern existence—and rubbed salt in the wound. Both groups shared the opinion, however, that reality could no longer be reproduced unreflectively.

Emphatic as these new realists were in their wish to distinguish themselves from the ecstasies of Expressionism, the aesthetic harmony of Cubism, and the empty dynamic of Futurism, they just as emphatically refused to divorce themselves from the history of art. Other ideals determined their direction. One after another various fathers of the modern movement entered their line of vision as exemplars: Henri Rousseau, whose naively constructed reality composed of individual forms and experiences Kandinsky perceived as opposed to all abstract tendencies (calling it a "great realism"); André Derain, who, while avoiding Cubism yet remaining aware of both Cubism and Cézanne, attempted to create a new realistic picture structure; Picasso—then spoken of as the "Ingresque" Picasso—who adopted a plurality of styles allowing for the coexistence of classic-realistic forms alongside the more complex form language of Cubism and the more radical form language of abstraction; Jean Cocteau, who loudly proclaimed his *Rappel à l'ordre,* lending a certain chic to the various conservative-restorative tendencies of the postwar years; and Fernand Léger, who in his "conceptual" realism championed acceptance of the industrial world with the same vital optimism that he proclaimed the almost unattainable utopia of a man-made world of reconciled differences. However, the central role in the development of this new realism was played by Giorgio de Chirico and his Pittura Metafisica.

Giorgio de Chirico, who spent two crucial adolescent years (1906-08) studying in Munich, had always had an affinity for German culture. Even in Athens he had studied German along with French, and read Goethe and Heine alongside Dante and early French authors. Thus it is not surprising that the Italian de Chirico learned to see Italy through the eyes of two non-Italians. Arnold Böcklin's image of Tuscany, the longing of a Northern Romantic for a timeless ideal, first took hold of de Chirico during his years in Munich and gave his homesickness a mythical, metaphysical aspect from the start. (He discovered this longing in Max Klinger as well.) It was Nietzsche's passion for Turin, the city he had discovered in 1888—the year de Chirico was born—and extolled in countless letters, that inspired de Chirico's Turin experience and made this place so important to

De Chirico and the Realism of the Twenties

Wieland Schmied

him during his early years. Turin was filled to the last doorway with the presence of the German philosopher who, one day early in January 1889, embracing a broken-down carriage horse, collapsed into madness in the city's Piazza Carlo Alberti.

De Chirico's fascination with specific city landscapes and his sensitivity to the mystery of architecture as the stone traces of long-departed generations will make little sense unless we view them against the background of nineteenth-century German philosophy, particularly the world of Arthur Schopenhauer, Friedrich Nietzsche, and Otto Weininger. De Chirico was at least as influenced by their books as he was by the paintings of Böcklin, Klinger, Gaetano Previati, and Giovanni Segantini or by the contemplation of the squares of Florence and Turin. In addition, the pessimistic and tragic mood in the books of these philosophers struck in him a chord that gave depth and resonance to his visual impressions. It was philosophical reflection that added tension and complexity, we might even say profundity, to his experience of space as well as of objects. The odd character of de Chirico's early work, its formal characteristics as well as its intellectual aspect, within the Parisian scene of 1914 (Cubism, Orphism, the origins of abstraction), cannot be understood without examining the specific philosophical experiences of the young de Chirico. Similarly, his later influence on the Surrealists and the painters of the Neue Sachlichkeit and Magic Realism, which was based on this unique spatial experience and his new view of objects (including people), also had its source in German philosophy.

Perhaps de Chirico's crucial accomplishment was this new way of seeing, this new perception of the familiar the commonplace. He freed the eye to see the pure, inexplicable existence of things and cleared away everything that obstructed the view. "What is needed above all is to rid art of all that has been its familiar content until now; all subject, all idea, all thought, all symbol must be put aside," de Chirico said in an early manuscript. He had found this historical positioning of the problem outlined in the work of the philosophers. Books such as Schopenhauer's *World as Will and Determination,* Nietzsche's *Beyond Good and Evil,* and Weininger's *On the Last Things* made everything around appear new, unfamiliar, different, and awakened an urge to confront artistically the now foreign objects in the newly disjointed environment.

Schopenhauer's thoughts from *Parerga and Paralipomena* left an indelible impression on him: "To have original, extraordinary, and perhaps even immortal ideas, one has but to isolate oneself from the world for a few moments so completely that the most commonplace happenings appear to be new and unfamiliar, and in this way reveal their true essence." In Nietzsche's *Ecce Homo* he found this sentence: "The involuntariness of the painting, of the image, is what is most remarkable: one no longer has a concept of what painting is or what image is, everything appears to be the most immediate, the most correct, the simplest expression."

The posthumously published collection of literary fragments by the twenty-three-year-old suicide victim, Otto Weininger, provided him not only with his notion of the "metaphysical," but also with the key to an understanding of Schopenhauer's and Nietzsche's concept of space and objects as the necessary expression of man. Weininger comments: "Space is thus a projection of the self (out of the realm of freedom into the realm of the necessary). It consists of the coexistence of that which can only be experience in temporal sequence." Further, "since man has a relationship with all objects in the world, all these things must somehow preexist in him...the system of the world is identical to the system of man..."

From this point on, de Chirico felt that the fatal blinders must be stripped from our eyes so that we may see objectively the concealed relations of things. At the same time, he recognized that intellectual exertion—the sight of the painter, the insight of the philosopher—had to precede this new view of objects. He addressed the subject himself in 1919: "The exclusion of the sense of logic from art is not the invention of us painters...art was liberated by modern philosophers and poets." Schopenhauer and Nietzsche were the first to teach the deep significance of "non-sense" in life and how this "non-sense" could be transformed into art.

How was this "non-sense" to be transformed into art? De Chirico's answer sounded simple: through discontinuity. The first sensation we experience with his pictures is that of the discontinuity of space and time. De Chirico builds a shockingly foreign world out of ostensibly familiar elements. We might think, despite such obvious indicators of the modern day as smokestacks and locomotives, that this world belonged to the *quattrocento*. However, we can no longer find our way in this world. Where our glance falls, it is turned away, frustrated. De Chirico contradicts our Renaissance-trained visual perspective imperceptibly, but thereby even more persistently. The space that de Chirico painted during his Metaphysical period (1910-19 — until 1915 in Paris, then in Ferrara) is characterized by a dialectic of emptiness and constriction, or, more correctly, by a gradual development in the pictures from emptiness to constriction. The claustrophobia of the Metaphysical Interiors of 1917 appears as the inevitable consequence of the constant and unalleviated horror vacui of the early Piazza pictures.

Constriction replaces the void. The complete filling-in of space with the most contradictory objects in the pictures of the Ferrara period marks the gradual expiration of the original impulse and impetus of his work. From the beginning, de Chirico's picture space had the character of a stage. This allowed him to eliminate classical perspective. The stage transformed all architecture into scenery, so that it appeared without depth, as in the theater. Perspectives could thus be openly contradictory without compromising the suggested reality of the picture. It often appears as though the facades and arcades had been shoved onto the stage like so many backdrops without having to orient themselves to the same vanishing point. The formal incoherence of diverse perspectives emphasizes the contextual peculiarity of the buildings. Fortress and factory, palazzo and train station are juxtaposed, unexpected and unconnected.

The stage is an empty room, before the entrance of people, before the appearance of objects. Only the light prevails, and it is stage light; often it comes from different sides, as though from spotlights, which illuminate the scene in different ways. Where the light meets scenery or properties that define the stage, it produces shadows. That is the point of departure of the Metaphysical picture world. "The hideous discovered void has the same soulless and tranquil beauty as matter," wrote de Chirico. The quality of this void should be maintained, even when individual objects appear on the stage as attendants or actors in an enigmatic, opaque performance.

For de Chirico, objects were the equivalent of people who were almost never present. During the Parisian period, man appeared as an antique or contemporary statue, as a shadow or silhouette, as a plaster bust on a pedestal or as a mannequin; as an actual figure he remained tiny and completely in the background, more a footnote or a distant memory than a corporeal being. In the Ferrara period, de Chirico added new variations to this stiff mechanistic view of man with the large wooden constructions made of geometric implements, the pillarlike monuments (*The Disquieting Muses,* pl. 71) and the marionettelike jointed dolls (often with partially hallowed-out heads, which opened up strange vistas). The more casually people were handled in these pictures, the greater intensity objects assumed. De Chirico saw this himself when he wrote: "We are building a new metaphysical psychology of objects."

Architecture became a "thing" for de Chirico, as well. It was separated, in other words, from the people who had created it: set loose, estranged, irrationalized. De Chirico devised a second "nature" in the philosophical sense: as there is human nature, there is a nature of artifacts. Human history, human action is frozen in it and confronts us in unfamiliar and inexplicable objects. De Chirico's world is a world of man, exclusively a world of man. He shares it with no other living thing. He occupies it alone, with his history and with himself.

That is the unsolvable contradiction in this world: it is completely man-made, but it is not made *for* man. No one lives behind the arcades of the palazzi, and the factories whose smokestacks we see produce nothing. They are nothing but empty and menacing stage props. It would be an easy matter to develop a complete theory of alienation based

on an analysis of these pictures and just as easy (consider the stone monuments in which man confronts himself) to read its equivalent in them — irrationality.

Causality and continuity are shattered in de Chirico's world; the old order of consciousness is lost. We are unable to find it again in the visible reality; it disintegrates into many individual pieces, into "things." Nietzsche's famous statement "God is dead" is based on this decay of order, this loss of orientation. The power to provide logic dies with God, the unity of being is destroyed, orientation is lost. De Chirico sensed the tragedy of these moments of human intellectual history, and his pictures vibrate with the violent emotion he experienced at their full realization. Neue Sachlichkeit and Magic Realist painters, who had neither the stature nor the sensitivity of the artists who inspired them, were left only with their horror at this now foreign world and attempted to adapt themselves to it as best they could.

Just as during the *époque floue,* the period of transition between Dada and Surrealism, de Chirico served André Breton and his friends at *Littérature* (who as good Dadaists doubted the potential and justification of art) as irrefutable evidence that it was possible to create works of art without compromising oneself or sabotaging the purity of the revolution, so he became the great and heroic example for the artists of the Neue Sachlichkeit and Magic Realism. In the search for direction in a world without recognizable order, he identified the things of the world so that one need not lose oneself completely. With de Chirico the realists were confronted with the world of things: with de Chirico they discovered their ambivalence. What do things, these fragments of the world, have to say to us? What meaning do they conceal? Do they conceal any meaning at all?

De Chirico, who posed this question much more radically in his early pictures and writings than any of the later realists, concluded that objects have different sides, that is, that they belong to two different realms. In his essay "On Metaphysical Art" (published in *Valori Plastici,* April-May 1919), he said: "Schopenhauer defines the insane as people who have lost their memory. An ingenious definition. The logic of our normal activity and lives is in fact a continuing band of memory of the relationships between our environment and ourselves…with this we have reached the metaphysical aspect of things. I can infer from this that everything has two aspects. The first aspect is the familiar, which we see all the time, and which is seen by people in general. The other is the spectral or metaphysical aspect. This one is recognized only by a few in moments of clairvoyance or metaphysical abstraction…"

Through what formal devices does the artist make this "metaphysical aspect" visible? Quite simply through geometry, the geometric manipulation and simplification of forms, the correspondence of mathematical proportions, the play of perspective. De Chirico was inspired in this by Otto Weininger, who wrote: "Oftentimes one glimpses symbols of a higher reality in geometric forms. Whether the basis for this phenomenon lies solely in our rediscovery in them of an a priori function of our perception remains undecided." What fascinated de Chirico about Weininger was his references (both concealed and overt) to the demands of the exterior and interior world. "Regarding the symbols of a higher reality," he believed with Schopenhauer and Nietzsche in the mute inexplicability of symbols, which lent them the full majesty of mystery.

At the end of his Metaphysical period, in 1919, de Chirico attempted to describe the connection between the material world and geometry and their effect on the viewer in a short essay entitled "Metaphysical Aesthetic." He wrote: "An absolute knowledge of the space that can be occupied by the objects in a picture, as well as the space that divides them, establishes a new astronomy of those things that are tied to the planets by the fateful law of gravity. The precise and clever use of planes and volumes results in the laws of the metaphysical aesthetic…." This points to a much too rarely noticed aspect of the early work of de Chirico: his Metaphysical pictures are strong geometric constructions, and their mystery stems largely from his specific use of geometry.

Thus, in the works of his Parisian period (1911-15), Giorgio de Chirico created a stagelike, discontinuous, incoherent realm, combining individual backdrops like so

many spatial fragments, a realm that robs the individual of his orientation and leaves him homeless, without any sense of place at all. De Chirico further complicated this spatial theater during his years in Ferrara (1916-19). At this point, space generally meant interior space, transected by walls rather than facades, threatened by steep-pitched roofs, crammed with draftsmen's tools — triangles, rules, compasses, angles, frames — which invite the construction of further contradictory spaces. What horror of latent space is expressed there! The viewer of these impenetrable interiors is further unsettled by window vistas or by "pictures-within-pictures" placed on easels. These pictures present a completely different reality, into whose naturalistic order one would gladly flee; but the context of these pictures, of their seemingly "normal" reality, appears as a long-departed reality, remaining only as a dream, as a fata morgana haunting this claustrophobically narrow space.

Not only the Surrealists but also the painters of the Neue Sachlichkeit were affected by this picture world, which appeared to derive from tradition, but actually broke radically with it. The Surrealists, however, concentrated more on the alienating methods of expression of this art and elaborated on them (without being able to increase their effect). They also picked up and cynically played out the irony often present in de Chirico, where mannequins and wooden monsters perform like actors, miming violent emotions. The painters of the Neue Sachlichkeit, however, absorbed de Chirico in homeopathic doses, concentrating on individual elements such as the doll-like, mechanized view of man.

The young German painters of a New Objectivity or a new Verism, who in 1918 were seeking a style, casting about in various directions — Expressionist, Dadaist, Cubist — were struck by Pittura Metafisica as though by a shock, and the pictures significantly influenced their course. These young painters had been overwhelmingly affected by the horror of the war, by the experience of the modern metropolis, and by the ever more incomprehensible technical world. They attempted to give expression to these experiences and emotions without formal speculation or metaphysical digression.

At this point they encountered the painting of Giorgio de Chirico and Carlo Carrà. In their eyes, these pictures formed a bond between the melancholy atmosphere of the waning nineteenth century and the formal innovations of the twentieth: *Weltschmerz* expressed in bold geometric constructions. The tremendous impression this art made on the young German realists is surprising, particularly because their first encounter occurred not at an exhibition or in a museum, but through a magazine, *Valori Plastici,* which Mario Broglio had been publishing in Rome since 1918.

This unique factor — inspiration not through contact with originals, but with black-and-white reproductions — could only occur because the painters of the Neue Sachlichkeit were not primarily interested in color and gesture, as were the Expressionists, but in the recognition and presentation of the world of things.

They sought a particular graphic objectivity, characteristic of Renaissance and classical painters (up to Ingres and David). Through emphasis on the contour of objects and thereby the isolation of individual phenomena, they hoped to come closer to their goal of understanding our complex technical world. In de Chirico they found a painter who, in contrast to almost all of his contemporaries, emphasized the primacy of the line and based his pictures on line rather than color. If anything links the early Metaphysical de Chirico of the Paris years until 1915, through the period in Ferrara, to the de Chirico in Rome from 1919 to 1924 who was converted to the classical tradition by the pictures of Titian and Raphael, it is his high esteem for line.

In his essay "Classicismo pittorico," published in *La Ronda* (Rome, July 1920), he wrote: "In Greek painting, line and design have an inexplicable force that goes directly to the goal…without doubt, the painters of ancient Greece considered drawing the basis of every art form — as did Ingres and the fifteenth-century Italians…" Thus it is understandable that the linear method of composition and the architectural sense of the pictures of de Chirico and the Pittura Metafisica, their perspective, their geometry, and the feeling of

George Grosz. *Untitled.* 1920
Oil on canvas, 31¾ x 24″ (81 x 61 cm)
Kunstsammlung Nordrhein-Westfalen,
Düsseldorf

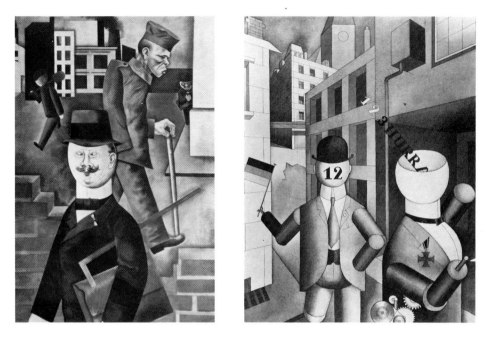

George Grosz. *Gray Day.* 1921
Oil on canvas, 45¼ x 31½″ (115 x 80 cm)
Nationalgalerie, Berlin

George Grosz. *Republican Automatons.* 1920
Watercolor, 23⅝ x 18⅝″ (60 x 47.3 cm)
The Museum of Modern Art, New York,
Advisory Committee Fund

mystery, isolation, loneliness, and anxiety they produce — that which most fascinated the painters of the Neue Sachlichkeit — lost none of their effect, even in a simple, small-format reproduction in a magazine such as *Valori Plastici.*

Broglio was a journalist, collector, and, to a modest extent, also a patron, passionately interested in forming a new artistic avant-garde in the spirit of the Italian tradition. A number of young painters joined him, and he placed *Valori Plastici* at their disposal. Broglio had met de Chirico, who had just moved to Rome, through Roberto Melli, and he publishes a first brief monograph on de Chirico in 1919. Broglio was closer to Carrà, however, and to his more conservative definition of Metaphysical painting in the sense of *italianità.* An artist who found her way to the *Valori Plastici* circle, Edita Walterowna zur-Muehlen, later became Broglio's wife. According to Franz Roh, in his book *Nach-Expressionismus — Magischer Realismus,* she occupied a prominent position in the circle.

In the first issue of his magazine, which bore the date Novermber 15, 1918, Broglio published pictures and drawings by Carrà, de Chirico, and Melli, along with essays by Carrà, de Chirico, Alberto Savinio, Melli, and Filippo de Pisis. The group of artists who had worked together in formulating Pittura Metafisica during the war years in Ferrara were thus harmoniously assembled once more.

The second issue of *Valori Plastici* (number 2-3, published in February-March 1919), introduced the paintings of Picasso, Braque, Léger, Severini, Gris, Herbin, Metzinger, and Maria Blanchard, as well as the sculpture of Laurens and Lipchitz — thus signaling their proximity to the position of Léonce Rosenberg and his L'Effort Moderne in Paris. Contributions by Rosenberg, Cocteau, Breton, Philippe Soupault, Louis Aragon, and Max Jacob were also included. The third issue of the magazine (number 4-5, published in April-May 1919) was a testimonial to Pittura Metafisica, containing essays by Carrà, de Chirico, and Savinio, accompanied by reproductions of works by Carrà, de Chirico, and Giorgio Morandi.

Valori Plastici quickly became known throughout postwar Europe. It entered Germany through the bookstore of Hans Goltz in Munich, who was assigned its distribution there. It was at Goltz's bookstore that, one after another, the artists H. M. Davringhausen, George Grosz, Max Ernst, and Georg Schrimpf discovered *Valori Plastici* and with it the pictures of de Chirico, Carrà, and Morandi.

Davringhausen's first one-man show was held in April 1919 at Hans Goltz's Galerie Neue Kunst in Munich. George Grosz, whom Goltz knew from Berlin, exhibited one

year later in the same gallery. Davringhausen and Grosz saw the first issues of *Valori Plastici* shortly after they appeared and reacted spontaneously in their work. This prompted Paul Westheim's *Kunstblatt* (published in Berlin) to criticize *Valori Plastici* as early as 1919: "…characteristic of his [Carrà's] work,…characteristic indeed of an entire group of younger artists, is a peculiar extreme Verism, devoted to a correct, austere design suppressing every sign of individuality. In Germany, as we know, Grosz and Davringhausen are following the same path."

It is interesting that the artists of the New Objectivity were drawn to Carrà, whereas Max Ernst, who saw *Valori Plastici* in September 1919 at Hans Goltz's, was much more influenced by de Chirico from the start. In a later autobiographical sketch (1959), he described his album *Fiat modes: pereat ars* as a homage to de Chirico. Anton Räderscheidt, who was probably introduced to *Valori Plastici* in the winter of 1919 by Max Ernst, mentions both artists: "Strongest impression of all made by Chirico and Carrà."

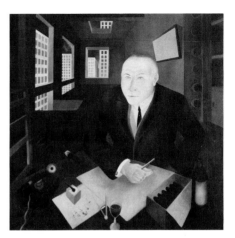

Heinrich Maria Davringhausen. *The Profiteer.* 1920-21
Kunstmuseum, Düsseldorf

The reaction of George Grosz, who between 1919 and 1921 was intensely influenced by the perspective, architecture, and figures of Pittura Metafisica, was singular. Dedicated to the ideals of the revolution, he inwardly resisted this dependence and rejected the art of Carrà as petit bourgeois. In an essay entitled "About My New Pictures" (*Kunstblatt,* volume 5, 1921), he wrote: "I am trying once again to produce an absolutely realistic view of the world.…in the attempt to create a clear, simple style, one involuntarily encounters Carrà. Nonetheless, everything sets me apart from him, who wants to be appreciated as very metaphysical and whose orientation is bourgeois.…man is [in Grosz's work] no longer individually portrayed with finely detailed psychology, but as a collective, almost mechanical concept. The fate of the individual is no longer important."

It was not until two years later that, thanks to the initiative of *Valori Plastici*, German artists were able to view examples of Pittura Metafisica and the Novecento movement in the original. A circulating exhibition, "Das junge Italien," which encompassed the work of Carrà, de Chirico, Morandi, Arturo Martini, Edita zur-Muehlen, Melli, Riccardo Francalancia, and Ossip Zadkine, opened at the National Gallery in Berlin in the spring of 1921, traveled to the Kestner-Gesellschaft in Hannover, and then on to Hamburg.

What was it about the painting of de Chirico and Carrà that made such an immediate impression on the young German painters and kept them so persistently fascinated?

They discovered what they perceived as their own fate—the discontinuity and irrationality of life, the paralysis and isolation of the individual—expressed in a completely new and convincing manner. These pictures were full of contradictions, but these contradictions were made to appear self-evident, combined to form a fateful unity. Despite the feeling of coldness and remoteness that emanates from these pictures, particularly those of de Chirico, they still possess something familiar that touches the heart long before the intellect can begin to analyze it. De Chirico and Carrà built an absolutely alien world out of ostensibly familiar elements. Words such as "enigma" and "mystery" force themselves upon the observer in viewing the abandoned squares, narrow vistas, elongated shadows, and skewed interiors, but one cannot explain wherein the enigma lies or what constitutes the mystery. In contrast, the individual objects—the architecture, statues, tailor's dummies, draftsmen's tools—are clearly and unequivocally defined, bound by solid outlines. Their solidity is unquestionable even though they are juxtaposed according to incomprehensible principles.

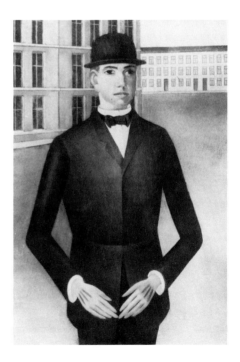

Anton Räderscheidt. *Young Man with Yellow Gloves.* 1921
Private collection

The influence of Pittura Metafisica on the young German realists was twofold. First, they adopted its frustrating, alienating perspective, with its various contradictory focal points and consequent unreal spatial sense. Thus they could construct a space like an airless glass room and arrange in it collagelike objects as though on a imaginary stage with contradictory perspectives. Secondly, they were influenced by two elements of the Metaphysical iconography: its treatment of architecture and its modification of the human figure (as statue, pillar, mannequin, mask, wooden scaffolding). Architecture appears repeatedly in de Chirico's work as empty facades behind which no one lives or as endless repetition of arcades. In Carrà's work, architecture appears in the form of uniform

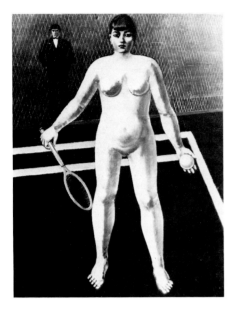

Anton Räderscheidt. *Tennis Player.* 1926
or 1928
Bayerische Staatsgemäldesammlungen,
Munich

Carl Grossberg. *The Diver.* 1931 or 1933
Private collection

skyscrapers with rows of black window openings. Both painters depict man as a stiffened
doll, mechanical and marionettelike.

Here the painters of the Neue Sachlichkeit could join in. Their unique accomplishment
was to take the world of a de Chirico or a Carrà out of its timelessness and into the reality
of our own time in its private and social aspects. This is most evident with George Grosz.
In pictures such as an untitled oil, 1920, and *Gray Day,* 1921, and watercolors such as
Republican Automatons, Diablo Player, and *Handsome Fritz,* all from 1920, he transformed
the timeless loneliness of an Italian piazza into the perspective of a modern metropolis
with its standardized drawing-board architecture of factories and office buildings. He
translates the mannequins of a de Chirico and a Carrà into a historical system of relations.
For him they become war victims (arm and leg amputees outfitted with pipelike artificial
limbs) or automatons of the Republic, whose inner life consists of a set of gears that mesh
perfectly and function involuntarily and precisely according to setting. On the wall above
the diablo player hangs an engineering or architectural blueprint: everything proceeds
according to the prescribed plans of the ruling class in a "diabolical" game.

H. M. Davringhausen's transposition of Pittura Metafisica into contemporary
reference is comparable. His *Profiteer,* 1920–21, sits in a framework that is reminiscent
of a de Chirico Metaphysical Interior. The exterior world, which looks in through the
window openings, is marked off by uniform architectural elements. The soulless world
outside corresponds to the soulless creature at the worktable. This cold, calculating man
has something mechanical about him, even though he is not depicted as a doll or an
automaton. Writing materials and telephone bind him to the regulated exterior world and
leave him no time for cigars and wine.

The same geometric architecture appears in the view from the barred window in
Georg Schrimpf's *Self-Portrait* of 1919. The figure in *Young Man with Yellow Gloves,* 1921, by
Räderscheidt, probably also a self-portrait, stands in an empty square before a row of houses,
their facades barely articulated. The stiffened figure in his black suit (as though in armor
or as though he were a monument) stands alone with his bowler hat, petrified in the
geometry of the modern metropolitan square, indecisive and incapable of acting for
himself.

In other Räderscheidt pictures, such as *Tennis Player,* 1926, we find this man
completely dominated by modern woman, who fascinates and controls him. The woman,
his goddess of sport, appears to derive directly from Carlo Carrà's *Metaphysical Muse,*
1917, which, like his *Girl of the West,* 1919, features a dressmaker's dummy or statue
outfitted in sporting costume and carrying tennis ball and racket, ready to enlist in the
competition of the modern world.

Man is almost completely absent in the paintings of Carl Grossberg. Man can assert
himself there only when he appears as a machine, or when hidden in a suit of "armor,"
like *The Diver,* 1931, in his gear, being lowered like a marionette into the geometric frame
of a space cage. The diving outfit isolates man from his environment and from things. It
isolates and protects him—just as the black suit offers safety to Räderscheidt's young man.
The machine can be as isolated as man in Grossberg's paintings. In *Boiler with Bat,* 1928,
the boiler sits on a platform like a monument on a pedestal, detached from all function. It
appears to be on exhibition in a museum and gives the impression of being a memorial
to itself—as though it were a relic of the industrial age, an age already past. Grossberg's
extension of de Chirico's vocabulary into the technical world is thoroughly consistent: the
sharp-cornered, tapering room in which the boiler stands, imposing and senseless, is
obviously based on de Chirico's Metaphysical Interiors.

Many further examples might be cited. Raoul Hausmann (*Kutschenbauch Composes,*
1920), Georg Scholz (*Industrialized Farmers,* 1920), and Rudolf Schlichter (*Attic Studio,*
1920) modified the mannequin figures of de Chirico and Carrà and turned their auto-
matons into robots or marionettes. Scholz adopted the narrow interior with window
view, Schlichter the boxlike geometric architecture. De Chirico's plunging perspective
with its juxtaposed vistas is found again in Karl Völker's *Industrial Picture,* 1923, and even
more strongly in his *Cement,* 1924, where it appears as oppressive definition and exitless

entrapment. One might also view Franz Radziwill's visions of enormous ship construc-
tions as an echo of de Chirico's perspective, but that is open to discussion.

If we review the path from the Pittura Metafisica of a de Chirico and Carrà (Morandi
was always a special case) to the Neue Sachlichkeit, it appears as progress and regression
at the same time: progress, when the German painters attempted to fit the Metaphysical
iconography into a contemporary context; regression, when everything they did became
unquestioning, narrow, and anxious.

With his Pittura Metafisica de Chirico discovered appropriate symbols for a world of
alienation and irrationality. Strictly speaking, his are "antimetaphysical" pictures, because
they announce the decay of the old "metaphysical" order that held all appearances
together and gave them meaning. Without this order, all things become isolated and
enigmatic. We encounter them in de Chirico's spatial theater in irritating perspective, as
in a museum. Man sees himself confronted by a world of artifacts which have become
foreign to him, among which he can no longer find his way.

Out of de Chirico's horror at an alienated world, objectivity wins a new security
through intimacy with objects, as limited as that may be. If de Chirico — with Nietzsche —
asked again about the metaphysic of objects in order to lament (and simultaneously
celebrate) its absence, painters of the Neue Sachlichkeit declined to pose such a question.
This renunciation marked their objectivity; they accepted things as they appeared (and
with them, our universe), without explaining them or even completely believing in
them. Limited vision permitted them to express — simultaneously — concerned opinion,
bitter criticism, and final acknowledgment.

The position of Fernand Léger is quite different. Adopting Kandinsky's terminology,
we could identify the position of the Neue Sachlichkeit as a "modest realism." Léger
would then represent the "great realism." The Neue Sachlichkeit painter felt that he had
been placed in a world he neither understood nor controlled. He had been abandoned in
it and therefore clung to things. In contrast, Fernand Léger's man is a new breed of *homo
faber,* a creature arising out of the reconciliation of man and machine, capable of ruling
the world, shaping his own future.

Fernand Léger's people are on the way to the great utopia of a livable classless world.
It is the tragedy and the sin of the twenties that they did not take a chance on this utopia
but succumbed instead to the seduction of apparent security.

<div align="right">— Translated by Kathleen Fluegel</div>

Carl Grossberg. *Boiler with Bat.* 1928
Private collection

Carl Grossberg. *Machine Room.* 1925
Von der Heydt-Museum, Wuppertal

GIORGIO DE CHIRICO produced his most important work early in his career, during the second decade of this century. It was five years after de Chirico had abandoned the style of this, his most inventive period, that the Surrealist movement was formally launched with the publication of Breton's first Surrealist manifesto in 1924. Nevertheless, de Chirico's early paintings have often been mistakenly classified as Surrealist, in part because of the immense influence they had on artists involved in the illusionistic branch of the Surrealist movement — Tanguy, Magritte, Dali, Ernst.

Many of the artists for whom de Chirico's work was to become important made their initial discovery of his paintings through chance encounters. In the summer of 1919 Max Ernst first saw reproductions of de Chirico's art in Hans Goltz's bookstore in Munich. In 1922 Magritte saw a reproduction of *The Song of Love* and, "moved to tears," gave up working as a commercial artist to commit himself to painting. E. L. T. Mesens, composer and Magritte's friend as well as critic and art dealer, saw the illustration with Magritte and left music for painting. Tanguy glimpsed a de Chirico painting from a bus and was prompted to become a painter. Breton, while also in a bus, saw de Chirico's *The Child's Brain* hanging in Paris art dealer Paul Guillaume's window. He relates how "an irresistible impulse forced me to get off the bus and return to gaze at it."[1] Each experienced a profound reaction that became a point of departure for a new direction in his work.

Surrealism, as evolved by Breton, was largely inspired by Freud's research into free association and dream imagery. Breton, who had visited Freud in Vienna in 1921, recognized the import of the scientific application of psychoanalysis and free association to the recollection of dreams and the revelation of their meanings. He adapted Freud's discoveries to his own poetic investigation, using automatic writing as a method of freeing the unconscious levels of the mind and as a means of self-revelation. Breton furthermore was convinced that dream and reality, the inner and outer worlds, two seemingly contradictory entities, would eventually be unified in an absolute reality which he called a "surreality." Breton first described Surrealism in 1922 as "a certain psychic automatism that corresponds rather closely to the state of dreaming, a state that is today extremely difficult to delimit,"[2] and in 1924, in the first Surrealist manifesto, he defined Surrealism as follows:

SURREALISM. noun, masculine. Pure psychic automatism, by which one intends to express verbally, in writing or by any other method, the real functioning of the mind. Dictation by thought, in the absence of any control exercised by reason, and beyond any aesthetic or moral preoccupation.
ENCYCL. *Philos.* Surrealism is based on the belief in the superior reality of certain forms of association heretofore neglected, in the omnipotence of dreams, in the undirected play of thought....[3]

It is the second part of this definition that encompasses de Chirico and the illusionist Surrealists who did not employ automatism as a tool to discover the functioning of the mind. Nevertheless they believed that certain images, remembered from a dream or revelation, indicated the existence of a higher reality.

De Chirico, both in his thinking and in his art, anticipated much of Surrealist theory. He wrote repeatedly of the dream and of the metaphysical reality it implied. His 1919 essay "On Metaphysical Art" begins: "We should keep constant control of our thoughts and of all the images that present themselves to our minds even when we are in a state of wakefulness, but which also have a close relationship with those we see in dreams."[4] Even as early as his first stay in Paris he had stated: "I believe and have faith that, from certain points of view, the sight of someone in a dream is proof of his metaphysical reality — in certain accidental occurrences that sometimes happen to us; in the manner and the arrangement in which things appear to us and awaken in us unknown sensations of joy and surprise: the sensations of revelation."[5]

De Chirico embodied these beliefs in his painting through the creation of an enigmatic world suggested in dreams and removed from customary notions of reality. Some of the aspects that characterize this oneiric world often produce in the beholder intense feelings of disorder, surprise, and foreboding. De Chirico evokes these sensations by employing in a personal way certain techniques of linear perspective as devised

De Chirico's Influence on the Surrealists

Laura Rosenstock

Notes to this essay begin on page 127.

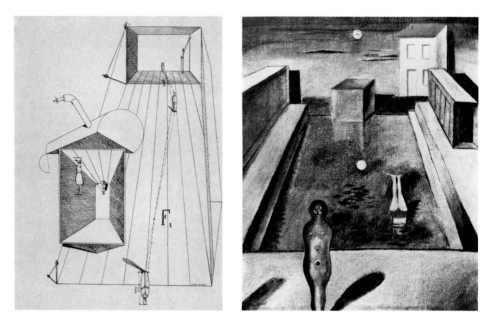

Max Ernst. Plate from the portfolio *Fiat modes: pereat ars* (Let there be Fashion: down with Art). (c. 1919)
Lithograph, printed in black, sheet 17⅛ x 12″ (43.5 x 30.5 cm)
The Museum of Modern Art, New York, Purchase Fund

Max Ernst. *Aquis submersus.* 1919
Oil on canvas, 21¼ x 17¼″ (54 x 43.8 cm)
Private collection, London

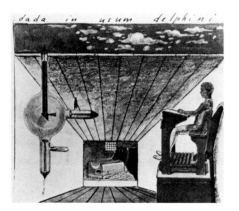

Max Ernst. *Dada in usum delphini.* 1920
Collage with gouache and pencil on paper
Whereabouts unknown

by the fifteenth-century Italians to create a rational, deep space; but he distorts this space in various ways, by making it appear hallucinatory in its rapid, infinite recession, by depicting multiple and conflicting orthogonals, and by foreshortening and tilting his planes to produce a seesaw perspective.[6] These devices give rise to a pervasive sense of dislocation and anxiety. Often he presents a scene of awesome vastness, its effect enhanced by his use of long shadows and diminutive figures. He thus employs a suggested illusionistic space not for purposes of order, but for emotive force.

In this rearranged space de Chirico places the banal objects of everyday life; but removed from their usual function, incongruously juxtaposed with unrelated elements, and frequently depicted on an irrational scale, they further create disturbing relationships and a sense of malaise. By wrenching these commonplace objects from their normal setting, de Chirico relieves his art of the expected, achieving what he said "...is needed above all...to rid art of all that has been its familiar content until now; all subject, all idea, all thought, all symbol must be put aside."[7] In questioning the rational world of space and object, making it no longer familiar but not imaginary either, de Chirico suggests another reality, one in contact with our subconscious mind. He reinforces the sense of a surreality by peopling his world with statues, mannequins, and enigmatic shadows whose sources remain mysteriously concealed or unrelated in shape to the cast shadows themselves. His simplified, abstractedly handled forms, stark geometries that lack any detail, strong, contrasting light and shade that produce flattened positive and negative areas, and mysterious, otherworldly light further enhance dreamlike sensations of silence, solitude, and isolation, of time suspended, of intensified experience and clarity.

Breton and the Surrealist painters appreciated how de Chirico had delved into the unconscious realm of dream, investing it with his own blend of poetic mystery. They were indebted to de Chirico "for the direction of the dream," Breton would write in 1941 in his survey of Surrealist painting.[8] In this same text he observed: "The model of yesterday, taken from the external world, no longer existed and could no longer exist. The model that was to succeed it, taken from the internal world, had not yet been discovered."[9] Earlier he had written: "I believe that a veritable modern mythology is in the process of formation. To Giorgio de Chirico belongs the function of fixing it imperishably in memory."[10]

It was Breton who defined de Chirico's importance for Surrealism, referring to him as a "sentry" along the Surrealist route; he and the nineteenth-century poet Lautréamont were "fixed points" which "sufficed to determine the straight line ahead for us."[11] As William Rubin has observed,[12] de Chirico was the first to translate into painting the

principle of Symbolist *dépaysement* in Lautréamont's paradigm of "the chance encounter of a sewing machine and an umbrella on a dissection table." For the Surrealists, de Chirico's poetic image of incongruity, like Lautréamont's, was of formative importance.

Thus the cult of de Chirico was taken up. His painting *The Enigma of a Day* (pl. 29), which hung in Breton's apartment from 1924 to 1935, became a focal point of discussions, and members of the Surrealist group indulged in intellectual puzzles about objects and locations in the painting.[13] By the very nature of oneiric illusionism those artists who practiced it would be drawn to de Chirico, whose images, like theirs, were figurative and representational, and whose personality, that of the tormented visionary, would appeal to them.

In investigating the character of de Chirico's impact upon Surrealism, one must be wary of such hyperbolic attention. When we discuss below the influence de Chirico had upon the major illusionist Surrealists, we shall see that in many instances de Chirico was just one of many precursors whose work formed the roots of Surrealist art. Yet his powerful conceptions, so dramatically expressed in his paintings, served as a spiritual point of departure for the Surrealists and provided a direct, significant, and substantial contribution to Surrealist art.

Max Ernst. *The Last Judgment.* c. 1919–20
Oil on canvas, 47¼ x 65¾" (120 x 167 cm)
Whereabouts unknown

Max Ernst first learned of de Chirico's work in 1919 when he saw reproductions either in the booklet/monograph *12 opere di Giorgio de Chirico,* published in the spring of 1919 by *Valori Plastici,* or in issues of the magazine *Valori Plastici* itself. This discovery had a profound effect upon Ernst, resulting in his creation of Surrealist-type works prior to the official commencement of Surrealism in 1924. He particularly felt the impact of de Chirico's *The Sacred Fish* (pl. 77), which had not only been illustrated in the 1919 booklet, but circulated, in 1920, throughout Germany in an exhibition sponsored by *Valori Plastici.*[14]

Ernst, like de Chirico, was concerned with irrational space and scale, and these concerns appeared in his work, if in a less formalized manner, prior to his acquaintance with de Chirico's work, as is shown by the enlarged foreground animals and the spatial dislocation of the cityscape in his *Landscape Fantasy,* c. 1916. His joint discoveries in 1919 of both de Chirico and the disjunctive quality of Dada collage would eventually enable him to develop these themes fully.

As has been frequently noted, the direct influence of de Chirico was immediately visible in Ernst's eight lithographs, *Fiat modes: pereat ars,* 1919, which adopt de Chirico's distorted, plunging linear perspective, mannequinlike figures, and emphatic shadows. Also reflecting contact with de Chirico's work—Ernst recalled painting it after first seeing the reproductions in *Valori Plastici*[15]—is *Aquis submersus,* 1919, a work that bears a bizarre similarity to de Chirico's *The Delights of the Poet* (pl. 16), although it is improbable that Ernst would have been familiar with this painting, as it was not reproduced by *Valori Plastici. Aquis submersus* displays de Chirico's unnaturally tilted planes and odd shadows, both attributes of *The Sacred Fish.* However, the fantastic touches of the clock-moon and strange foreground figure are Ernst's own.

Ernst's collages of this period, such as *Dada in usum delphini,* 1920, or *The Master's Bedroom: It's Worth Spending a Night There,* 1919-20, similarly incorporate the deep plunging perspective and illogical jumps in scale characteristic of de Chirico. The cow in *Dada in usum delphini* is much too large in comparison with the foregound figure to exist in the distance implied by the spatial perspective. Another painting of these years, *The Last Judgment,* c. 1919-20, likewise paraphrases de Chirico's format. The linear system established on the left recalls the infinitely receding building arcades frequently employed by de Chirico, as in *The Enigma of a Day* (pl. 29) or *The Mystery and Melancholy of a Street* (pl. 31), while the tilted perspective and the background invoke *The Sacred Fish,* where a partition similarly bisects the open vista.

However, all these works, their obvious allusions to de Chirico notwithstanding, are primarily motivated by the process of collage, which allowed Ernst to manipulate space and incorporate images totally removed from the priorities of logical scale, and none

Max Ernst. *Two Ambiguous Figures.* 1919-20
Collage with gouache, 9½ x 6½"
(24.2 x 16.5 cm)
Private collection

Max Ernst. *Here Everything Is Still Floating.*
(1920)
Pasted photoengravings and pencil, 4⅛ x 4⅞″
(10.5 x 12 cm)
The Museum of Modern Art, New York,
purchase

Max Ernst. *The Horse, He's Sick.* (1920)
Pasted photoengravings and pencil, 5¾ x 8½″
(14.6 x 21.6 cm)
The Museum of Modern Art, New York,
Abby Aldrich Rockefeller Fund

Max Ernst. *The Massacre of the Innocents.* 1920
Collage of photographs with watercolor and
ink on paper, 8¼ x 11½″ (21 x 29.2 cm)
Private collection

capture the essential poetry of de Chirico or share his sense of isolation, nostalgia, or enigma. Thus in *Fiat modes: pereat ars,* Ernst alternates between deep space and lines that adhere to the picture surface to such a degree that the technical exercise of space manipulation becomes almost an end in itself, while the juxtapositions of *The Master's Bedroom: It's Worth Spending a Night There* can be characterized as bland and anecdotal.

De Chirico's overpowering qualities of mystery and poetic dislocation, his sense of the dream image, are absent from Ernst's most obviously de Chirico-derived works of this period, which, aside from their paraphrase of de Chirico's perspective, at this point still bear a closer resemblance to Picabia and Ernst's own Picabia-inspired mechanistic-anthropomorphic collages of 1919-20. Even the Ernst *Two Ambiguous Figures,* 1919-20, whose bespectacled mannequins James Thrall Soby relates to de Chirico,[16] is somehow, like others of Ernst's Picabia-influenced works, too comical to be related to de Chirico's disturbing images; rather it is closer to the Metaphysical works of Carlo Carrà, which Ernst would have known from illustrations in the same issues of *Valori Plastici* that reproduced de Chirico. Like Carrà, Ernst in this collage projects little of de Chirico's foreboding, but devotes more attention to the specific relationships that bind and separate the objects depicted.[17]

In general, a stronger affinity with de Chirico's enigmatic spirit exists in those Ernst collages of this period which did not make obvious reference to de Chirico's perspective and mannequin forms, but instead drew on de Chirico's random juxtaposition of disparate elements. Hence *Here Everything Is Still Floating,* 1920, and *The Horse, He's Sick,* 1920, works that have no perspectival depth at all, nevertheless employ arbitrary combinations and disconcerting scale to probe the unconscious and provoke a malaise as pervasive as that found in de Chirico's work.

The specific images in these two collages reflect additional relationships with de Chirico and produce a dreamlike ambiance comparable to that created by him. The presentation of the horse and fish (an image used frequently by the Surrealists, as well as by de Chirico) in skeletal form and the transformation of this form into Ernst's depiction of hollow and volumetric shapes, certainly relate to de Chirico's pictures that employ anatomical charts (e.g., *The Span of Black Ladders* (pl. 44) or *The Scholar's Playthings),* as well as works such as *I'll be there... The Glass Dog* (pl. 42), with its hollowed-out, "transparent" heart, and *The Astronomer* (pl. 51), whose spinal column is visible through the hole or "window" in the mannequin's chest. While the actual collaged skeletal images derive from scientific diagrams found in encyclopedias,[18] nevertheless Ernst's use of this motif forms a strong iconographic link with de Chirico. Indeed, hollowed-out and skeletal shapes appear in the butchered meat in *The Last Judgment,* a work that Lucy Lippard relates to Ernst's early development of de Chirico's devices.[19] William Rubin has also observed the relationship of de Chirico to the transparent heads in Ernst's *Two Ambiguous Figures.*[20]

In some collages of 1920 Ernst does adopt de Chirico's distorted perspective to produce a disoriented space. In *The Massacre of the Innocents* and *The Flamingos,* Ernst employs aerial views to convey feelings of chaos and panic similar to those created by de Chirico in his paintings of 1914-15, e.g., *The Evil Genius of a King* (pl. 47), where conflicting orthogonals and multiple vanishing points tilt the picture plane, imparting confusion and unease. As with de Chirico, the perspective ends by reversing the rational order which it originally created.

However, it is with Ernst's proto-Surrealist paintings of 1921-24 that the artist truly begins to capture a sense of enigma and heightened reality and to impart consistently a comparable image of a dream world, one premised on the belief in a counterreality stemming from the recesses of the unconscious mind. These paintings are no longer primarily exercises in spatial manipulation, combining dissimilar objects on a simplistic level; Ernst now adopts de Chirico's deep dreamlike space and within this spatial structure juxtaposes incongruous images, which when joined attain a poetic poignancy equal to de Chirico's own.

One wonders why Ernst, having been familiar with de Chirico's work since 1919, did not employ a similar medium or strive for a comparable monumentality until 1921. Lucy Lippard has noted the change in Ernst's 1921 collages to a more narrative, integrated image. She believes this evolution may have been due to Ernst's contact in that year with Breton and Eluard.[21] Perhaps the acquaintance of these poets and future Surrealists, who were deeply involved with de Chirico themselves, may have renewed and reinforced de Chirico's original impact on Ernst.

It is, of course, important to appreciate that this evolution in Ernst's work cannot be laid solely to de Chirico's influence, but derives as well from precursors who anticipated and affected both de Chirico and Ernst. Both artists were familiar with and admired Alfred Kubin's illogical use of scale. Both were impressed with Max Klinger, who presented different time periods simultaneously within a single work and, like Kubin, juxtaposed objects on an unrelated scale. Arnold Böcklin's metaphysical use of nature to impart a sense of mystery and dream was of paramount importance to both Ernst and de Chirico. Böcklin's significance for de Chirico lay in the Swiss artist's ability to make the unreal appear real and the fantastic seem credible. Both de Chirico and Ernst were avid readers of Schopenhauer's philosophical writings as well as his theories on the apparitional aspects of sculpture. Finally, of vital consequence for both artists was Friedrich Nietzsche, who questioned established notions of reality and presented a counterreality found in dream worlds. Soby describes how Nietzsche stimulated de Chirico's principal images of the Piazza series and of the Metaphysical still lifes.[22]

Max Ernst. *The Elephant Celebes.* 1921
Oil on canvas, 49⅜ x 42½″ (125.4 x 108 cm)
The Trustees of The Tate Gallery, London

While the appeal of these precursors to both de Chirico and Ernst suggests affinities already existing between them, there are, nevertheless, specific images and stylistic approaches which, as of 1921, clearly relate Ernst's works to de Chirico's paintings and proclaim de Chirico a main inspiration for Ernst's transition from Dada to Surrealist activity.

In *The Elephant Celebes,* 1921, one of Ernst's most renowned proto-Surrealist paintings, Ernst incorporates many of de Chirico's innovative concepts to evoke a truly moving image and to create a representational dreamlike figure in a three-dimensional space. De Chirico's immense influence upon this work may be best appreciated by comparing the Ernst with de Chirico's *The Great Metaphysician* (pl. 73), possibly the first de Chirico reproduction seen by Ernst if he indeed saw the November 1918 issue of *Valori Plastici.* In both paintings a monumental central image of ambiguous size composed of disparate elements—scaffolding and mannequin head in the de Chirico, an African cornbin and horned bull in the Ernst—stands in the foreground of a vast, receding, illusionistic space. The peculiar object that tops Ernst's figure is actually similar in form and color to the strange armature and drafting tools that compose de Chirico's image. Although composed of basically different iconographic visions, both paintings present thoroughly disquieting but utterly believable images. Furthermore, the ambiguously gesturing hand in the Ernst is not unlike the red metal glove of de Chirico's *The Enigma of Fatality* (pl. 37). In fact, de Chirico's description of "The huge zinc-colored glove, with its terrible golden fingernails," appears in the November 1918 issue of *Valori Plastici.*

Stylistic congruence is evident in the Ernst and de Chirico paintings in the luminous, translucent pigment, elimination of details, unmodeled areas and color tones. Although Ernst was familiar—through *The Sacred Fish* and other pictures—with the more sensuous painterly quality de Chirico later developed in Italy, Ernst's thin, dry paint-handling characteristic of his works of 1921-24 was indebted to de Chirico's works from his Paris period.

Max Ernst. *Oedipus Rex.* 1922
Oil on canvas, 36 x 45¾″ (91.5 x 116.2 cm)
Private collection

In comparing another work by Ernst, *Oedipus Rex,* 1922, with de Chirico's *Gare Montparnasse* (pl. 32), we again find incongruous objects of unidentifiable scale set in the foreground of a vast architectural space. The tiny balloon in the Ernst performs the same distancing function as the tiny figures in the upper right of the de Chirico, and both works employ dark, ominous windows and arcades and disorient the viewer with distorted perspective and conflicting orthogonals. However, major differences between

Max Ernst. *Woman, Old Man, and Flower.*
(1923-24)
Oil on canvas, 38 x 51¼″ (96.5 x 130.2 cm)
The Museum of Modern Art, New York,
purchase

Max Ernst. *The Beautiful Season.* 1925
Oil on canvas, 22⅞ x 42½″ (58.2 x 108 cm)
Private collection

de Chirico and Ernst are also apparent in this comparison. The imagery is emphatically different in the two cases. De Chirico's personal autobiographic iconography depicts objects which, while they elicit a particular poetic mystery, are familiar, if not banal. (Even his mannequins are based on tailors' dummies.) De Chirico also ambiguously alludes to several temporal realities, frequently uniting antique sculpture, contemporary buildings, medieval, Renaissance, and Victorian architecture in a single work.[23] Ernst's imagery, while equally personal, incorporates fantastic elements and does not refer to different periods. Instead, Ernst treats his subject with a combination of whimsy and irony that is both lighthearted and menacing.

In Ernst (as we shall also see with Dali) there is constantly a sense of dynamic motion; we are always aware of something waving, crawling, etc. Rather than depict an empty window or arcade, Ernst shows fingers protruding from these openings, fingers which in turn are pierced by a metallic instrument. De Chirico, on the contrary, enunciates the static quiet of suspended time. Even in the works that incorporate his most distorted perspective and dramatically tilted planes, such as *The Evil Genius of a King* (pl. 47), we never feel that the objects will tumble off the picture, but rather that they are caught, frozen in motion. Only in his later sculptures, such as *The Table Is Set,* 1944, does Ernst come close to attaining this sense of suspension and frozen confrontation.

Finally, the most important distinction between de Chirico and Ernst, as well as between de Chirico and other Surrealists, is the reliance of the Surrealists on Freudian premises.[24] Ernst, as well as other Surrealists, relied on dreams to probe the unconscious and intended that his works refer to the desires and instincts elucidated by Freud. Hence an image such as fingers reaching through the window and being punctured refers specifically and explicitly to sexual penetration, while that of the horned figure alludes to sexual power. Most critics agree that de Chirico did not consciously intend his images to be sexual symbols, although we are certainly aware of their underlying sexual implications. However, the unconscious appearance of sexual urges and replay of childhood experience in de Chirico's iconography assumed an importance for the Surrealists because it supported their belief in the universality of Freudian theory.[25]

Ernst's indebtedness to de Chirico is also apparent in the motif of hollow and volumetric, transparent and solid, which was so vital to de Chirico's work of 1914-15 — e.g., *I'll be there…The Glass Dog* (pl. 42), *The Inconsistencies of the Thinker* (pl. 52), *The Astronomer* (pl. 51), *The Two Sisters* (pl. 50). This concept symbolized in a concrete format the relationship between the inner and outer consciousness, which for the Surrealists were inextricably linked.

De Chirico's interpretation of this theme exercised influence on Ernst's work of 1919-21, and it continued to play a strong role in Ernst's proto-Surrealist paintings. In *Woman, Old Man, and Flower,* 1923-24, the hollows in the metallic jacket allude directly to the holes in de Chirico's metallic mannequins.[26] De Chirico viewed the apertures in his

mannequins as another type of "window" onto reality. Likewise, the body of the old man, composed of a hollow shell or cup, suggests de Chirico, while the elimination of vital body parts, evidenced by the headless figure with mysterious transparent arms, mirrors the armless mannequins of *The Duo* (pl. 53). Aside from the disturbing image it creates, Ernst's use of hollow and transparent forms succeeds in stressing the frontality of the picture plane. In *Woman, Old Man, and Flower,* the receding background of water and distant horizon, visible through the hollow armature and transparent arms, is brought back to the picture surface, so that the deep perspective is neutralized. This emphasis on the surface if reinforced by Ernst's lateral disposition of the figures across the painting and his repetition of vertical elements to echo the shape of the canvas. The use of hollowed-out or transparent figures appears in some form in almost all of Ernst's proto-Surrealist painting of 1923; the poetic enigma it evokes is later strikingly shown in the 1925 *The Beautiful Season,* a recapitulation of the collage *The Horse, He's Sick,* but now rendered vastly more monumental and poignant. Ernst, particularly in his sculpture, transmuted the contrast between hollow and solid into an opposition of concave and convex forms. We will find that the other Surrealists, too, dealt frequently with this theme.

Many other relationships between de Chirico and Ernst have already been noted by scholars. William Rubin has described how devices such as the deep, stagelike space and columnar forms, the orthogonal that cuts diagonally across the foreground, and the ambiguous object situated in the front area of Ernst's *The Teetering Woman* remind us of de Chirico.[27] Diane Waldman has pointed out the striking similarity between the girl rolling a hoop in *The Mystery and Melancholy of a Street* (pl. 31)) and the fleeing child in *Two Children Are Threatened by a Nightingale,* 1924,[28] a work further marked by de Chirico in its stretched, illusionistic perspective, long retaining wall, and archway. Also frequently mentioned in discussions of de Chirico and Ernst is Ernst's *Pietà or the Revolution by Night,* 1923, whose central figure of the artist's father, portrayed with moustache and bowler hat, is an obvious paraphrase of de Chirico's image of his own father in *The Child's Brain* (pl. 33), a painting owned by Breton. In the Ernst, the gray figure being held is an antique statue, a further reference to de Chirico, who tended to represent humanity by sculptured monuments and who was himself depicted as a statue in Ernst's 1922 *The Meeting of Friends.*

No less striking than the visual correlation between these two paintings is the similarity in the descriptions written respectively in 1927 and 1924 by Ernst and de Chirico about visions of their fathers, whom they saw as oppressive and authoritarian. Both texts underscore the fact that many of the disturbing associations found in these two paintings were specifically drawn from the realm of unconscious dream imagery.

Surrealism was essentially a philosophical, literary movement. Its painters depended on literary motifs and freely exchanged ideas with Surrealist poets. Ernst felt that he should proceed in his painting in the same manner as the poets, and in describing the processes one should follow he paraphrased and generalized Lautréamont's passage in the following language: "*a chance meeting of two distant realities on an unfamiliar plane* or,…the culture of *systematic displacement* and its effects."[29] De Chirico, Magritte, and Dali, as well as Ernst, wrote extensively of their theories, which frequently reveal relationships as striking as those immediately apparent in their paintings. These relationships took the form of focusing in a determined, hallucinatory manner on a childhood inspiration or memory, as well as other revelatory experiences, and expressing, often in similar terms, their desire for a new vision, one which revealed in art those poetic images which sprang from their unconscious.

During his stay in Paris from 1911 to 1915 de Chirico wrote:

To be really immortal a work of art must go completely beyond the limits of the human: good sense and logic will be missing from it. In this way it will come close to the dream state and also to the mentality of children…The truly profound work will be drawn up by the artist from the innermost depths of his being. There is no murmur of brooks, no song of birds, no rustle of leaves…there is only what I see with my eyes open — and even better closed.[30]

Max Ernst. *Two Children Are Threatened by a Nightingale.* (1924)
Oil on wood with wood construction, 27½ x 22½ x 4½" (69.8 x 57.1 x 11.4 cm)
The Museum of Modern Art, New York, purchase

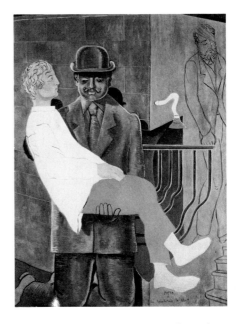

Max Ernst. *Pietà or the Revolution by Night.* 1923
Oil on canvas, 45⅝ x 35" (115.9 x 88.9 cm)
The Trustees of The Tate Gallery, London

Max Ernst. *Day and Night.* 1941-42
Oil on canvas, 44⅛ x 57½" (113 x 146 cm)
Private collection

Max Ernst. *Europe after the Rain, I.* 1933
Oil and plaster on plywood, 39¾ x 58¾"
(101 x 149.2 cm)
Private collection

Compare this with Ernst, who describes his aim "to bring into the light of day the results of voyages of discovery in the unconscious," to record "what is seen…and experienced…on the frontier between the inner and outer world,"[31] and who cites Caspar David Friedrich as saying: "Close your physical eyes in order to see first your painting with the spiritual eye."[32] "When asked, 'What is your favorite occupation?' he always answered, 'Seeing.'"[33] These sentiments were echoed by Magritte, who said, "The art of painting, as I conceive of it, consists in representing through pictorial technique the *unforeseen* images that might appear to me at certain moments, whether my eyes are open or shut,"[34] and by Breton, who as if to underscore the relationship of the Surrealists, whose eyes should be open to the world within, to de Chirico, in 1950 published a retouched photograph of *The Child's Brain* in which the figure's eyes were open. Indeed, the strong parallels in philosophical outlook between de Chirico and Ernst and other Surrealists made it almost inevitable that the Surrealists should find in de Chirico's work a style and sense of poetry that they would seek to emulate. De Chirico's early statement "I say that such a revelation (or if you like, conception) must be felt so strongly, must give us such joy or such pain, that we are obliged to paint, impelled by a force greater than the force which impels a starving man to bite like a wild beast into the piece of bread he happens to find"[35] is not unlike Breton's "Beauty will be convulsive or will not be at all"[36] or Magritte's "One cannot speak about mystery, one must be seized by it."[37]

Ernst may have been familiar with these writings of de Chirico; Eluard once owned the manuscript that contained them, and Ernst may have seen it. This possibility seems strengthened in the light of a comment de Chirico had written: "One final effort and painting too will have its picture that will carry us *beyond all pictures*"[38] — a destination Ernst in his book *Beyond Painting* clearly wanted to reach.

De Chirico's impact was most clearly experienced by Ernst prior to his discovery of frottage in 1925; as he entered the automatic phases of his oeuvre, he withdrew from the illusionist mode in which he had been working and de Chirico's influence dissipated.

Two themes in de Chirico's abstract Metaphysical interiors, however, did appear at later periods in Ernst's career. First, in the collage series of 1929-32 that introduced Loplop, Superior of the Birds, an avian creature with whom Ernst identified and whom he often depicted as resembling himself, Loplop appears in the guise of the painter who presents fragments of various images. These images take the form of smaller pictures within the overall sheet or canvas. Ernst continued to utilize this theme in the works he executed in the 1940s in the United States. De Chirico had employed the motif of a picture within a picture in his Metaphysical still lifes as well as in earlier works such as *The Endless Voyage* (pl. 43). And in Ernst's *Day and Night,* 1941-42, we see similarities to works such as de Chirico's *Evangelical Still Life* (pl. 68), not only in the incorporation of smaller paintings, but in the illusionistic space, strong diagonal shadows, trapezoidal

shapes, and vertical scaffolding system as well. We shall see how Magritte develops the implications of this idea more fully.

Second, while it is extremely doubtful that the interest in texture shown by de Chirico—apparent in the encrusted handling of his Ferrarese depiction of candies and biscuits and in the sensuous pigment of *The Sacred Fish*—played any role in Ernst's use of texture in the technological discoveries of frottage and grattage, there is one instance that may be judged influential. Three of de Chirico's works simulate the texture of relief maps—*Evangelical Still Life,* 1916 (pl. 68); *Politics,* 1916 (pl. 60); *The Melancholy of Departure,* 1916 (pl. 62)—and may have been partially responsible for Ernst's *Europe after the Rain, I,* 1933, where the surface of Europe takes on a relieflike form. Ernst, of course, used the texture symbolically, for the encrustation obliterates the individual features of the continent and represents the political corruption and disintegration spreading across Europe.

In later years Ernst would move ambivalently between illusionism and innovating techniques that stressed flatness of surface. Yet, even though for the most part Ernst would reflect little of de Chirico's influence, there is an interesting parallel in that de Chirico, like Ernst, alternated between spatial extremes; de Chirico's space, too, ranged from the quasi-illusionism of his Italian cityscapes to the claustrophobic crowd-ing out of any sense of depth in his abstract Metaphysical works of 1916 (e.g., *The Regret,* pl. 67). In fact, at least one of de Chirico's paintings, *The War* (pl. 63), employs a bird's-eye perspective. Ernst's grattage *Birds above the Forest,* as well as earlier collages such as *The Massacre of the Innocents,* similarly incorporates this unusual vantage point.

René Magritte. *The Difficult Crossing.* 1926
Oil on canvas, 31⅞ x 25½" (81 x 64.8 cm)
Private collection

In 1922 René Magritte and E. L. T. Mesens saw de Chirico's *The Song of Love* (pl. 34) reproduced in *Les Cahiers Libres.* Mesens describes the impact of that initial encounter: "We were fascinated. Several days later Magritte discovered in a shop a booklet published by *Valori Plastici* and devoted to the same painter. A unique emotion engulfed us. The encounter with the work of de Chirico was so overwhelming that it determined the point of departure for Magritte's research."[39] Indeed, according to Magritte's own account, the painting moved him to tears.[40]

De Chirico was the most important single influence on Magritte's development. Although Magritte's exposure some years later to Max Ernst's collage illustrations for two books of poems by Paul Eluard was also formative, Magritte, as Ernst had done before him, turned original collage usage to the purposes of de Chirico's very particular enigmatic juxtapositions and disconcerting contexts. Like de Chirico, Magritte sought to reveal through these devices, as well as by fusions and transparencies, the hidden affinities that link ordinary, even banal objects, endowing them with a mysterious poetic reality, one frequently characterized by a sense of menace, isolation, and silence.

Magritte, perhaps more than any of the other illusionist Surrealists, adhered to de Chirico's tenets of provoking disturbing relationships by stressing the disparity of scale between his incongruously conjoined images. Both Magritte and de Chirico altered the normal proportions of objects so that these elements could be experienced in a new and original manner. While this motif had evolved from collage, where images from different sources, having different scales, were merged in one work, Magritte's shifts in scale were heavily influenced by de Chirico's suggestion of physiological and psychological disorientation. Significantly, de Chirico makes excellent use of illogical scale in *The Song of Love,* the first work by de Chirico that Magritte saw, enabling a simple ball, rubber glove, and antique head to seem extraordinary and wondrous. Magritte employed this effect in 1925-26, the years he first began painting under de Chirico's influence, as is evidenced by the enormous baluster or bilboquet form in *The Difficult Crossing,* 1926, and he continued this technique throughout his career, as is beautifully shown in *Personal Values,* 1952.

Believing that the visible world provided more than an adequate source of images, Magritte avoided the invented forms that were used by other Surrealists—in which respect he was most akin to de Chirico. Indeed, even his anthropoid bilboquet form, his only imaginary form, recalls de Chirico's mannequin bodies, the de Chirico image which,

René Magritte. *The Midnight Marriage.*
1926-27
Oil on canvas, 54¾ x 41¾" (139 x 106 cm)
Musées royaux des Beaux-Arts de Belgique,
Brussels

René Magritte. *The Invisible World.* 1953-54
Oil on canvas, 76⅞ x 51½" (195.2 x 130.8 cm)
Private collection

René Magritte. *The Menaced Assassin.* (1926)
Oil on canvas, 59¼ x 6′4⅞" (150.4 x 195.2 cm)
The Museum of Modern Art, New York,
Kay Sage Tanguy Fund

while based on a real source, seems most fantastic. This resemblance would become even more pronounced in Magritte's later development of this motif. Magritte also depicted realistic armatures and wigs, as in *The Midnight Marriage,* 1926-27, again reminiscent of de Chirico (e.g., *The Two Sisters,* pl. 50).

Although Magritte did not develop fantastic imagery, he did employ disconcerting fusions—shoes sprout toes, eagles turn to stone—and depicted scenes of levitation and defiance of gravity. As with the other Surrealists, his imagery relied on Freudian theory. Witness his use of the cannon as a symbol of aggression and phallic power in *On the Threshold of Liberty,* 1929.

Like de Chirico and Ernst, Magritte had his own personal iconography, much of it derived from boyhood memories. But in many ways Magritte's iconography, although personal, recalls de Chirico's, if not in appearance then in spirit. For example, the monumental chunk of granite in *The Invisible World,* 1953-54, has great poetic power, comparable to that found in de Chirico's depiction of sculptures and mannequins, as in *The Seer* (pl. 55). In both paintings the central image sits isolated in the foreground, delineated by the clear light and marked by strong shadows. Magritte felt that if weight could play a role in poetry it would be evoked by stone, and he did not limit this poetic quality to giant boulders, but calcified living beings, even men.

There are, of course, instances where Magritte employs iconographic motifs similar to those used by de Chirico. Both artists depict simulated wood, a motif important as well for Ernst's discovery of frottage, and curtains (the curtain in the 1948 version of *Memory* recalls that in *The Child's Brain*). The appearance of antique sculptured heads in an architectural setting in Magritte's *Eternity,* 1935, as well as in his *Memory,* 1938,[41] is reminiscent of de Chirico's *The Song of Love.* The veiled faces in Magritte's paintings of 1928 also suggest stone sculpture—but this image probably relates to the memory of his mother; her face was covered by her clothing when she was found after drowning herself.

As was the case with Ernst, Magritte's creation of the dream image was largely derived from de Chirico's illusionistic representation of space. In *The Menaced Assassin,* 1926, Magritte uses the perspective lines of the floorboards to define the space extending from foyer to living room to landscape. De Chirico made similar use of perspective lines in many works, *The Seer,* for example. Magritte's abrupt shifts from distant vista to foreground objects may equally be judged to reflect de Chirico, who treated space theatrically, separating the stagelike foreground from the backdrop-type background.[42] James Thrall Soby has observed that *Young Girl,* 1922, painted the same year Magritte came to know de Chirico's work, already suggested de Chirico's influence by the theatrically exaggerated space found in the side wings of the composition.[43] Like de Chirico, Magritte alternated

between deep and shallow perspective and ranged from enormous panoramas to small enclosed spaces. In *The Invisible World* the giant rock is jammed into an unrealistically constricted area, while beyond the balcony the vista opens up to the sea and sky. And in common with de Chirico, Magritte evokes, through spatial manipulation, physiological sensations of being crowded or immobilized, inducing a similar oppression and claustrophobia. Compare, for instance, the zeppelinlike menacing loaves of *The Golden Legend,* 1958, with de Chirico's Ferrarese Metaphysical still lifes. However, while Magritte's composition is usually symmetrical, recedes in parallel planes, maintains a strict frontality, and consistently employs a more shallow space, de Chirico's space is irrational, distorted, angular, and foreshortened. Magritte approaches this style to a certain degree by breaking up the sky and earth into building blocks, as in *The Progress of Summer,* 1938, thereby recalling the confusing planes and platforms that figure in works such as de Chirico's *The Serenity of the Scholar* (pl. 35). On the whole, however, Magritte's overall treatment of space is dissimilar in feeling from de Chirico's, which, as we saw, was more closely approximated by Ernst's extreme treatment.

More directly related to de Chirico were a luminous treatment, a subtle blending of tone and light, and generalized, abstracted, unmodeled forms that enhanced the dream image and effected a sense of silence, stasis, and suspension of time capable of inducing calm and peace as well as dread. And echoing de Chirico, Magritte reinforces this otherworldly perception by frequently juxtaposing figures with their shadow or silhouette image. As the statue in de Chirico's *The Red Tower* (pl. 13) is rendered in a silhouette as if, Soby observes, it had been usurped by its own shadow,[44] so the figure in Magritte's *The Hunters at the Edge of Night,* 1928, seems to struggle with its own living, menacing shadow.

One theme that we saw Ernst derive from de Chirico was the contrast of solids and voids, indicative in Surrealist thought of the relationship between inner and outer consciousness. Magritte, who enjoyed contradictions, deals with this motif and other related spatial ambiguities as well. De Chirico examined the relationship between solidity and hollowness when he cut out parts of his mannequins to reveal interior structure. Magritte, too, contrasted the solid with the void by depicting holes through doors *(The Unexpected Answer,* 1933), an empty cross-section of a boot *(The Well of Truth,* 1963), an arrangement that suggests a human body when there is none *(The Therapeutist,* 1937).

However, Magritte's most significant exploration of this theme was to transmute this comparison from the void to the vaporous or transparent, as in *The Human Condition, I,* 1934. By doing so he could combine in one image, the window, many de Chiricoesque

René Magritte. *The Golden Legend.* 1958
Oil on canvas, 37⅜ x 50¾" (95 x 129 cm)
Private collection, New York
© A.D.A.G.P. 1982

René Magritte. *The Progress of Summer.* 1938
Oil on canvas, 23⅝ x 28¾" (60 x 73 cm)
Private collection

René Magritte. *The Human Condition, I.* 1934
Oil on canvas, 39⅜ x 31½" (100 x 80 cm)
Private collection

Yves Tanguy. *He Did What He Wanted.* 1927
Oil on canvas, 31⅞ x 25⅝" (81 x 65 cm)
Richard S. Zeisler Collection, New York

innovations. Thus, beginning with his works of 1926, Magritte employed the image of the picture-within-a-picture. Although this might take the form merely of a reshuffling of pictorial images within separate frames or compartments, as in *The Difficult Crossing,* 1926, or *Act of Violence,* 1931-32, which recall de Chirico's Metaphysical interiors or his earlier *The Endless Voyage* (pl. 43), more specifically it echoes de Chirico's presentation of the subimage not as a self-contained painting, but ambiguously "continuous with the illusion of the painting's space as a whole."[45] De Chirico depicts this in *The Double Dream of Spring* (pl. 54), "where the retreating orthogonals of the center ground connect with those of the picture-within-a-picture in the foreground"[46] to make the illusion consistent. Magritte develops this theme to its furthest implications in *The Human Condition, I,* where, because a portion of the landscape is precisely covered by a painting of that portion, we feel as if we are looking through clear glass rather than at a painting.

Moreover, the use of the window permits Magritte to place inside a room a painting of an outdoor scene, and thereby bring together the two realms of exterior and interior.

> For the spectator [the landscape] was simultaneously inside the room, in the picture, and outside, in the real landscape, in thought. Which is how we see the world, namely, outside of us, though having only one representation of it within us. Similarly, we sometimes situate in the past something going on in the present. Time and space then lose that unrefined meaning in which daily experience alone takes stock.[47]

De Chirico, too, delighted in depicting this ambiguity. In *The Seer* (pl. 55) the planked floor suggests an interior setting, yet the scene occurs outside the church. The Metaphysical interiors, in contrast, bring an outdoor landscape inside an enclosed room. De Chirico also enjoyed combining several temporal illusions within one work. This theme of contrasting time and place is beautifully choreographed in de Chirico's *The Astronomer* (pl. 51). Marianne Martin, in her analysis of de Chirico's Metaphysical painting, discusses how the multiwindowed or multieyed sunlit building in this painting is paired with the black picture of celestial night (the "window" partly revealing infinite space and time) on the easel within.[48] Similarly Magritte, in the series entitled *The Empire of Light,* presented two different time periods, night and day, within the same painting. To some extent Ernst also portrayed this contradiction in his *Day and Night.*

These intertwined themes of windows, apertures, transparencies, "pictures-within-a-picture," exploring the difference between the real two-dimensional surface of the canvas and illusory three-dimensional depth, and the intermingling of different spatial and temporal periods, relate to the Surrealist concept of a different level of reality where dream and physical reality, the subconscious and conscious converge. Perhaps because they are representing the juncture of the inner and outer worlds, de Chirico and Magritte frequently eliminate the physical eye or face. De Chirico's mannequins lack faces. The faces of Magritte's figures are either turned away or concealed by another image, or else the figures are decapitated, as in *The Horns of Desire,* 1960, a work recalling de Chirico's armless mannequins and Ernst's figures that similarly lack vital parts. Again, in *The Serenity of the Scholar* (pl. 35), the statue's head is neatly cut off from view, although the gargantuan eyeglasses are prominently displayed.

In treating these themes de Chirico understood the emotional power generated by certain architectural forms, such as windows. Directed toward this concern by the Austrian philosopher Otto Weininger, de Chirico wrote: "In Giotto, too, the architectonic sense creates great metaphysical spaces. All the openings (doors, arcades, windows) that accompany his figures portend the cosmic mystery."[49] He further regarded geometric forms to be invested with symbolic content:

> Symbols of a superior reality are often to be seen in geometric forms. For example, the triangle has served from antiquity…as a mystical and magical symbol, and it certainly often awakens a sense of uneasiness and even of fear in the onlooker.[50]

Although Magritte disclaimed any interest in symbols, feeling that his paintings had their own irreducible meaning, he recounts finding door moldings endowed with mysterious

life, and he believed that standardized forms were necessary for perfection. Thus he gives preponderant importance to circular and square shapes, as in *Mental Arithmetic,* 1931. Both artists, in addition, employed shaped or irregular canvases. We see this in de Chirico's *The Serenity of the Scholar* (pl. 35) and *The Enigma of Fatality* (pl. 37) and in the oblique slant of *Evangelical Still Life* (pl. 68). Magritte uses a curious compartmental format in *The Eternal Evidence,* 1930, although this is more a development of his interest in polyptychs than a result of de Chirico's influence. He does, however, portray an off-square window in *Natural Encounters,* 1945.

The writings of the two artists also reveal strong ties, and even the poetic titles of their paintings are similar in their ambiguous, nondescriptive, nonexplanatory nature. This is true of Ernst, Tanguy, and Dali as well.[51] In writing about de Chirico, Magritte said, "He is actually the first painter to have thought of making painting speak of something other than painting,"[52] and in referring to *The Song of Love* he says that the de Chirico "deals with poetry's ascendancy over painting and the various manners of painting. Chirico was the first to dream of *what must be painted* and not *how to paint.*"[53] Both artists painted with clarity, determined not to obscure the purity of their image.

Moreover, both Magritte and de Chirico elucidated the difference between the phenomenal and metaphysical worlds and believed that certain images shared a secret affinity. De Chirico declared, "The dormer windows on the roofs of the houses in Paris always produce a strange impression in me...I see a link between the dormer window and the red trousers of the French soldier, and the characters of the revolution, and a thousand other things I cannot explain, and this is true for all peoples, all periods, all countries."[54]

Both artists manifested these concepts in their painting by combining seemingly unrelated objects that nevertheless share poetic relationships. Magritte, however, advanced a deliberate system in which objects formed a specific response to one another, while de Chirico's juxtapositions remained more ambiguous and enigmatic.

Yves Tanguy. *The Storm.* 1926
Oil on canvas, 32 x 25¾" (81.3 x 65.5 cm)
Philadelphia Museum of Art,
The Louise and Walter Arensberg Collection

Tanguy's decision to become an artist was determined in 1923 by his encounter with the work of de Chirico, whose paintings he declared to be the greatest of his time.[55] Indeed, Tanguy's earliest paintings, which juxtapose irrationally combined figures of ambiguous scale, were clearly derived from de Chirico, as well as from collage as it was developed by Ernst. Elements of Tanguy's iconography in these early paintings also find precedence in de Chirico. In *He Did What He Wanted,* 1927, the inverted pyramid bearing letters reflects shapes and colors employed by de Chirico, not only in the paintings of his Ferrarese period, as Soby pointed out, but also in works of 1914-15 such as *Still Life "Torino 1888"* (pl. 49). Tanguy's wraithlike ribbony figures appearing here and in other early works such as *The Storm,* 1926, are anticipated by the romantic Böcklinesque de Chirico figures found in *The Delights of the Poet* (pl. 16) or *The Enigma of the Hour* (pl. 10). His lacy, cloudlike forms echo de Chirico's puffs of smoke from locomotives, an image often combined in de Chirico's backdrops with boats and squat towers, all of which appear in Tanguy. One early work, *The Lighthouse,* 1926, which combines several of these elements, also displays an anatomical view of a man familiar from de Chirico.

However, as Tanguy matured, he developed his own unique iconography, which he consistently employed from 1927 until his death. His images, culled from subconscious fantasy, suggested the vegetal and mineral forms of an underwater landscape or desert wasteland, and now bore little resemblance to de Chirico's representation of recognizable real objects. Moreover, the biomorphic construction of this imagery pertained to the abstract branch of Surrealist art, to Arp and Miró, rather than de Chirico.

Yet de Chirico continued to exert a strong influence on Tanguy's painting—if not on his imagery, then on the style he had similarly formed and consolidated by 1927. The deep, illusionistic space with high horizon and small band of sky is reminiscent of the format of de Chirico's piazzas, and the plunging perspective that became the basis of Tanguy's art was inspired by de Chirico. Tanguy also emphasized the sensation of vast space by illogically scaling down the background figures—a device employed by

Yves Tanguy. *The Lighthouse.* 1926
Collage with matches, cardboard and paper,
24 x 19¾" (61 x 52.2 cm)
Private collection

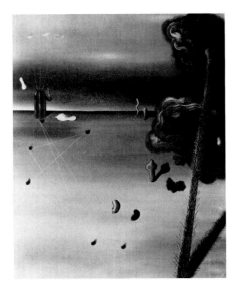

Yves Tanguy. *Mama, Papa Is Wounded!* 1927
Oil on canvas, 36¼ x 28¾″ (92.1 x 73 cm)
The Museum of Modern Art, New York,
purchase

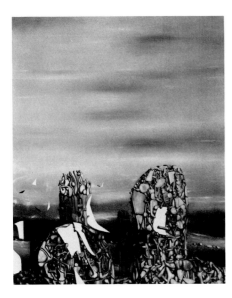

Yves Tanguy. *The Hunted Sky.* 1951
Oil on canvas, 39⅛ x 32⅜″ (99.3 x 82.3 cm)
Private collection

de Chirico and Ernst. This format also existed in Tanguy's pre-1926 paintings, few of which survive. It has been frequently noted that the deep, distorted perspective, high horizon line, and architectural forms of his *Rue de la Santé,* 1925, reflect de Chirico's Italian city scenes.

By 1929 Tanguy had reversed the proportion of earth to sky, and eventually he suppressed the horizon line altogether, merging land, sky, and water into one atmospheric, emphatically ambiguous background on which objects float mysteriously. Although his use of modulated tones of continuous aerial perspective to form the illusion of distance differs from de Chirico's treatment of space, both in its lack of obvious perspective lines and orthogonals and in its consistent projection into depth (instead of a division into foreground and background), Tanguy does reflect aspects of de Chirico's distortion in the ambiguous field he creates. As Soby has observed, the superimposed cats-cradle linear perspective web which Tanguy incorporates into his paintings beginning in 1927 — for example, in *Mama, Papa Is Wounded!,* 1927 — and which becomes more pronounced in later works, heightens the illusion of limitless space by manipulating perspective in a twofold manner, from far to near and high to low.[56] This contrast between depth and height is reinforced by objects and their shadows that drift across this vertical space. The spatial tension thus produced had been achieved previously by de Chirico, notably in the aerial viewpoint of *The War* (pl. 63). Tanguy further distorts perspective by mingling solid and vaporous elements, by depicting in one work objects that range from opaque to transparent — a theme directly derived from de Chirico and developed, as we have seen, in a variety of ways by Ernst and Magritte.

Tanguy was drawn to de Chirico's eerie, pristine light and dense, elongated shadows. And while not seeming quite as immobile as de Chirico's, Tanguy's paintings impart a similar sense of silent, empty space, of loneliness, of the calm yet menacing world of dream.

Furthermore, even though Tanguy's biomorphism has little in common with de Chirico's imagery, when Tanguy depicts his imagined shapes he presents them with a hallucinatory force that gives them as strong a reality as that of de Chirico's objects — just as for de Chirico Böcklin's technique had made the unreal appear real and the real, imaginary. In addition, Tanguy's shapes occasionally take on anthropomorphic characteristics reminiscent of the Italian's work, especially in Tanguy's later paintings such as *The Hunted Sky,* 1951, where small bonelike shapes coalesce into two forms that resemble the mannequins of de Chirico's *The Two Sisters* (pl. 50), or as in *The Furniture of Time,* 1939, where intricately combined, elongated configurations recall the humanoid scaffold structure of de Chirico's *The Great Metaphysician* (pl. 73). William Rubin has noted that the posture and the position of the form on the left of *A Large Picture Which Is a Landscape,* 1927, reflect de Chirico.[57] And the cactuslike shape in *Mama, Papa Is Wounded!* recalls the curtain of *The Child's Brain* (pl. 33); the Tanguy, whose title is taken from a psychiatric case history, manifests the psychosexual elements contained in the earlier painting.

While Tanguy said and wrote little about his art, the few statements he made reiterate de Chirico's sentiments. He had a poetry of the invisible as well as the visible: "It amuses me to imagine what is beyond a hill. I want so much to represent those things behind the hill that I will never see."[58] These remarks are not unlike some of de Chirico's:

The square of sky outlined by a window is a second drama inserted into that enacted by the figures. Indeed, more than one disturbing question comes to mind when the eye meets that blue or greenish sky, enclosed by the lines of geometricized stone: *What lies beyond? Perhaps that sky lies over a deserted sea or a populated city? Or perhaps it stretches over a great expanse of free and restless nature, wooded mountains, dark valleys, and plains gouged out by rivers?...*[59]

There are, of course, many ways in which Tanguy diverges from de Chirico. These include depiction of scenes of levitation, a theme explored by Magritte, visible in Tanguy's earliest works and continuing throughout his oeuvre; the strong modeling in the round, unlike de Chirico's and even Magritte's flat, abstracted forms that adhere to the

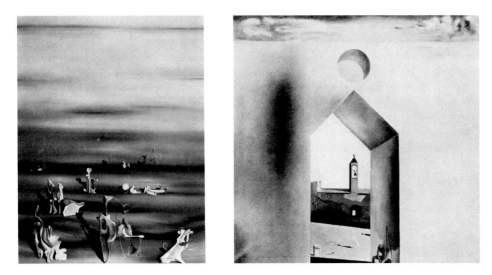

Yves Tanguy. *The Furniture of Time.* 1939
Oil on canvas, 46 x 35¼" (116.9 x 89.5 cm)
The Museum of Modern Art, New York,
James Thrall Soby Bequest

Salvador Dali. *Nostalgic Echo.* 1935
Oil on canvas, 38¼ x 38¼" (97.2 x 97.2 cm)
Private collection

surface and negate perspective; and in most instances the pure, smooth-finished surface which, like Magritte's and Dali's, is free of brushwork, impasto, or texture. Yet Tanguy's shapes, space, shadow, and light indelibly mark him with de Chirico's influence.

There were other Surrealist artists who, while they did not experience as intense a reaction to de Chirico as did Ernst, Magritte, and Tanguy, nevertheless assimilated aspects of his art. Among these must be counted Salvador Dali, who, according to Breton, "for three or four years…incarnated the Surrealist spirit."[60]

By 1923 Dali knew of the Scuola Metafisica through reproductions published by *Valori Plastici.* Much of Dali's work of the second half of the 1920s, although derived directly from several of the Surrealists, assumed those elements of de Chirico's art that had similarly attracted Tanguy, chiefly the manner in which de Chirico used deep perspective. Dali, like de Chirico, emphasized depth by a rapid scaling down of background figures and landscape; he also used dramatically receding walls and arches and mysterious light and irregular shadows to depict a vast, empty space. As had de Chirico, Dali employed perspective for its poetic force, for its ability to create a dream world in which rational order was wrenched and disrupted. Dali created this sense of disruption by juxtaposing distant scenes with near surfaces and by freeing enigmatically combined objects from the requirements of logical scale.

Much of Dali's iconography is directly indebted to de Chirico as well. Dali's frequent small background figures echo those found in such de Chirico works as *The Double Dream of Spring* (pl. 54). Soby has observed the affinity of the tiny girl skipping rope in Dali's *Nostalgic Echo,* 1935, to the girl in *The Mystery and Melancholy of a Street* (pl. 31),[61] an image that similarly inspired Ernst; and William Rubin, in his thorough analysis of Dali's iconography,[62] has traced the development of such Dalinian themes as the shamed son and bearded father to de Chirico's *The Prodigal Son* and *The Child's Brain.* Rubin also discusses the precedents in de Chirico for Dali's images of the boxed picture within a picture, the strong elongated shadow cast by an unseen presence, and the seamed cephalic shape with a toupee. But while Dali, as de Chirico, presents real objects, his iconography has abnormal, terrifying associations, whereas de Chirico's imagery provides a generalized sense of the malaise and oppression encountered in ordinary dreams.

De Chirico's influence is also seen in Dali's frequent use of hollow and transparent forms. The woman in the Freudian guise of a vessel shown in hollow cross-section in *Portrait of Paul Eluard,* 1929, reflects de Chirico's hollow metal mannequin heads, just as Dali's anatomical views, especially of hands, recall works such as de Chirico's *Span of Black Ladders* (pl. 44). And when Dali paints a figure with a hole cut where the heart should be, as in *Atavism of Twilight,* 1933, or a woman's body from which a wardrobe-

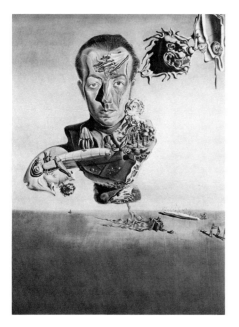

Salvador Dali. *Portrait of Paul Eluard.* 1929
Oil on cardboard, 13 x 9⅞″ (33 x 25.1 cm)
Private collection

André Masson. *The Four Elements.* 1923-24
Oil on canvas, 28¾ x 23⅝″ (73 x 60 cm)
Private collection

shaped portion has been removed, as in *The Weaning of Furniture-Nutrition,* 1934, he echoes de Chirico's *I'll be there…The Glass Dog* (pl. 42). Moreover, Dali's "paranoiac-critical method," whereby the sight of any object provokes the vision of one or more counterappearances, and the system of multiple images that Dali developed to accommodate this hallucinatory power, as, for example, in *The Invisible Man,* 1929-33, are again suggestive of de Chirico's transparent and hollow images.

Other Surrealist artists were influenced to varying degrees by de Chirico's innovative and dramatic concepts. André Masson, known primarily, like Miró, for his automatic, abstract Surrealist paintings, nevertheless admired de Chirico, as seems evident in his paintings of 1923-24. These works employed a semiillusionistic but disoriented and inconsistent space, similar to de Chirico's. Moreover, Chiricoesque iconographical themes proliferate in Masson's paintings of this period: boxlike forms and architectural partitions; enlarged still-life elements; detached hands; mannequin figures and statues; and draftsman's triangles (depicted also by Miró in several of his paintings of the 1920s). A most obvious kinship exists between Masson's *The Four Elements,* 1923-24, and *The Song of Love* (pl. 34).

Giacometti's platform sculptures with their empty open spaces echo de Chirico's piazzas, transposing his illusionism to the third dimension and evoking comparable sensations of silence and isolation. De Chirico provided the impetus for the spatial recession in Victor Brauner's paintings of the early 1930s—and also for Brauner's mannequin figures. The oversized images in Man Ray's Surrealist works are reminiscent of de Chirico's outsized juxtapositions. Likewise, as noted by Diane Waldman, a number of Arshile Gorky's "Nighttime, Enigma, and Nostalgia" drawings of the early 1930s are indebted to de Chirico's *The Fatal Temple* (pl. 39) for their imagery (fish form and double-profiled figure), the compartmentalized space, deep recession, and stark lights and shadows; even the evocative title of this series is imbued with de Chirico's spirit.[63]

Although not formally a Surrealist, Paul Delvaux drew on de Chirico's perspectival vistas and, like de Chirico, emphasized the depth of his space by placing tiny, scaled-down figures in his backgrounds. Picasso, also not a Surrealist although a participant in their events, may likewise have been influenced by de Chirico. John Russell has observed the relationship of Picasso's chairlike figure in the 1933 etching *Model and Surrealist Sculpture* to de Chirico's drawings of semimannequin and semiscaffolding figures such as *The Mathematicians* (pl. 109).[64] And while Joseph Cornell never officially belonged to the Surrealists, he was influenced by them and de Chirico and shared their spirit. His boxes bring de Chirico's space into the realm of three dimensions, and his crowding of objects into these boxes is suggestive of de Chirico's sealed Metaphysical interiors. Moreover, Cornell invests his works with a poetic mystery by juxtaposing unrelated ordinary objects. Like de Chirico, he created a sense of isolation, immobility, and nostalgia for past time. However, this last aspect was one characteristic of de Chirico not widely ascribed to the Surrealists, who generally broke with the past.

It is of course true that de Chirico's paintings are certainly recognizably different from the Surrealists' and that the affinities that linked de Chirico with the Surrealists also made them susceptible to other forerunners. They intuited relationships with and absorbed ideas from many movements and precursors, all of whom conveyed an enigmatic, visionary quality. As these antecedents frequently exerted influence on de Chirico himself as well as upon the Surrealists, his contribution to Surrealism often overlaps with that of these precursors.

If Magritte's domestic interiors with ordinary objects and views through windows remind us of de Chirico's Metaphysical interiors, they also reflect Flemish art, which similarly conveys a sense of quiet and suspended time. De Chirico's work recalls Uccello in its obsessive use of orthogonals, simplified forms, and stagelike, backdrop effect. In the first Surrealist manifesto Breton listed Uccello, along with de Chirico, as a painter of interest to Surrealism, and Uccello was a significant source for Gorky. Like Uccello, Piero della Francesca elicits a sense of mystery and suspended time, and his depiction of the Renaissance square, with its arcades, geometries, and strong lights and shades, antici-

pated and attracted de Chirico. The belief that inner and outer realities coincide extends beyond de Chirico to German Romanticism, from which much of the dream landscapes of Dali, Tanguy, and Ernst derives. Klinger and Böcklin deeply affected both Ernst and de Chirico, and Dali declared Böcklin to be one of the master artists of all times. De Chirico as well as the Surrealists was inspired by Seurat's ability to portray stasis and silence and by his mysterious, inconsistent lighting and "reversal of the role and meaning of perspective."[65] Rousseau, too, anticipated Surrealism in his belief in apparitions, and in his presentation of the dream image through simplified forms and enigmatic light, but many of Rousseau's precedents were transmitted to the Surrealists only through de Chirico.[66] Even the abstract, unmodeled surfaces that Ernst and Magritte adopted from de Chirico could equally well derive from the prismatic overlapping planes of Orphism. Soby believed de Chirico too may have been influenced by this movement: "I can see — at least think I can see — some affinity between the labyrinths of the early Delaunay and those of de Chirico, even if the color and drawing are entirely different."[67]

Yet de Chirico was unique in the dramatic and effective manner in which he brought together and conveyed these enigmatic and visionary concepts. He more than any of these other precursors served to inspire the illusionist Surrealists and to define the direction of their art. Drawn to the irrational, dreamlike, yet representational three-dimensional world he created, attracted by his affirmation of the poetic, emotive quality of deep perspective, they sought to echo his vast, illusionistic, albeit distorted space. Employing his illogical juxtapositions, irrational scale, and hallucinatory light and shadows, they similarly created disturbing relationships. All pursued his depiction of transparent and hollow images, a motif which became a major Surrealist theme. All shared a related poetic aim with de Chirico, and directly assimilated many of his stylistic ideas and iconographic forms.

Notes

1. Interview of Breton by Charles Henri Ford in *View*, Surrealist Number, Oct.-Nov. 1941, p. 2. Breton would have been familiar with de Chirico's work prior to this encounter with *The Child's Brain.*

2. André Breton, "Entrée des médiums," *Littérature*, Nov. 1, 1922, p. 2. Cited in William S. Rubin, *Dada and Surrealist Art* (New York: Abrams, 1968), p. 121. The earliest reference to "surréalisme" was made by Apollinaire in 1917.

3. André Breton, *Manifeste du Surréalisme* (Paris: 1924), p. 42.

4. Giorgio de Chirico, "Sull'arte metafisica," *Valori Plastici*, vol. I, nos. IV-V, Apr.-May 1919, p. 15. Cited in *Metaphysical Art* (New York: Praeger, 1971), p. 87.

5. De Chirico, manuscript written in Paris during 1911-15. Cited in James Thrall Soby, *Giorgio de Chirico* (New York: Museum of Modern Art, 1955), p. 244.

6. For a discussion of de Chirico's reversal of fifteenth-century perspective, see Rubin, *Dada and Surrealist Art*, pp. 132-34.

7. De Chirico, 1911-15 manuscript. Cited in Soby, *Giorgio de Chirico*, p. 246.

8. André Breton, *Genesis and Perspective of Surrealism*, 1941. Cited in André Breton, *What Is Surrealism? Selected Writings*, ed. Franklin Rosemont (Monad Press, 1978), p. 223.

9. Ibid., p. 221.

10. André Breton. Cited in Soby, *Giorgio de Chirico*, p. 160.

11. Breton, *Le Surréalisme et la peinture*, 1928. Cited in André Breton, *Surrealism and Painting*, trans. Simon Watson Taylor (New York: Harper & Row, Icon Editions, 1972), p. 13.

12. William S. Rubin, *Dada, Surrealism, and Their Heritage* (New York: Museum of Modern Art, 1968), p. 80.

13. Replies to a questionnaire were published: "Sur les possibilités irrationnelles de pénétration et d'orientation dans un tableau — Giorgio de Chirico: L'Enigme d'une journée," *Le Surréalisme au Service de la Révolution*, May 15, 1933, pp. 13-16. Cited in Soby, *Giorgio de Chirico*, p. 70.

14. According to Ernst this painting "helped propel him and numerous other German and Swiss Dadaists in the direction of Surrealism." Soby, *Giorgio de Chirico*, p. 76.

15. Lucy R. Lippard, "Dada into Surrealism," *Artforum*, Sept. 1966, p. 13.

16. Soby, *Giorgio de Chirico,* p. 152.

17. For a discussion of differences between de Chirico and Carrà, see Caroline Tisdall, "Historical Foreword," in *Metaphysical Art* (New York: Praeger, 1971), p. 14.

18. Diane Waldman in the catalog *Max Ernst* (New York: Solomon R. Guggenheim Museum, 1975), pp. 32, 42.

19. Lippard, "Dada into Surrealism," p. 13.

20. Rubin, *Dada and Surrealist Art,* pp. 96-98.

21. Lippard, "Dada into Surrealism," p. 15.

22. Soby, *Giorgio de Chirico,* p. 28.

23. Ibid., pp. 54-55.

24. Akin to their interest in Freud was the Surrealists' involvement in the art of children and the insane, for they believed both these groups capable of an inner vision. De Chirico, too, wrote of the mentality of children (see n. 30 below) and in this anticipated Surrealism.

25. Rubin, *Dada and Surrealist Art,* p. 132. One other movement deeply attracted the Surrealists because its reliance on myth, ritual, and sexual symbolism supported Freud's belief in the collective consciousness. This was primitive art, which like de Chirico's paintings manifested "super-normal presences." Archer and Melville have written: "There is no evidence that Chirico was actually influenced by primitive art, but some of his stylistic methods and the content of his compositions are in correspondence with some of the ancestor figures of Negro and, more especially, Oceanic art. His paintings, in fact, are the bridge by which surrealist poets and painters crossed into the mysterious and remote territory of Oceanic form." W. G. Archer and Robert Melville, *40,000 Years of Modern Art* (London: Institute of Contemporary Arts, 1949), p. 27. There is little evidence to suggest that de Chirico was responsible for the Surrealists' interest in this art form.

26. Rubin, *Dada and Surrealist Art,* p. 146.

27. Ibid., p. 145.

28. Waldman, *Max Ernst,* p. 31. The de Chirico image itself paraphrases a similar child in Seurat's *La Grande Jatte,* as Soby observes, *Giorgio de Chirico,* p. 74.

29. Ernst, "Au-delà de la peinture," *Cahiers d'Art,* vol. II, no. 6/7, 1936, pp. 169-72; English translation in *Beyond Painting* (New York: Wittenborn, Schultz, 1948), p. 13.

30. De Chirico, 1911-15 manuscript. Cited in Soby, *Giorgio de Chirico,* p. 245.

31. Ernst. Cited in Waldman, *Max Ernst,* p. 43.

32. Ibid.

33. Ernst. Cited in the catalog *Max Ernst* (New York: Museum of Modern Art, 1961), p. 8.

34. Magritte, letter to Mr. and Mrs. Barnet Hodes, 1957. Cited in *Magritte* (Chicago: William and Noma Copley Foundation, n.d.), p. 5.

35. De Chirico, 1911-15 manuscript. Cited in Soby, *Giorgio de Chirico,* p. 246.

36. Breton, *Nadja.* Cited by Edward B. Henning in the catalog *The Spirit of Surrealism* (Cleveland: Cleveland Museum of Art, 1979), p. 28.

37. Suzi Gablik, "A Conversation with René Magritte," *Studio International,* Mar. 1967, p. 129.

38. De Chirico, 1911-15 manuscript. Cited in Soby, *Giorgio de Chirico,* p. 245.

39. E. L. T. Mesens, "René Magritte," *Peintres belges contemporains* (Brussels: Editions Lumière, [1945]), p. 158. Cited in Soby, *Giorgio de Chirico,* p. 76.

40. René Magritte, "Esquisse Auto-biographique," *L'Oeuvre de René Magritte* (Brussels: Editions de la Connaissance, 1962), p. 17. Cited in James Thrall Soby in the catalog *René Magritte* (New York: Museum of Modern Art, 1965), p. 8.

41. Rubin, *Dada and Surrealist Art,* pp. 199-200.

42. See n. 6 above.

43. Soby, *René Magritte,* p. 9.

44. Soby, *Giorgio de Chirico,* p. 50.

45. Rubin, *Dada and Surrealist Art,* p. 205.

46. Ibid., p. 134.

47. René Magritte, "Lifeline," *View,* Dec. 1946, p. 22.

48. Marianne W. Martin, "Reflections on De Chirico and *Arte Metafisica*," *Art Bulletin,* June 1978, p. 350.

49. Giorgio de Chirico, "Il senso architettonico nella pittura antica," *Valori Plastici,* vol. II, nos. V-VI, May-June 1920, p. 60. Cited in *Metaphysical Art,* p. 95.

50. De Chirico, "Sull'arte metafisica," p. 17. Cited in *Metaphysical Art,* p. 91.

51. For a discussion of the importance of enigmatic, poetic titles to the Surrealists, see Rubin, *Dada and Surrealist Art,* pp. 96, 205, 228.

52. Magritte, letter to André Bosmans, Mar. 27, 1959. Cited in Harry Torczyner, *Magritte: Ideas and Images* (New York: Abrams, 1977), p. 66.

53. Magritte, letter to James Thrall Soby, May 20, 1965. Cited in Soby, *Magritte,* p. 8.

54. De Chirico, 1911-15 manuscript. Cited in Soby, *Giorgio de Chirico,* p. 246.

55. James Thrall Soby, *The Early Chirico* (New York: Dodd, Mead, 1941), p. 96.

56. James Thrall Soby in the catalog *Yves Tanguy* (New York: Museum of Modern Art, 1955), p. 15.

57. Rubin, *Dada and Surrealist Art,* p. 196.

58. Julien Levy, "Tanguy, Connecticut, Sage," *Art News,* Sept. 1954, pp. 24-27. Cited in George Heard Hamilton, *Painting and Sculpture in Europe: 1880-1940* (Baltimore: Penguin Books, 1972), p. 404.

59. Giorgio de Chirico, "Il senso architettonico nella pittura antica," p. 60. Cited in *Metaphysical Art,* p. 95.

60. André Breton, *Entretiens 1913-1952* (Paris: Gallimard, 1952), p. 161. Cited in Rubin, *Dada and Surrealist Art,* p. 213.

61. Soby, *Giorgio de Chirico,* p. 150.

62. Rubin, *Dada and Surrealist Art,* pp. 220-32.

63. Diane Waldman in catalog *Arshile Gorky* (New York: Solomon R. Guggenheim Museum, 1981), p. 31.

64. John Russell, *The Dominion of the Dream,* vol. 7 of *The Meanings of Modern Art* (New York: Museum of Modern Art, 1975), p. 30.

65. Rubin, *Dada and Surrealist Art,* p. 129.

66. Ibid., p. 127.

67. Soby, letter to James W. Alsdorf, Nov. 16, 1963. From the James Thrall Soby Papers in The Museum of Modern Art Library, New York.

Plates

In plate captions, height precedes width. Unless otherwise specified, drawings are works on paper, for which sheet sizes are given.

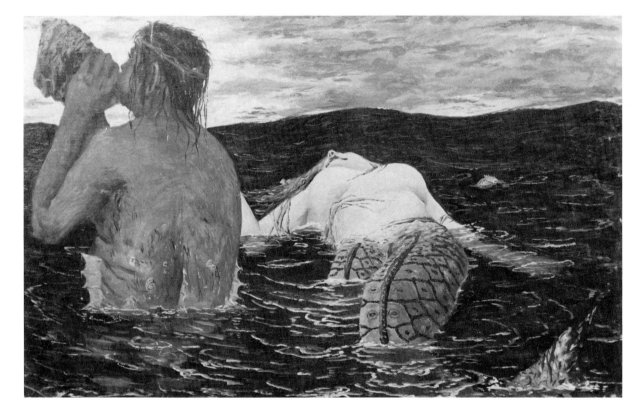

Pl. 1. *Triton and Mermaid.* 1909
Oil on canvas, 33½ x 55⅛″ (85 x 140 cm)
Private collection, Florence

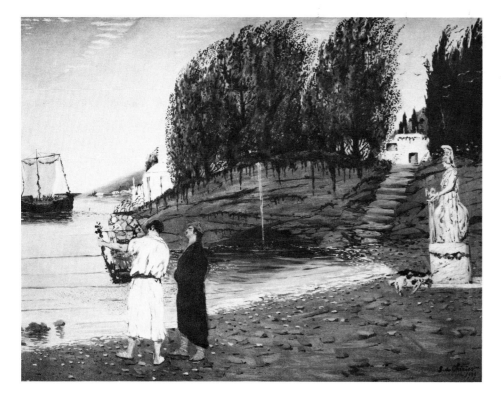

Pl. 2. [*The Departure of the Argonauts.*] 1909
Oil on canvas, 28¾ x 36¼″ (73 x 92 cm)
Collection Claudio Bruni Sakraischik, Rome

Pl. 3. *Serenade.* 1909
Oil on canvas, 32¼ x 47¼″ (82 x 120 cm)
Staatliche Museen zu Berlin,
Nationalgalerie, D.D.R.

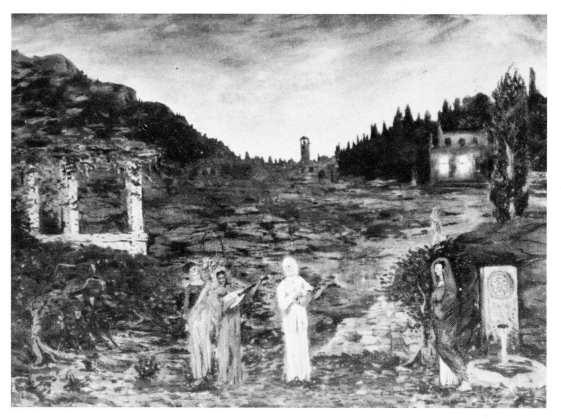

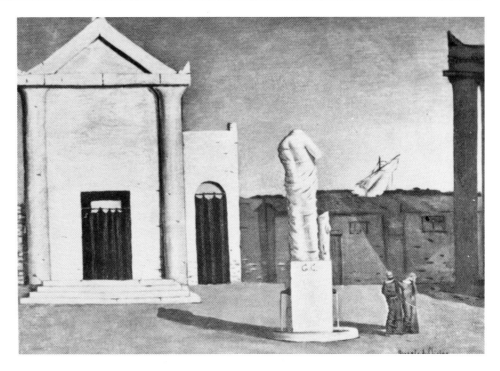

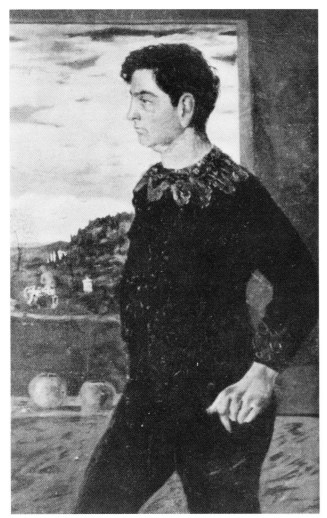

Pl. 4. *The Enigma of an Autumn Afternoon.* 1910
Oil on canvas, c. 14 x 18″ (35.5 x 45.7 cm)
Private collection

Pl. 5. [*Portrait of Andrea de Chirico (Alberto Savinio).*] 1910
Oil on canvas, 46⅞ x 29½″ (119 x 75 cm)
Staatliche Museen zu Berlin, Nationalgalerie, D.D.R.

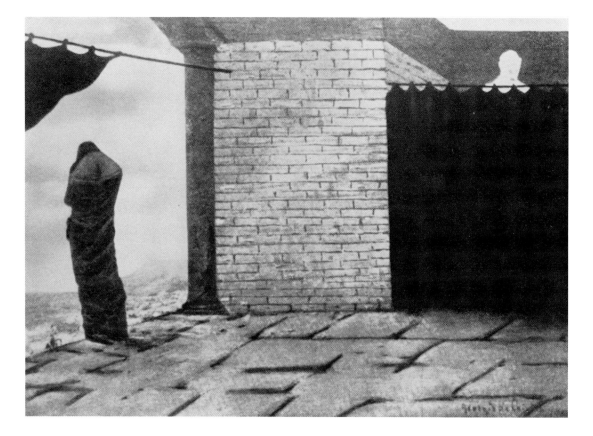

Pl. 6. *The Enigma of the Oracle.* 1910
Oil on canvas, 16½ x 24″ (42 x 61 cm)
Private collection

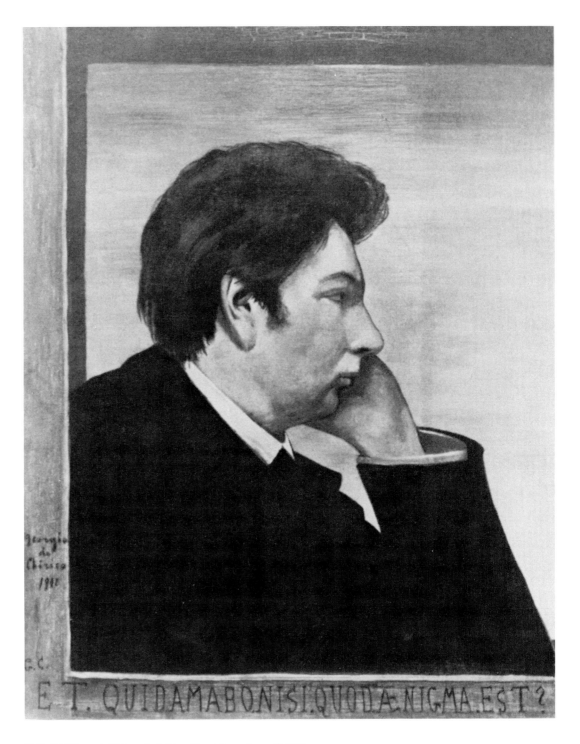

Pl. 7. *Self-Portrait (What shall I love if not the enigma?)*. 1911
Oil on canvas, 28½ x 21⅝″ (72.4 x 55 cm)
Private collection

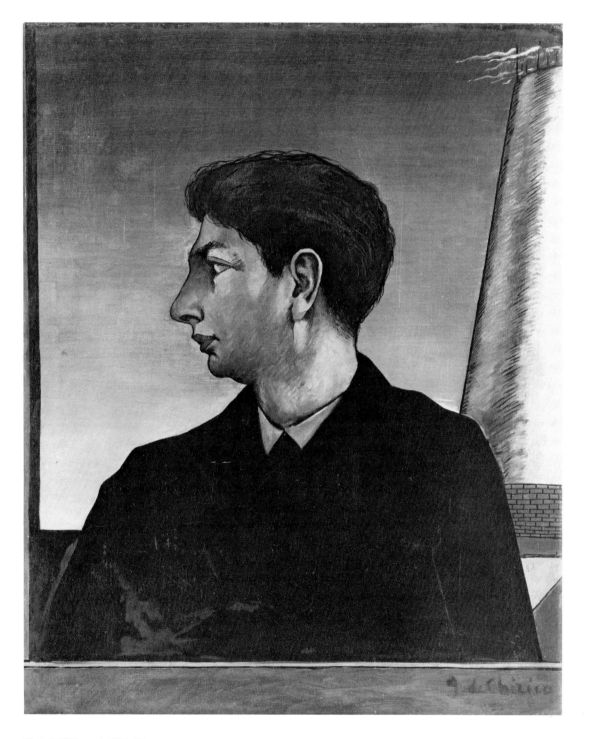

Pl. 8. *Self-Portrait.* 1911–12
Oil on canvas, 34⅜ x 27½″ (82.5 x 68.5 cm)
The Metropolitan Museum of Art, New York, gift
in memory of Carl Van Vechten and Fania Marinoff
Copyright © 1981 The Metropolitan Museum of Art

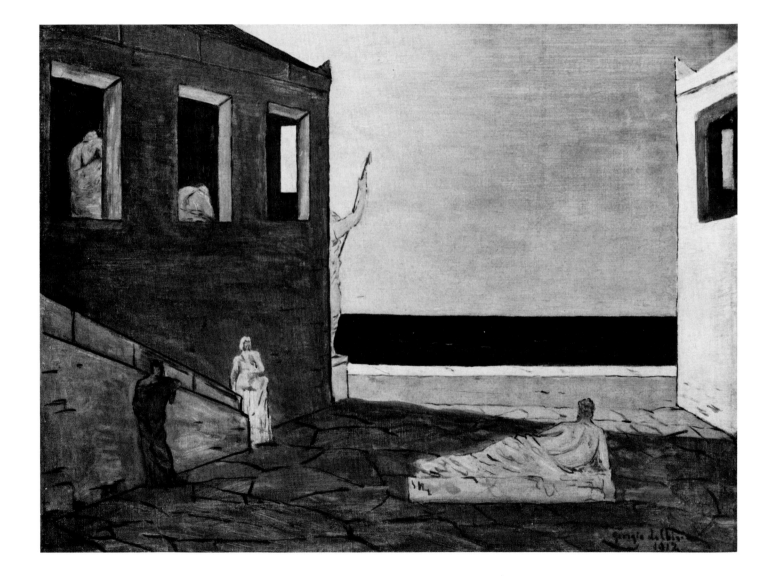

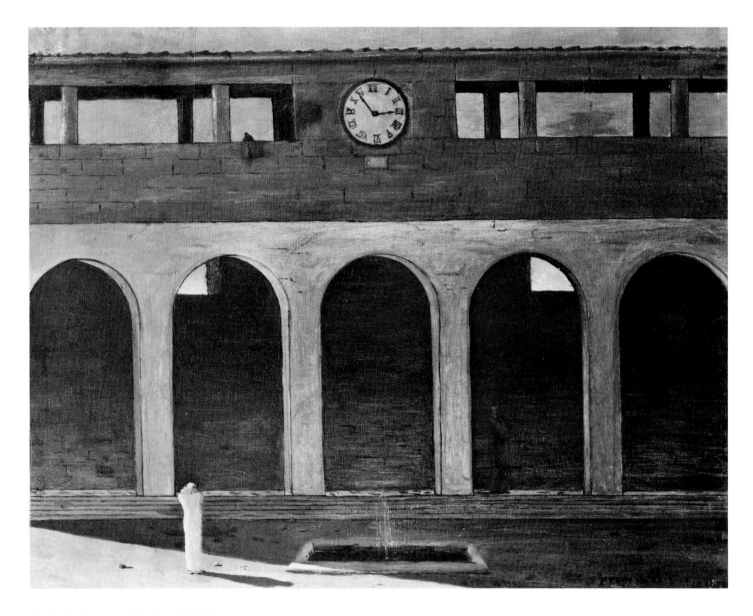

Pl. 10. *The Enigma of the Hour.* 1911–12
Oil on canvas, 21⅝ x 27⅞" (55 x 70.8 cm)
Private collection

Pl. 9. *Morning Meditation.* 1912
Oil on canvas, 20½ x 28" (52 x 71 cm)
Riccardo and Magda Jucker Collection

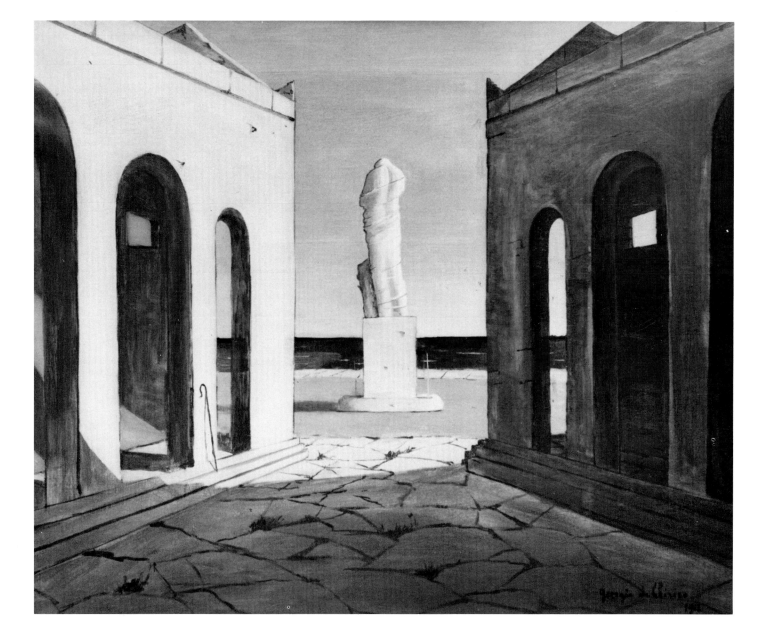

Pl. 11. *Autumnal Meditation.* 1912
Oil on canvas, 21 x 27½″ (53.3 x 69.8 cm)
Private collection, U.S.A.

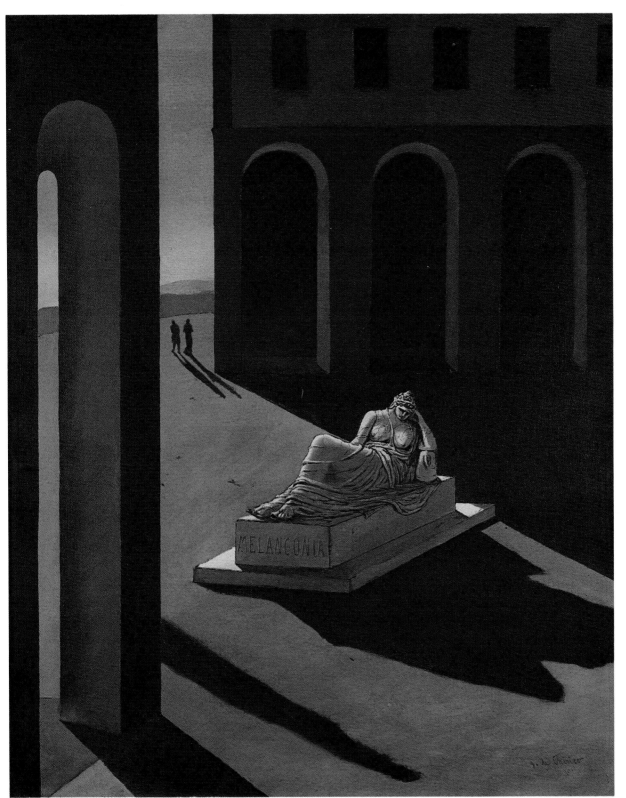

Pl. 12. *Melancholy.* 1912
Oil on canvas, 31 x 25″ (78.8 x 63.5 cm)
Collection Mr. and Mrs. E. Estorick

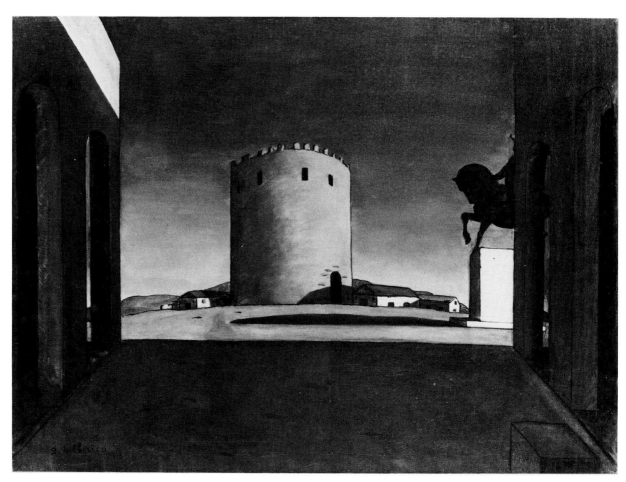

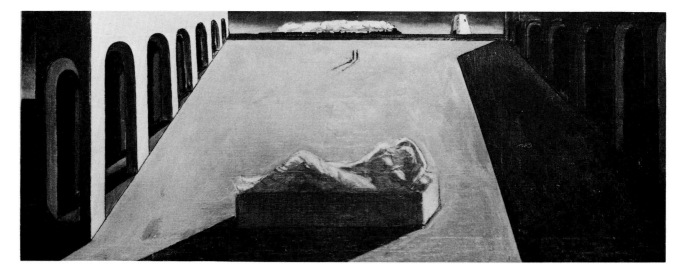

Pl. 13. *The Red Tower.* 1913
Oil on canvas, 29¾ x 39⅜″ (75.5 x 100 cm)
Peggy Guggenheim Collection, Venice,
The Solomon R. Guggenheim Foundation, New York
Formerly titled *The Rose Tower*

Pl. 14. *The Lassitude of the Infinite.* 1912–13
Oil on canvas, 17¼ x 44″ (43.8 x 111.8 cm)
Private collection

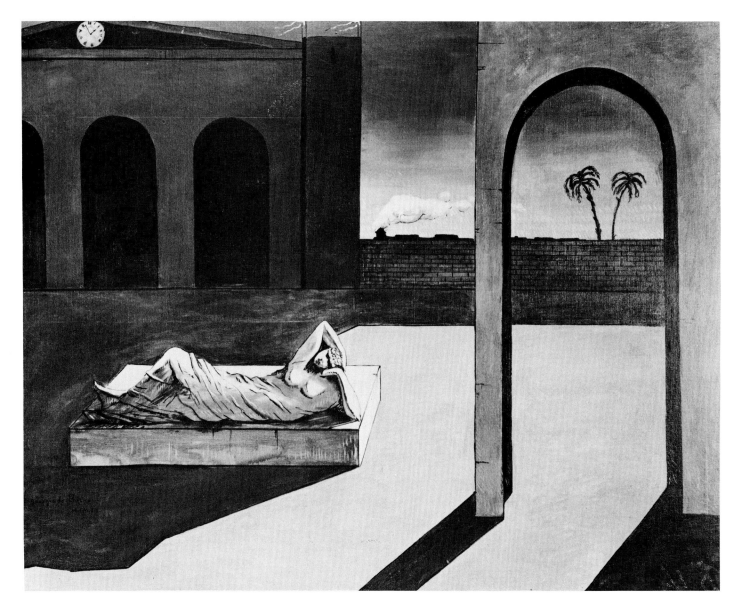

Pl. 15. *The Soothsayer's Recompense.* 1913
Oil on canvas, 53½ x 71″ (135.9 x 180.4 cm)
Philadelphia Museum of Art,
The Louise and Walter Arensberg Collection

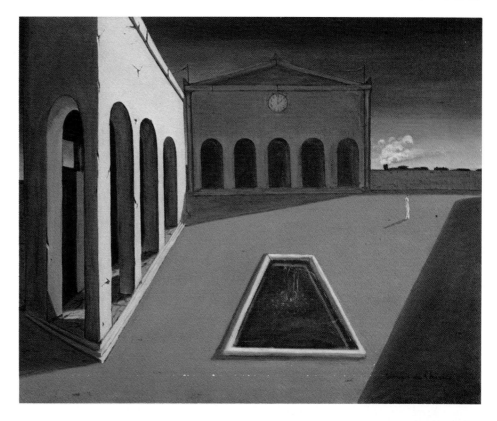

Pl. 16. *The Delights of the Poet.* 1913
Oil on canvas, 27⅜ x 34″ (69.5 x 86.4 cm)
Collection Mr. and Mrs. Leonard C. Yaseen

Pl. 17. *The Joys and Enigmas
of a Strange Hour.* 1913
Oil on canvas, 33 x 51″ (83.8 x 129.5 cm)
Private collection

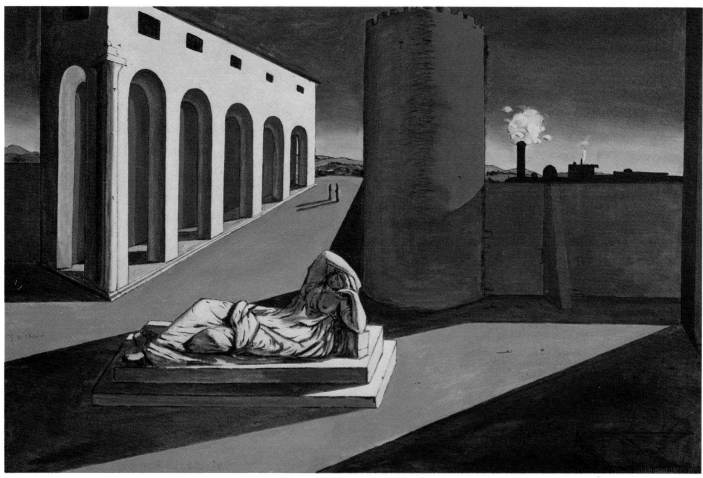

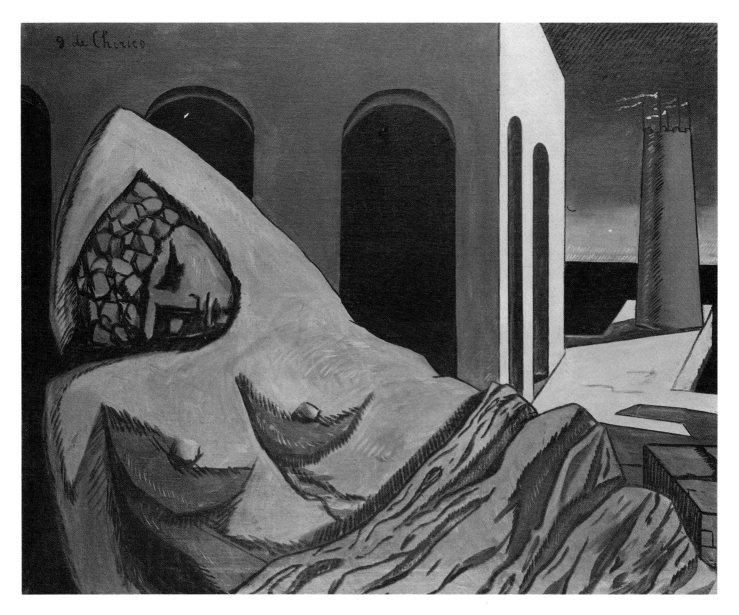

Pl. 18. [*The Silent Statue.*] 1913
Oil on canvas, 39¼ x 49⅜″ (99.5 x 125.5 cm)
Kunstsammlung Nordrhein-Westfalen, Düsseldorf

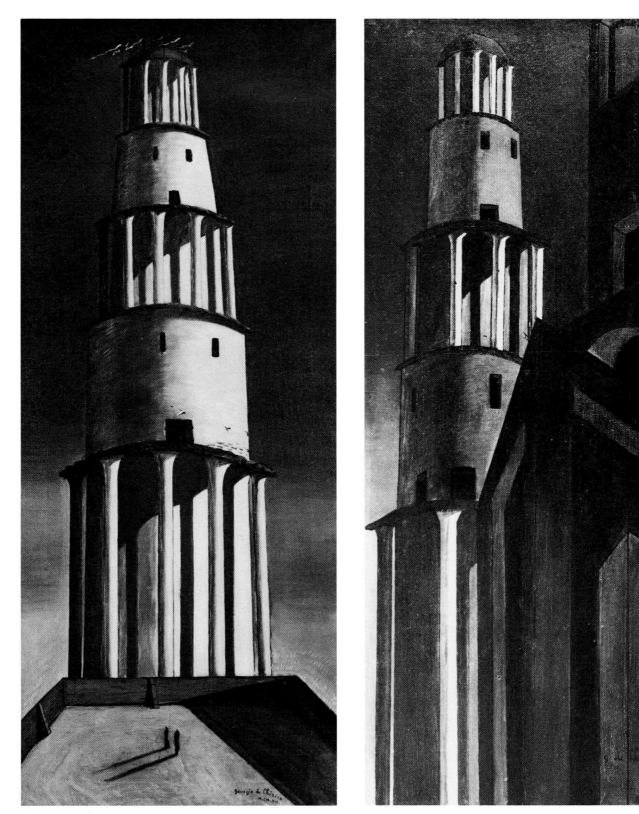

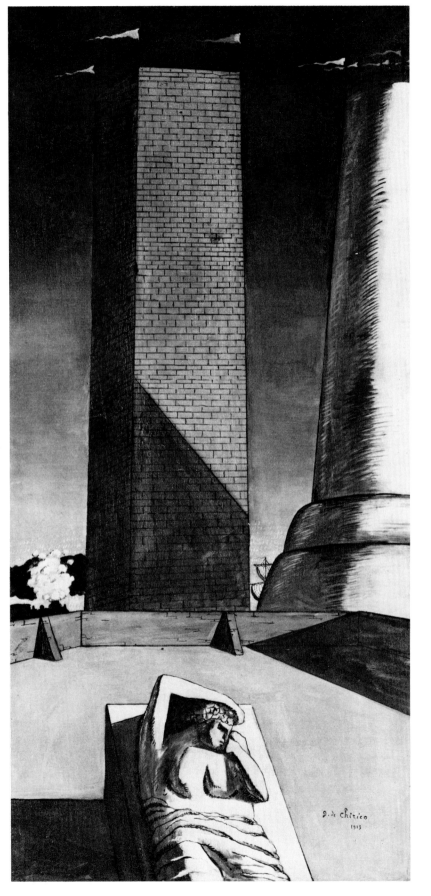

OPPOSITE, LEFT:
Pl. 19. *The Great Tower.* 1913
Oil on canvas, 48⅝ x 20¾″ (123.5 x 52.5 cm)
Kunstsammlung Nordrhein-Westfalen, Düsseldorf

OPPOSITE, RIGHT:
Pl. 20. [*The Tower.*] c. 1913
Oil on canvas, 45½ x 17¾″ (115.5 x 45 cm)
Kunsthaus Zürich, Vereinigung Zürcher Kunstfreunde

LEFT:
Pl. 21. *Ariadne's Afternoon.* 1913
Oil on canvas, 53 x 25⅝″ (134.5 x 65 cm)
Private collection

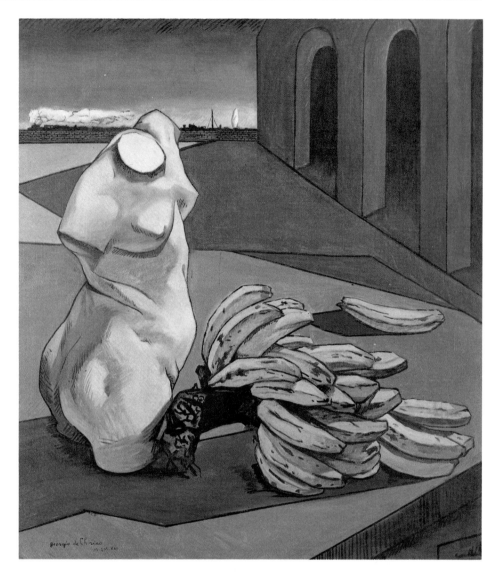

Pl. 22. *The Uncertainty of the Poet.* 1913
Oil on canvas, 41½ x 37″ (105.4 x 94 cm)
Private collection, London

Pl. 23. *The Transformed Dream.* 1913
Oil on canvas, 24¾ x 59⅞″ (63 x 152 cm)
The St. Louis Art Museum, anonymous gift

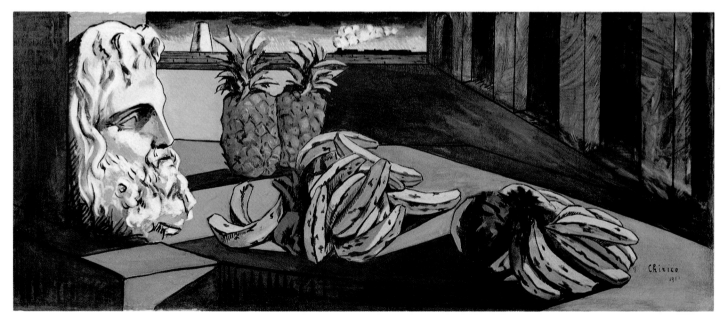

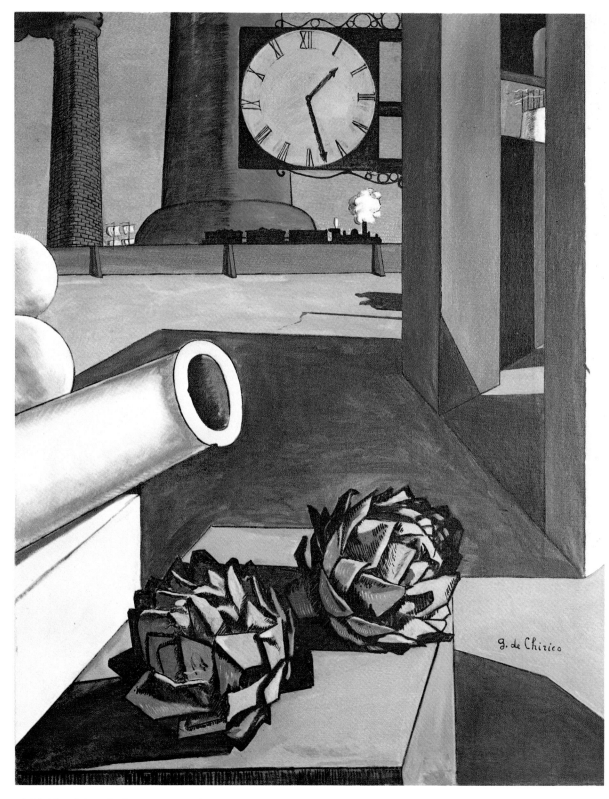

Pl. 24. *The Philosopher's Conquest.* 1914
Oil on canvas, 49½ x 39½″ (125.7 x 100.3 cm)
The Art Institute of Chicago,
The Joseph Winterbotham Collection

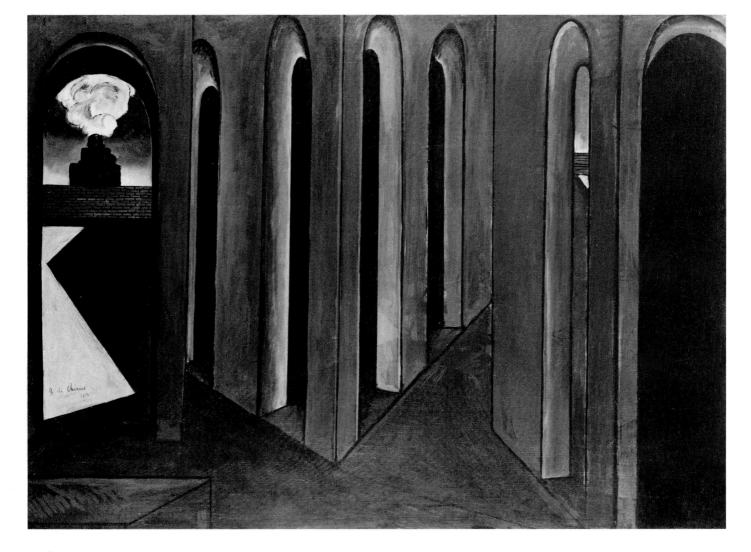

Pl. 25. *The Anxious Journey.* 1913
Oil on canvas, 29¼ x 42″ (74.3 x 106.7 cm)
The Museum of Modern Art, New York,
acquired through the Lillie P. Bliss Bequest

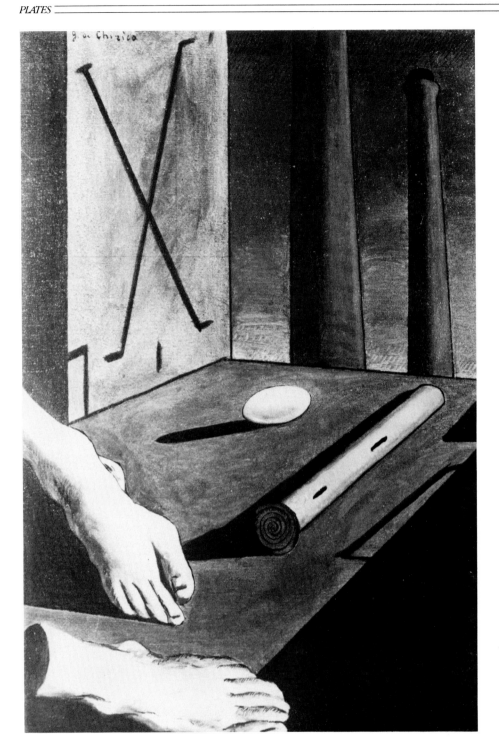

Pl. 26. [*Self-Portrait.*] 1913
Oil on canvas, 32 x 21¼″ (81.3 x 54 cm)
The Alex Hillman Family Foundation, New York

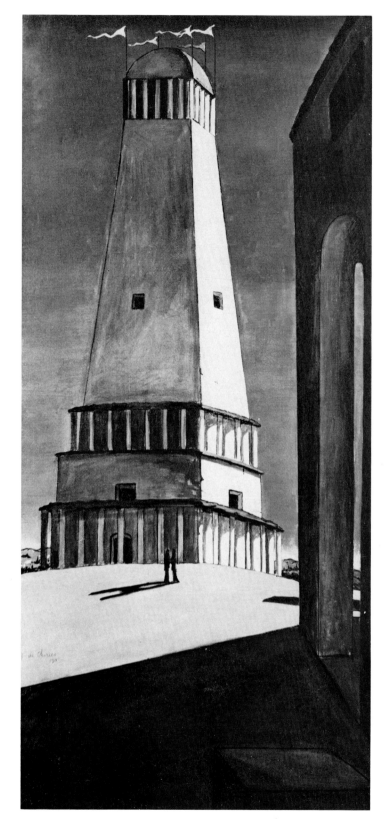

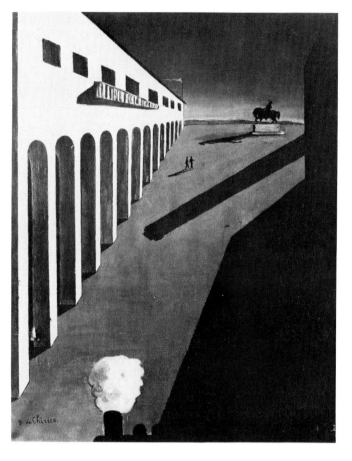

Pl. 27. *The Departure of the Poet.* 1914
Oil on canvas, 34 x 16″ (86.4 x 40.7 cm)
Private collection

LEFT:
Pl. 28. *The Nostalgia of the Infinite.*
(1913–14? Dated on painting 1911)
Oil on canvas, 53¼ x 25½″ (135.2 x 64.8 cm)
The Museum of Modern Art, New York, purchase

OPPOSITE:
Pl. 29. *The Enigma of a Day.* 1914
Oil on canvas, 73¼ x 55″ (185.5 x 139.7 cm)
The Museum of Modern Art, New York,
James Thrall Soby Bequest

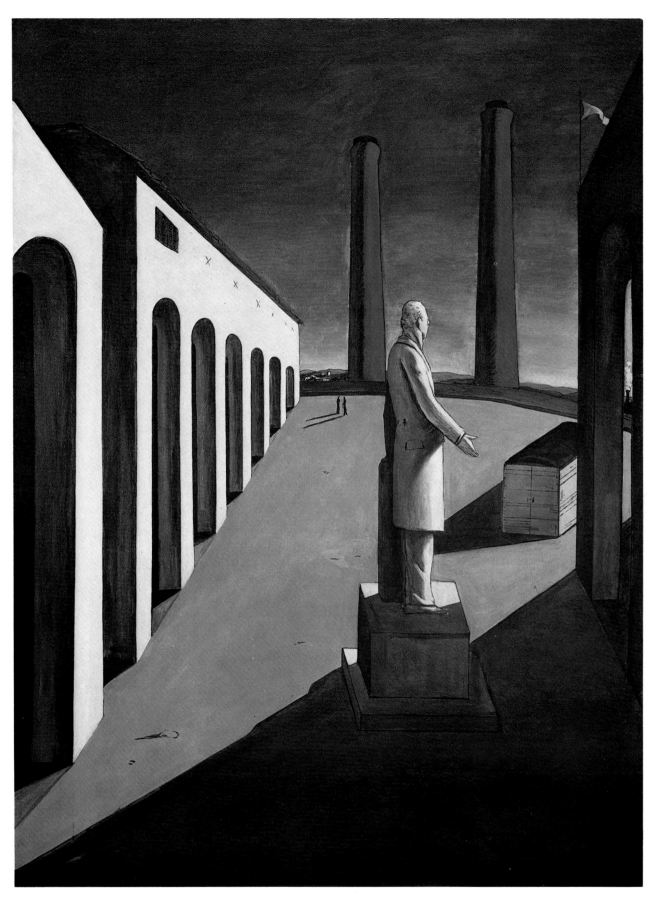

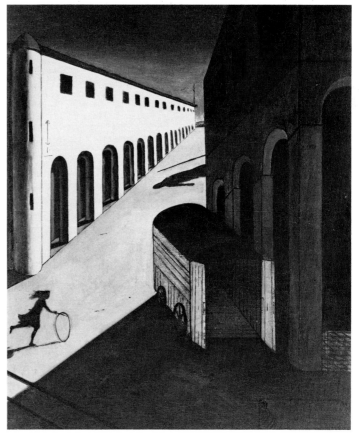

Pl. 31. *The Mystery and Melancholy of a Street.* 1914
Oil on canvas, 34¼ x 28⅛″ (87 x 71.4 cm)
Private collection

Pl. 30. *The Anguish of Departure.* 1913–14
Oil on canvas, 33½ x 27¼″ (85 x 69.2 cm)
Albright-Knox Art Gallery, Buffalo, New York,
Room of Contemporary Art Fund

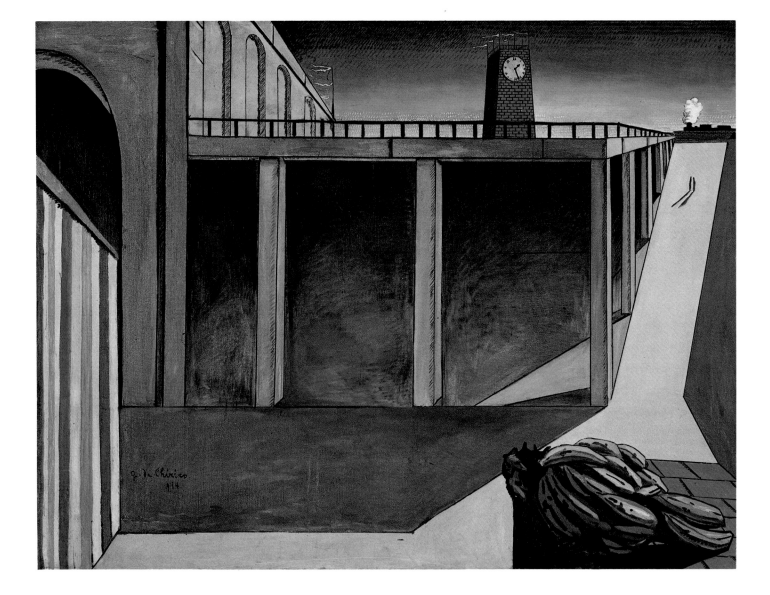

Pl. 32. *Gare Montparnasse (The Melancholy of Departure)*. 1914
Oil on canvas, 55⅛ x 72⅝″ (140 x 184.5 cm)
The Museum of Modern Art, New York, gift of James Thrall Soby

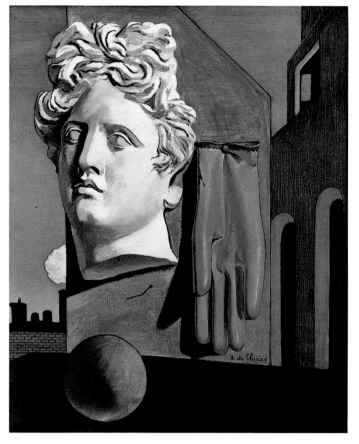

Pl. 34. *The Song of Love.* (1914)
Oil on canvas, 28¾ x 23⅜″ (73 x 59.1 cm)
The Museum of Modern Art, New York,
Nelson A. Rockefeller Bequest

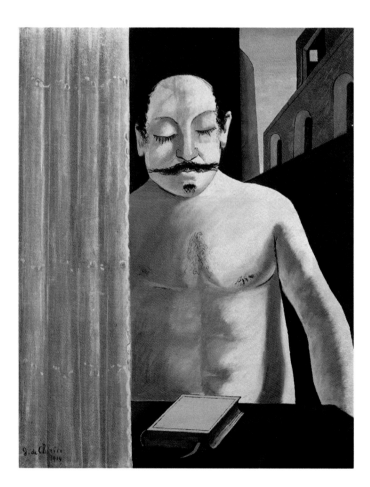

Pl. 33. *The Child's Brain.* 1914
Oil on canvas, 32 x 25½″ (82 x 64.7 cm)
Moderna Museet, Stockholm

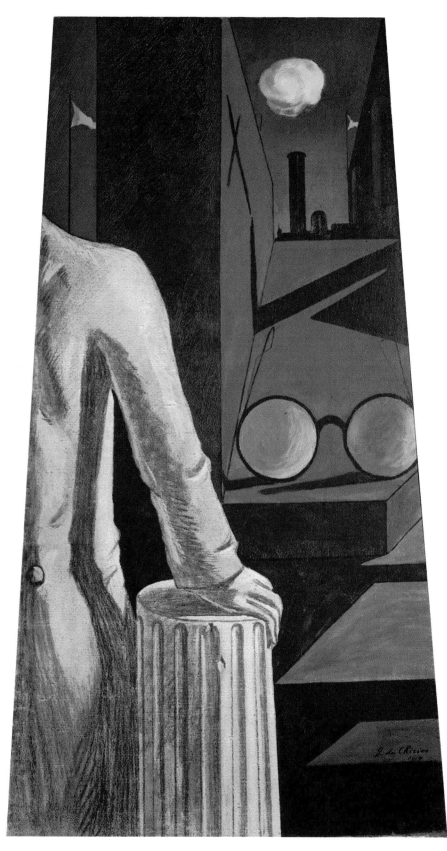

Pl. 35. *The Serenity of the Scholar.* 1914
Oil on canvas, 52 x 28⅝ bottom x 21⅜″
top (132 x 72.7 x 54.3 cm)
Collection Sylvia and Joe Slifka, New Jersey

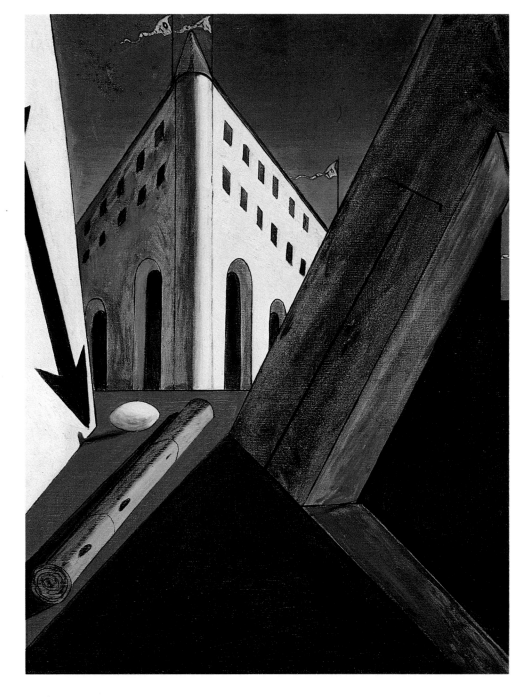

Pl. 36. [*The Fête Day.*] 1914
Oil on canvas, 30½ x 23¾″ (77.5 x 60.3 cm)
Collection Mr. and Mrs. Morton Neumann, Chicago

Pl. 37. *The Enigma of Fatality.* 1914
Oil on canvas, 54⅜ x 37⅞″ (138.1 x 95.5 cm)
Emanuel Hoffman-Stiftung, Kunstmuseum Basel

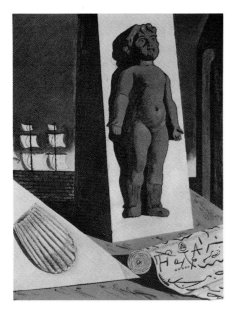

Pl. 38. [*Spring.*] 1914
Oil on canvas, 13¾ x 10⅝″ (35.5 x 27 cm)
Private collection

Pl. 39. *The Fatal Temple.* 1914
Oil and pencil on canvas, 13⅛ x 16⅛″ (33.3 x 41 cm)
Philadelphia Museum of Art,
A. E. Gallatin Collection

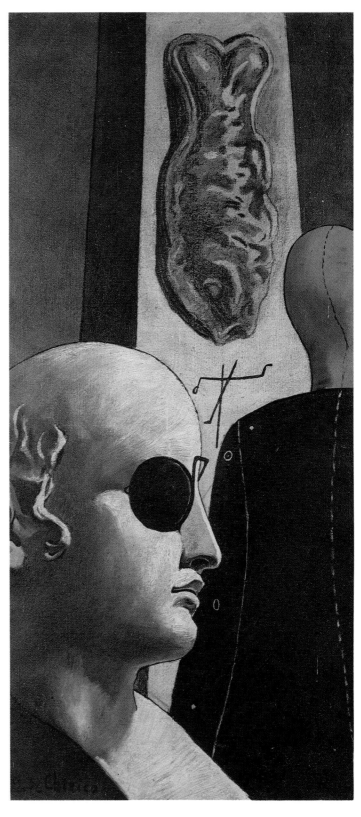

Pl. 40. *The Dream of the Poet.* 1914
Oil on canvas, 35 x 15¾″ (88.9 x 40 cm)
Peggy Guggenheim Collection, Venice,
The Solomon R. Guggenheim Foundation, New York

Pl. 41. *Portrait of Guillaume Apollinaire.* 1914
Oil on canvas, 32⅛ x 25⅝″ (81.5 x 65 cm)
Musée National d'Art Moderne, Centre National
d'Art et de Culture Georges Pompidou, Paris

Pl. 43. *The Endless Voyage.* 1914
Oil on canvas, 34½ x 15¼″ (87.6 x 38.7 cm)
Wadsworth Atheneum, Hartford

Pl. 42. *I'll be there…The Glass Dog.* 1914
Oil on canvas, 27 x 22½″ (68.5 x 57 cm)
Private collection

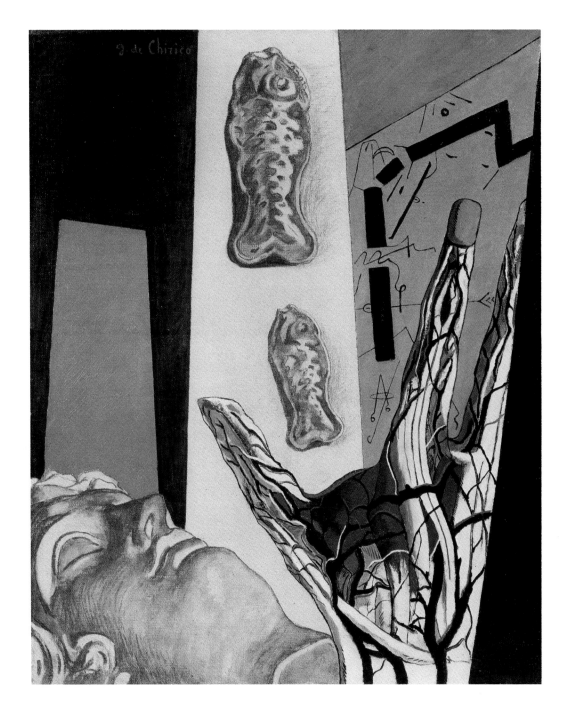

Pl. 44. *The Span of Black Ladders*. 1914
Oil on canvas, 24 x 19⅝″ (61 x 49.8 cm)
Collection Mr. and Mrs. James W. Alsdorf, Chicago

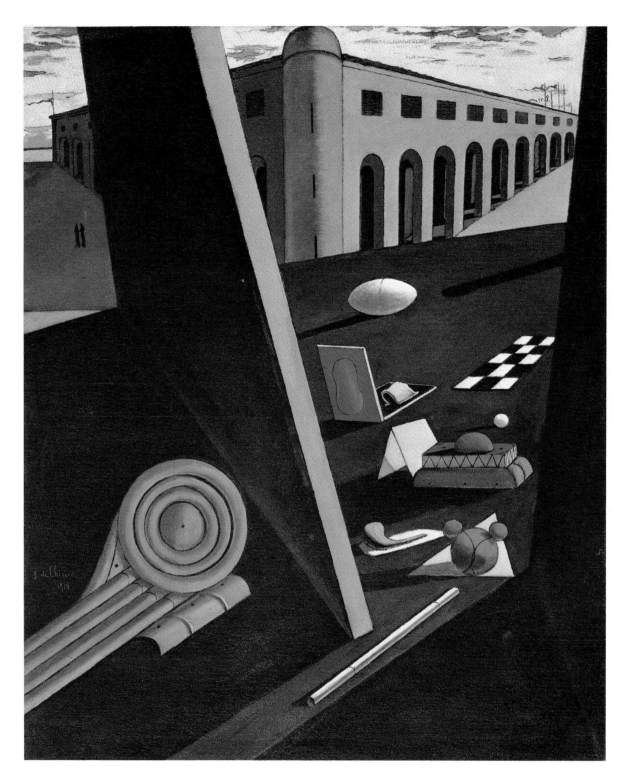

Pl. 45. *The Sailors' Barracks.* 1914
Oil on canvas, 32 x 25½" (81.2 x 64.8 cm)
Norton Gallery and School of Art,
West Palm Beach, Florida

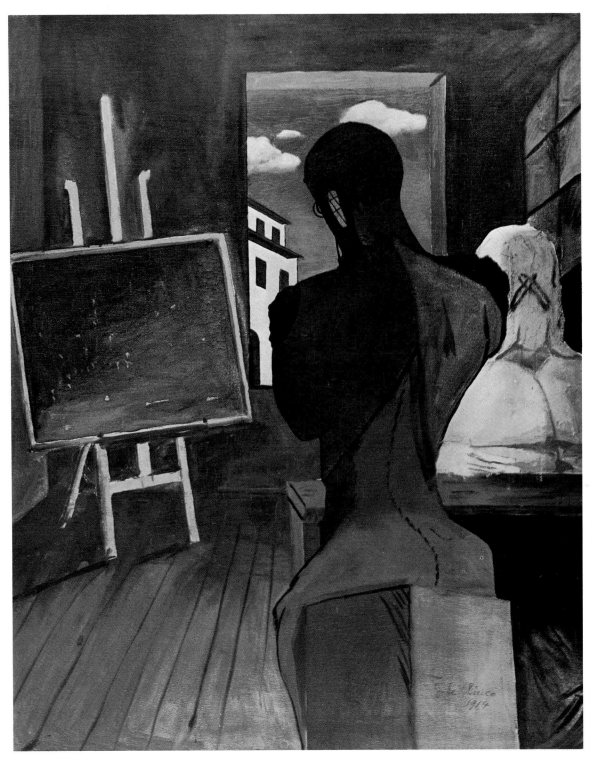

Pl. 46. *The Philosopher and the Poet.* 1914
Oil on canvas, 32¾ x 26″ (83 x 66 cm)
Modern Gallery S.A., Geneva

Pl. 47. *The Evil Genius of a King.* (1914-15)
Oil on canvas, 24 x 19¾″ (61 x 50.2 cm)
The Museum of Modern Art, New York, purchase

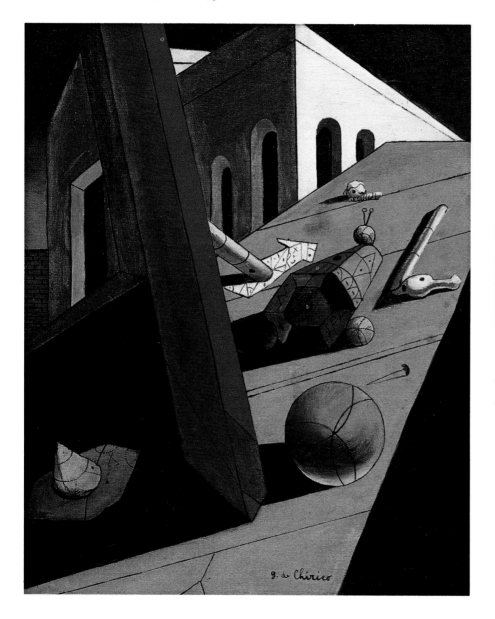

Pl. 48. *Playthings of the Prince.* 1915
Oil on canvas, 21⅞ x 10¼″ (55.4 x 25.9 cm)
The Museum of Modern Art, New York,
gift of Pierre Matisse
in memory of Patricia Kane Matisse

Pl. 49. [*Still Life "Torino 1888."*] 1914-15
Oil on canvas, 23⅝ x 18⅛" (60 x 46 cm)
Collection Rolf and Margit Weinberg, Zurich
Formerly titled *Still Life "Torino 1828"*

Pl. 50. *The Two Sisters.* 1915
Oil on canvas, 21⅝ x 18⅛″ (55 x 46 cm)
Kunstsammlung Nordrhein-Westfalen, Düsseldorf

Pl. 51. *The Astronomer.* c. 1915
Oil on canvas, 15¾ x 12⅝″ (40 x 32 cm)
Private collection, U.S.A.

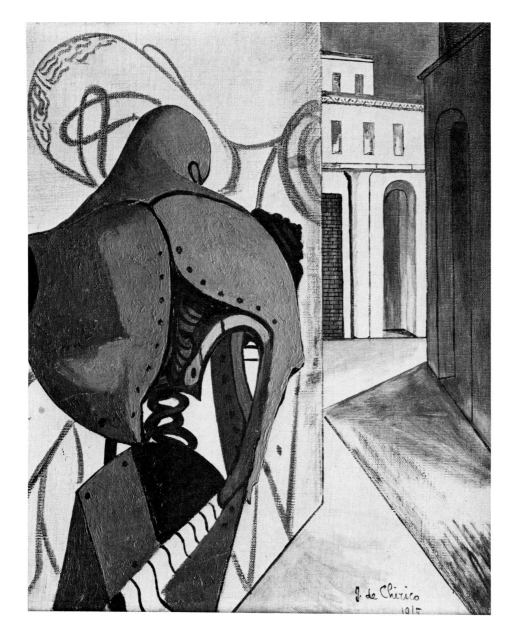

Pl. 52. *The Inconsistencies of the Thinker.* 1915
Oil on canvas, 18¼ x 15″ (46.4 x 38.1 cm)
San Francisco Museum of Modern Art,
Templeton Crocker Fund Purchase

Pl. 53. *The Duo*. 1915
Oil on canvas, 32¼ x 23¼″ (81.9 x 59 cm)
The Museum of Modern Art, New York,
James Thrall Soby Bequest

Pl. 54. *The Double Dream of Spring*. 1915
Oil on canvas, 22⅛ x 21⅜″ (56.2 x 54.3 cm)
The Museum of Modern Art, New York,
gift of James Thrall Soby

Pl. 55. *The Seer.* 1915
Oil on canvas, 35¼ x 27⅝″ (89.6 x 70.1 cm)
The Museum of Modern Art, New York,
James Thrall Soby Bequest

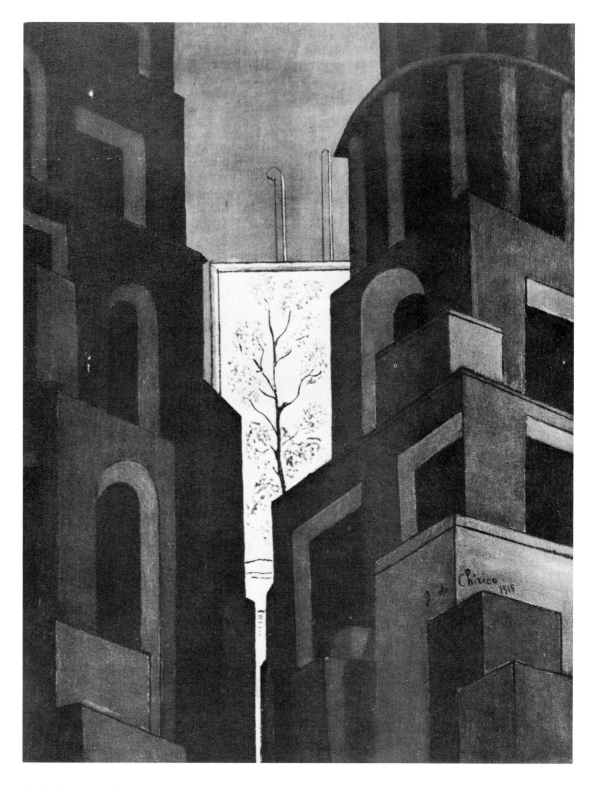

Pl. 56. *The Purity of a Dream.* 1915
Oil on canvas, 25⅝ x 19⅞″ (65 x 50.5 cm)
Private collection

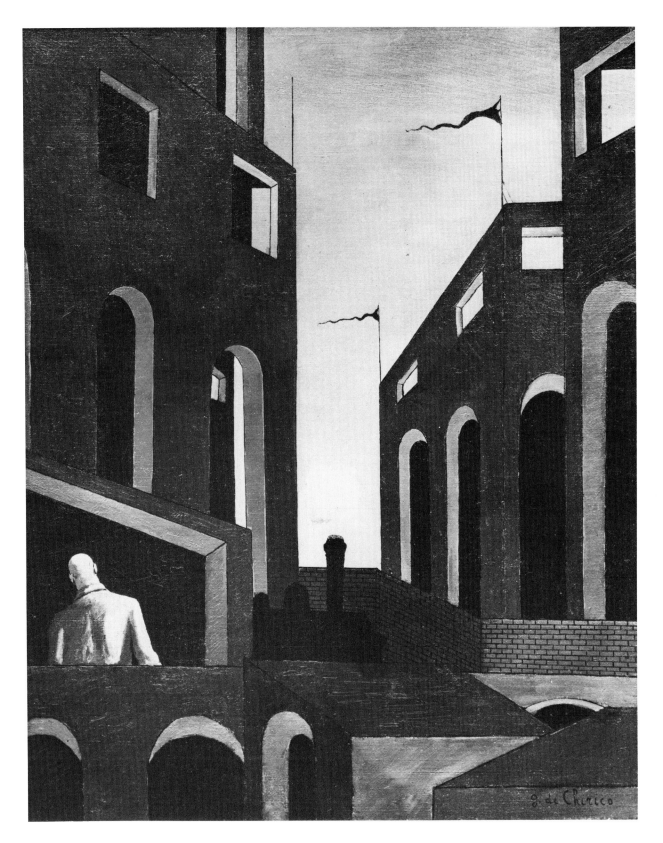

Pl. 57. *The Joy of Return.* 1915
Oil on canvas, 33½ x 27" (85 x 68.5 cm)
Collection Mr. and Mrs. James W. Alsdorf, Chicago

Pl. 58. *The Greetings of a Distant Friend.* 1916
Oil on canvas, 19 x 14½″ (48.2 x 36.5 cm)
Private collection, New York

Pl. 59. *The Jewish Angel.* 1916
Oil on canvas, 26½ x 17¼″ (67.3 x 43.8 cm)
Collection Mr. and Mrs. Jacques Gelman, Mexico City

Pl. 60. *Politics.*. 1916
Oil on canvas, 12⅞ x 10¼″ (32.7 x 26 cm)
Private collection

Pl. 61. *Metaphysical Interior.* 1916
Oil on canvas, 12¾ x 10½″ (32.4 x 26.4 cm)
Private collection, Greenwich, Connecticut

Pl. 62. *The Melancholy of Departure.* 1916
Oil on canvas, 20⅜ x 14¼″ (51.8 x 36 cm)
The Trustees of The Tate Gallery, London

Pl. 63. [*The War.*] 1916
Oil on canvas, 13½ x 10½″ (34.3 x 26.7 cm)
Ophiuchus S.A.

TOP RIGHT:
Pl. 64. [*The Faithful Servitor.*] (1916 or 1917)
Oil on canvas, 15⅛ x 13⅝″ (38.2 x 34.5 cm)
The Museum of Modern Art, New York,
James Thrall Soby Bequest

RIGHT:
Pl. 65. *The Amusements of a Young Girl.* (1916?)
Oil on canvas, 18¾ x 16″ (47.5 x 40.3 cm)
The Museum of Modern Art, New York,
James Thrall Soby Bequest

Pl. 66. *The Revolt of the Sage.* 1916
Oil on canvas, 26½ x 23¼″ (67.3 x 59 cm)
Collection Mr. and Mrs. E. Estorick

Pl. 67. *The Regret.* 1916
Oil on canvas, 23⅜ x 13″ (59.3 x 33 cm)
Munson-Williams-Proctor Institute, Utica, New York

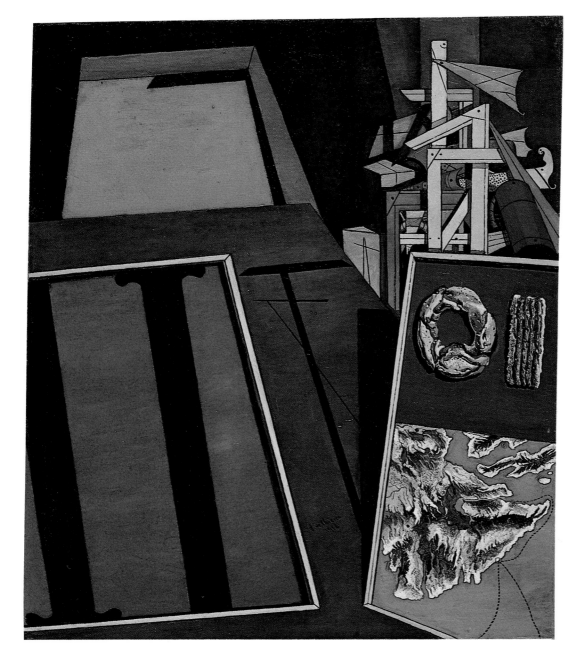

Pl. 68. [*Evangelical Still Life.*] 1916
Oil on canvas, 31¾ x 28⅛" (80.5 x 71.4 cm), irregular
The Museum of Modern Art, New York,
The Sidney and Harriet Janis Collection

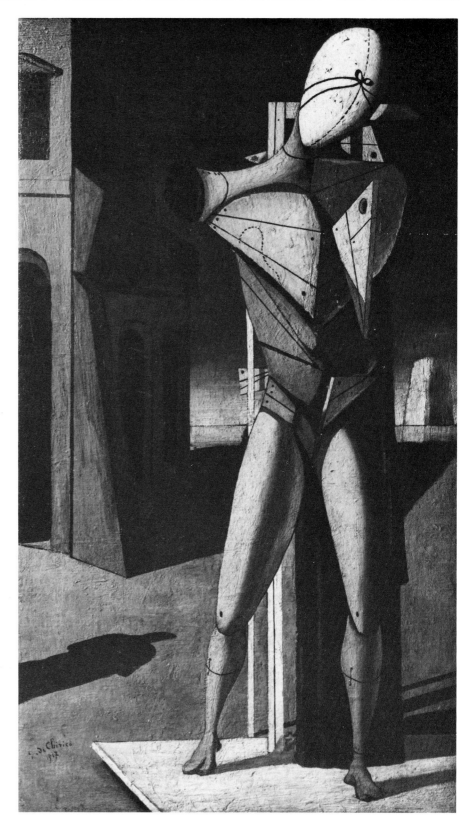

Pl. 69. *Troubadour.* 1917
Oil on canvas, 34¾ x 20⅜" (88.3 x 51.7 cm)
Riccardo and Magda Jucker Collection

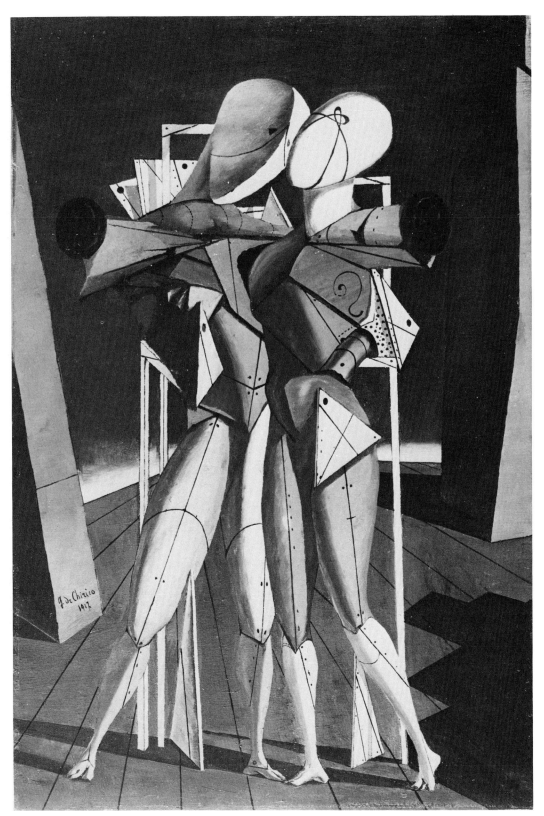

Pl. 70. *Hector and Andromache.* 1917
Oil on canvas, 35½ x 23⅝″ (90 x 60 cm)
Private collection

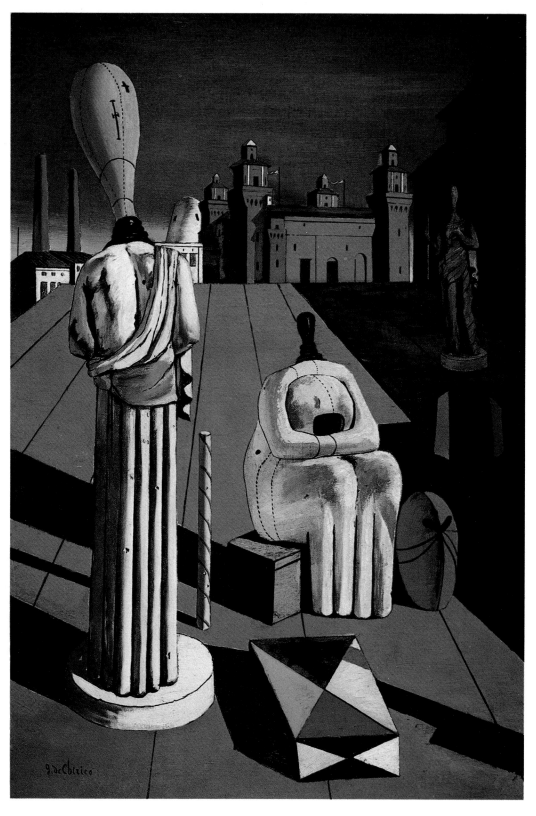

Pl. 71. *The Disquieting Muses.* 1917
Oil on canvas, 38¼ x 26″ (97.1 x 66 cm)
Private collection

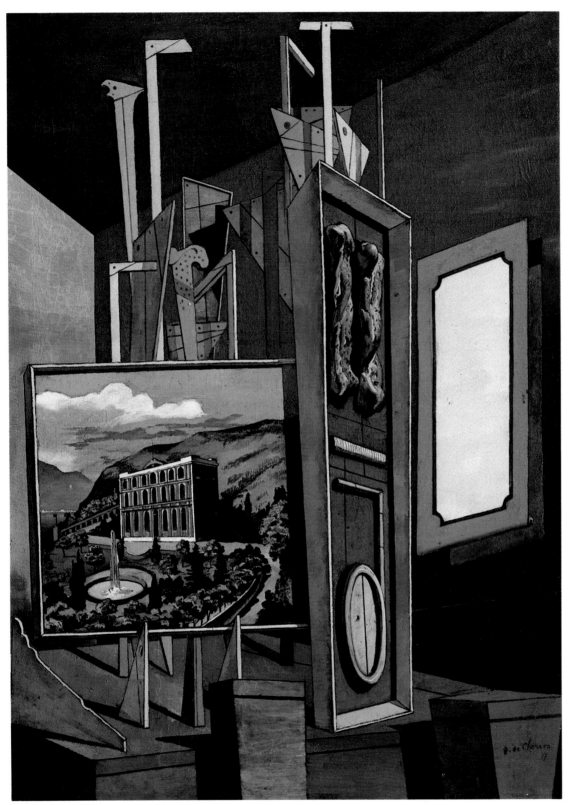

Pl. 72. *Great Metaphysical Interior.* 1917
Oil on canvas, 37¾ x 27¾" (95.9 x 70.5 cm)
The Museum of Modern Art, New York, gift of James Thrall Soby

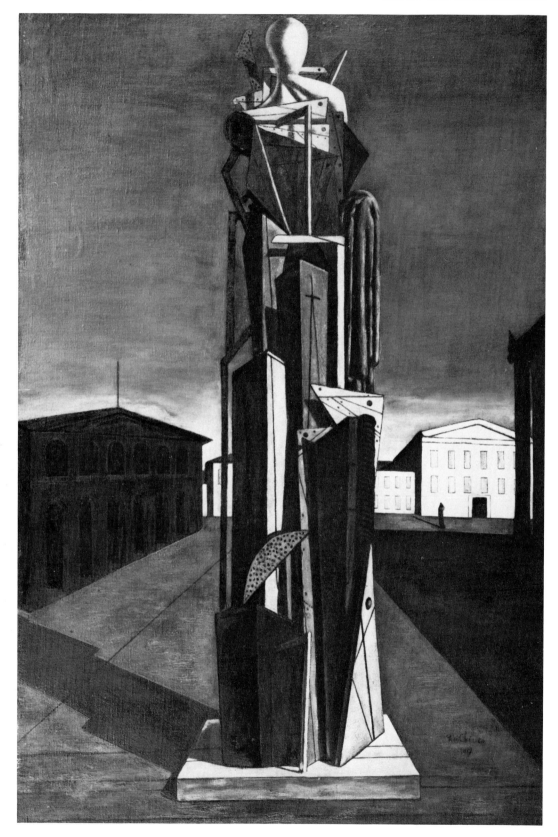

Pl. 73. *The Great Metaphysician.* 1917
Oil on canvas, 41⅛ x 27½″ (104.5 x 69.8 cm)
The Museum of Modern Art, New York,
The Philip L. Goodwin Collection

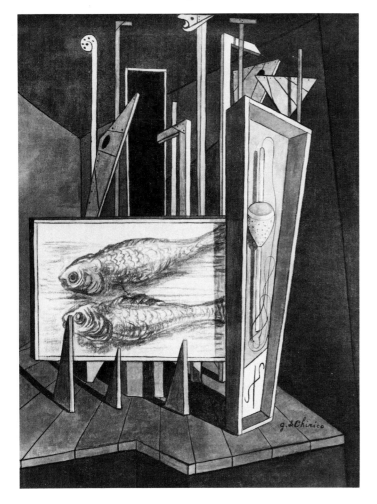

Pl. 74. [*Metaphysical Interior.*] 1917
Oil on canvas, 28⅛ x 20¾″ (71.3 x 52.7 cm)
The Cleveland Museum of Art, purchase,
John L. Severance Fund

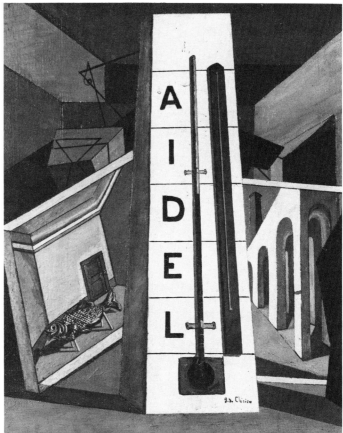

Pl. 75. *The Dream of Tobias.* 1917
Oil on canvas, 23 x 19″ (58.5 x 48 cm)
Trustees Edward James Foundation,
Chichester, England

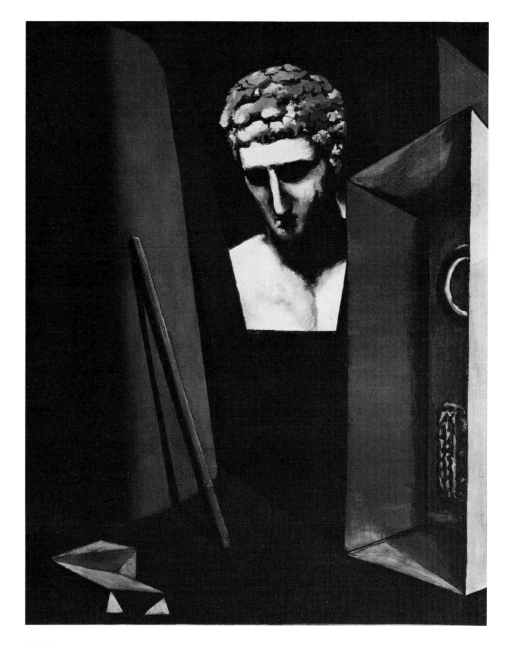

Pl. 76. *Hermetic Melancholy.* 1919
Oil on canvas, 24⅜ x 19¾″ (62 x 50 cm)
Musée d'Art Moderne de la Ville de Paris

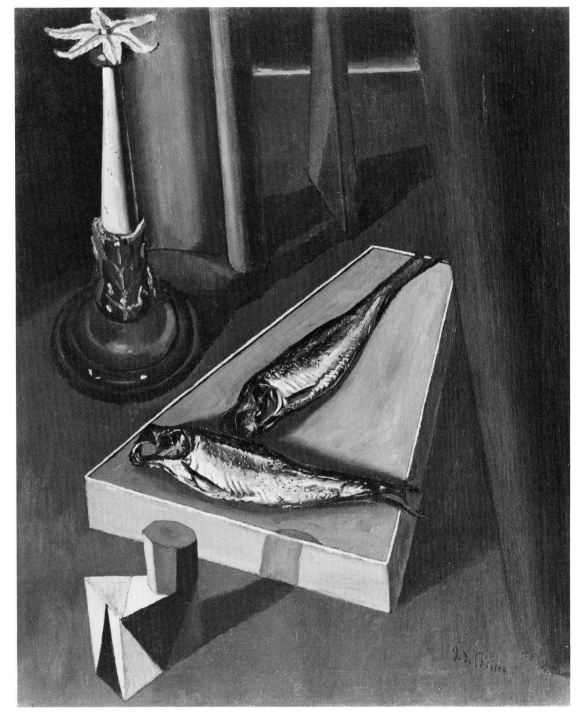

Pl. 77. *The Sacred Fish.* (1919)
Oil on canvas, 29½ x 24⅜″ (74.9 x 61.9 cm)
The Museum of Modern Art, New York,
acquired through the Lillie P. Bliss Bequest

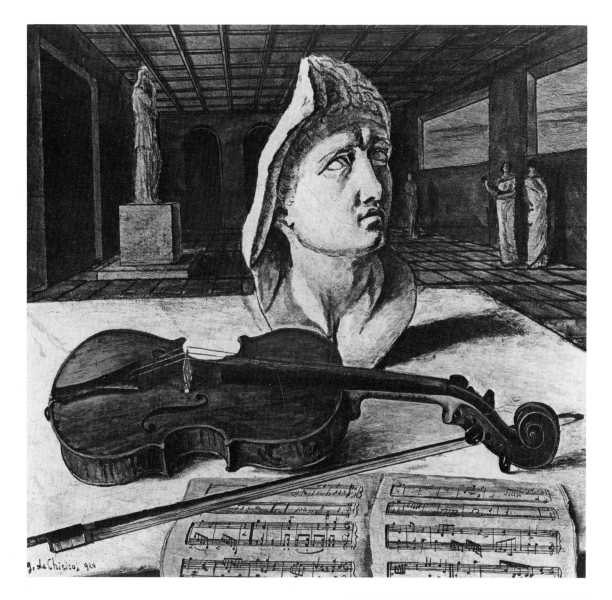

Pl. 78. *The Hall of Apollo* [*The Broken String*]. 1920
Oil on canvas, 25 x 27″ (63.5 x 68.5 cm)
Private collection

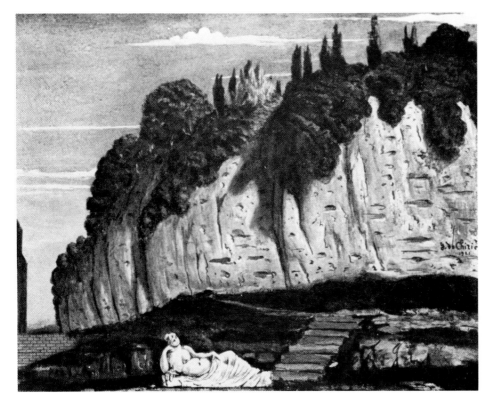

Pl. 79. *Roman Rocks.* 1921
Oil on canvas, 15⅜ x 19¾″ (39 x 50 cm)
Private collection

Pl. 80. [*Italian Square.*] 1921
Oil on canvas, 22 x 29⅞″ (56 x 76 cm)
Private collection

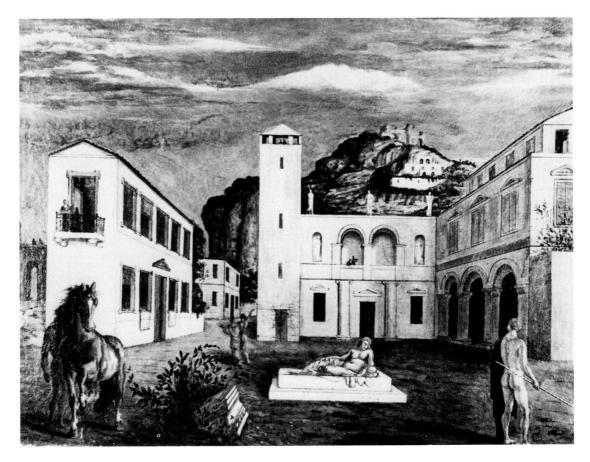

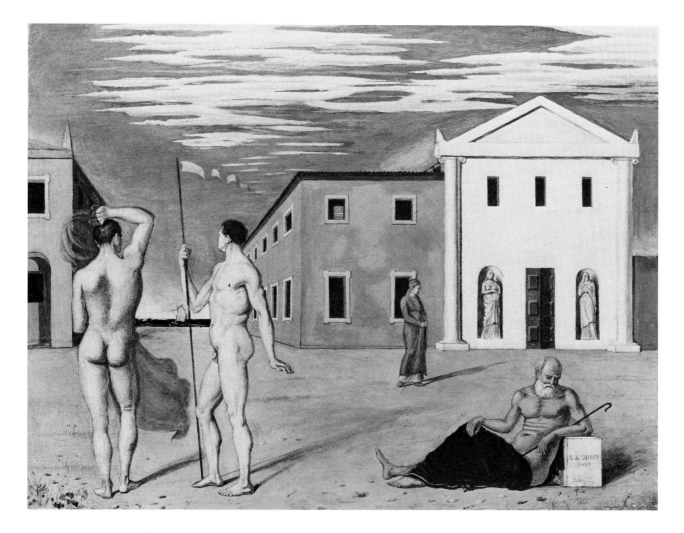

Pl. 81. *The Departure of the Argonauts.* 1922
Tempera on canvas, 21⅝ x 29¼″ (55 x 74.3 cm)
Private collection

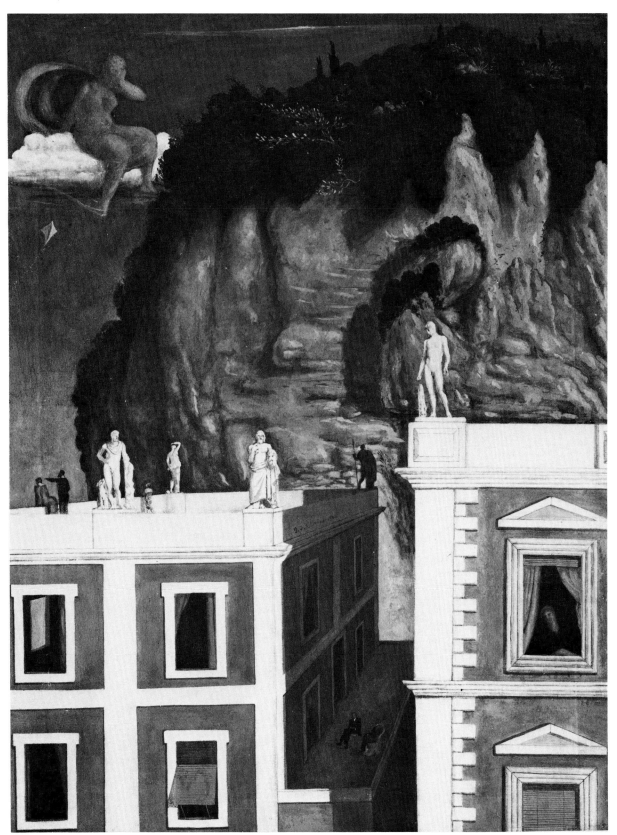

Pl. 82. *Roman Villa.* 1922
Tempera on canvas, 40 x 30″ (101.5 x 76.2 cm)
Collection Giulia Pagliai, New York

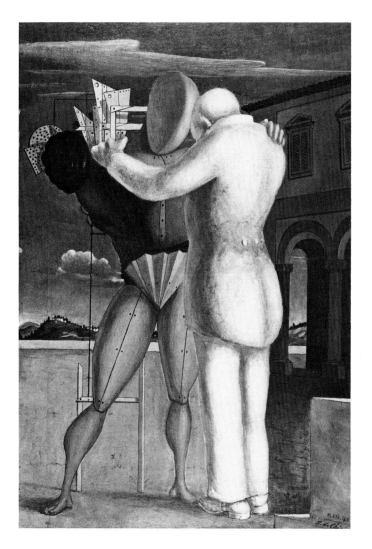

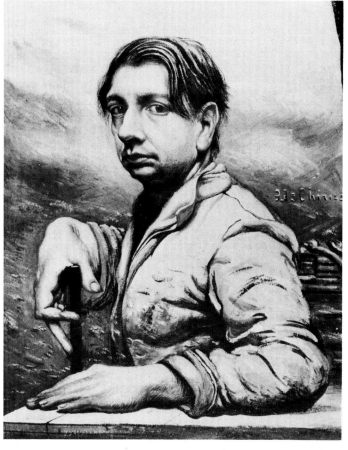

Pl. 84. *Self-Portrait.* 1922
Oil on canvas, 29½ x 24⅜″ (75 x 62 cm)
Collection Giovanni Deana, Venice

Pl. 83. *The Prodigal Son.* 1922
Oil on canvas, 34¼ x 23¼″ (87 x 59 cm)
Civica Galleria d'Arte Moderna, Milan

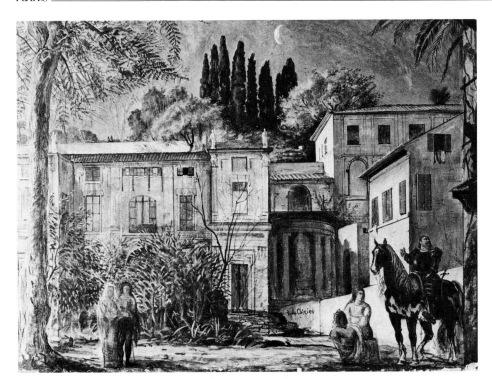

Pl. 85. *The Departure of the Cavalier.* 1923
Oil on canvas, 19⅜ x 26⅜″ (49 x 67 cm)
Private collection, Rome

Pl. 86. [*Florentine Still Life.*] 1923
Oil on canvas, 19⅜ x 25⅜″ (49 x 64.5 cm)
Memorial Art Gallery of the University of Rochester,
gift of Miss Helen C. Ellwanger in memory of Miss Gertrude Newell
Formerly titled *Balcony in Venice*

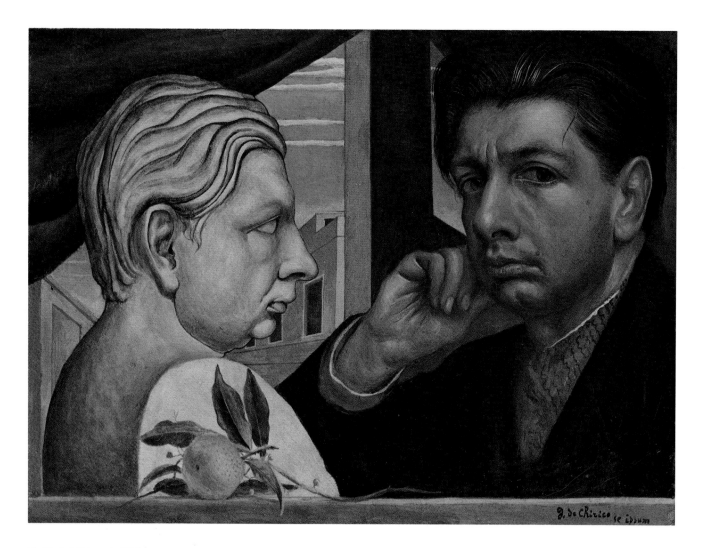

Pl. 87. *Self-Portrait.* 1924
Oil on canvas, 15⅛ x 20⅛″ (38.4 x 51.1 cm)
The Toledo Museum of Art,
gift of Edward Drummond Libbey

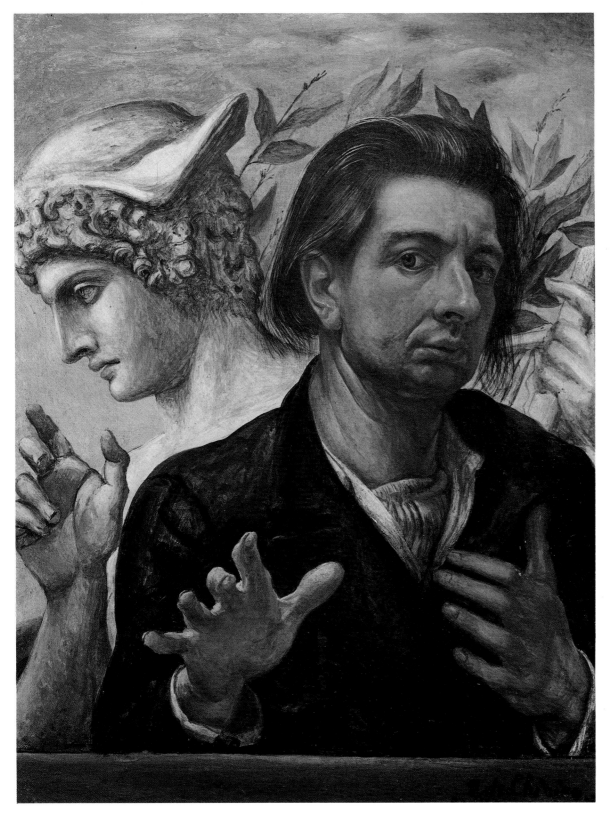

Pl. 88. [*Self-Portrait with the Head of Mercury.*] 1924
Oil on canvas, 25⅝ x 19¾" (65 x 50 cm)
Private collection, Florence

Pl. 89. *The Disquieting Muses.* 1924
Oil on canvas, 38 x 25″ (96.5 x 63.5 cm)
Selma and Nesuhi Ertegun Collection

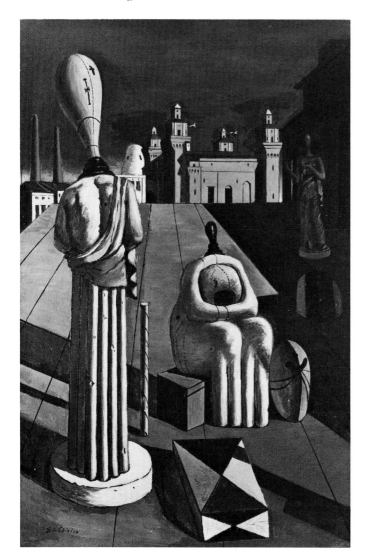

Pl. 90. *The Prodigal Son.* 1924
Oil on canvas, 41⅜ x 27⅝″ (105 x 70 cm)
Private collection

Pl. 91. *The Shores of Thessaly.* 1926
Oil on canvas, 36¼ x 28¾″ (92 x 73 cm)
Private collection

Pl. 92. *Reading.* 1926
Oil on canvas, 36¼ x 28¾″ (92 x 73 cm)
Collection Claudio Bruni Sakraischik, New York

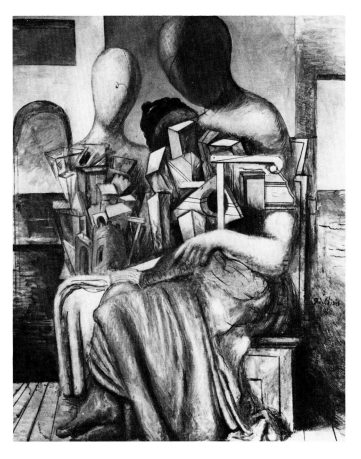

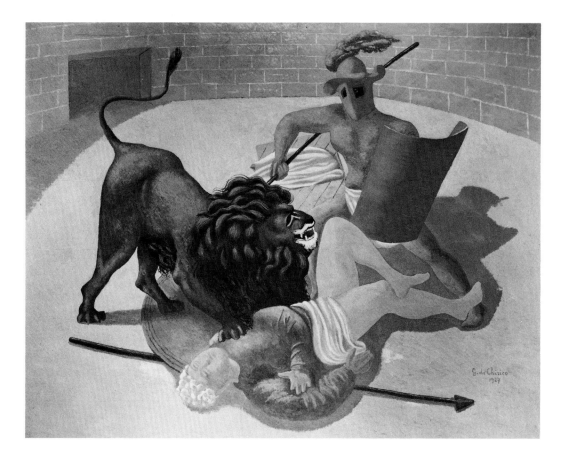

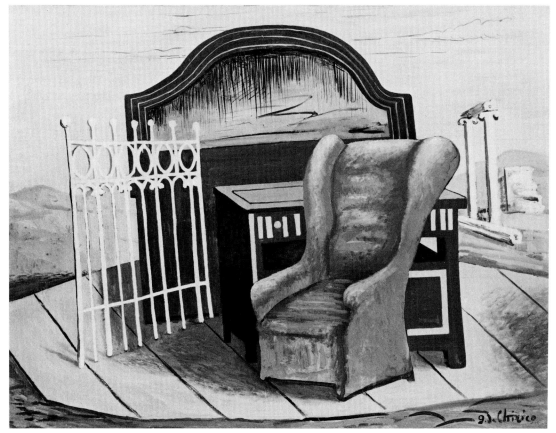

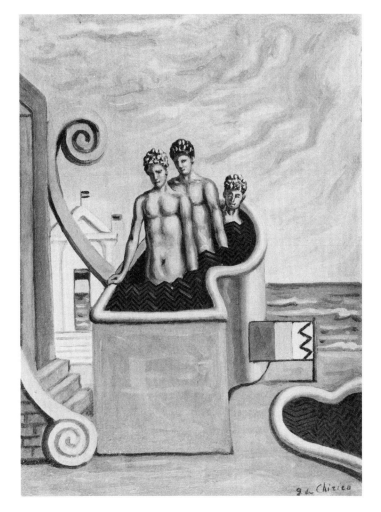

OPPOSITE, TOP:
Pl. 93. *Gladiators and Lion.* 1927
Oil on canvas, 51 x 64″ (129.5 x 162.5 cm)
The Detroit Institute of Arts, gift of
City of Detroit Appropriation

OPPOSITE, BOTTOM:
Pl. 94. *Furniture in a Valley.* 1927
Oil on canvas, 39⅜ x 53¼″ (100 x 135 cm)
Philippe Daverio Gallery, Milan

ABOVE:
Pl. 95. *Mysterious Baths.* 1934
Oil on canvas, 13¾ x 9⅞″ (35 x 25 cm)
Private collection

RIGHT:
Pl. 96. *The Cabana of the Mysterious Bathers.* 1935
Oil on canvas, 28¾ x 19⅜″ (73 x 49 cm)
Private collection

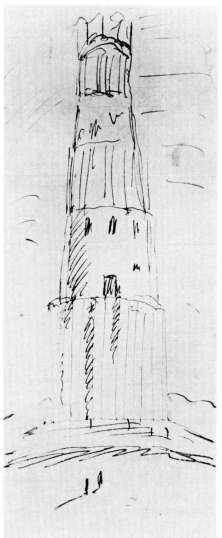

OPPOSITE, TOP LEFT:
Pl. 97. *The Enigma of Arrival.* 1912
Pen and ink and pencil, 8⅞ x 12¼″ (22.5 x 31 cm)
Philippe Daverio Gallery, Milan

OPPOSITE, BOTTOM LEFT:
Pl. 98. [*Italian Square with Statue behind Wall.*] c. 1913
Pencil, 11 x 7⅞″ (28 x 20 cm)
Marie-Louise Jeanneret, Art Moderne, Geneva

OPPOSITE, RIGHT:
Pl. 99. *The Great Tower.* c. 1913
Ink, 8¼ x 3⅝″ (21 x 9 cm)
Collection Jacques Benador, Geneva

ABOVE:
Pl. 100. *The Soothsayer's Recompense.* 1913
Pencil and pen and ink, 5½ x 6¾″ (14 x 17 cm)
Private collection

RIGHT:
Pl. 101. [*The Railroad Passage.*] c. 1914
Pencil and pen and ink, 6½ x 5⅞″ (16.5 x 15 cm)
Giulio Einaudi Editore S.p.A., Turin

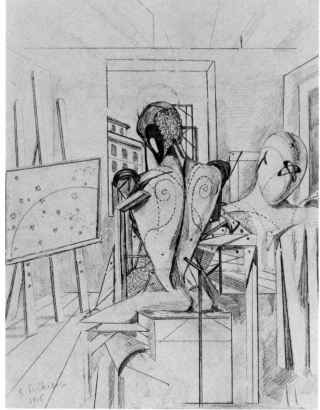

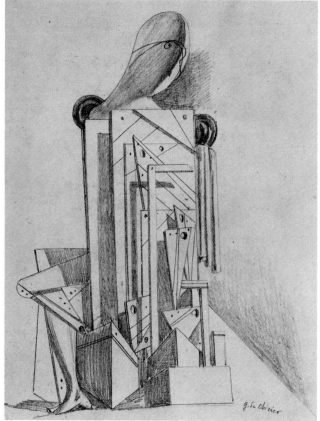

Pl. 102. *The Poet and the Philosopher.* 1914
Pencil, 12⅝ x 9½″ (32.2 x 24.2 cm)
Collection Rolf and Margit Weinberg, Zurich
Dated on drawing 1913 and previously reproduced
as of that date

TOP RIGHT:
Pl. 103. *The Philosopher and the Poet.* 1915-16
Pencil, 11 x 8¾″ (28 x 22 cm)
Galleria Nazionale d'Arte Moderna
e Contemporanea, Rome

RIGHT:
Pl. 104. [*The Condottiere.*] (1917)
Graphite pencil, 11⅝ x 8⅝″ (29.5 x 21.8 cm)
The Museum of Modern Art, New York,
James Thrall Soby Bequest

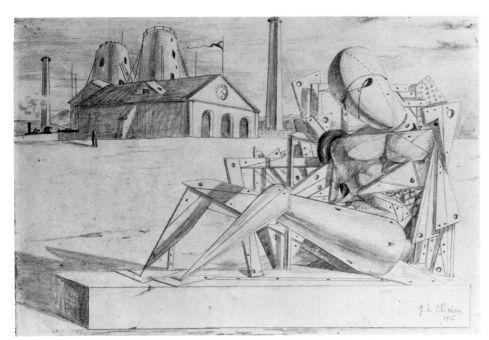

Pl. 105. *Solitude.* 1917
Pencil, 8¾ x 12⅝″ (22.2 x 32.1 cm)
Collection John R. Gaines, Lexington, Kentucky

BELOW:
Pl. 106. *Hector and Andromache.* 1917
Pencil, 8⅞ x 6⅜″ (22 x 16 cm)
Private collection, Switzerland

BOTTOM LEFT:
Pl. 107. *The Duo.* 1917
Pencil, 12⅜ x 8½″ (31.5 x 21.5 cm)
Collection Maramotti, Albinea,
Reggio Emilia, Italy

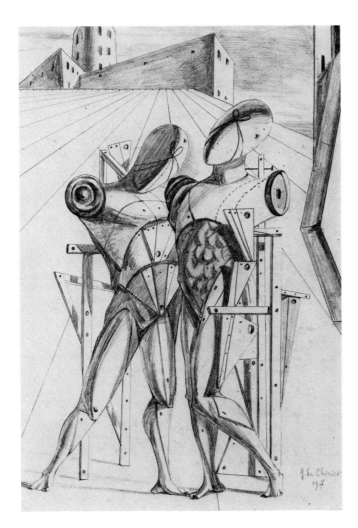

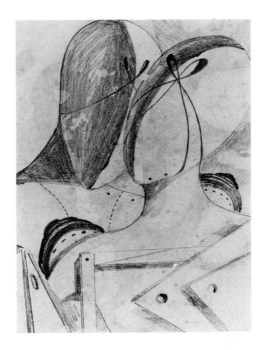

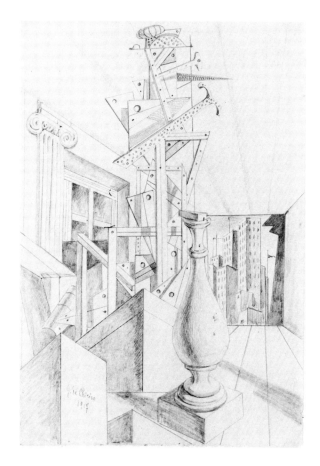

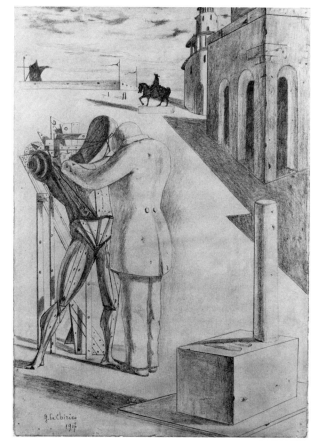

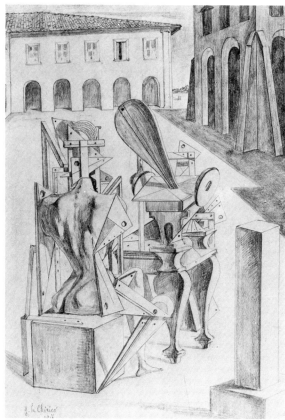

TOP LEFT:
Pl. 108. *Metaphysical Interior.* 1917
Pencil, 12⅝ x 8¾″ (32 x 22 cm)
Private collection

LEFT:
Pl. 109. *The Mathematicians.* 1917
Pencil, 12⅝ x 8⅝″ (32 x 22 cm)
The Museum of Modern Art, New York,
gift of Mrs. Stanley B. Resor

ABOVE:
Pl. 110. *The Prodigal Son.* 1917
Pencil and gouache, 12⅜ x 8⅞″ (31.5 x 22.5 cm)
Collection Judith Rothschild

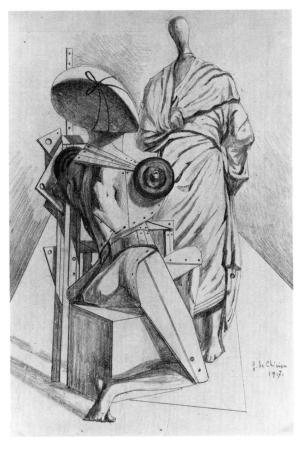

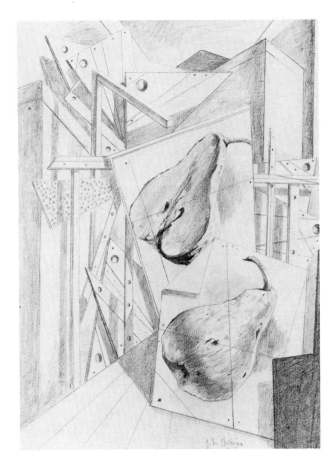

Pl. 111. *Still Life.* 1917
Pencil, 12⅝ x 8¾″ (32 x 22 cm)
Private collection
Formerly titled *Autumnal Geometry*

TOP RIGHT:
Pl. 112. *The Apparition.* 1917
Pencil, 12⅝ x 8⅞″ (32 x 22.5 cm)
Galleria Nazionale d'Arte Moderna
e Contemporanea, Rome

RIGHT:
Pl. 113. *The Faithful Wife.* 1917
Pencil, 12⅝ x 8¾″ (32 x 22 cm)
Galleria Nazionale d'Arte Moderna
e Contemporanea, Rome

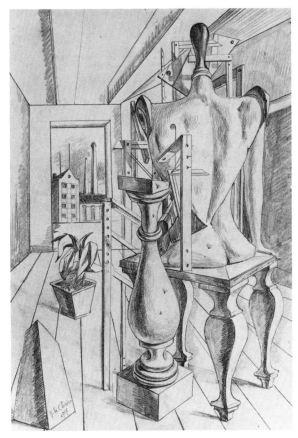

Pl. 114. *The Great Metaphysician*. 1918
Pencil, 12 x 7⅞″ (30.5 x 20 cm)
Private collection, New York

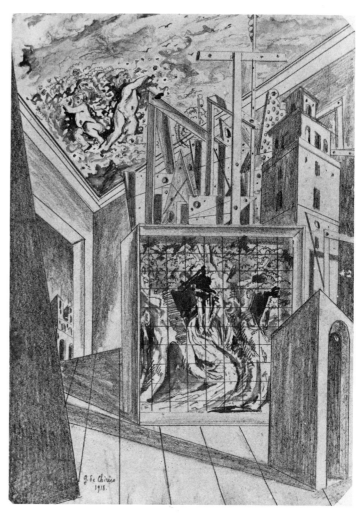

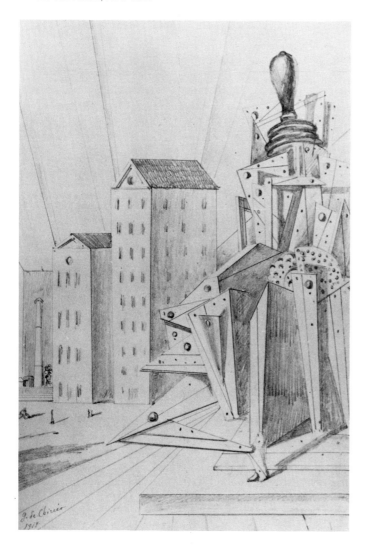

Pl. 115. *The House of the Poet*. 1918
Pencil and watercolor, 12⅝ x 8¾″ (32 x 22 cm)
Galleria Nazionale d'Arte Moderna
e Contemporanea, Rome

Pl. 116. *Portrait of Young Sergio Castelfranco.*
July 1920
Pencil, 8½ x 5½″ (21.5 x 14 cm)
Collection Sergio Castelfranco, Florence

Pl. 117. [*Euripides.*] 1921
Pencil, 12½ x 8½″ (31.7 x 21.5 cm)
The Museum of Modern Art, New York, gift of Mr. and Mrs.
Wolfgang Schoenborn in honor of René d'Harnoncourt

Photograph Credits

Photographs reproduced in this volume have been provided, in the majority of cases, by the owners or custodians of the works, indicated in the captions. The following list, keyed to page numbers, applies to photographs for which a separate acknowledgment is due: